Inventing the Medium

D1592122

INVENTING THE MEDIUM

Principles of Interaction Design as a Cultural Practice

Janet H. Murray

The MIT Press
Cambridge, Massachusetts
London, England

For information about special quantity discounts, please email special_sales@mitpress.mit.edu

This book was set in Stone Sans and Stone Serif by Toppan Best-set Premedia Limited. Printed and bound in the United States of America.

Library of Congress Cataloging-in-Publication Data

Murray, Janet H.
Inventing the medium : principles of interaction design as a cultural practice / Janet H. Murray.
 p. cm.
Includes bibliographical references and index.
ISBN 978-0-262-01614-8 (hardcover : alk. paper) 1. Human-computer interaction. 2. Digital media—Design. 3. Social media—Design. 4. Intercultural communication. I. Title.
QA76.9.H85M87 2012
004.1'9—dc22

 2011007751

10 9 8 7 6 5 4 3 2 1

For my mother, Lillian Horowitz

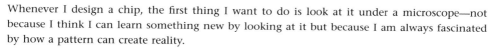

Whenever I design a chip, the first thing I want to do is look at it under a microscope—not because I think I can learn something new by looking at it but because I am always fascinated by how a pattern can create reality.

—Danny Hillis, *The Pattern on the Stone* (1998)

Contents

Acknowledgments

It is a pleasure to acknowledge all the people who were helpful to me in writing this book.

First and foremost I want to thank those very busy people who made time to read draft chapters and to offer me their expert feedback and suggestions, saving me from many errors and making this a much better book: I am enormously grateful to Chaim Gingold, Carl DiSalvo, Ali Mazalek, Gonzalo Frasca, William Murray, Celia Pearce, and Ozge Samanci for reading and commenting on parts of the manuscript and to Shelley Evanson for teaching with it at Carnegie Mellon and giving me her encouragement and feedback. I am also grateful to the anonymous readers for MIT Press whose insights were very helpful to me in the final stages of revision.

I owe a great deal as well to my colleagues, collaborators, research assistants, and students at the two world-class toy shops where I have spent my career: MIT and Georgia Tech. I first learned about computational affordances, project development, and design from working on projects at MIT with Steve Lerman, Glorianna Davenport, Bob Berwick, Doug Morgenstern, Hal Abelson, Henry Jenkins, John Belcher, Claire Kramsch, Gilberte Furstenberg, Kurt Fendt, Pete Donaldson, Shigeru Miyagawa, Phil Bailey, Lestra Litchfield, Andrew McKinney, Michael Privat, Freedom Baird, Stuart Malone, Sue Felshin, Ayshe Farman-Farmaian, Michael Roper, Olga Brown, and Dorothy Shamonsky, and with our Stanford collaborators Larry Friedlander and Charles Kerns. I also learned a great deal from my then-students, especially Nick Montfort, Kevin Brooks, Philip Tan, Marleigh Norton, and the many others who took my interactive narrative course. The projects that we worked on together remain part of my creative imagination; the lessons we learned in those early days of digital media have stayed with me as touchstones of good practice.

I am tremendously fortunate to have been a professor at Georgia Tech since 1999, and although my ten-year stint as director of graduate studies in digital media (DM) certainly delayed the writing of this book, it was more than balanced by the unique opportunity of thinking about design in the context of the innovative theory and practice of my DM colleagues past and present: Jay Bolter, Ian Bogost, Carl DiSalvo,

Brian Magerko, Ali Mazalek, Celia Pearce, Michael Nitsche, Diane Gromola, Fox Harrell, Robert Kolker, Michael Mateas, and Sha Xin Wei. I am also grateful to our media-focused colleagues in literature, communication, and culture and in the interdisciplinary GVU center, and especially to Ken Knoespel and Jay Telotte, to Nancy Nersessian who introduced me to the work of Michael Tomasello and Merlin Donald, and to my fellow faculty investigators in the NSF InTEL project, Sue V. Rosser, Larry Jacobs, Wendy Newstetter, Christine Valle, John Leonard, and Sneha Veeragoudar Harrell. Most of all I am grateful to Sue Rosser for her leadership as dean of the Ivan Allen College of the Liberal Arts at Georgia Tech, during the period 1999 to 2009, which was crucial to the growth of the graduate program in digital media and the establishment of a strong humanities-focused research culture.

I am grateful for the design insights that have come from working with so many talented, experienced, and deeply engaged Georgia Tech students, in courses and in project work. I want to thank all our pioneering PhD students and especially Calvin Ashmore, Hank Blumenthal, Ayoka Chenzira, Clara Fernandez-Vara, Sergio Goldenberg, David Jimison, Hartmut Koenitz, Susan Robinson, and Brian Schrank for their intellectual companionship and creative inspiration. I am enormously grateful to Sergio Goldenberg, Chaim Gingold, Drew Cogswell, and Gunthar Hartwig, who set up and ran several instantiations of my Georgia Tech project lab over the past ten years and generously contributed their deep technical knowledge and design insights to build up a sustained community of practice; to Brinda Cockburn, Sarah Cooper, and Sinhwa Kang, who were my first and wonderfully talented research assistants when I arrived at Georgia Tech; and to Zuley Clark, Karyn Lu, Daniel Upton, and Beth Schechter, who were such extraordinary managers of individual projects.

The Georgia Tech DM and HCI (human–computer interaction) master's degree students have played a crucial role in the evolution of this book, taking LCC 6313 Principles of Interactive Design, which I taught every spring since 2001 and offering me feedback after graduation from their experience in the fast-track worlds of Apple, CNN, Disney, EA, IDEO, IBM, Amazon, Google, Yahoo, Showtime, and other design, entertainment, and information firms. I could not have taught the course at all without the help of expert teaching assistants including Patrick Quattlebaum, Mayhew Seavey, Jason Alderman, Will Hankinson, Micah Horvath, Adam Rice, Joshua Cuneo, and Daniel Fuller. I particularly want to thank the students in the Spring 2010 course who found errors in the near-final manuscript for this book and offered such excellent design examples, including Mariam Asad, Matthew Drake, Daniel Fuller, Shiva Muthiah, Vedrana Novosel, Dilip Patharachalam, Andrew Quitmeyer, Nicole Blackwell, Jayraj Jog, Chip Schooler, and Cory Simon.

I also benefited during this time from many insightful conversations with Will Wright, Dale Herigstad, Nick DiMartino, Joe Garlington, Mary Flanagan, Kate Hayles, Marie-Laure Ryan, Katie Salen, Tracy Fullerton, Espen Aarseth, Chaim Gingold, Gonzalo

Frasca, Jesper Juul, and Eric Zimmerman at Georgia Tech and elsewhere. I am grateful to them all for the inspiration of their work and for the encouragement and constructive challenges with which they have engaged my own projects and theoretical formulations.

I have been very fortunate to have the partnership of MIT Press throughout the long process of writing this book. Doug Sery's patience and encouragement, and his astute insights about the evolving field, have been essential to its creation; I owe him a large debt of gratitude for this and for all he has done to nurture the work of scholars in this young and growing field. I also want to thank his assistant editor, Katie Helke Dokshina, and manuscript editor Mel Goldsipe for their care and expertise in shepherding this large and complex volume through the production process, and Julia Collins for her vigilant and skillful copyediting. I was very fortunate to have the help of PhD candidate Rebecca Rouse in preparing the final page proofs. Many very busy and productive people were kind enough to respond to my requests for permission to use their images and in many cases to supply higher-resolution files, and I am very grateful for these contributions, which are acknowledged in the image credits.

The work of writing this book has benefitted from all of these richly collaborative activities, but any errors in it are mine alone. I thank in advance any readers who can point them out to me for correction on the web and in future editions.

On a personal note, I want to thank my family: my daughter Elizabeth Murray, my son William Murray, and Will's fiancée, April Holm, who have so generously encouraged my obsessions and shared their knowledge and keen insights on media, culture, and technology with me; and my mother, Lillian Horowitz, to whom this book is dedicated, whose own life now spans more than a century, whose mind remains vigorous and open, and who has avidly followed her unexpected baby's circle of attention from century to century, from Victorian women to Holodeck gamers, inspiring me—as she inspires everyone around her—with her energetic optimism, inexhaustible compassion, and relentless advocacy for a more humane and just society.

Introduction: A Cultural Approach to Interaction Design

We are, in sum, incomplete or unfinished animals who complete or finish ourselves through culture.

—Clifford Geertz (1973)

The Collective Process of Design

This book is meant for anyone whose work involves shaping new **digital artifacts** and the systems of behavior in which they are embedded, not just for those with designer in their job title. It aims to complement expertise in related fields such as graphic design, industrial psychology, or programming by providing lead designers and other team members with a set of common principles and a common design vocabulary to aid in the collective **design** process. Unlike other useful books in **HCI** (**human–computer interaction**) or **interaction design**, this book is written from a humanistic rather than a social science or industrial design perspective. One of the most important characteristics of humanistic inquiry is that it accommodates multiple frameworks of interpretation, a habit of mind that is a good fit for the design process, which never has a single right answer and is strengthened by an expanded palette of possibilities.

From a humanities perspective, the design of digital objects is *a cultural practice like writing a book or making a film.* **Culture** is the name we give to the infinite web of meaning that human beings have been weaving for millennia. We participate in culture when we imitate one another's behaviors, adopt common values and practices, share symbolic codes like language, music, or the latest dress style. To see any **artifact** (i.e., any human-made object) as part of culture is to understand how it becomes meaningful through the social activities, thoughts, and actions of the people who engage with it. Humanists understand that cultural objects and practices can be meaningful in many ways. For example, a digital telephone can be understood as a neutral piece of business equipment, a stylish status symbol, an intrusive disruptor of family rituals, or a lifeline between an isolated individual and a distant community. *The humanist designer aims to see as much of this larger web of meaning as possible in order to*

understand the context and connotations of particular design choices. This book provides a method for invoking this wider view of design possibilities, a vocabulary for identifying and characterizing design elements, and a set of principles for making choices within this expanded **decision space**. In referring to this practice as "inventing the medium" I am asserting three foundational design principles:

All things made with electronic **bits** and computer **code** belong to a single new **medium,** the **digital medium**, with its own unique **affordances**.

Designing any single artifact within this new medium is part of the broader collective effort of making meaning through the invention and refinement of digital media **conventions**.

When we expand the meaning-making conventions that make up human culture, we expand our ability to understand the world and to connect with one another.

This book is an effort to support the creation of an expanded range of meaningful cultural artifacts by clarifying the task and providing a unifying framework for many disparate but related efforts.

The design of digital artifacts is very young (a matter of a few decades), compared to the design of alphabets and pencils (measured in millennia), printed books (over five hundred years), or sound and image recording (over a century). Until the invention of the PC around 1980, computers were mostly used as mainframe number crunchers, while only a handful of researchers, educators, and game designers were tentatively exploring the larger symbol-manipulating potential of the machines. Yet now, in the second decade of the twenty-first century, the once-restricted bitstream of numbers has become a global floodtide of images and sounds, flowing across rapidly expanding broadband and wireless networks, and the new generation of digital natives are fluently integrating computer-based devices into their daily lives. In fewer than thirty years we have moved from the cumbersome, colorless, command-driven desktop machine that had to be coaxed into processing simple spreadsheets and text files, to the multitasking and pervasive miniaturized processors that power our indispensable laptops and mobile devices, and are embedded in everything from the walls of banks to the dashboards of cars to the human body.

Digital artifacts pervade our lives, and *the design decisions that shape them affect the way we think, act, understand the world, and communicate with one another.* But the pace of change has been so rapid that technical innovation is outstripping design. We are making too many new things too quickly, with the result that as users of the devices we often feel overwhelmed and unable to take appropriate advantage of the opportunities they offer us. The icon bar of a photo-editing program, word processor, or role-playing game can be as complicated as the cockpit of an airplane. This wealth of possibilities raises our expectations, but the functions are so mysteriously offered or

so compromised by unintended secondary consequences that we can find ourselves spending hours in frustrating trial and error in order to accomplish simple tasks, such as formatting a text document or adjusting the privacy setting in a social networking application. Vital information like a beloved family photo in a personal archive, a credit card number in an online account, or the name of a terrorist in a government database is stranded in an outdated format or falls into the wrong hands, or cannot be retrieved in the right context, with disastrous results. In order to get the benefit of the new digital environment in which we live, we will have to do a much better job of designing it.

This book offers a new framework that I believe can help to speed the process of useful and lasting design innovation by focusing on *the collective cultural task of inventing the underlying medium.*

Designing the Unfamiliar

Designers in established fields are often engaged in a process of *refinement,* creating slightly improved or distinctive versions of a familiar artifact; for example, modifying the familiar metal toaster with cooler ceramic sides or larger bagel-sized slots (figure 0.1). The digital designer is more often inventing something for which there is no standard model, like word processing in the age of the typewriter, or video games in the age of pinball.

There are three problems associated with this situation that differentiate digital design from other design practices.

First, we are dealing with an immature medium, which is much more diffuse and has much cruder building blocks at its disposal than a mature medium like print. Designers can draw on many standardized conventions to make a new history book, newspaper article, magazine layout, or romance novel without much thinking about how it will be produced, distributed, or navigated by the end-user. Any established medium has diverse, elaborated formats and genres that reflect a long collective process of trial and error, offering the designer many generic and specialized components to draw upon in creating a new work.

In some ways it is easier to be innovative in an established domain of practice because of this larger and more differentiated repertoire of components. Stable media provide a reliable framework on which to experiment with useful and pleasing variations. Architecture, furniture, and clothing are always active areas of design innovation because human beings have been sheltering and clothing themselves for millennia, providing a well-stocked cultural inventory to match the range of material possibilities that arise from developing technology and crafts. Similarly, some media formats are old enough and stable enough to be open to innovation without confusion. Print magazines, for example, are a productive area of design because their basic

Figure 0.1
Toasters are composed of known, stable elements that are open to refinement by designers. Ivo Vos's concept toaster on the bottom right is calibrated to propel the toast onto the plate.

components are unchanging but open to stylistic variation. For example when *Wired* magazine appeared in the early 1990s it did not have to invent the table of contents or the page numbering system or the grid-based page layout; it was startlingly innovative by merely restyling familiar elements in a manner that reflected the energy and plasticity of the new digital world. And the stable conventions of magazines are also available for simple **remediation** into digital form (figure 0.2).

But in the digital sphere we have often had to invent the building blocks of design while we are designing the specific artifact. In fact, much of the achievement of the first decades of digital design has been the establishment of such building blocks: the joystick game controller, the point-and-click mouse and cursor, the hypertext link, the search engine,

Figure 0.2
The FlipBoard application for the iPad platform rearranges web content, mimicking the layout of a magazine.

the navigation bar, the online shopping basket, the TV remote control with scrolling channel display. But despite their wide adoption and usefulness, all of these design conventions are now stretched beyond their capacity, outpaced by the exponentially increasing quantities of online information and the escalating demands of users for more functionality and less frustration. Once the pop-up electric toaster was invented in 1919, it could be routinely improved for several decades without drastic change of form or function. Web pages and cell phones, in contrast, have incorporated wholly new functionalities and required new formal conventions almost every year since the mid-1990s. Designers need to become more aware of the process of design as the invention and refinement of media conventions in order to move more quickly toward more mature, coherent, and expressive digital genres.

Second, digital designers inherit too many building blocks that are quite familiar and practical, but suited to legacy media formats, and in conflict with one another. When newspaper editors and television producers work together on a news site should they be thinking in terms of soundbytes or headlines? or both? or neither? Design processes are often stalled by such unproductive attempts to apply legacy conventions to new digital frameworks.

Figure 0.3
Before playing Catan: The First Island, the iPhone version of the popular and appealing board game Settlers of Catan, the player must page through several consecutive screens of dense text like this one to learn the rules.

A robust digital media design process should pay attention to the values of all the relevant design disciplines and media traditions. But designers cannot merely transpose the design criteria of these contributory disciplines onto digital practice. Pages of text that read well in a board game manual can be irritatingly long-winded on a computer or mobile device screen, where the **interactor** expects to be in command of information (figure 0.3). The scrolling text of a news ticker, whose pace and size perfectly suited a billboard in Times Square in 1960, is much harder to follow when compressed at the bottom of a television newscast (figure 0.4). In order to avoid making such mistakes, developers need to become more aware of principles of design specific to digital media, such as the need to establish conventions of semantic segmentation for text in interactive environments.

Third, though we have a well-developed design protocol for user need analysis and user testing of industrial products, users cannot tell us how to resolve problems that require new design strategies. Consumers of digital artifacts often cannot think past the familiar conventions of existing devices and applications, and may even claim to prefer more limited functionality because it is more familiar. Industrial design and the social

Figure 0.4

Right-to-left scrolling text on a television screen creates disturbing gaps in information. If we tune in at this moment we see mention of a bombing, and viewers may not have any way of rewinding to find out where it happened. The convention that remedies this problem displays complete, shorter headlines refreshed with vertical wipes instead of horizontal scrolls.

sciences have methodologies for framing design questions by analyzing the needs and expectations of user communities. But if a needs assessment team had asked people what they wanted a computer to do in 1970 they would not have elicited a desire for the personal computer, let along the iPod or GPS-enabled cell phone. Innovation in digital media design is often driven by a small group of technologists consulting their own desires and targeting user communities that do not yet exist and cannot yet be studied. Sometimes a design team has to get ahead of the expressed desires of users, relying on a prototype to introduce potential users to new possibilities. In such circumstances it is useful to think of the individual project in the larger context of trends that run across the entire digital medium, in order to indentify kindred efforts that may not be immediately visible. For example, the makers of search engines might have paid more attention to online photo albums and digital video archives in the late 1990s if they had recognized the common thread of encyclopedic aggregation of information that was going to make searching as relevant for still and moving images as it already was for text.

If users are unreliable, legacy conventions are inappropriate or conflicting, and existing digital conventions are often inadequate to the task at hand, how can designers make good choices? How do we know what is worth making that has not been made before?

How (Not) to Talk about Design

Design problems involving computer-based interactive artifacts must be solved by bringing multiple forms of expertise to bear, including the very divergent fields of programming and graphic design. But digital design has been hampered by the lack of useful common vocabulary to express common design goals, a problem that this book (and its Glossary) addresses by drawing on multiple fields within a unified approach. But before we begin the conversation we have to clear the air by looking at some common misconceptions about the goals and values of good design.

New Media/Digital Medium

Before we identify how we should design something we need to know what it is that we are designing. Academic departments and even some textbooks have used the blanket term "new media" to refer to the Internet, videogames, computer-based installations, mobile phones, and other artifacts that have been made possible by the rapidly increasing power and decreasing size of computers. The virtue of the term is that it puts computer-based artifacts into the category of **media**, which are aimed at complex cultural communication, in contrast to the instrumental view of computational artifacts as tools for accomplishing a task. "New media" also has the advantage of not specifying a particular application like games or hypertext, and of automatically including whatever is invented in the future. *But the vagueness of the term encourages sloppy thinking about design by suggesting that novelty is the salient property of these phenomena.* Video games and word processors have been around since the 1970s, but they pose design problems that are also found in the most cutting-edge robotics or virtual reality installation. Calling objects made with computing technology "new" media obscures the fact that *it is the computer that is the defining difference not the novelty.* After all, a newspaper printed on a cereal box would be a new medium if it were to appear tomorrow, but no one would refer to it as "new media" because it is not computer based. It can also be confusing to think about media **convergence** or **transmedia** properties, though older media are certainly migrating to digital formats, and entertainment and information products are indeed being linked across platforms. But these are secondary effects of the foundational change that is the arrival of a wholly new form of representation: the networked, programmable computer.

Therefore, throughout this book I argue for the advantage of thinking of digital artifacts as parts of a single new medium, which is best understood specifically as the **digital medium**, the medium that is created by exploiting the representational power of the computer.

Focusing on computation allows us to see all of these disparate artifacts—games, web pages, cell phones, music players, interactive TV shows—as belonging to a single

evolving medium, in which formats that we once thought of as fixed and separate, like spoken and written messages, books and games, movies and file cabinets, television and telephones are being deconstructed into their component parts and reconfigured for interactivity. It also allows us to identify the distinct effects of the **inscription** of information on electronic bits rather than clay tablets or printed books, and its **transmission** across space and time through binary codes rather than analog waves. Most of all, as we will be exploring in detail, it allows us to focus on the *four representational properties* of digital environments (the **procedural**, **participatory**, **spatial**, and **encyclopedic** affordances) that provide the core palette for designers across applications within the common digital medium.

Intuitive/Transparent

"Intuitive" is by far the most abused word in digital design and it is one that should perhaps be banned for a decade or so until it can once more be employed meaningfully. Properly used, intuitive means drawing on our unconscious expectations about how things behave, expectations that come from experience and from ideas about the world that we have internalized so deeply that we don't think about them consciously. Intuitions about the world are often based on repeated experience (like our intuitions about balancing things, based on our repeated experiences with gravity) or established conventions (like our intuition that a big red button on a device will turn it on and off). As Donald Norman pointed out in his classic work *The Design of Everyday Things* (Norman 1988), we expect doors to open when we push or pull them, and if something new looks like a door we will look for the design cues that we should push it or pull it, without consciously reasoning. Intuition is also acquired by expert practice, becoming **tacit knowledge** that is hard to transmit because a skilled practitioner does not employ it consciously; for example, we are able to intuitively apply the rules of grammar in our native language without being able to explicitly state them. It is an appropriate design strategy to exploit the interactor's unconscious expectations and knowledge to cue their interaction with a new artifact or process, making the experience feel "intuitive" rather than difficult to understand or hard to learn. But the designer or critic of the design should be able to name the conventions that make the **interface** seem familiar and to identify the reason why it works. For example, a trash can icon provokes an "intuitive" response that it is for deleting files because it looks like something that serves a similar function in the real world and because it has become a standard symbol in computer interfaces. Swiping to the right also feels "intuitively" right as a way to delete an email on an iPhone because it mimics the gesture of flicking something off a physical surface and the left-to-right orientation mimics the progression of western text.

 It is important not to confuse a desire to give the interactor a satisfying experience that feels intuitive because it is so well thought out, with a magical faith in the designer's creative

intuitions. While it is essential to encourage creativity and exploration in the design process, intuitive design is rarely the result of lucky guesses. In order to make truly intuitive interfaces, designers must be hyperaware of the conventions by which we make sense of the world—conventions that govern our navigation of space, our use of tools, and our engagement with media. Furthermore, designers must be able to distinguish among the many possible conventions that can be employed in any application and decide which one is best suited to the artifact they are making. Intuition is a poor way to make that judgment, since we have so much unconscious knowledge to bring to any situation. Should a device that is combining the functions previously performed with a telephone, a typewriter, and an appointment book draw on our intuitions from one or all of these?

A better design value than intuitive is **transparent**: a good interface should not call attention to itself, but should let us direct our attention to the task. Interfaces can be immediately transparent, like a conventional light switch in a room we have never been to before, or easy to learn like the mouse pointer was when first introduced. Both of these examples are intuitive because they provide immediate **feedback** when we manipulate them, and because they exploit the ease with which we absorb binary relationships like up/down, on/off, left/right, and the close mapping between hand and brain. Once we have learned how to use a light switch, we have a strong, taken-for-granted expectation that flipping the switch turns the light on. If we encounter a new object with an up/down switch, such as a digital sound mixer, we will intuitively assume that the up position is the on position because we will be drawing on our tacit experiential knowledge of the world. Instead of trying to create a magically intuitive interface by an unspecified process, designers should consciously exploit the user's preexisting knowledge by looking for familiar interaction patterns that will be easy to learn and will quickly become transparent.

Interface Design/Interaction Design

Interface is a convenient but imprecise term for the outward appearance, the visible control and feedback apparatus, for interactive devices. The interface is what the user sees and operates; it sits between the machine and the person, like the knobs and dials on a toaster, or the icons on a computer screen. In industrial design, psychologists and graphic designers have long worked on creating interfaces like control panels for machinery or home appliances with the object of making them easier to operate and more "usable." Similarly, in the early days of digital design, graphic designers were often brought in at the end of the development process and asked to create visually appealing "user-friendly" interfaces to wrap around the functional but unsightly code created by a separate team of programmers. This model has been replaced by a more inclusive design process and a focus on the **interaction** between the human being and the automated system.

The design of any computer-based object or environment goes beyond the outward appearance to include the architecture of the code and the expectations of the user. Although it is still useful in some contexts to refer to an interface, and to think about the interface design as a distinct part of the design process, **interaction design** is the more appropriate term for capturing the many aspects of the system that have to be the subject of coordinated design decisions, including social and cultural elements as well as technical and visual components.

Interaction design can be applied to any system of behaviors, and need not involve digital artifacts. Although this book emphasizes the specific affordances of the digital medium, it is consistent with design programs that employ a transmedia approach to interaction design, resting on the same premises: the primacy of interaction and the interpretation of artifacts as part of larger social and cultural systems.

User/Interactor

In HCI research we often refer to the human being as the **user.** This is another convenient but narrow and somewhat outdated term like "interface," reflecting a model of the computer as a tool that we put to use. We might think of someone as a user when they are setting a digital alarm clock or entering data in a spreadsheet program, but it seems much less appropriate for someone flying over a virtual landscape in a social networking world or shooting zombies in a cell phone video game. In this book we will refer to the "user" from time to time because it is a convenient and well-understood term, but we will always think of the human being more inclusively as the **interactor,** someone who is not so much using a device as acting within a system. Interactors focus their attention on a computer-controlled artifact, act upon it, and look for and interpret the responsive actions of the machine. A user may be seeking to complete an immediate task; an interactor is engaged in a prolonged give and take with the machine which may be useful, exploratory, enlightening, emotionally moving, entertaining, personal, or impersonal. Interactors are also engaged with one another through the mediation of the machine, and with the larger social and cultural systems of which the automated tasks may only be a part. By designing for interactors rather than users we remind ourselves of the larger context of design beyond mere usefulness.

Content/Information

Starting in the 1990s as CD-ROMS and the Internet become widespread, those seeking to develop products for the new digital **platforms** started to talk about "content providers" and "content" as separate from the "technology." The problem with this way of thinking is that there is no such thing as content without form. Everything we put into the digital medium has to be explicitly shaped for it. Otherwise we are just using the computer as a fat telephone wire for shipping old-fashioned media artifacts around

the world. When we think of digital artifacts as content that is transported by technology we lose sight of an important focus of design, which is the medium: the point of intersection between the logical patterns of the technical layer and the cultural web of meaning in which human beings live. *When the technical layer changes, the possibilities for meaning making change as well.* The agenda for filmmakers in the beginning of the twentieth century was not to get better and better at photographing plays, but to figure out how to use the camera and the plasticity of film to invent movies. Attempts in our era to use computers to imitate books or television sets are equally shortsighted. Content is not a useful concept for designers because digital design is not about filling a neutral technical container with a preexisting package; digital design is about shaping interaction within new combinations of the **format** and **genre** conventions that make up a new medium.

Information is a more useful term than **content** for what media convey, because it points us toward issues of **information design,** such as how best to label and organize media segments so that we can retrieve and navigate them Thinking of legacy genres as information rather than content also allows us to focus on the organizational features of the **legacy media** that we otherwise take for granted, such as the division of television shows into thirty- and sixty-minute segments with commercial breaks, or books into pages and chapters, or newspaper articles into headlines and leads, and how these genre conventions reflect the affordances of analog broadcast or ink on paper and the social and economic arrangements that support them. As designers we should be looking for ways to restructure legacy formats to create satisfying interactions and more expressive genres by exploiting the affordances of the digital medium.

Interactivity/Agency

As we will be discussing in chapter 2, **"interactivity"** is an overused term that can be confusing when invoked as the goal of design. Properly understood, interactivity refers to the combination of the procedural and participatory properties of the digital medium: the structures by which we script computers with behaviors that accommodate and respond to the actions of human beings. Interaction cannot be a design goal in itself since there can be good and bad interactions between computers and humans. Although designers and others often praise a piece of software or a new device as "highly interactive, " the appropriate design goal for interactive environments is not the degree of interactivity, but whether or not the system creates the satisfying experience of **agency** for the interactor. Agency results when the interactor's expectations are aroused by the design of the environment, causing them to act in a way that results in an appropriate response by the well-designed computational system. This matching of the interactor's participatory expectations and actions to the procedural scriptings of the machine creates the pleasurable experience of agency. Bad design frustrates

the interactor by creating confusing or unsatisfiable expectations, or by failing to anticipate actions by scripting the machine with appropriate responses.

Creating the experience of agency does not mean always giving interactors what they want. An archive may not have the item they are seeking; a game may make it hard to level up. But interactors will still experience agency if the limits of the archive are made clear, and the difficulty of the game is conveyed as an intentional challenge rather than as faulty misdirection. Agency is much more helpful than the vaguer value of interactivity as a focus for design decisions, such as choosing an implementation platform, weighing conflicting professional values, assessing the importance of legacy media conventions, or prioritizing proposed features. *The most appropriate elements for a design are always those that increase rather than obstruct the agency of the interactor.*

Artifact—Environment—Application—Device—System

As you will have noticed by now, throughout this book I refer to the objects we design in a general way, as artifacts, environments, applications, devices, systems, and so on. This is because the design method of this book is meant to apply to anything made of bits. If you find this confusing I suggest you substitute something familiar. For example, when I say that agency is "the characteristic pleasure of *interactive environments*" you can substitute "word processors" or "video games" or "cell phones" or "websites" for the more general term. The examples and exercises in each chapter are meant to be helpful in pointing out the connections between the general principles and specific design environments. But since the digital medium is still evolving and the artifacts and systems that designers are working on today are not the ones they worked on ten years ago or the ones they are likely to be working on ten years from now, it is good to get in the habit of thinking of the methods and principles of design *abstractly*—as separate from specific formats and genres, and therefore more likely to be useful to you over the course of a long career.

Media Expand the Scope of Our Shared Attention

Inventing a medium is a collective process as old as human culture. Media are important building blocks of culture: they form the basis of communication and knowledge transmission across time and space. Culture—the web of shared meaning in which we understand our lives and our world—is conveyed in large part through symbolic representations of various kinds—alphabetical writing, paintings, movies—and through the performance of symbolic rituals closely associated with media documentation, such as legal and religious ceremonies. Human beings, unlike other animals, are able to endow inscriptions, utterances, and performed actions with meaning because our minds can handle symbolic thought. Our media allow us to organize those shared symbolic meanings into more complex and expressive forms. New media technologies

are attractive to us because they offer new opportunities for the defining human activity of symbolic expression.

Before the invention of language, human beings communicated through gestures, and built up cultural patterns through imitation and synchronized behaviors like clapping and dancing (Donald 2001). This delight in imitating one another is apparent in babies and grows out of the recognition that other people have consciousness and intentionality just as we do. Cognitive scientists have identified a fundamental milestone in the cognitive development of children at around nine months of age when they start to point at things. It marks an awareness of the caretaker's attention as something that can be directed by the child. Other primates do not spontaneously point in this way, although they can learn to point for the benefit of humans. The human baby's pointing takes place in the context of the **joint attentional scene.** A baby, a caregiver, and a toy make up a joint attentional scene if the baby and the caregiver each know that the other is looking at the toy. The caregiver may hide the toy and make it appear again. The baby may repeatedly throw the toy out of the crib and make clear that he expects the caregiver to pick it up again. This common experience of **shared attention** lays the groundwork for language, since once we share attention with another person we can establish shared patterns of cultural behavior, and agree to associate particular gestures or sounds with specific meanings (Tomasello 2001).

This ability to use shared attention to externalize what we think in symbolic form—the ability to communicate by inventing and elaborating media of representation, starting with gesture and spoken language—has been the deciding factor in human achievement, differentiating us from other primates and allowing us to share our experiences with one another and to pass on knowledge from generation to generation.

All of human media can be seen as an elaboration of the baby's gesture of pointing at something in order to draw the caregiver's attention to it. Media conventions extend our ability to point across time and space. For example, associating objects with uttered sounds—naming things with words—allows us to share the idea of something even if it is not physically present. Spoken language allows us to focus shared attention on events that have happened in the past or that we imagine might happen in the future. But oral culture puts great demands on memory, leading to the development of new media genres, such as poetry and song, which make words more memorable by arranging them in repetitive patterns of rhythm and rhyme and engage groups of people in the shared task of preserving knowledge. With centuries of collaborative effort, memory specialists in oral cultures can create and transmit encyclopedic works like the Homeric epics or the Indian oral epic the Mahabharata, which is composed of 100,000 two-line stanzas that in written form covers 3,000 pages.

Figure 0.5
Engraved slate plaques from around 3000 BC Iberia are thought to have represented family lineage (Lillios 2003).

Oral cultures often rely on inscription technologies such as representational drawings or symbolic markings on tally sticks or engraved stones (figure 0.5) to externalize and fix knowledge. **Writing** expands the amount of information that can be accessed without the need for memorization because we only need to remember where to look it up. It allows us to organize information as lists and tables, and to fix contracts with one another that can be consulted in the future. With the invention of alphabets capable of transcribing complex utterances, we can record discourse containing complex arguments and study it at a distance from the person who is the source of the information. Writing also increases the power of structures of social control. Laws can be carved in stone; orders can be transmitted to distant colonies; births and deaths can be tracked, taxes can be levied and payment recorded. The invention of a new form of external media augments our capacity for shared attention, potentially increasing knowledge, but also increasing the possibilities for imposing fixed ideas and behavior and for proselytizing for disruptive causes. *Media can augment human powers for good or for evil; and they often serve cultural goals that are at cross purposes,* as literacy served both the Roman Empire and the rise of Christianity.

As with the development of language and manuscript writing, the invention of the printing press in 1455 augmented human cognition, by supporting new formats for our focused attention: scientific treatises and comic novels, personal letters and public newspapers. And as with other great advances in media technology, the rise of print

culture has expanded the range and power of constructive and destructive ideas by exponentially increasing our ability to share ideas and coordinate behavior across time and space.

The advent of the computer may mark the beginning of a cultural change of similar magnitude to the advent of language, writing, or print. We now have the power to make every book, every museum piece, and every university lecture available to anyone on earth who can receive a telephone call or a radio broadcast. We can engage a hundred thousand people in playing the same shooting game at the same time, or induce tens of millions of people to make donations to distant earthquake victims with an instant text message. The challenge for designers is how to make such an abundance of information coherent and how to coordinate such massive participation in interactive environments so that it best serves human needs.

The Medium Is the Method

Our media make us human by externalizing symbolic thought so it can be shared. Media of representation extend the range of shared attention, providing us with an enormous repertoire of behaviors and ideas, and with a wide range of strategies for preserving them and sharing them with one another. In an oral culture we are dependent upon memory; in a written and print culture we can sustain longer thoughts, share them more widely, and record a greater variety of human experience. Now the cultural practices supported by print culture have led to the advent of another new and powerful medium of representation. *By inventing and refining the format and genre conventions of the emerging digital medium, we are widening the circle of shared attention, and participating in the ancient project of expanding human cognition and enlarging human culture.*

Media conventions are important because they are part of the shared cultural patterns that allow us to make sense of complex information. The cognitive system of human beings can be thought of as a giant pattern-recognition and pattern-generating machine. We recognize objects in the world by the perceptual patterns associated with them (how they look and sound) and by the behavioral patterns they exhibit (the bird flies away as we draw near). Human beings can find coherence in a wider range of experience than bees (or any other living creature) because of our more extensive pattern-making abilities. Most important, we make symbolic patterns, patterns that do not directly correspond to what is immediately before our senses, and we assign them meaning by using them in the same way. Human beings routinely create patterns to refer to things not present (a dead ancestor) and things that do not exist (a magical tool). We can abstract general patterns from multiple specific experiences (kinds of animals, categories of food, the platonic idea of a chair), or apply patterns from one kind of experience to another (metaphorically thinking of the future as "in front of" us, or of earth as a spaceship). We can make up seemingly arbitrary

transmission patterns like the written alphabet or Morse code or the 00s and 11s of computer bits and assign interpretations to them. *We are born with the ability to make meaningful patterns out of experience and we spend our lives acquiring, refining, elaborating, and reinventing these patterns.*

Although we are constantly processing information at both the symbolic and literal level, most of our pattern-recognition activity is automatic, below consciousness, as free of thought as a bee's dance. The bees do not have to reinvent their dancing every time they find a new pollen source. They just have to adapt it to the current stimuli. Similarly, we do not have to relearn what a kitchen is every time we enter a house we haven't visited before. We have a general pattern of expectations for the concept of a kitchen, and then we are free to pay attention to where the sink and refrigerator are, or to whether there is a gas or electric stove. Patterns of meaning in cognitive science are called **schemas**. A schema is an abstract model of experience or beliefs into which we can fit new experiences. Just as we have generalized cognitive schema for a house, a kitchen, a college course, or a blind date, we have media schema for a newspaper, a television show, and a website. *Media formats and genres are externalized cognitive schemas,* strategies for making us smarter by standardizing complex repeated experiences into recognizable patterns. They are part of the **distributed cognition** by which culture is propagated and shared: We do not have to figure out how to drive a car every time we get into one, because the placement of the steering wheel, ignition, gas pedal, and brake remain the same each time, reminding us of what to do. We do not have to figure out how to read a newspaper every time we consult one because the function of the front page, headlines, photo captions, and lead sentences remain the same, reminding us of how to find the most important story of the day. Design **conventions** are important parts of this elaborate, expanding, system of distributed cognition, the familiar organizing features of the world that provide consistent cues for individual intelligence (Minsky 1986; Lakoff 1987).

To be a designer is to deal with the external patterns that correspond to existing cognitive schema or form the basis for new schema. Our job is to create the media **templates** that make new media artifacts understandable in the same way that new kitchens are understandable. A paper newspaper is a well-established template that we know how to map to cognitive schema so that we can take in the multiple stories it is telling us through media conventions like headlines, columns, and lead paragraphs. The templates of online news can potentially contain much more information—moving images, original documents, previous stories, interactive visualizations, reader comments, recommendation systems—but we have yet to establish a stable media form comparable to the paper newspaper (figure 0.6). Creating the templates and conventions that will organize this expanded universe of news reporting is an ongoing collective task for digital designers.

Figure 0.6

Home page of the *New York Times* online, from 1996 and from 2010. The first screen of the newspaper is equivalent to the area "above the fold" of the print paper: the area where the most important news is communicated. In 1996 the designers aimed to reproduce online the authority and familiar look of the printed newspaper. By 2010 they had many more digital conventions at their disposal—grid columns, menus, tabs, popularity indexes—to support complex navigation and a more dense display of information.

The argument of this book begins with the insight that *everything made of bits is part of the same digital medium,* because it shares the substructure of computation, which offers a unique combination of properties that can be used for symbolic communication. By understanding the affordances of the digital medium—its procedural, participatory, encyclopedic, and spatial properties—we can exploit them appropriately to develop more coherent media conventions, the digital formats and genres that will expand the scope of human expression. This book is an exploration of those properties and of the methods that designers can use to maximize them in the service of individual projects as well as the larger collective goal of advancing the expressive resources of the digital medium.

Part I of this book describes the basic components of the design process: the framing and **reframing** of design questions in terms of the core human needs served by any new artifact, the assembling of a palette of existing media conventions, and the search for ways to more fully serve the core needs that may lie beyond these existing conventions. It surveys the four **affordances** of digital media and key concepts drawn from diverse fields of study that can contribute to exploiting each of these affordances. Part I concludes with a framework for innovative thinking based on examining individual projects within a grid of possibilities.

Parts II–V deal in detail with each of the four affordances, exploring foundational models that provide useful conventions and strategies for the design of digital artifacts.

Part II focuses on the procedural affordance of the medium, and on the powerful strategies of **abstraction** by which we can describe objects and behaviors with computer code. It presents key concepts for the design of digital artifacts such as **modularity**, **encapsulation**, **instantiation**, and **state**; and it presents methods for representing conditional processes and complex systems that facilitate communication between programmers and other team members.

Part III surveys basic strategies for exploiting the spatial affordance of the medium in order to create meaning, in geographical virtual landscapes including Second Life that are inhabited by avatars and also in abstract information spaces such as the World Wide Web. It covers foundational building blocks of spatial design such as tables, containers, landscapes, maps, and places, and methods for establishing coherent navigation and fostering the **collocation** of like information, taking the library as a physical model for digital information spaces.

Part IV covers the encyclopedic affordance of the digital medium, focusing on the **database** and the **structured document**, two foundational models of information design in digital formats. The database is perhaps the oldest established digital genre of information organization, based on the fundamental principle of semantic segmentation, and offering designers many challenges and opportunities for expressive aggregation, juxtaposition, and visualization of information. The structured document is

the basis of the World Wide Web, the model for the creation of meaning with meta-data, and the foundation of next-generation information design including the **Semantic Web** envisioned by Tim Berners-Lee. The design of structured documents and structured archives will be crucial to the development of entertainment and information applications in the coming decades.

Part V covers four foundational models for structuring the participatory affordance of the digital medium, all of which can be present within any single design problem. When we think of the computer as a **tool** we emphasize transparency of operation, and the support of virtuosity through direct manipulation that is an extension of the hand. When we think of the computer as a **machine** we value **visibility** of its internal workings and strategies for giving the interactor feedback and control over the automated processes it performs. The sense of the computer as a **companion** is a powerful model for interaction, but designers have to avoid triggering the pervasive fantasy of the magical mind-reading servant, while appropriately and politely anticipating the interactor's needs. Finally, the **game** is a vital genre of digital media and also a powerful model for interaction in general, and especially for synchronizing the behavior of large groups of interactors and for structuring engagement with digital artifacts as sustained exploratory play.

Each chapter of this book includes a set of Design Explorations that provide practice in the habits of analysis that lead to good design. Design can only be learned by focusing on particular artifacts, and these explorations offer the opportunity to apply the ideas in each chapter to specific design problems, starting with the close observation and critique of existing designs, and moving toward the design of original projects. Student responses to these assignments may be diagrams, essays, slide presentations, or interactive artifacts, depending on the students' skill level and instructor's course goals. The design explorations are meant to provide practice in important strategies for communicating design ideas such as flowcharts, storyboards, pseudocode, and rapid prototyping, and to serve as starting points for larger projects.

Instructors should feel free to pick and choose among the suggested exercises to suit the particular course, to modify them to suit time and resources, and are encouraged to use them as starting points for inventing your own design activities. However they are used, the most important result is that the students engage in focused discussion of the design of specific artifacts, and that the discussion be based on explicitly defined design values. It is important to encourage students to be constructive and critical in their assessment of one another's design responses, to use specific language, and to refer to specific details of a design.

The practicing designer reading this book mid-career may also want to read through these Design Explorations, using them as thought experiments to increase awareness of the possibility space for design. I encourage designers to spend time with the explorations that involve areas in which you have not yet had a chance to work,

in order to keep your thinking ahead of the curve of converging formats and evolving genres.

Throughout this book, the emphasis is on connecting the design of individual artifacts with the larger cultural project of inventing the medium. Media of representation shape our understanding of the world. They do not just contain information; they also determine what can be communicated. They provide the loom on which we can weave the fabric of human culture. A stone tablet is a good medium for inscribing fixed laws of behavior. A multipage volume is a good medium for fixing the contents of a single consciousness over a long period of time. A television broadcast is a good medium for witnessing events at a distance as if they were happening near at hand. The computer combines elements of all of these, as well as its own unique affordances. It offers us a larger and more complicated cultural loom, one that can contain the complex, interconnected patterns of a global society, and one that can help us to see multiple alternate interpretations and perspectives on the same information.

As a designer of interactive media who is also a student of literary history, I believe in the power of new genres of representation to expand our powers of understanding and our capacity for empathy with one another by expanding the circle of our shared attention. A printing press is just a mechanical device, but a scientific journal is a means of bringing our shared attention to the task of explaining the mysterious universe, a newspaper is a way of focusing our collective political thinking, and a novel is a means of changing the soul. A computer is just an electrical device, but when we exploit its affordances for symbolic expression we make possible new genres that hold a similar possibility for changing what we can know and what we can share with one another. That is why I have written this book. It is my hope that those who use it will find it helpful in our collective effort to invent the medium, to put the vast power of the computer to the task of expanding the boundaries of human understanding and deepening the ties of human connection.

1 CHANGING TECHNOLOGIES, LASTING INNOVATIONS

Media expand the scope of our **shared attention**, making the **design** of media a crucial building block of **human culture**.

All things made with electronic **bits** and computer **code** belong to a single new medium, the **digital medium**, with its own unique affordances.

Designing any single **artifact** within this new medium is part of the broader collective effort of inventing and refining the shared **conventions** that allow us to understand new kinds of media objects.

Good design is aimed simultaneously at perfecting the object and at improving the overall practice of the field.

It is the designer's task to foster the development of meaningful common conventions at all three levels of media making—**inscription, transmission**, and especially **representation**—to accelerate the collective project of expanding the expressive power of the new digital medium.

To design something new that transcends the expressive limitations of **legacy media** and existing **formats** and **genres**, the designer should think about the core human needs served by the new artifact, survey the ways those needs have been met across multiple media **platforms**, and then attempt to reimagine them as they might be served by the **affordances** of the emerging digital medium.

All digital artifacts belong to a shared landscape of potential **affordances**, and designers should consider every individual project within the context of **procedural, participatory, encyclopedic**, and **spatial** design strategies.

The characteristic goal of interactive environments is **agency**. We create agency by scripting the **interactor** and the **computer** so that the human being's expectations and behaviors elicit appropriate responses from the machine. When an interdisciplinary team is confronted with a conflict in design values, the design goal of creating agency can serve as a touchstone to resolve the issue.

A recognizable pleasure of interactive environments is the interactor's sense of **immersion**. We create immersion by increasing scope, detail, and consistency while establishing clear boundaries and means of navigation.

In a well-designed environment, agency and immersion reinforce one another through the **active creation of belief**.

1 Design in an Evolving Medium

The best way to predict the future is to invent it.
—Alan Kay, <http://www.smalltalk.org/alankay.html>

Design as Framing and Reframing

To **design** is to shape a specific **artifact** or process by choosing among alternate strategies in order to achieve explicit goals. Design is always concerned with discretionary choices that take into account the benefits and liabilities of alternate strategies. A designer must be able to envision multiple approaches to the same design problem, including novel approaches that exploit the **affordances** of new materials.

Design can be directed at objects meant to last for a season or a century, for pleasure or utility, for comfort or style. But design is always *the conscious creation of a particular artifact within a longer cultural tradition of practice.* It always involves a choice of **conventions** in a context in which there is not just one correct way of doing something. Most of all, good design is aimed simultaneously at perfecting the object and at improving the overall practice of the field. This double focus is particularly important for the designer of **digital media** because the field is so new and because there are so many competing methodologies that are relevant to the design of a digital artifact.

Professional designers in any field know how to **frame** a new design problem within existing traditions, practices, and goals. We know how to design a toaster because we know how people use it, and the underlying technology of heating element and regulators has not changed. Innovation in toaster design can focus on **refining** familiar elements: making them a little bit more reliable (less burnt toast), usable (easier to get the toast out of the slot), functional (more slots, bigger slots, a defrost setting), visually appealing (e.g., ceramic toasters with whimsical shapes), or marketable (designer-brand toasters). Some tasks in digital media design involve similar refinement of established artifacts. For example, the laptop computer can be designed for greater reliability (longer battery life, tougher shell, fewer viruses), usability (ergonomic keyboard design, less heat generation, lighter weight), functionality (faster operation,

Figure 1.1
Standard web conventions for a retail site on <http://www.landsend.com> include logo banner, keyword search, store locator, order tracker, account sign-in, shopping bag, and menu bar with conventional clothing categories.

Figure 1.2
Standard web conventions similar to the Lands' End website are found on <http://www.macys.com> with the additional features of a rotating ad space (here promoting "Online Deals") and a rating system for customers to recommend purchases.

larger hard-drive capacity, increased connectivity), visual appeal (custom colors, mini-malist design), or marketability (Apple or PC brand appeal).

Designing a website for a retail operation can be a matter of refining existing con-ventions, similar to designing a new toaster, because retail websites currently rest on standardized technical elements (shopping basket with secure credit-card entry, inven-tory stored in a database, web pages generated on the fly) and include **genre** features that consumers are familiar with (home page, menu navigation, product images, sorting by size, recommendation systems). Like toasters, retail websites are stable enough in design to compete on style and relatively small functional refinements (see figures 1.1–1.4).

But many tasks in digital media design are not a matter of refining clearly estab-lished traditions and practices, but of inventing new conventions within a more open-ended context of possibilities. Creating a virtual world, a social networking site, a media-playing device, a handheld communication device, a website for a newspaper or a television station are much more open-ended tasks that cannot be approached within a single-standard framework. They require us to reframe familiar practices to take advantage of the new affordances of digital technology.

Innovative design is often the result of **reframing** familiar activities, such as rethink-ing the context in which they can be performed. The small portable radios introduced with the invention of transistors are based on reframing the activity of listening to music, which was previously thought of as something done in the home, or perhaps

Figure 1.3

Macy's display of merchandise provides rollover text that duplicates the information below the picture.

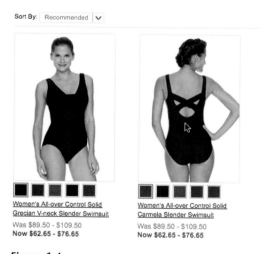

Figure 1.4

On the Lands' End site, rolling over the front-view image of a swimsuit displays the back of the garment, a refinement of the standard retail web convention.

while sitting on the grass or the beach with a "portable" radio the size of a toaster. The addition of earphones to the transistor radio made music listening into something that you could do privately, even when walking around outdoors and in public, paving the way for later inventions such as the tape-driven (and later CD-based) Sony Walkman and the digital mpeg3 player like the widely popular iPod. Telephoning has seen a similar shift in the past twenty years, changing the circumstances under which people contact one another and conduct conversations. For designers of digital artifacts, there is always the possibility of introducing a similarly durable reframing of a common activity.

Reframing can also be done at the level of social context. We see this quite often in advertising. For example, the bathing suits in figures 1.3 and 1.4, though both meant to present images of attractive women, are based on very different assumptions about shopper's motivations. The Macy's models are photographed in sexually seductive poses, an exaggeration of the cultural convention of objectifying women's bodies as objects of male desire; they also suggest urban sophistication about fashion trends since high fashion is often framed in risqué poses. The Lands' End images reframe the conventional bathing suit pose to suggest wholesome athleticism and a less overtly sexual attractiveness. Similarly, the Apple "I'm a Mac/I'm a PC" advertising campaign framed the Microsoft operating system as the unreliable choice of unimaginative nerds and the Mac platform as the hassle-free choice of the creative and cool. Advertising works by exaggerating such cultural connotations, so it is a good guide to the stereotypes considered mainstream by corporate culture. The designer should strive to identify such stereotypes and conventional value assumptions, and to be aware of whose interest they serve. It is often useful to reframe the scenario by reversing roles. For example, suppose the Microsoft people rewrote the Apple ads: would the hip Apple guy seem pretentious and incompetent and the PC guy seem coolly efficient and in control?

Cultural values and economic imperatives drive the direction of design innovation in ways that we usually take for granted, making some objects the focus of intense design attention while others are ignored altogether. For example, over the past century, music distribution and listening devices have experienced intense redesign, including dramatic changes in technology, from wax cylinder recordings and crystal radios to vinyl, tape, CDs, and Internet distribution. As a result we have gone in one hundred years from poor reproduction of a limited range of music, available to relatively few people worldwide, to a massive, globally distributed shared library of every conceivable form of musical performance. If a similar level of engineering resources and design inventiveness had been devoted to solar energy devices in the past fifty years, we might have made similar progress in an area more directly related to human survival.

Military technologies have been pursued with diligence over centuries, leading to many design innovations in the history of swords, missiles, vehicles, and gun mechanisms. But the massive funding of military equipment does not necessarily favor improvements. Organizations become attached to equipment because it is familiar, or because it has political support through the influence of the manufacturer. Contractors are most eager to innovate in areas of large profit, and may not give equal resources to developing body armor, for example, over much more lucrative missile systems. Design sometimes gets fossilized around "good enough" solutions. The Russian-made Kalashnikov rifle or AK-47 is widely believed to be easier for soldiers to maintain than the corresponding American weapon, the M16, which is more accurate. Despite the half century of hostility and proxy warfare between the United States and communist bloc countries, with billions spent on weapons, neither side has produced an assault rifle that combines accuracy and ease of maintenance. If research budgets were in the hands of infantry soldiers, body armor and assault rifles might have gotten more design attention than fighter jets and missile defense systems.

Everyone has cultural biases, expectations, and value judgments that are the result of living in a particular society or subgroup. *It is the job of the designer to identify and consciously examine these biases so they can become the subject of active choices rather than passive acceptance.* In order to uncover unspoken cultural biases for an assigned task, designers can bring multiple stakeholder groups into the design process and elicit their different perspectives and needs. They can also ask themselves how the project would be different if it were being designed for people of a different social class, ethnicity, nationality, gender, age, profession, neighborhood, educational background, or physical ability. The more we imagine such alternatives, the richer the set of possible strategies from which to make our design choices.

For example, the joystick game controller is an explicitly phallic device, evocative of male sexual excitement and potency. It reinforces the macho cultural values of shooting and driving games, which are structured around pressured individual performance and competition. But in Mary Flanagan's art installation piece [giantJoystick] (2006), the classic Atari game controller is reproduced in a ten-foot-tall version, turning it into a device that must be controlled collectively and cooperatively (see figure 1.5). Although we may not want to market a 10-foot joystick commercially, it is important to keep such creative reframing in mind in order to understand the cultural assumptions and design conventions behind the familiar version.

Three Layers of Media Design: Inscription, Transmission, Representation

In common parlance the word "medium" (and its plural form "media") can refer to anything from a set of charcoal pencils to a multinational entertainment corporation, encompassing technologies as tangible as marble sculpture or as imperceptible as radio

Figure 1.5
Mary Flanagan's [giantJoystick]—ten-foot-tall giant working model based on the handheld controller from the classic Atari 2600 video game system—is an art installation that redefines the social context of the familiar device by increasing its scale to provoke group play. See <http://www.maryflanagan.com/giant-joystick>.

waves. The term refers equally to a television news broadcast aimed at hundreds of millions of people or a private diary hidden under a teenager's pillow. In order to understand how best to develop the digital environment as an expressive medium, we need to distinguish the common elements of all of these varied phenomena and to identify the several levels at which design takes place.

For our purposes, a *medium is any combination of materials and cultural practices that is used by human beings to support the intentional communication of meaning.* It is important to remember that a medium is both material and cultural: a stone and chisel only become a medium for writing when a society develops practices of marking the stone and interpreting the chisel marks. Furthermore, the materials and cultural practices that make up any medium serve three nested processes: **inscription**, **transmission**, and **representation.** Design choices shape all three levels, and a change in any one of these levels can have consequences up and down the structure. For designers, it is helpful to think of anything made out of electronic **bits** and meant to be directly used by human beings as an **artifact** created in the emerging **digital medium.** A digital artifact might be a website, a research archive, a video game, a mobile device, a virtual environment, a wired piece of clothing, an art installation, an interactive television

Figure 1.6
Two inscription technologies: a modern reproduction of biblical-era stylus and clay tablets and a digital multitouch screen created by Jefferson Y. Han of New York University.

program, and so on. Anything that is inscribed in bits and transmitted in computer **code** is part of the emerging, evolving, constantly changing, and significantly immature digital medium.

In a mature medium, the processes of inscription—of making perceptible marks on a receptive material—are so reliable and well-learned that they become **transparent:** we can perform them with little conscious effort. Writing on paper with a pencil has been a transparent process only since the mid-nineteenth century. Before that, paper was scarce and the pencil was an unreliable tool, differing from one maker to another, producing uneven markings, breaking easily, and lacking an eraser (Petroski 2000). The digital medium includes some inscription technologies, like the desktop computer keyboard, that work as reliably as pencil and paper do today, and some, like the too-small keyboards on mobile devices, that are more like pre-nineteenth-century pencils—unreliable and distractingly clumsy to use. Inscription remains an active area of digital innovation for input and output devices (figure 1.6).

Similarly, in a mature medium, transmission—the transfer of a message across space or time or both—is stable, standardized, and transparent. Transmission involves turning a meaningful **message** into a coded **signal** of some kind, and conveying it from sender to receiver with a minimum of **noise** (meaningless transmissions like static in a radio broadcast or misprints in a newspaper). Inscription involves marking a malleable material with a perceptible imprint; transmission involves arranging the marking into recognizable patterns we can think of as a transmission codes. Transmission codes are logical structures established by social agreement, like Morse code patterns that correspond to letters of the alphabet, or the unique phone number assigned to every landline or cell phone. The digital medium includes some mature (though still evolving) transmission codes such as data transfer **protocols**, media compression **formats**,

and computer languages, as well as some relatively inelegant and unreliable codes that make the medium less transparent, such as the triple tap system for writing alphabetically on a telephone keypad and the many password barriers that regularly challenge our memory and patience. In a mature medium, the inscription and transmission layers become standardized into formats by socially established customs, and are so well learned or so buried under more meaningful layers that they do not distract the human being who is depending on them.

Inscription technologies and transmission codes change over time (table 1.1). When they coalesce into lasting arrangements, we recognize stable formats or platforms. Representational forms are also changing, but they tend not to disappear even over long periods of time and remain available for meaning making. The digital medium rests on **binary** code inscribed on electrical charges, and it includes multiple evolving inscription and transmission technologies. Its formats and platforms are therefore also shifting, making it harder to stabilize conventions of representation. For example, electronic book readers and tablet computers have sold many millions of units and led to the downloading of billions of dollars worth of electronic books and magazines, even though the conventions for display and navigation are far from stabilized.

In any medium, the transmission layer is logical and well organized but meaningless until it is interpreted through our shared systems of representation. Morse code or alphabetical writing, for example, mean nothing until translated into a message in a human language. But the meaning of words in a language is much more elusive than the one-to-one relationship of Morse code to written alphabets. The representational layer is characterized by open cultural codes in which meaning is fuzzier, less stable, and more dependent on interpretation by **discourse communities** than the meaning of logical transmission codes.

The words of a language, the images we create for one another, the stories that we tell are all part of the representational layer of media. The inscription layer is grounded in the physicality of the inscription materials; the transmission layer is grounded in the logic of the coding system. The representational layer is more diffuse, created by cultural tradition and open to an ongoing process by which we negotiate meaning with one another. We understand what words mean not because the meanings are fixed or absolute, but because we draw on shared contexts and associations to interpret them. The combination of the written letters D-O-G, or the vocalized sounds represented by this alphabetical sequence, denote an animal with four legs, a tail, and a loyal disposition because English speakers have collectively associated these letters and sounds with the perceptions and experiences that make up our familiarity with dogs. But words and other cultural constructs are also **connotative.** For example, we can standardize pronunciation of a word like "mother" so that all English speakers will recognize it as the same word, but we can never standardize all the meanings that the

Table 1.1

Examples of Stable Formats, Conventions, and Genres

Inscription Materials	Transmission Codes	Stable Formats	Conventions of Representation	Genres of Representation
Pencils and paper	Alphabets, numbers	Loose sheets, bound books, conventions for the direction of writing and reading (e.g., left to right)	Words, lists, tables	Letters, shopping lists, love notes, financial records
Printing presses	Alphabets, numbers, letter press machines	Newsprint sizes and folding patterns, fonts, photography in newsprint	Words, lists, tables, headlines, bylines, photographs with captions	News stories, feature stories, editorials, letters to the editor
Video cameras (analog or digital)	Analog or digital TV signals via satellite, cable, wireless broadcast	Network TV delivery by broadcast or subscription	Program guide as a grid, remote control as channel selector, title sequences, credit sequences, commercial breaks between acts	Sit-coms, news broadcasts, police dramas, hospital dramas, reality shows, quiz shows, live sports, etc.
Electrical charges in transistors Multiple input devices like keyboard, mouse, touch screen, game controller, and multiple display technologies like computer screens, mobile device screens, digital or analog TV screens	Binary code ASCII code Audio and video codices Internet protocols HTML RSS Proprietary encodings (e.g., iTunes, Kindle)	Webpage Internet Protocol Television (IPTV) Electronic music and books in proprietary platforms	Shopping carts, navigation bars, headings Audio and video software players Page-turning and bookmarking in electronic "readers"	Retail sites, news sites, personal journals, university sites, online radio, search engines, etc.

word might have for different individuals (an eight-year-old child, a woman with twin babies) and subcultures (stereotypical Jewish mothers, Chinese mothers limited to one child), and in different contexts (the "mother of all battles," a "mean mother" of a convict). We build up these related but divergent meanings experientially and we decode the meaning of our sentences by referring to these specifically situated experiences.

Abstract nouns like "justice" require even more complex patterns of shared cultural interpretation. To explain what "dog" denotes we just point to Lassie and Fido. To explain what "mother" means in all these connotative contexts we might point to specific people in movies and news reports as well as in our own families. To explain what "justice" means we need an extensive system of shared **schema** and the ability to evoke multiple alternate outcomes and complex chains of events. Media help us to form these complex concepts by allowing us to organize our fluid culture codes into fixed units of meaning—sentences, manuscripts, diagrams, and rules—so that they can be externalized, shared, and refined. We need stability of inscription and transmission in order to focus our attention on what our words and images represent. New technologies and codes introduce new possibilities and destabilize older formats.

Design decisions involve all three levels of a medium—physical inscription, logical transmission codes, and cultural conventions of meaning. *In the digital medium, inscription and transmission technologies are constantly changing, subverting existing formats and opening up new design possibilities.* For example, digital technology has led to new kinds of mobile devices that contain degraded voice processing, making telephoning less reliable and harder to decipher, but opening up new uses for telephones as messaging devices, navigators, and cameras. Similarly, the shift from **analog** to digital television— from inscribing the image on the screen as analog lines to inscribing it as an array of pixels—has given designers higher resolution to work with, increasing the amount of information that can be included in the frame, rendering the standard remote control obsolete while multiplying the choices available to the viewer. Refinement of digital transmission codes can change the platform available for design. For example, the first versions of **HTML** (the transmission code by which programmers tell browsers how to display pages on the **World Wide Web**) did not allow designers to create tables on web pages. The extension of HTML to include tables allowed designers to format a web page as a **grid**, a big step forward in the visual organization of the web.

When inscription and transmission conventions become linked and standardized, designers can think in terms of a stable format (like a web page, a video compression codec, a music CD). When delivery is linked to specific hardware and software combinations, like a particular game console or mobile device with its own operating system, hardwired (inscribed and coded) chips, and input technologies (keypad, game controller, accelerometer) system, a number of formats, each with their own affordances and **constraints**, are fused into a fixed **platform**. The establishment of a stable

Figure 1.7
The Apple iPod device, iTunes software, and iTunes online store together make a stable platform for the distribution of music without infringement of copyright.

platform like the Atari 2600, the Macintosh operating system, or the World Wide Web is an important precondition for the sustained development of expressive genres like arcade video games, word-processing applications, or retail websites. Platforms usually require social and economic arrangements, not just technical engineering (figure 1.7).

Limiting design to a strongly branded, widely used format or platform can provide assurance of technical support and a customer base for a new product. It can save development time and provide useful constraints to design, limiting the scope of a project within manageable, familiar boundaries. Every established format and plat-form configuration has its own set of affordances and constraints, which the designer should consider carefully. Designing a game for the Nintendo Wii offers different pos-sibilities and problems than designing the same game for a smartphone. It is best to postpone format and platform decisions until the functional requirements and expres-sive goals of a project are clearly understood. Designers should then survey available options and perform a competitive analysis by creating a table that summarizes the relevant features and limitations of each implementation strategy. Wherever possible, components of the project should be developed in platform-independent formats to increase the flexibility of implementation and delivery.

Although it is easiest to work with stable platforms—with established combinations of inscription technologies and transmission codes—*designers can also work with digital components to invent their own platforms.* Inscription can be shaped with the choice of input and output devices: keyboard, mouse, joystick, gestural controller, environmental sensor, computer screen, vibrating tactile device, projected images, directional sound, and so on. Designers can also establish their own standardized transmission formats, such as customized database tables and fields, specialized tagging conventions for digital **documents**, unique sets of bar patterns to be read by mobile devices, or new gestural codes for the control of multitouch screens or sensors.

Just as conventions of inscription and transmission become fixed in standardized configurations called formats, conventions in the representational layer (like newspaper headlines and bylines) coalesce into larger units of meaning that we refer to as **genres** (like newspaper news stories). Genres are sometimes tightly tied to specific formats (like print newspapers), but formats can support multiple representational genres (like advertising supplements, comics sections, television listing booklets as well as standard news pages) and genres can exist on multiple formats (like newspapers on line, or news reporting in print, radio, television, and web pages). The television sitcom genre and the game show genre both rest on the television format of the half-hour commercial television show, and they share common TV formatting conventions such as commercial breaks, intro music, credit screens, and so on. TV sitcoms and TV game shows can be thought of as media-specific genres. When we put a TV sitcom on the web, advertising and credit conventions are reinvented for the new transmission format. Genres can also transcend media. For example, a television sitcom might belong to the cross-media genre of romantic comedy, which exists on stage and film and has contributed to the plot of novels, poems, operas, and country songs. A game show belongs to the cross-media genre of games, which includes mystery dinner theater, radio game shows, and board games.

The communications theorist James Carey proposed the **ritual** model of communication as an alternative to the **transmission model** of **information theory**. In Carey's view, reading a newspaper cannot be understood as the decoding of logical code, but as the performance of a meaningful social ritual:

A ritual view of communication will . . . view reading a newspaper less as sending or gaining information and more as attending a mass, a situation in which nothing new is learned but in which a particular view of the world is portrayed and confirmed. News reading, and writing, is a ritual act and moreover a dramatic one. What is arrayed before the reader is not pure information but a portrayal of the contending forces in the world. . . . The model here is not that of information acquisition, though such acquisition occurs, but of dramatic action in which the reader joins a world of contending forces as an observer at a play. We do not encounter questions about the effect or functions of messages as such, but the role of presentation and involvement in the structuring of the reader's life and time. (Carey 1989, 16–17)

A media genre is more than the organizing structures that allow us to decode the words; it is a set of practices by the people who create and consume it, and a context of interpretation in which it is understood. When we introduce new media formats or disrupt established inscription and transmission technologies, we are also disrupting the rituals that have formed around these artifacts. Television was blamed, for example, for disrupting family rituals centered around reading together or playing board games or outdoor sports; more recently computers have been blamed for disrupting the shared ritual of family TV viewing.

In a mature medium, we rely on familiar formats and genres to guide us in making sense of complex media artifacts. Because so much of our communication is in cultural codes that require experiential knowledge to decode, we need to have our attention focused on the salient parts of the communication. Mature media have developed elaborate conventions like newspaper columns, headlines, sections, bylines, and so on, to focus us on the most important parts of the communication. We recognize the kind of communication we are receiving because it has common elements with similar communications. We know what to expect of a commercial television program in general, and of a sitcom or a game show in particular because we recognize the common format and the familiar genres. Similarly, we know what to expect of a first-person shooter video game or a retail website because we recognize the format and the genre that provide the conventions of interaction.

In a mature medium, format and genre are well matched and reinforce one another. For example, television writers use commercial breaks to build suspense for the comic climax of the sitcom or the big-money question on the game show; newspaper editors use page position and headline size to indicate the importance of a story. In the digital medium, the mapping of a pointing device, like a game controller or a mouse, to a graphical user interface (**GUI**) has been foundational to establishing stable formats and genres by giving designers *a set of conventions for coordinating the attention of the interactor with the attention of the machine* (figure 1.8). The pointing system allows us to create icons that mean one thing to the human (a trash can, a Pac-Man figure) and another to the computer (a command to delete the addresses of particular places in memory, a change in a pattern of pixel display) but whose behavior is coherent to both.

Where existing conventions, formats, and genres are a good fit for the immediate project, it is the designer's responsibility to employ them and to refine them as necessary. Refining individual media conventions—how we open a file, how we choose the attributes of an **avatar**, how we steer a virtual vehicle, or what label we give to a database field, menu item, or website section—all contribute to the development of the medium as a whole. For example, the Lands' End convention of showing the back of a garment on rollover of a catalog image (figure 1.4) is a refinement of the rollover convention of merely displaying a text message. If other designers use it, it could become a standard feature of retail sites.

Figure 1.8
Image from the original mouse patent, filed in 1967 by Douglas Engelbart, showing it controlling a "tracking point" (cursor) on the screen, and a still image from Engelbart's public demonstration of his system in 1968 in which he is using the mouse with his right hand and a chording system similar to command keys with his left hand.

In an evolving medium, formats are unstable and genre conventions of older media are disrupted, making it harder to create expressive works. There is disruption of inscription methods, such as the confusion over nonstandard keyboards and the pressure to use telephone keypads to do the work of typewriter keyboards. There is incompatibility of transmission formats, between older and newer versions of devices or software packages, and between competing operating systems and compression technologies. These shifts in the underlying technologies make for disruptions at the

level of representation, leaving interactors confused about which conventions to employ to perform common tasks.

In addition, formats and genres may prematurely fossilize around particular devices or authoring applications that are widely adopted but soon become outdated. This can make for stable platforms that have the wrong functionality. For example, designers of CD-ROMs in the 1990s relied on an authoring system that was optimized for animation, thereby limiting the possibilities for interactivity in their projects. Genres that have large numbers of enthusiastic early adopters—like specialized business applications, social networking sites, or certain kinds of games—may standardize around these highly specialized user communities, creating conventions of interaction that are unnecessarily hard for novice users to learn, but that developers cannot change for fear of alienating their most loyal customers. It is therefore not always good design to conform to an established genre, no matter how many people are using it. Instead, an innovative design team could *take the longer-term view, and work to develop new conventions, formats, and genres that will better serve a broader range of applications.* For example, DOS, the command-line operating system for PCs, had millions of loyal users in the mid-1990s when Microsoft belatedly followed Apple and Xerox PARC by introducing the now-standard Windows interface. The fact that PC users have become habituated to DOS, a severely limited form of representation based on a more limited inscription and transmission format (e.g., no graphics, slower processors), seems in hindsight like a foolish reason for retaining it. Yet the current digital environment includes many similarly feeble and cumbersome interfaces—such as the television remote, the joystick-and-button game controller, and the form-based query systems for many relational databases (such as course registration systems in universities). Designers should be alert to opportunities to radically rethink familiar interaction patterns when they no longer support the transparent interaction necessary for the experience of user agency.

The digital medium is still in an immature state but it is evolving rapidly and unevenly, with some very stable genres and others still quite disorganized. It will continue to evolve and to experience disruptions and unexpected opportunities arising from changes in inscription and transmission technologies. *It is the designer's task to work at all three levels of media making—inscription, transmission, and especially representation—to accelerate the collective project of inventing a new medium by creating and refining the conventions that will bring coherence to new artifacts and enhance their expressive power.*

Designing for the Core Human Needs

The design process begins by asking: Who needs this object and for what? This question must be asked at three levels:

- *Function* How will specific end-users employ the product in particular tasks and activities?
- *Context* What social and cultural customs, relationships, institutions, and value structures does this product reflect or subvert?
- *Core* What deeper, enduring general human activities and values does this object serve?

It is simplest to frame a design problem in terms of known genres and formats and immediately observable functions. *But innovative design requires that we look beyond received opinion and familiar solutions to identify the deeper, cultural connections.* This method can uncover potential users and functionalities that might otherwise be overlooked and will help us to expand the design palette and to sharpen our design goals.

The designer's task must be in the service of specific human needs. A design is not good or bad because it uses a particular technology, makes money or fails to make money, or preserves or erodes a particular power structure. It is good or bad according to how well it serves a core human need whose value is larger than the immediate task. Examples of core needs would be: increasing understanding of complex phenomena, fostering the acquisition of skills, supporting works of the creative imagination, expanding communication across distances. We can recognize the core need (or needs) behind a design problem when it can be identified independent of the technology that currently supports it. We should not be focused on making an electronic version of a book, record collection, television show, etc.; we should be focused on serving the information, entertainment, or community needs that these particular books, records, television shows are addressed to, by rethinking those needs in terms of the affordances of digital media.

For example, if we are making an online newspaper with only a print newspaper as a guide, and a narrow sense of the end-user as a newspaper reader, then we might focus design on reproducing the masthead and the columns of the front page as accurately as possible. By shifting to a more open-ended assessment of needs, we widen our range of design choices.

- At the level of function, in addition to duplicating current coverage, we can look for unserved news needs of potential interactors, including those who do not currently read the newspaper (Do they want more local sports coverage? Are there local demographic or interest groups that would welcome more coverage?), and examine the likely conditions in which people would consume news in digital rather than paper form (on a mobile device in frequent, short bursts while out and about, or on a larger screen for longer periods?).
- At the context level, we would want to understand the role of the paper in the community it serves, and also how the switch to online publication would affect the social and economic structure of the newspaper organization. We would look for

the strengths of the paper in particular genres of reporting (political news? sports? lifestyle?), each of which has its own associated social rituals and media conventions.

• Most importantly we can identify the core human activities—the media-independent needs—that make newspapers important to us: our curiosity about what is happening around us; our need for speed, frequency, accuracy, and reliability in reporting; and our reliance on shared information to connect us to the communities we belong to.

By identifying the design task as furthering the media-independent core activity of news consumption, we can capture a wider range of potentially useful format and genre conventions. We can think historically and cross-culturally about oral news sources like town criers and barbershop gossips; print sources like letters, newspapers, and magazines; and broadcast sources like local and national TV and radio news, discussion, and documentaries. We can think about digital news genres, such as texting, webcasts, podcasts, aggregators, and blogs. This exercise reframes the immediate task, giving us *a larger palette of design conventions* to choose from, and helping us to see the advantages and liabilities of previous approaches. Framing our goals in terms of the core human needs also helps us to *prioritize design choices* so that we are not overwhelmed by all these alternatives. For example, in order to maximize the pleasure of satisfying curiosity we might increase the number of headlines and teasers we display, allowing interactors to choose which stories to follow, rather than limiting their choices with longer initial story segments or pop-up ads that block content. Knowing that news serves the important core human need of connecting us to others, we might prioritize popularity ratings or user-created content (like the neighborhood bulletin board). Or we might prioritize location-sensitive news bulletins to serve the core need for anticipating opportunities and dangers in our immediate surroundings (like the town crier).

Although it may seem obvious that we as designers should orient ourselves to the core human needs served by the artifacts that we make, in practice other forces often dominate. Because digital artifacts are based on changing technologies, the demand for new applications is sometimes driven by a delight in novel features or an appeal to the status value of the latest gadgetry. But *novelty cannot drive the design process* because whatever is new and fashionable today will be displaced tomorrow by a yet newer fashion. New platforms come and go quite quickly, while the development of interactive applications is necessarily slow. Solutions that only work on one device or that emphasize a single innovative feature risk seeming out of date by the time they are released, or losing users when the novelty wears off.

Designers should therefore resist the easy excitement that comes from merely employing emerging technologies. Technical experimentation is crucial to keeping

current in a changing field, but it should not drive the design process. A project that has no clear human need behind it may engage the skills of talented people, and may generate contracts for design firms, but it cannot be a focus for truly professional design because it will lack coherence. If you do not know why you are making something you will not be able to tell whether or not you are getting it right. *The designer's task must be grounded in the service of specific human needs: this is what gives the work clarity and direction.*

Advancing the medium does not mean choosing the newest platform to implement a project or adding in the coolest new bells and whistles. Such superficial advances may appeal to a forward-thinking designer and may get immediate attention, but they do not serve the task. Because newly introduced technologies are unstable, they are best explored for demonstration projects, in a research context like a university or industry laboratory; they are risky for projects that have to be done within limited time spans and which must work on a regular basis for a wide population of users.

Even if the new technology is stable, it is not helpful to use it if it distracts from the task served or meaning expressed by the artifact. For example, in the early days of the World Wide Web blinking buttons were an easily implemented, reliable, and therefore irresistible addition to websites. They expressed an exuberant embrace of the vitality of the new medium, but they very quickly went from being a **sign** of advanced skillfulness to the defining symbol of naive design. A clear focus on the expressive goals of your design can save you from similar missteps, while helping you to look for appropriate applications of new technologies. For example, a similar technique to the one that produced the annoying blinking buttons is now used routinely to rotate informational or promotional images on a home page, with each image linked to more information deeper in the site. The wise designer avoids employing novel technical formats—like blinking buttons—for their own sake and looks for the longer-lasting expressive uses—like the more slowly changing hyperlinked images—that might be built on top of them.

To avoid seduction by mere novelty, it is best to keep a separate playpen or scratch pad area for trying out new technologies. It is often a good idea to test something out as an alternate version of an existing project. Project leaders often make the mistake of testing out an innovation with phony data or filler content, but the expressive potential of a new format only becomes clear when it is implemented with real content, when it is measured against a specific human purpose that exists outside of the excitement of technological wizardry. Because the digital medium depends on interaction, *the true usefulness of a new approach cannot be assessed until it is mocked up with real information* that will provoke interactors to come up with specific expectations and actions.

Identifying the core activity is useful as a counterweight to technophilia and infatuation with mere novelty. It is also useful in coping with the opposite problem:

technophobia and resistance to change. Domain experts and design clients often define a task in terms of work patterns that have been shaped by legacy media. Users of consumer products can also be closely wedded to their familiar ways of doing things. Finding the alignment between the abstracted, generalized, core human need—something so basic that you can state it without any specialized jargon—and the particular digital design task often takes patience and hard work. Designers have to think about the needs of their users that lie beneath the particular artifacts and practices by which they currently go about satisfying those needs. For example, a group of scholars once asked me for advice on how to make a better scholarly edition of Shakespeare's works but became agitated at the thought that their end product might shift from a book to a digital artifact, such as a CD-ROM. They knew that the footnote on a paper-based page was a clumsy way of expressing the depth of research that went into a scholarly edition. Their own editions often separated the note from the text by several pages, or squeezed the text into a few lines per page in order to accommodate the dozens of lines of footnotes chasing after them. But an "edition" to them meant paper pages bound between covers. They were not thinking as designers, or even as scholars, but as members of a print culture with a deep attachment to the physical form of the book.

Designers should be prepared to encounter this mindset and they should be prepared to show appropriate respect for the core task—such as creating a variorum edition of a Shakespeare play or using a card catalog or "leaning back" to watch a conventional, noninteractive television program—while tactfully discounting panicky attachment to the physical formats of print and analog culture—such as an insistence on squeezing a complex, **multisequential** knowledge structure into the **unisequential** format of a bound book. Thinking as a designer means focusing on the core task of a variorum edition: the coherent presentation of centuries of commentary on Shakespeare's plays. This is a task that has a clear human imperative behind it, linked to the more general goal of expanding human knowledge and understanding. Focusing on the physical format of the delivery medium—the creation of a bound book or a simulated bound book (as in a PDF photo facsimile of each page)—distorts the design task.

There is always a temptation to use the digital medium as a means of duplicating the appearance and behaviors of legacy media. We can make an excellent facsimile of a book in digital form, and in some circumstances it can be helpful to do so. But it is a poor use of the affordances of the digital medium to create an artifact that must be paged through, and in which footnotes remain cryptic abbreviations, displayed separately from the items they are commenting on.

Addressing the core need may be harder for others on the team than for the designer. Clients often resist rethinking media structures that legitimize well-established professional distinctions. For example, expanding the available space for

commentary in a variorum edition reopens the awkward question of how the editors decide which commentaries to include and which to exclude. Such decisions may not be as easy to justify when space is no longer the constraint. Reconfiguring the database system of a complex organization, such as the index-card based catalog of a library, may eliminate some jobs, change the skill sets for other jobs, foster more open access to formerly closed information, or otherwise disrupt political and social arrangements. Changing the delivery structure of television disrupts the advertising model and therefore the revenue stream that supports the production of entertainment. The anxiety produced from such disruptions can make it harder to get a clear fix on the patterns of information and interaction that the designer most needs to serve.

Orienting oneself to the core human task provides the designer with a necessary corrective to the distractions of organizational politics and the fetishism of legacy formats, focusing design choices toward empowerment of the most enduring and valuable functions. Of course some clients may prefer outdated solutions. In that case it is the designer's job to make sure that the client understands the trade-offs. As a practical matter, one might try in such situations to help people move to the next comfortable stage of digital organization, such as moving the production of the variorum editions from shoeboxes of index cards into a uniform electronic database, or delivering the variorum as a book with a CD-ROM tucked into it. In that way, the integrity of the information is preserved in the eyes of the clients, by the production of the book, and also for the designer, by the digital organization that might one day support a better-organized digital version.

As we have seen, focusing on the core task can protect us against both the seduction of new technologies and the fetishism of older media. The scholars holding onto their shoeboxes of index cards are at the opposite end of the spectrum from the marketing manager who wants the latest bells and whistles on the company website. But sophisticated practitioners can also derail design by insisting on fitting each new project into their own favorite software or hardware framework. As the proverb goes, to a man with a hammer, everything looks like a nail. Designers should be skeptical of any project that begins with an implementation strategy. *Instead, we must discipline ourselves to begin by identifying the core human need, without reference to whether it is going to be served with bits or boom boxes or bowling balls.*

Identifying the core task may make it clear that this is not a problem that calls for a computer at all. Maybe the fundamental design problem is in the social, political, or information structure itself, and the computer will not solve the problem, only distract from it. Maybe the computer will even make the problem worse. For example, suppose that in a large liberal arts university, students are extremely bright and motivated, but 20 percent of the freshman class is getting poor grades in a required course. This course is taught by lecture; students can be seen at all the lectures, their eyes glazed over, and some of them asleep in their seats. Suppose that money becomes available to the university to offer computer-based education, and the instructor of

this required course secures some of the funds. His plan is to put his lectures on digital video and make them available from a web page in all student dormitory rooms. This plan presents itself as a simple design problem: make a web page that students can find with clear links to digital video. But if the underlying problem is how to improve student performance in the course, this is not a satisfactory solution. If the lectures in this course are not effective in person they are unlikely to be more effective when seen remotely. The digital design is doomed to failure because it is not an appropriate response to the presenting problem of the high failure rate. The same logic holds if the presenting problem is a failing newspaper or an unpopular television program. Adding "interactive" bells and whistles for their own sake will not make for a successful application, and such projects undermine confidence in the medium and in the work of interactive designers.

As the designers of interactive artifacts we are engaged in a collective task of inventing a new medium of representation. We cannot be satisfied with just reproducing older information formats in digital form, settling for mere **remediation** of the textbook, the lecture, the broadcast TV show, the paper newspaper. We have to think more radically. But we cannot redesign the world with every object we make. We have to accept the creative boundaries of the project at hand, such as resistant power structures, technophile or technophobe collaborators, preexisting platform commitments, and limited resources. Yet even on the most constrained project, the fully professional designer can make decisions based on the larger collective task. We can always do a better job with the immediate task by seeing it as a single step toward the development a future, more radical version. We can think of this future artifact as the endpoint of a collective journey, providing an orientation point, a general direction in which we are moving in the company of the larger body of designers, each of us at our pace and from our own starting point.

Orientation toward the core need and toward development of the affordances of the digital medium (as we will be discussing in chapter 2) can guide us even in creatively constrained projects. In the case of the boring college lectures, for example, we can design the underlying data structure so that it supports a more active learning style. Following good information design principles, we can semantically segment the lectures, labeling all segments that contain live demonstrations in a similar way so that they can be accessed by those students who will find them more effective than the whiteboard parts of the lecture. We can look for ways to link our project with those of other designers exploring more participatory learning tools. We can also steer the general design process in the direction of collective change by raising questions that orient the team toward the core human tasks and the expressive opportunities of the medium, preparing the way for more original projects in the future. Even if we use only a limited range of the representational power of the computer, we can remain fully professional by cultivating an awareness of wider possibilities, and doing our best

to orient the current project toward the collective goal of an increasingly mature medium.

DESIGN EXPLORATIONS: EXPLORING DESIGN IN A NEW MEDIUM

Increasing Awareness of Design Choices that Shape Everyday Experience

• In a familiar environment, such as a room in your own home, look at three or more manufactured objects and identify the design decisions that went into producing each one, including size, materials, color, shape; placement of buttons, functions of buttons; relationship to human senses such as softness/roughness, retention of heat or cold; relationship to other objects, such as size of shelves or counters the object sits on, size and shape of any of its own container compartments (e.g., pockets on an apron, oven size in an appliance), need for electrical or other energy source, and portability (e.g., can it fit inside a pocketbook? A car trunk? Can it be carried from floor to floor?). What trade-offs were made in designing it (e.g., capacity versus portability, pleasing appearance versus cost)?

• Choose a household object, such as a microwave oven or media-recording device or clock radio, that has been confusing to you or to someone you know. What design choices led to this confusion? Do you know of similar devices that employed alternate strategies for the same feature? How would you redesign the device to make it less confusing?

• Compare two cell phones that have different approaches to providing a keyboard for dialing a telephone number. What requirements and constraints were common to both design teams? What different choices did they make? What similar or different trade-offs did they make in order to fulfill the requirements within the constraints? How would you justify both design paths?

Increasing Awareness of the Cultural Traditions behind Familiar Media Conventions

• Take an aspect of a commonly used medium and trace its form back to a design innovation or design choice of at least a hundred years earlier. Report your findings in a brief essay, slide presentation, or interactive artifact. You may come up with your own example or choose one of the following:
 • The forms of printed letters (i.e., A a, B b . . .)
 • The arrangement of keys on a keyboard (e.g., QWERTY, telephone pad)
 • The image of a file folder in a computer operating-system interface.

• Choose a website you are very familiar with. What features and functions does it have that resemble older media? Does it have conventions in common with a pamphlet, newspaper, television show, social experience, or other nondigital cultural form (e.g., captioned images, headlines, list of contents, opening credits, rituals for greeting other people)? How are these conventions changed in digital form? What aspects of

the site are unique to digital media? What computational inscription and transmission technologies (e.g., mouse, links, HTML code) make them possible?

Differentiating Layers of Media Innovation

• Make a chart similar to table 1.1 for movies. What inscription and transmission code changes of the twentieth century changed the format of movies? What stable formats were important to the film industry as a business? What innovations in the technologies of inscription and transmission were important to the development of film art?

• Make a chart similar to table 1.1 for video games. Indicate important innovations in input and output (inscription) devices. What are some important innovations for mapping actions with the game controller to complex actions, like fancy fighting moves, on the screen (we can think of coordinated keystrokes as similar to Morse code, a symbolic transmission code for sending a message from the player to screen display)? Indicate important platforms and representational genres. What relationships do you see between changes to the inscription and transmission layers and changes in representation?

• Make a chart similar to table 1.1 for Internet-based formats and genres. What other inscription and transmission technologies can you identify? What formats and platforms have disappeared in the past five years? Which have lasted longer than five years? What are the most recent examples of a stable platform for building applications at the level of representation? What codes do they share? What genres have been built on top of these platforms (e.g., podcasts, blogs)? What conventions do they have in common? How have the underlying technologies shaped the level of representation?

Increasing Awareness of the Cultural Values Reflected in Design Decisions

• Choose a digital or mechanical artifact you use regularly and identify the cultural values that have shaped it. Does the design incorporate assumptions about privacy, space, leisure time, or other aspects of life that might vary across societies or groups? Does the artifact include features that reflect historical values, such as stricter gender roles? What activities does the artifact assume to be the most valuable? What related activities does it ignore or support less completely? How would the design be different if it came from a different cultural context?

• Microsoft and Apple make operating systems that have very similar functions, but users identify themselves with either the Windows or Mac similarly to the way sports fans identify with teams. Look at the advertising campaigns for Apple and Microsoft products. What values do each of these companies emphasize in their approach to potential customers? Do the designs of the Mac and PC systems reflect these different corporate values?

• Choose an artifact that you would like to see redesigned for a different demographic group. Identify the differences in experiences, expectations, and values between the two groups. How does the artifact reflect its current user group? How would it change to appeal to the new group? What features would remain the same across user groups? (Examples: How would you redesign a miniaturized music player so that it would be usable by the elderly? How would you redesign a shooting game so that it would appeal to pacifists or a cooperative game so that it would encourage competition?)

Increasing Awareness of Media-Specific Conventions

• Compare any two platforms for listening to recorded music (e.g., vinyl records and cassette tapes or CDs and MP3 players) or for watching television programs (e.g., digital recorder; broadcast, cable, satellite, computer, or mobile device; DVD player). What features and conventions do the two systems have in common? What features and conventions differ? How does the experience of the user change with the change in delivery medium? Consider capacity, playing time, ways of acquiring the music, portability, ability to share, privacy, noise, and so on. What conventions remain the same across platforms? What new conventions (e.g., for labeling, playing, storing, advertising, purchasing) were invented to take advantage of the affordances of new delivery formats?

• Compare a paper newspaper to a web-based news site of the same newspaper on the same day. What purpose do headlines serve in the paper version? Do headlines change in any way when they move from paper to the web? What is on the masthead of the paper newspaper? Where is the same information presented or the same functions served on the website? What new conventions exist on the website that do not exist in the paper version? What purpose does the menu bar serve? How was this purpose served in the paper version?

• Make a two-column table, similar to table 1.2, listing at least five inscription methods you have used in the past week and the task you performed with each of them. How appropriate is each method for its task? How are the specific affordances that made them appropriate?

Table 1.2
Inscription Methods

Task	Performed With
Bank withdrawal	ATM kiosk keyboard
Shopping list	Pen and paper
Appointment calendar	PDA stylus on screen
Slide presentation	Laser pointer and projection

Now invent an **algorithm** for randomizing the two columns in relation to one another and execute it. (For example, you sort the items in one of the columns alphabetically while leaving the other column as is.) You now have new pairings (such as a PDA stylus for making a bank withdrawal). How would you perform each of these tasks with the mismatched inscription system? How would the experience change? What would be the challenges for accomplishing the task? Would there be any advantage in the new system or any opportunity for an innovative approach to a familiar task?

• One of the marks of an immature medium is the need for the interactor to have to pay attention to transmission codes (e.g., telephone numbers) rather than the representational layer (e.g., names of contacts). For a week, write down every time you are confronted with a code that is meaningful to a computer but not to you as a human being. How would you redesign the system so that interactors did not need to focus on the transmission code?

Orienting Design toward the Underlying Human Needs, Not the Legacy Media Conventions

• Telephones have been in use for a century and a half, but have changed tremendously in the past twenty years. What core human needs do they serve? How were these needs met before the invention of telephony? What communication conventions and rituals made the land-based original telephone system coherent (e.g., assigning of telephone numbers, invention of the dial, ringing, new greeting rituals, human operators)? How did mobile phones incorporate these older conventions? What new conventions and social rituals have been invented for the new devices (e.g., dialing by hyperlink, custom ringtones for different callers, texting)? What needs have been met by these new features that were not met by predigital telephones?

• Identify the core human needs or activities served by one of the following: Google, Amazon.com, eBay, iTunes (or choose another widely used digital environment such as an instant messaging or social networking site). How were the same needs met before the invention of writing? How were they met before the invention of the computer? How has the activity remained the same and how has it changed as a result of the switch to the digital framework?

• Choose an example of a device or application that you find poorly designed. Analyze its design objectives in terms of core human needs. What design elements prevent it from serving those needs appropriately? Why do you think the design team made those unfortunate choices? What did they value more than the needs that you expected them to address? What other media artifacts serve these needs? Do they offer other conventions that might have been applied here? How would you redesign the artifact so that it better served the core needs?

2 Affordances of the Digital Medium

Think of the computer not as a tool but as a medium.
—Brenda Laurel (1993)

The Four Affordances

All **digital** artifacts are made of a common substance: programmable **bits** that can be used for symbol manipulation. As a result, we can think of digital artifacts as part of a common medium, rather than as a diffuse collection of multiple "New Media." Looking at the **computer** as a single new medium of representation, we can see its defining representational affordances: The computer is **encyclopedic, spatial, procedural,** and **participatory** (Murray 1997). These four properties constitute our design space, the context for all of our design choices. Individual projects will be located at various points in that design space, exploiting one property more than another. But thinking of the potential for any project to more fully exploit each of the four properties can help us to discover new directions that we may have previously overlooked. *In approaching interaction design as a cultural practice our aim is always to make an object that is satisfying in itself and that advances the digital medium by refining or creating the conventions that best exploit these four affordances.* This chapter provides a brief overview of these four properties as well as the most important contributory disciplines that designers can draw on to maximize the expressive potential of individual digital artifacts and of the larger digital medium.

The Computer Is a Procedural Medium

The biggest difference between the computer and earlier media of representation is its procedural property, its ability to *represent and execute conditional behaviors.* As I have argued elsewhere, one of the most striking early signs that the computer was a new expressive medium was Joe Weizenbaum's Eliza, an interactive program that was widely mistaken for an actual person (box 2.1). Eliza was experienced as real even

Box 2.1
Dialog with Eliza

> Men are all alike.
> IN WHAT WAY
> They are always bugging us about something or another.
> CAN YOU BE MORE SPECIFIC
> Well, my boyfriend made me come here.
> YOUR BOYFRIEND MADE YOU COME HERE
> He says I am depressed much of the time.
> I AM SORRY TO HEAR YOU ARE DEPRESSED
> It's true. I am unhappy.
> DO YOU THINK COMING HERE WILL HELP YOU NOT TO BE UNHAPPY
> I need some help, that much seems certain.
> WHAT WOULD IT MEAN TO YOU IF YOU GOT SOME HELP
> Perhaps I could learn to get along with my mother
> TELL ME MORE ABOUT YOUR FAMILY
> (From Weizenbaum 1966)

though there were no images or sound track to reinforce the illusion. The program played the role of a nondirective psychotherapist responding to free text input (unrestricted words typed in ordinary natural language) into a Teletype terminal. Eliza had no understanding of what was said to her, but looked for keywords like "depressed" or "mother" and applied cleverly formulated rules of response, including the use of simple grammatical inversions to echo back statements. Despite her many inappropriate replies, and to Weizenbaum's dismay, many interactors believed she was an actual person. She was animated by the power of her procedural design, by the ingenuity of the rules of behavior that determined her reactions to novel input (Weizenbaum 1966, 1976; Murray 1997; Wardrip-Fruin 2009).

Draw on Computer Science Concepts and Conventions

The discipline most relevant to procedural design is of course computer science. *Even for those who will not be doing the coding, understanding how computer science describes objects and processes is crucial to making sound design decisions.* A key element of this process is **abstraction**. Computer science strives to master **complexity** by creating abstract representations that describe elements of systems in the most general terms that most accurately describe their most salient features. For example, to describe the items [apples, bananas, grapes] in a single abstraction we might choose fruit, food, or groceries depending on the context. Of these three terms, fruit would be the best term

for limiting the category and establishing common qualities such as sweetness or perishability. If those qualities are not relevant to the task we are performing and if we want to add other items such as [bread, meat, cereal] to the system later on, then food would be a good choice. And if we are making a shopping **list** and distinguishing between hardware store and supermarket items then groceries might be best. The computational frame of mind sees the world as composed of multiple alternate abstraction systems such as this.

Most important, programmers abstract *behaviors*. Before a programmer writes a line of code they conceptualize the processes the computer will be executing as an abstract set of instructions and rules known as an **algorithm**. A useful algorithm describes a process at its most generalized level but in such a way that every important variation and condition can also be accounted for and responded to appropriately. *Deciding how flexible a program should be, how many possibilities it should anticipate and accommodate is an important part of the design process.* The more possibilities it encompasses, the more powerful and widely useful it will be, but also the more challenging to design.

Legacy media practices like animation and film editing specify unconditional sequences that are always executed in the same order. They are often represented in a **timeline**, and some computer-based authoring systems also use timelines as an organizing framework (figure 2.1). The problem with this approach is that it reinforces our tendencies toward **linear** or **unisequential** design. Programmable bits can imitate **legacy media** and present unisequential **documents** and film clips, but they are particularly well suited to more complex **multisequential** objects that can be assembled and navigated in more than one order. Computational structures allow us to describe entities as **variables** that can have different values at different times, and to make **conditional statements** that have more than one possible outcome. Objects in digital form can have multiple **instantiations,** existing as identical copies or as variant examples of a common pattern. Computational systems change over time, exhibiting different **states.** When we make something with computer code we are creating not a single version of an object or event, but many possible versions with interesting variations. Computational artifacts exist not as fixed entities, like books or movies (even though we may think of them that way), but as a set of easily altered bits governed by conditional rules.

By harnessing the procedural power of the computer to represent objects and processes we can create **simulations,** working models of complex systems that can be run with controlled variations and that aspire to reproduce the complexity we recognize in natural and social systems like the human body or the global financial markets. Such systems are made up of multiple independently operating **objects** or **agents,** whose complex interactions produce results too numerous and multicausal to be predictable in advance. Although many beginning programmers see the core computational structures as a **branching tree,** in fact the inner workings of computer code

Figure 2.1

Timeline from Adobe Flash authoring environment, which is based on the **metaphor** of a movie. Flash also includes object-oriented scripting for more fully exploiting the procedural and partici- patory affordances of the medium.

have been growing more interactive: more like the ecology of a pond rather than the command structure of an army. Systems are now written that exhibit **emergent behavior,** behavior that is more than the sum of its parts, and therefore can be seen as similar to life forms.

Computer programs are judged by how efficiently and reliably they perform. Programmers aim for **robustness,** for not failing under a variety of error-inducing conditions, including coping with unpredictable user input and portability to multiple systems; and for **scalability**, for being able to accommodate more users, more data, more related procedures without having to be reengineered. The programmer values predictability and formula, aiming for the most generic, reusable solution that is also the most adaptable. The digital media designer, like the computer scientist and the programmer, should think of the process of representing meaning on the computer as a process of abstracting objects and behaviors as efficiently as possible, and should be aware of the possibility of representing complex systems as composed of multiple abstract actors in multivariable configurations.

In part III we will be looking more closely at the procedural affordance and identifying ways in which designers can make use of the power of computational abstraction for the purposes of describing objects and processes in the most coherent and expressive manner.

The Computer Is a Participatory Medium

It is surprising that the Eliza program fooled people when it first appeared, since it now seems so primitive in its ability to simulate a conversation that the tendency for people to assume that computer programs are more capable than they actually are is often referred to as "Eliza effect." But Eliza also owed her success to an element of Weizenbaum's design that is often overlooked: Weizenbaum did not merely script the machine; by framing his experiment in natural language processing as the highly conventionalized and familiar scenario of a therapy session he was also *scripting the interactor*. His character was successful because it exploited the participatory affordance of computer environments as much as it did the procedural affordance.

The relationship between the interactor and any digital artifact is reciprocal, active, and open to frustrating miscommunication. *The designer must therefore script both sides so that the actions of humans and machines are meaningful to one another.* Sometimes the script is quite rigid, as in a touchscreen ATM machine or a phone-based automated customer service system. Such rigid systems work best with screen-based multiple-choice answers, where there are a limited number of routine transactions, with each one taking few steps to complete. When used for more complex transactions, like the decision-tree diagnosis of a consumer problem, they can be maddeningly frustrating.

Sometimes the script is more flexible, offering the interactor an array of props with which to improvise their part of the exchange, like the iconized tool bars of word processors or role-playing adventure games. Some digital conventions are so familiar that they script us in a **transparent** way. For example, a blinking insertion point in a text box is a transparent cue to type in information; blue or underlined text on a website cues us to the presence of a link; arrows at the left edge or bottom-left corner of application windows cue us to the possibility of scrolling. *A large part of digital design is selecting the appropriate convention to communicate what actions are possible in ways that the human interactor can understand.*

Because the computer is a participatory medium, interactors have an expectation that they will be able to manipulate digital artifacts and make things happen in response to their actions. They will therefore become frustrated and impatient when they are not allowed to act. The responsiveness of digital media, whether accessed through a keyboard, mouse, joystick, touchscreen, scroll wheel, or gesture sensor,

excites our desire to do something, to see what will happen if we drag something around, click on an underlined word, or otherwise poke at the environment.

Participation in digital media increasingly means social participation. Previous mass-communication technologies provided either one-to-one (telephone) or one-to-many (books, television) **transmission** channels. The computer provides one-to-one (e.g., email) and one-to-many (e.g., DVDs) communication. It also provides new forms of many-to-many communication, most notably on the **World Wide Web**, which provides the same potential distribution to an album of baby pictures as it gives to CNN.com's coverage of a presidential inauguration, disrupting the media conventions for both. New participatory **genres** such as chat rooms, bulletin boards, discussion lists, blogs, wikis, instant messaging formats, virtual environments (Second Life), social networks (Facebook, Myspace, Twitter), and media-sharing technologies (Flickr, YouTube) convene communities of participants in discussions that are **synchronous** and **asynchronous**, spoken and written, individual and collective. They also quickly assimilate the functions of one another, posing new design challenges in providing coherence to a sustained collective conversation (see figures 2.2, 2.3).

Mass participation in digital environments has also raised questions of security and privacy. Designers have the power to capture input from users without their intentional action, and even without their knowledge and consent. As citizens of a digitally enabled world we are subject to many kinds of monitoring. Digital cameras record our images, digital networks record our purchases, and global positioning technology in our cars or cell phones pinpoints our personal location (figure 2.4). We are open to photographic and sound recording through portable devices that were once the domain of superspies and are now available at mass consumer prices. This capacity can be reassuring, as in devices that allow the elderly to call for help even if they are far from a telephone; or it can be menacing, as in spyware programs that surrepti-

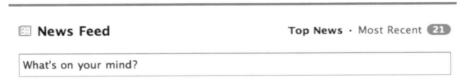

Figure 2.2

Status line on Facebook. The status line, cued here by a generic question, is a convention that has been widely accepted as a way of formatting participation in large common spaces. The box provides a constrained container (even when longer posts are allowed) that focuses contributions so they can be composed easily, distributed widely, and collected in lists that can be scanned quickly by the recipient. This simple convention—a limited size, rapidly posted container for messages that can be targeted at one or many recipients—has created new, globally accessible channels of communication for personal and organizational use.

Most Recent Customer Reviews

★★★★☆ **Great product!**
Used in a small room this product
produces a noticeable difference in the air
quality in a short period of time.
Read more
Published 5 days ago by

★★★☆☆ **Air Purifier**
It's a bit on the small side and I'm not
sure how effective it is but, so far, I'm
satisfied.
Published 6 days ago by

★★★★★ **honeywell air purifier table
model**
so far the air purifier has performed very
well making a large contribution to my
health and well being.
Published 6 days ago by

★★☆☆☆ **Crappy little fan filter at a
crappy little price**
. ll generally makes good products
(I own another ell that I really like)
but this model is very cheaply made and
noisier than it should be for its size.
Read more
Published 8 days ago by

★★★★★ **Great purchase - want to get
one for each room in the house!**
For the price, this,....l air purifier
was a fantastic deal for me. I have terrible
allergies and I often wake up with my eyes
crusted over, my nose congested, and my
throat... **Read more**
Published 8 days ago by

Figure 2.3
It has now become standard to provide a space for visitors to a website to talk back, like this customer review utility on Amazon.com. Other standard feedback conventions include email links, live chats, Frequently Asked Questions (**FAQs**), and polls. The refinement of these features and the invention of new ways to support participation will be a growing area of digital design for decades to come.

tiously record our keystrokes and page views in order to steal passwords or deliver unwanted advertising. The increasing mediation of our actions by digital technology has led to new kinds of counterfeiting, including the crime of identity theft in which possession of data about someone becomes the power to act as that person. For the purposes of many social transactions, we are identical with the sum of the digital information we have input. *Designers must therefore take care to limit access to information and to give interactors control over their own information and knowledge of how it is being collected and used.*

The participatory nature of the medium has also profoundly affected legacy media enterprises. Media now appears to us as something to be cut, pasted, reassembled, and

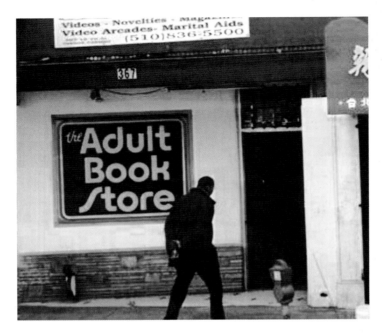

Figure 2.4
Google Map Street View of San Francisco includes a figure in a potentially embarrassing moment, an example of how once-private experiences are becoming publically—and even globally —visible.

distributed with ease. The music industry underwent a tremendous change starting in the late 1990s when users began trading digital music files over the Internet. As sales of CDs fell and threats of prosecution escalated, Apple Computer came up with a design solution that included a commercial solution: the introduction of the iTunes website and the iPod device gave users a legal method for collecting digital music files. As increasing bandwidth and memory make it easier to collect moving-image files, movies and television face similar challenges and the need for similar design solutions. *One of the key tasks for information designers is to satisfy increasing demand for access to media while preserving the property rights of those who create media artifacts.*

The production of entertainment is also becoming more participatory, with digital recording and editing equipment, and development platforms for interactive gaming, that were formerly the prerogative of studio professionals now available at consumer prices. One result is the exponential explosion of user-generated and self-published content, often indexed by other participants through popularity ratings (figure 2.5).

Participatory structures are increasingly being incorporated into legacy frameworks. In England, television viewers have access to a remote control with a special button for

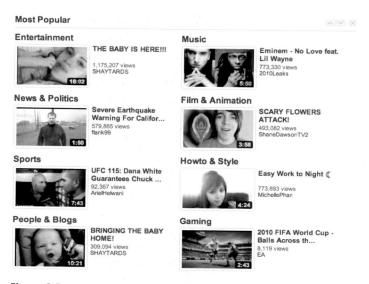

Figure 2.5
YouTube displays user-created videos based on popularity.

interactivity, and interactive enhancements are added to hundreds of television shows every year, giving viewers a choice of which tennis match or garden tour to watch, letting them vote for their favorite British person, inviting them to take an IQ test in sync with a live audience, or allowing them to participate in interactive stories (figure 2.6). As television merges with games and the Internet and more powerful computing is incorporated into media players of various kinds, the opportunity for inventing new participatory conventions for entertainment and for information resources will expand.

Draw on HCI Concepts and Conventions

The discipline that is explicitly concerned with the study of the relationship between human beings and computers is **human–computer interaction (HCI)**, which has its roots in industrial design. In fact, one of the most influential books for the interactive designers, Donald Norman's *The Design of Everyday Things* (1988), hardly mentions the computer. Norman, who began as a cognitive psychologist, called attention to the importance of the **mental model** formed by the user based on the appearance and behavior of the object. Mental models can derive from existing conventions and past experience. For example, we expect wall switches to turn on overhead lights. But they also derive more generally from what we perceive as the **affordances** of the artifact,

Figure 2.6
Red Button TV in Great Britain was among the first widespread interactive services to be delivered as part of the standard television package. Interactive features are accessed through a dedicated red button on the remote control, including on-demand content like news and traffic reports, local government public services, and multifeed coverage of sports events and concerts.

that is, the functions that the physical properties of an object make possible. Wood, for example, affords carving and burning; blackboards afford writing and erasing. Other affordances are more like cultural signals to the users, like the door handle that affords pulling, triggering the mental model that the door will move toward us in response to our action. Much of our confusion in coping with an unfamiliar environment like a hotel shower in a foreign country, or a rental car in an unfamiliar make and model, derive from poor signaling of what functions a hidden knob or mysterious gizmo affords. Mental models are particularly important for machines whose workings are usually hidden from us. We need to know not only the results of a command but

also the causal relationship: such as why a digital music player has chosen a particular song, a search engine has prioritized certain sites over others, or a computer operating system has suddenly caused all my working windows to disappear.

In digital design we must ask ourselves what mental models the interactor will bring to the object. For example, if we make a computer "notepad" how far should we follow the model and mimic the affordances of the paper notepad? Should we allow the user to turn its pages? To write on the "reverse side" of a page? To tear out a page and save it separately? With machines whose workings are complicated and hidden Norman advocates the key design principle of **visibility.** We should be able to see what the machine is doing—not by looking at the gears, but by understanding its behavior as determined by a logical system of cause and effect. In particular, we should have clear **feedback** from the machine on the effects of our own actions. For example, in an operating system, the mini-animations of a clock face or an hourglass are feedback mechanisms that acknowledge our commands and indicate the machine is working on executing them. In an electronic notepad, an animation may reinforce the model of turning a page as feedback for the interactor's gesture and reinforcement of the legacy model.

In digital as in mechanical design, our goal should be to remove distraction, to allow the user to focus on the task at hand rather than the tool, by making the interface elements transparent, and allowing the interactor **direct manipulation**, as we do, for example, when we drag a file folder to the trash can. **Usability** is a key concept in HCI. The usability design process starts with the gathering of all the stakeholders of a system, with an understanding that there will be multiple kinds of users of the end product and multiple criteria on which that final product will be evaluated. Such a process identifies tasks and models alternate ways of performing them, relying on repeated testing and revision with small groups of users, including groups that work with paper **mock-ups** before anything is built. **User testing** often focuses on the performance of tasks, and takes quantitative data on how long it takes new or experienced users to complete them, and how many mistakes these users make in performing them. Users may also be asked to provide **think-aloud protocols** describing their assumptions, intentions, and reactions as they use an object, which can provide insight into the mental models they are forming. Such testing can be part of an *iterative and formative evaluation* in which the designers repeatedly test and redesign versions of the product. *Human-centered design* is an important usability concept, emphasizing the physical and cognitive capabilities and limitations of human beings. Keyboard design, for example, is the subject of ergonomic standards that take into account the size of the human hand and the positioning that creates the least strain (figure 2.7). (For more on usability guidelines, see Jakob Nielsen's website <http://useit.com>; government guidelines at <http://www.usability.gov>; and the guidelines issued by the International Standards Organization at <http://www.iso.org>).

Figure 2.7
The Microsoft Natural Ergonomic Keyboard addresses the problem of repetitive motion injuries by providing wrist support and an angled split design to create a more "natural" rotated positioning for the hands. The buttons in the middle just above and below the spacebar are dedicated to zooming in and out on and moving between web pages, reducing the need for mousing.

Usability studies work particularly well within the model of the computer as a tool or machine, requiring a "user" whose main goal is efficiency in performing a task. But interactors can be understood in larger contexts than as tool users and task performers. They also make complex judgments about what they want to know, what they want to do, and where they want to go in the digital realm. They make these judgments based on social and cultural contexts that can resist quantification.

Social anthropology, for example, has introduced the useful concept of situated action, as a way of understanding human–computer interaction. **Situated action theory** sees users not as interchangeable processors of information, who all behave the same way according to pre-scripted, machine-friendly rational plans, but as uniquely positioned, complex actors whose frame of reference is shaped by the surrounding social and material world. Lucy Suchman, studying the interaction of users with copier machines in the late 1980s, demonstrated the many ways in which their model of where they were in the process of copying and binding a document at any given moment differed from the machine's model, and from that of the Help system. Instead of asking the user to conform more fully to the **machine model** of a generic process, Suchman argues for an embodied and relational model, in which humans and machines are constantly reconstructing their shared understanding of the task at hand (Suchman 1987) (figures 2.8, 2.9).

Ethnographic research, grounded in cultural anthropology, is a fruitful way of looking at interactors in online social networks and virtual communities as cultural

Figure 2.8
A GPS navigational system must understand action as situated, adjusting to the current position of the car and the driver's real-time changes in position, rather than expecting drivers to conform to a single invariant route.

Figure 2.9
YELP provides location-sensitive information, including many user reviews of the same venue, and it does so for multiple platforms, illustrating three different ways in which the same interaction can be contextualized or "situated."

Figure 2.10
Celia Pearce has documented the ways in which players who were exiled from the short-lived Uru, a massively multiplayer online role-playing game (MMORG), have reconstructed elements of the game's culture in other online environments. Shown here is the Uru Fountain, an important gathering place, in (clockwise from upper left): Uru, There.com, Adobe Atmosphere, and Second Life.

beings, actively creating and negotiating the meaning of shared actions and objects. For example, Celia Pearce has found striking resemblances between the community-making behaviors of a gaming community displaced from one virtual world to another and those of similarly displaced émigré communities in the real world (Pearce 2009) (figure 2.10).

Another useful approach to capturing the many ways in which objects participate in systems of meaning is **participatory design**, which engages the potential users of a new system in every step of the design process, not merely as informants or testers but as collaborating members of the design team. Participatory design emphasizes the empowerment of marginalized stakeholders in proposed designs, such as poor people receiving a government service like a homeless shelter, workers rather than managers in a business introducing a new IT system, or people without technological expertise who are expected to be the users of a new device. Participatory

designers look to such groups as providing valuable knowledge of the relevant real-world contexts and of the core human needs underlying the design brief (Dearden, Rizvi 2008).

Individual experiences with interactive environments can vary widely from one another and from the designers' expectations. The emotional component of interaction, which is important to understanding players' engagement with game environments, is particularly hard to capture with experimental user testing. Players may suppress emotional information in nondirective think-aloud protocols, and directed questioning can limit responses to predetermined categories. One promising approach is to ask game players to provide feedback by manipulating evocative but nonspecific tactile figures that serve as symbols for whatever emotions the individual player associates with them (Isbister et al. 2007) (figure 2.11).

Figure 2.11

The Sensual Evaluation Instrument (SEI) used by Katherine Isbister and her collaborators to engage interactors in playful self-assessment of their emotional responses to computer systems. The system is composed of eight clearly differentiated, warm-to-the-touch, nonrepresentational objects created by a sculptor. The objects are meant to be appropriate to the kinds of feelings reported by interactors, such as confusion, surprise, and flow, without imposing any particular meanings. Subjects tend to associate more negative feelings with the spiky objects and more positive feelings with the smooth objects.

Participation in digital environments is always part of larger social and cultural contexts that the designer should bear in mind. In part V we will be examining several social and cultural models of interaction that designers can draw on to script the interactor.

The Computer Is an Encyclopedic Medium

The most capacious medium ever invented, the computer can contain and transmit more information in humanly accessible form than all previous media combined. Technically, this larger capacity is a function of engineering successes in electronic circuitry, signal processing, and a symbolic system of logical codes. Since the 1960s, advances in silicon technology have led to the creation of ever-larger repositories of bits in ever-smaller and cheaper machines. In 1965, Gordon Moore noticed that new computer chips seemed to be released every eighteen to twenty-four months and that each chip doubled the processing power of the preceding one. This rapidly accelerating growth became known as **Moore's Law** and has held true for almost half a century. The removable tape drives of the 1960s held two million characters each (two **megabytes**, or approximately two books worth of information), and were the size of a household refrigerator. By the end of the first decade of the twenty-first century we were measuring personal computer capacity in terabytes and carrying around on our key chains removable storage equivalent to dozens of those refrigerator-sized tape drives. The size of the available storage space and the ease with which it can be retrieved and displayed also has meant an expansion in the kinds of media formats that can be inscribed and transmitted as electronic bits. New technologies of signal processing have made it possible to represent audio, images, and moving images in digital form and to display them in a single environment. The phenomenon of media **convergence** challenges designers by creating a convergence of conflicting conventions with which to structure information. The encyclopedic capacity of the medium raises the expectations of the designer and the interactor, making it important to communicate the limits of any collection, and to make clear decisions on what lies inside and outside of the project's scope (figure 2.12).

I use the word "encyclopedic" to refer to both a technical and cultural phenomenon: to the unequalled storage potential of the new medium and to its promise of an infinite tablet, a library as big as the world. As a culturally encyclopedic medium the computer inherits age-old traditions of human culture, expressive of our core need to collect, preserve, and transmit knowledge across generations. Homer's epics, for example, include encyclopedic set pieces, such as a lengthy catalog of ships, similar to lists in other bardic works of preliterate **orature.** With the advent of a written alphabet the encyclopedic impulse appeared in scrolls of magical spells, detailed histories, Aristotle's knowledge compendia, and Pliny's thirty-seven-"book" survey of

Figure 2.12
The "My Life Bits" Project is an attempt to record the life of Gordon Bell, a Microsoft researcher, as completely as possible, including photographs, video, and audio recordings of events as they happen. The challenge it poses is how to annotate such a wealth of data so that it can be retrieved. Merely recording everything would be similar to recording nothing, since human memory relies on forgetting and selecting. See <http://research.microsoft.com/en-us/projects/mylifebits>.

"Natural History" published in the first century A.D. With the invention of the printing press, the accumulation of knowledge took on new, standardized forms, from scientific treatises to picaresque novels. By the middle of the eighteenth century, the editors of *Encyclopedia Britannica* felt confident enough to attempt an alphabetical survey of all of human knowledge, a project that lasted for two hundred years, with increasing numbers of volumes, and served as a respected and useful reference work for shared authoritative knowledge until overtaken at the turn of the twenty-first century by Internet information resources. The human encyclopedic aspiration is also reflected in data collection, for example census taking; in narrative traditions, such as Shakespeare's history plays and the novels of Charles Dickens, Honoré de Balzac, and George Eliot; and in the increasing development of film and television series that

follow multiple related characters and stories across time and space. All of these legacy genres are encyclopedic in scope, presenting sweeping panoramas and close-up detail of a particular complex society at a particular moment. *Their strategies of organization are part of the rich palette of media conventions that the designer can draw upon to create encyclopedic digital artifacts.*

The designer can also draw upon the conventions of emerging encyclopedic digital genres: vast databases such as world health surveys, stock market prices, soccer statistics, and recordings of electromagnetic impulses collected by spaceships exploring distant planets; massively multiplayer virtual worlds in which hundreds of thousands of people share a common landscape; a World Wide Web of "pages" describing everything in the world that can be captured in text, image, or sound; participatory information structures like Wikipedia that are created by multiple contributors acting independently within a common information structure; maps and satellite image systems that reproduce the whole earth in navigable form at multiple levels of **granularity**. The creation of encyclopedic networked resources will be a continuing challenge for digital design, posing the problem of how to shape our expanding capacity into coherent **genres** so that we can access information without being overwhelmed.

Draw on Information Science Concepts and Conventions

The exponential increase in information presents us with the challenge of finding more powerful means to organize it than the ones we have developed for legacy media. In doing so we can build on the methods of information science, which are themselves changing to accommodate the convergence of libraries, document archives, and museums. Information science is faced with the task of inventing the transmission technologies—the common standards for preserving, describing, cataloging, and accessing an exponentially expanding global knowledge base, the vast repository of human culture in all its artifactual manifestations.

The digital medium differs from legacy media in that it can store the **artifact** itself—the equivalent of the book, the audio tape, the film canister—as well as a description of the artifact, and it can **link** one to the other. The Google Book Search Library Project (<http://books.google.com>) is digitizing millions of volumes and making them directly searchable in the same way that web pages are searchable (figure 2.13). As scholarly journals, newspapers, magazines, and books move to digital delivery formats it will become increasingly possible to archive them in a manner that makes them open to free text searches for words and phrases. But free text search of large information resources (like typing words into a web search engine) produces too much information. The ability to find every mention of the word "freedom," for example, in every book in the Library of Congress is a daunting prospect. *The challenge for designers*

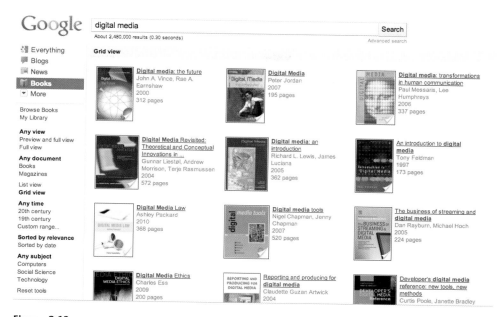

Figure 2.13
Google Books has scanned over seven million books held in research libraries, and it provides an online search that returns titles, images, and full or partial access to the text, depending on copyrights. It can also search for words and phrases within a single book.

is determining how to organize information so that it is retrievable in a coherent form that minimizes confusion and maximizes understanding.

One of the key affordances of moving encyclopedic resources to digital form is the ability to index and retrieve information at multiple levels of granularity. We can search or browse by titles of books or by chapter headings or single words within multiple 100,000-word texts. We can retrieve whole books, or particular pages within a book. Furthermore, when we bring multiple media into a single format we have a chance to rethink the **segmentation** conventions with which we index, retrieve, and display them. Should films be accessed by title, chapter, shot, or frame? Or perhaps by line of dialog? When we make new resources for digital delivery we have the opportunity to segment information for the screen, and to avoid physical interruptions—like the end of a page—of sections that should be kept together by content. Design of encyclopedic resources involves active decision making on granularity and segmentation conventions, and careful assignment of appropriate **labels**.

An important goal of archive design is support for **intellectual access** to individual artifacts, that is, retrieval of the appropriate item not by its size or shape or media type or donor's name, but by the relevant conceptual terms. This usually involves an

act of **classification,** of assigning objects to standardized categories, often through the use of **metadata.** Classification involves establishing **controlled vocabularies,** words that everyone agrees to use in the same way to refer to a class of artifacts. The subject index of the Library of Congress is a controlled vocabulary, as is the Getty Art and Architecture Thesaurus, which provides a **taxonomy** for everything from arches to urns. The virtue of a controlled vocabulary is that it allows us to juxtapose separate items that relate to one another by virtue of the fact that they carry the same label. In a library environment the number of labels by which we can juxtapose individual units of information is limited. We can sort them onto separate shelves, and we can cross-reference the shelves by assigning multiple subject labels. But one book can only be in one place at a time, and so can one index card describing the book. If a book is to be listed by various subjects it must have separate cards for each one, which limits the number of entries per book. But a digital artifact can be called up in multiple contexts without having to be duplicated. It takes up no more room in the computer's memory, although it may appear on hundreds of virtual shelves. Every query to a search engine constructs a new shelf, customized to the individual searcher.

The values of information science are concerned with minimizing ambiguity and maximizing accessibility. A well-designed information structure is open-ended and can accept new elements without confusion about where they will be placed. It provides a means of finding items without memorizing the controlled vocabulary words, either by providing them as a navigation system, as in the stacks of a library, or by offering an intermediary—human or mechanical—who can find the right label when offered a synonym or related term. With the right labels attached to the right items, we can find any needle in the rapidly expanding global haystack. But our methods for labeling items of information are lagging behind our technologies for retrieving and juxtaposing them. Designers in the twenty-first century are faced with the need to bridge this gap, and must find new ways to maximize the power of the digital environment to retrieve information with precision and to juxtapose information from varying sources in coherent ways. We will explore these approaches further in part IV.

The Computer Is a Spatial Medium

Since space and time are the two foundational coordinates of human cognition, we experience everything spatially and we have many genres for representing it, such as paintings, sculpture, architectural plans, and film. But the computer constructs space in a different way from other media: it creates virtual spaces that are also navigable by the interactor. Digital space is created out of bits rather than bricks, and it rests upon the procedural and participatory affordances of computation: it is navigable because it responds to our navigational gestures in a consistent manner.

Figure 2.14

The Xerox Star (1981) was the first commercially produced computer with a GUI (graphical user interface). It included icons for files and windows for applications and it was mouse driven, which became standard features of the familiar desktop interface. There was no fixed desktop menu; the keyboard had several dedicated function keys. The mouse was used to select an icon, but a physical "Move" key was used to reposition it, in contrast to the later click-and-drag convention. The functionality of the interface is well documented in videos available at <http://www.digibarn. com> or <http://video.google.com>.

The **spatial affordance** of the computer does not rest on its ability to present us with images of real-world spaces (Murray 1997): for example, we perceive web pages as occupying "sites" that we "visit." But the addition of spatializing images to computer displays has been an important part of the evolution of information organization. The familiar desktop **graphical user interface**, the world's most successful GUI, was invented at Xerox PARC in the 1970s, further developed by Apple Computer as the commercially successful Macintosh in 1984, and fully established as the dominant world standard when it was deployed in a robust PC version in 1995. The objects and the space that make up the computer desktop—the file folders, windows, manipulable icons, and menus—were developed over time, not as literal reproductions of physical objects, but as **abstractions** that include only those spatial properties that reinforce their functions as **chunks** of information and programming code (figures 2.14–2.16). Computer file folders have customizable labels like real file folders but they are not depicted as vertical objects stacked in wooden drawers. Because there is no need to mimic the extraneous tasks of the physical world, like opening a drawer, we can focus our attention on the placement of the file within the **hierarchy** formed by the labels. The desktop GUI is now so well established that it is regularly lamented as too limited,

Figure 2.15
Apple Lisa GUI (1983) includes windows, files, icons (including the trash can), and a (rather verbose) top **menu bar**. The operating system, called Desktop Manager, was document driven like the Xerox Star, rather than application driven like the later Macintosh. To create a new document the user would "tear off" a new piece of virtual "Stationery." Applications (or "tools" as they were called) like word processors would start up only when documents were opened and were otherwise hidden from the end-user within the operating system.

Figure 2.16

The Apple Macintosh GUI (1984) included windows, files, click-and-dragging of icons, and a menu bar at the top. The Macintosh, inspired by the Xerox Star, initiated the full WIMP interface we have come to think of as the standard for personal computers and workstations.

and even denigrated with the acronym **WIMP** (Windows, Icons, Menus, Pointing devices), but it has yet to be superseded, although web browsers, mobile devices, and entertainment systems offer partial alternatives.

By the 2000s proliferation of applications on the personal computer led to the addition of a "dock" at the bottom of the desktop screen, an abstraction of the function of docking a ship that allows users to park favorite applications in easy reach of top-level pointing. Desktops, windows, sites, tabs, and docks all occupy very different frameworks in the real world. We don't find file folders floating with yachts, or windows arranged in tabs within our physical world. But as abstractions of spatial functions these conventions have proved to be learnable and are now transparent to users. However, the space of **applets** on mobile devices remains disorganized and will no doubt be an active focus of design in coming years.

Some of the earliest applications of computers, even before the wide availability of graphical displays, were spatial applications including Spacewar! (1962), the first action video game, and the Aspen Movie Map (1978), which preceded the Google Street View by two decades (figures 2.17, 2.18). Digital technologies have developed the two-dimensional screen into increasingly realized three-dimensional spaces, both for conventional movies and for interactive environments. For example we can fly through highly detailed models of real places like Disney World (figure 2.19), virtual

Figure 2.17
The Spacewar! game created for the PDP-1 computer (1962) was the first representational video game. It was created as a demonstration of the new graphics system by a group of researchers who were avid pinball players and science fiction fans (Graetz 1981).

Figure 2.18
Aspen Movie Map (1978) one of the first demonstration projects of the group led by Nicholas Negroponte and Andy Lippman that went on to found the MIT Media Lab. It made use of early optical videodisk inscription to create a computer-driven, interactive experience simulating a drive through parts of Aspen, Colorado, including the ability to make right-angle turns. In 2007, Google Street View introduced a similar interaction pattern.

Figure 2.19
Fly-through of Disney World 3D model in Google Earth.

communities like Second Life, and inaccessible abstracted places like a detailed model of the inside of a cell or a chemical molecule (figure 2.20). As with video games, we can often switch camera positions within these environments and zoom in and out from overview to close-up. Such environments can be both captivating and over-whelming. Designers face challenges in providing a consistent model of the space as a whole and in making individual areas memorable and findable (Nitsche 2008). These challenges are similar to the design problems of filmmakers, landscape architects, and urban planners, combining problems of layout with consideration of point of view.

Draw on Visual Design Concepts and Conventions

The visual organization of digital environments should reflect the core principles of good graphic design, including the design values of *contrast and regularity,* which allow us to focus the interactor's attention on the key informational elements and their relationship to one another. For example, we establish table-like **grids** for web pages and assign specific horizontal and vertical areas to specific purposes such as a site logo, a navigation menu, or a news box. Regularity of proximity, size, color, and font allows users to recognize similar items and to distinguish dissimilar items from one another (figures 2.21, 2.22).

Because we are attuned to the spatial characteristics of digital environments, *users assume that spatial positioning is meaningful and related to function.* If an item calls attention to itself with a different color or size we will try to touch it or click

Figure 2.20
Three-dimensional, navigable visualization from the Allosphere, a huge scientific visualization facility similar to a planetarium, designed by JoAnn Kuchera-Morin at the University of California in Santa Barbara. Image is from an informational video at <http://www.allosphere.ucsb.edu>. Such installations hold the promise of new insight into otherwise unobservable phenomena, and they pose new challenges for the navigation of three-dimensional space.

on it, assuming that it has some behavior or link associated with it. If two items are next to one another on a list we will assume that they are parallel and behave in similar ways. Designers must therefore be careful not to introduce purely decorative elements that resemble icons or linked text. Such items trigger expectations of interactivity and lead to user frustration when they do not respond to the user.

Good graphic design matches visual elements with the meaning they are meant to convey, avoiding distraction and maximizing meaning. Graphic presentation of information can help to explain relationships and serve as an aid to brainstorming and discussing structure at every stage of the design process. Even those who are not good at sketching can use the organizing power of graphic design to clarify and communicate complex ideas by making use of graphic design software, including the many free charting and visualization programs available on the web. Information designer Edward Tufte, an influential exponent of the explanatory power of graphics, refers to extraneous decorative detail as "chartjunk" and insists that all the aspects of an image serve to convey salient information (Tufte 1983), such as magnitude, time, and causality. By these standards, Tufte has identified Charles Joseph Minard's 1869

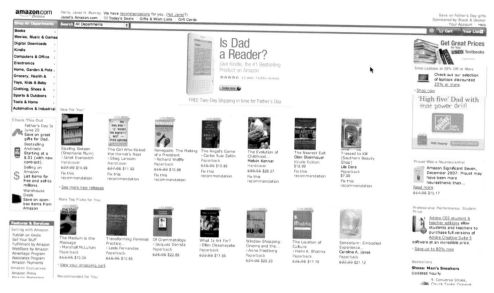

Figure 2.21
Amazon.com provides a great deal of coherent information on this page by using a grid that places navigational menus in the left-hand column, individual thumbnails of books in their own uniform grid within the middle column, and promotional displays in the right-hand column. The generous white space makes the page more readable and less aggressive. The banner at the top of the page includes the standard conventions of shopping cart and account access but is minimized to focus attention below.

map of Napoleon's campaign against Russia as "probably the best statistical graph ever made" because it conveys so many aspects of a complex event in a single unified presentation, including the geographical route of the army in advance and retreat, the size of the army at each point in the journey, and severe winter temperatures (figure 2.23).

Tufte's focus is on visual design, not as an end in itself, but as a means to communicate unambiguous information. Digital designers must be equally conscious of the weight of each design choice and equally critical of the merely decorative. But the culturally informed designer is also skeptical of claims to impartial factuality and to a simple one-to-one correspondence of code to meaning. As Tufte points out, the Minard map reflects antiwar values in its selection of details: it does not include the name "Napoleon" and is designed to dramatize the contrast between the large number of soldiers who began the campaign and the few who returned. Furthermore, the inclusion of so many data points does not mean that the presentation is

Figure 2.22

This site, like Amazon.com, is a three-column grid, but less well organized, with a mixture of digital elements and reproduced print elements. The navigation is confusing and the advertisements poorly separated from the editorial content. Stronger content is hidden at the bottom of the page, which visitors are unlikely to scroll to.

Figure 2.23

Charles Joseph Minard's 1869 map of Napoleon's invasion of and retreat from Russia, which Edward Tufte has called "probably the best statistical graph ever made." The brown lines were originally red, and represent the soldiers' progress from France to Russia; the black line represents the return. The thickness of the lines indicates the size of the force.

comprehensive. For example, Minard does not include statistics on the casualties among the Russians or the income level of Napoleon's soldiers, or the number of fatherless children they may have left behind.

The genre of statistical presentation is itself a reflection of cultural values characteristic of Minard's time, which saw a great growth of census taking and bureaucratic data gathering. Quantitative displays are important tools for understanding complex events, but they can prevent us from framing more open-ended questions. If we are to assess Minard's map as a comment upon the costs of war we might compare it to work in other genres, such Tolstoy's *War and Peace* (1869) which takes a great deal more space to cover some of the same ground from the Russian perspective, or Picasso's *Guernica* (1937), an abstract image memorializing civilian victims of fascist bombing in the Spanish Civil War. Minard's graphic is a powerful representation of the event, but it is not necessarily more informative or objective than other media artifacts, though its use of numbers may give it the appearance of impartial and comprehensive authority.

Since the digital medium is more than a conveyer of quantitative information, aesthetic and stylistic strategies are an important part of the designer's craft. Strategies that would work well in a paper poster can result in static and self-referential design in a participatory environment, so designers must remember that no element can be beautiful if it interferes with **agency**. But many poster-based strategies, like the grid, can be adapted to digital formats. The key to good design is to integrate the aesthetic elements so that they serve the meaning of the artifact and support (rather than distract from) interaction (figure 2.24).

Graphic design in digital environments must always be in the service of interaction. Designers should therefore avoid purely decorative clutter, but they should also resist the seductions of extreme minimalism. The minimalist style adopted by graphic designers in the late twentieth century limited the number of colors and valued smaller fonts over larger ones. This aesthetic of understatement is an understandable reaction to the overly commercial, overly emphatic, visual shouting of the advertising and mass entertainment environments. The softer voice of the art poster or intellectual book jacket—a style soon co-opted by upscale advertising—draws attention to itself by its restraint. But minimalism can interfere with clear communication when the poster or printed page is so faint and the typeface is so small that the words cannot be read, and the problem is exacerbated in interactive environments where the user is looking for cues to how to behave or to what the computer is doing or how the information is organized. An interactive artifact may have great visual authority but will not be well made if the visual elements do not support the interactive function. A Macintosh may be delightful to look at but if the on/off switch is so elegantly hidden that infrequent users can't find it, then visual design values have been allowed to subvert acceptable interaction design.

Figure 2.24
Heart-shaped menu for the British Heart Foundation Annual Review site for 2008, a whimsical but readable alternative to a conventional menu or **tag cloud**. Mousing over any of the words causes related items to remain red while other choices fade, providing an organized overview of the contents of the site. Created by Sennep.

DESIGN EXPLORATIONS: EXPLORING THE AFFORDANCES OF THE DIGITAL MEDIUM

Designing Coherent Behaviors
• Game developers often paper-test a game before it is built to refine interaction and gameplay and to gain a sense of users' actions and potential frustrations. For this

exercise, you will form teams to do the reverse. Take an actual computer-based single player game (like Tetris) with which you are very familiar and create a paper version of it. Take turns being the player and the operator of the game. What kinds of actions and decisions does it take to run the game as the computer?

• Based on the previous exercise, reverse-engineer the algorithm for the game. What variables would you have to keep track of? What player actions would you have to anticipate? What conditions would you have to check for? Are there randomized processes involved? How should they be constrained? (E.g., Should it generate more of one kind of shape than another? Should it become less random if the player is closer to winning?)

Write out the rules of the game. For example, for Tic Tac Toe the rules might look like this:

```
TurnTaking is Player, Computer (randomized first)
First = X, Second = O
One mark per square
Three X or O horizontal, diagonal, vertical = win
```

After you write out the rules of your game, consider how you might change any of them to make the game harder or easier. For example, to make Tic Tac Toe easier, one could allow the player two turns in a row:

```
TurnTaking is (Player, Player), Computer (randomized first)
```

Use **pseudocode** to describe the step-by-step game play: Give names to all the variables and objects in the game and write a sequence of instructions that is in human-readable language similar to high-level computer code for the major game actions. Assume that there is one player per game and that the computer is running the game and playing the opponent.

The goal of writing pseudocode is to improvise a notation that lets you specify the logical steps without worrying about the syntax of any particular programming language. Use // to indicate that what follows is a comment rather than an instruction to the computer.

For example, pseudocode for Tic Tac Toe could be something like this:

```
Define BoardSquares ABC DEF GHI
Define Computer as O, layer as X
Random choice (0=Computer first, 1=Player first)
IF Computer first, place O in BoardSquare E // E=center square
ELSE Go to PlayerTurn
Loop until WIN:
PlayerTurn (X, SquareN)
  IF X (ABC) OR (DEF) or (GHI) or (AEI) or (CEG) or (ADG) or (BEH) or (CFI)
```

```
THEN WIN(Player)
ELSE MAKE_BEST_MOVE //blackboxing this for now
IF O (ABC) OR (DEF) or (GHI) or (AEI) or (CEG) or (ADG) or (BEH) or
(CFI)
THEN WIN (Computer)
ELSE LOOP AGAIN
```

I have simplified the system, assuming the computer would always play O and **black-boxing** the mathematical part of the game into an unspecified module called MAKE_BEST_MOVE.

Doing this exercise should make clear how tricky it is to specify procedures so that the computer—which can only do what we explicitly tell it to do—will not make mistakes that any six-year-old would avoid.

Scripting the Interactor

• Games often use expectations derived from other forms of entertainment or from highly gendered activities to script players' actions and expectations. Take a familiar game that is mostly played by members of one gender or by a particular subculture (such as teenage girls or boys) and identify the elements in the game that set up player expectations. How would these elements be different if they were aimed at encouraging participation by a different group of people?

• Create a digital scenario that scripts the interactor without explicit words. Put a visual element on a screen (or in some other interactive or sensor-driven artifact) that elicits an action from an interactor. Reward the action in a surprising way.

• Create a **storyboard** of the scenario (like a comic strip showing the sequence of events: before the interaction, the interaction, after the interaction) and then implement it if you are able to.

Example: Display a picture (or animation) of a group of birds and some breadcrumbs. The interactor will be "scripted" to pick up the breadcrumbs in order to try to feed the birds. But when the interactor mouses over the breadcrumbs, the birds will fly away.

Note: Extra credit for avoiding guns, swords, and other forms of overly familiar conventions of game violence.

• Create a digital scenario like the previous one, but this time, make three distinct items with three different effects. Create a reason for the interactor to try each of them. Remember you may not use words, so depict a scenario that will motivate interaction and items with strong dramatic or causal associations.

Example: A crying baby with a choice of a teddy bear, a bottle, and a rattle. The baby will only quiet down if the items are given in the appropriate order: first the

bottle to soothe hunger, then the rattle to tire himself out playing, then teddy bear to snuggle to sleep. Giving them in a different order should produce an escalation of unhappiness, possible destruction to the toys.

Without providing any explicit directions or offering any hints, script the interactor to behave appropriately to elicit meaningful behaviors from your scenario. Take turns playing with one another's scenarios while providing think-aloud commentary on your expectations, intentions, and reactions. Watch people playing with your environment without offering any comments or direction, and take notes on their self-reports. What worked best in your environment? What worked best for you in other people's environments?

Identifying Encyclopedic Design Elements and Issues

• Identify a digital encyclopedic resource and compare it to a similar resource in legacy media, such as in box 2.2.

Box 2.2
Encyclopedic Resources

Digital	Legacy
Search engine	Telephone book or card catalog
Online encyclopedia	Multivolume print encyclopedia
Online dictionary	Print dictionary
Electronic Programming guide	Newspaper TV listings
Electronic map	Paper map

What is the smallest unit of each? How is it standardized? How do you know what items are available? How are items chosen for inclusion? How reliable is the information? How is the resource updated? Which resource (digital or traditional) would you choose to use if both were available? (The answer may be different for different circumstances.) What use does the encyclopedic digital resource make of the procedural, participatory, and spatial affordances of the medium?

• The proliferation of encyclopedic resources has raised questions of freedom of access, criminal stalking, identify theft, and government and corporate surveillance of individuals. What countries are currently limiting their citizens' access to online information resources? How have large corporations responded to the demand to restrict access to information or to turn over private records (e.g., consider the behavior of involving Google and Yahoo in China)? How have librarians responded to demands for government access to Internet use? How have corporations sought to amass

encyclopedic data on individual purchasing through covert and overt means? How have information resources like YouTube and Twitter been used to oppose authority?

• Make a list of all the kinds of information that are produced by or about a particular individual over the course of their lifetime. Make a diagram by placing the image of a single person at the center of concentric circles. The circles represent information that is known about the person, with the innermost circles being the most secret (diary entries, love letters) and personal, and the outermost circles the most public (birth certificate, professional credentials, winning the lottery). Label each circle with who should gain access to the information, such as Best Friends, Immediate Family, Trusted Professionals, Accredited Institutions, General Public, and so on, and indicate what kinds of information should be known by/hidden from each group.

 • How well does current information organization match your ideal categories? Where are the points of difference?
 • Compare your diagram with those drawn by others. Are there common categories?
 • Look at the kinds of information in the innermost circle of your diagram. Using the Internet—with the exception of illegal methods or sites—attempt to obtain this kind of information about yourself or other people. (Either use people whose permission you have obtained or use only voluntary self-revelations of public figures such as bloggers, celebrities, etc.) What conventions or standards make it harder or easier to obtain personal information? What are the trade-offs in designing a more secure environment?

Designing Coherent Spaces

• Select at least five pages of a large website, such as the site of an online department store, a university, or a government agency. Is there a common grid underlying the visual layout of all the pages? Can you draw it? How does this grid stay the same and how does it vary from the home page to pages farther down the hierarchy? How do these inner pages resemble or differ from one another in layout?

• Explore a virtual environment in a game or online community that provides a visual landscape that can be navigated. Choose two distinct places and describe all the ways that one can move between them. Is there a map of the domain? Can you navigate by clicking on the map? Can you fly over the landscape? Can you move rapidly on the ground? Is it pleasurable to move between places? Could you draw a picture of where the places are in relation to one another?

• Create a map for a confusing environment on or near campus that you know well, indicating landmarks as well as street names, and the best path from one familiar area to another, less-well-known area. For example, you might start at a central quad or public transit station and draw the route to a new coffee shop or specialized lab. Or you might start from your current classroom and find the nearest wheelchair-accessible bathroom or exit route.

Trade maps with another member of the class and try to follow the directions. Notice what helped or hindered your decoding of the map. How well did the diagram abstract the salient elements of the space? What did it leave out?

You can use a **think-aloud protocol** for this exercise in the following way:

- The person following the map describes what they are doing, what their guesses are about what the map means, what decisions they are making, and what their reasoning is about the route.

- The person who made the map should follow behind, remaining completely silent, giving no physical cues to the correct directions, and making no explanations about the written document. They should only record the behavior of the person they are following by taking notes or using recording equipment.

- Think-aloud protocols are powerful tools for designers because they make clear the gaps between what we think interactors will do and what they actually do. Take a confusing situation or information domain that you are already engaged with and are motivated to understand better. It could be a technical area, such as visualizing the human genome, or a recreational area, such as navigating television listings or choosing wines. Sketch a representation of the most important features of the subject you have chosen using three different visual frameworks such as:

 - A table
 - A **flow chart**
 - An organizational chart for a hierarchy of people or other actors
 - A taxonomy (also a hierarchical chart) of categories, such as the genus and species of living things
 - A network
 - A map of a geographical area
 - A timeline
 - A bubble diagram
 - An arbitrarily chosen ordered arrangement, such as a subway system map from a particular city

Notice how the act of diagramming forces you to clarify qualities and relationships. Notice how the different approaches change your perspective on the domain. Explain the topic to others in your group, using your illustrative drawings, and noting which specific visual features enhance or detract from your explanation.

3 Maximizing the Four Affordances

All media as extensions of ourselves serve to provide new transforming vision and awareness.
—Marshall McLuhan (McLuhan [1964] 1995)

The Grid of Affordances

The digital designer has two responsibilities: to create the artifact that best serves the needs of the people who will interact with it, and to advance the digital medium as a whole. *One way to think about advancing the medium is to aim at maximizing all of its affordances.* As we have seen, anything made of computer code has the potential for encyclopedic capacity, for modeling navigable spaces, for describing and performing conditional behaviors, and for supporting participation by interactors. By exploiting these properties we increase the expressive power of the particular artifact, and we advance our ability to create other expressive artifacts.

The principle of maximizing the affordances of the medium does not mean that every artifact should include every possible application of digital technology. It does mean that the designer should imagine the many ways in which each of these affordances can be applied to the design task. Even though a particular artifact will only exploit some of these potential applications, it is still helpful to think of it as positioned within a more expansive design space in which all of these development paths are possible.

Let us imagine the approach of two designers, Charlie Competent and Victor Visionary. It is the mid-1990s, when the **World Wide Web** is just beginning, and Charlie and Victor are immersed in making websites for retail businesses moving toward the **Internet**. Charlie does not see beyond the immediate task. His goal is to **remediate** (translate from one medium to another) existing print artifacts like a sales catalog and print advertising for the web. He builds the site as a set of individual pages, cutting and pasting the content, and limiting the offering to selected items from the store. Given the era, this is received as an innovative project. Victor, however, sees the encyclopedic affordances of the web as offering the possibility of listing more items

than could be displayed in any print catalog. He understands that he can facilitate the entry, search, and display of inventory items by putting them in a database. He knows that existing 1990s technology can generate individual web pages off line and he anticipates that in time there will be increasingly powerful ways of generating web pages on the fly in response to interactors' queries. Victor's team creates a website that contains much more content than the one Charlie's team builds and that is better positioned for expansion as the web evolves. Eventually Charlie's clients have to redo their site, building up a new information structure from scratch.

Poor design is often limited to exploiting the novelty of superficial features like hyperlinks, blinking buttons, a presence on the web, social networking, or whatever is hot at the moment. For example, early producers of CD-ROMs relied solely on the capacity of the disk to bring value, flooding the market with products that came to be derided as "shovelware," in contempt for the lack of discrimination in their creation and the difficulty of navigating all the texts and images that they contained. Early **hypertext** fiction and educational applications included so much associational linking that interactors found them confusing and lost interest in engaging with them. But encyclopedic websites like the IMDB and Wikipedia have endured and grown, in part because they were built with an understanding that they would contain large quantities of information and therefore needed computationally structured back ends (like databases and wikis) and well-segmented and labeled site navigation tools in order to support massive participation and reach their full encyclopedic potential (figures 3.1, 3.2).

Successful applications are designed from the beginning with an awareness of the appropriate directions of growth, and an understanding of growth as part of the collective effort to maximize the four key affordances of the digital medium. We can think of the four affordances as a grid, offering **conventions** and **genres** that have become sufficiently standardized to be adopted across projects and **platforms** (figure 3.3). When we begin a new project it is useful to think of it as situated at the center of such a grid, and to ask ourselves which of the characteristic applications, such as those listed in the four quadrants displayed here, we could potentially apply to the design problem. We can accustom ourselves to thinking this way by analyzing existing applications in terms of how well they exploit each of these affordances.

The success of the original Google search engine is a good example of a sophisticated approach to the affordances of the medium. Google searches exceeded other first-generation web searches because they had a more processing-intensive **algorithm** that took on the challenge of assessing reliability and relevance. Other competing search engines used brute-force approaches, reading every word on a page and looking for matches to search terms. The Google engine analyzed the links between web pages, to capture information about who was pointing to a site and how they were describing it (in the words of the link). The Google team **reframed** the problem, thinking of the

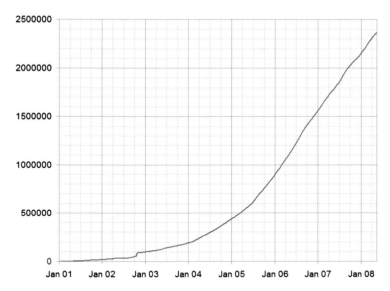

Figure 3.1
Graph showing the growth in articles written for Wikipedia, between January 2001 and 2008. In its first year Wikipedia grew to 20,000 articles and by 2010 it had reached over 3 million articles in English and over 15 million articles in all languages.

web that they were searching not as a vast array of text strings but as a participatory social structure whose knowledge base could be mined by building social reasoning into the search procedures. As a result, Google is not just a more reliable search engine; it also has become a useful barometer of public opinion and a real-time index of public concerns.

 If we were to place the original Google Search Engine on a grid representing the four affordances it would be strongest in the procedural quadrant (the algorithms of the search) and the encyclopedic quadrant (for its control over vast quantities of information), but also significantly present in the participatory quadrant (for its exploitation of user-created links and its later observation of which results users followed from similar search terms). But it clearly was not concerned with exploiting **spatial affordances**, keeping the home page free of clutter in an age when its competitor Yahoo was becoming an all-purpose portal. Google's only use of space in its original implementation was to organize the search results in a **list** with highest relevance at the top. By the end of the 2000s, however, it had expanded strongly into all four quadrants (figures 3.4, 3.5).

 Of course no single artifact can exploit all the possibilities of the medium, and design can be quite successful in serving human needs by focusing on one or

Figure 3.2

The earliest still-extant Wikipedia editing entry. Founded as an adjunct to a traditionally authored online encyclopedia project, Wikipedia is based on wiki software, which was designed explicitly for collaborative networked projects and includes a particularly useful architectural feature that separates discussion about a collectively edited page from the text of the page itself.

Figure 3.3

The four affordances of the digital medium with examples of standard formats and genres that exploit each of them.

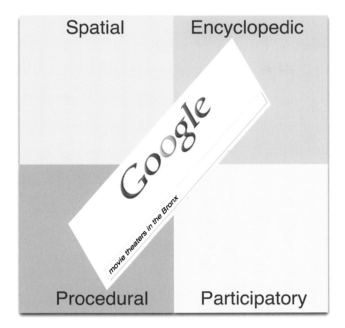

Figure 3.4
Google's original search engine mapped against the four affordances of the medium. It used little of the spatial affordance, presenting the results of searches as a rank-ordered list with the most relevant item at the top.

two affordances (see figures 3.6–3.8). But it is always useful to map an existing or proposed artifact against the larger design space in order to identify opportunities for growth and to predict the direction of media innovation. Affordance mapping can help to focus conversations about priorities. Perhaps the project is ignoring the possibility of spatial strategies. Perhaps it is overemphasizing participatory demands in the form of special features for individual users. Perhaps the major programming problems are coming from a particular procedural feature that is proving too hard to implement, but is not essential to the success of the project. The affordance grid can help to identify and clarify such design issues, and to organize thinking about paths not taken that may be worth revisiting on a future project. It can also suggest alternate ways of solving a problem, such as addressing a problem of user confusion (a participatory problem) with better information organization (an encyclopedic strategy) or a more orderly grid (a spatial approach). The affordance grid reminds us to contextualize design within the possibilities of the whole medium.

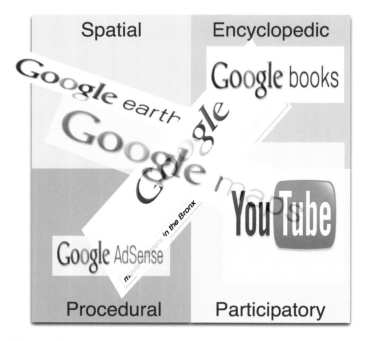

Figure 3.5
In the first decade of the twenty-first century, Google did not merely grow in size, it also built on its procedural strength to expand its use of the other three affordances of the medium. The foundational search engine expanded its coverage and its algorithms became more complex, including the participatory ad auctions system being built on advanced mathematical models; the Book Digitizing Project, Google News, and the acquisition of YouTube expanded its encyclopedic coverage. Gmail and YouTube expanded Google's exploitation of participatory structures; Google Maps and Google Earth established the standard for encyclopedic spatial exploration, from satellite image to road map to street view, while also providing for both procedural and participatory expansion with mash-ups.

One way to use the grid is to make it the focus of brainstorming at the beginning of a design process, placing an activity rather than an application at the center. For example, if we were making a new music player we might start with something like figure 3.9, thinking not of specific music-playing appliances but of the general activity of listening to music and asking how some of the existing digital formats and genres (like those listed in figure 3.3) might support that activity.

Alternately we can start not with the existing media structures but with the human activity of listening to music, asking ourselves in what ways it is spatial, encyclopedic, procedural, or participatory (figure 3.10).

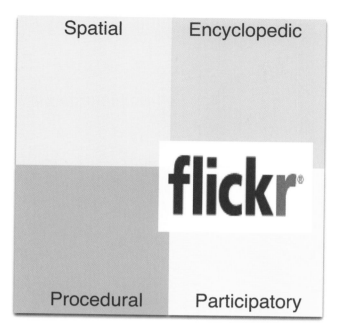

Figure 3.6
The photo-sharing site Flickr.com was among the first successful networked media-sharing sites, relying on the affordance of vast amounts of storage, easily accessed and made available to others. It expanded its participatory affordances by partnering with social networking sites to syndicate content. Potential areas of growth would be to increase the procedural affordances, such as automated search and retrieval based on visual features or specialized tools for collages and photo editing; or to expand the encyclopedic affordances by including more kinds of media (such as moving images or sound files) or more structured annotation of images.

Or we could identify existing music applications and place them on the grid in order to get an overview of the design space (figure 3.11).

Finally, we could ask ourselves what we wish we could do in relation to this activity if we had a magic wand to make it possible. The magic wand concept is useful because it takes us away from the existing media conventions and existing behaviors, and puts us in the realm of the desired innovation. The ideas that surface in this part of the exercise can then be examined to see if they are implementable by exploiting the appropriate affordance.

Magic wand brainstorming can be based on questions like the following:

Procedural brainstorming What actions do I wish that [the proposed device or application] could magically do for me?

Figure 3.7
Wikipedia.org has established itself as a global information source, redefining the encyclopedia as a digital rather than print genre. It has created a coherent information space by segmenting knowledge into consistent categories and establishing standardized formats for entries, making it possible for thousands of contributors to coordinate their work and build upon one another's contributions.

Participatory brainstorming What actions do I want in my power that are not now in my power? What choices do I want to make explicitly? How do I want to perform the relevant task?

Encyclopedic brainstorming What is the extent of the information I want to command? What large resources do I want to control that I can't reach or can't organize with current technology? What kinds of media do I want to access, create, and share with this device?

Spatial brainstorming What kinds of mapping and visual organization of information would help me to use this device more fully? What kinds of information spaces do I want to enter or control? How do I think of physical space when using this device? How could the device help me to think more clearly about physical space? Should there be a geographical map and if so, at what granularity and with what information foregrounded?

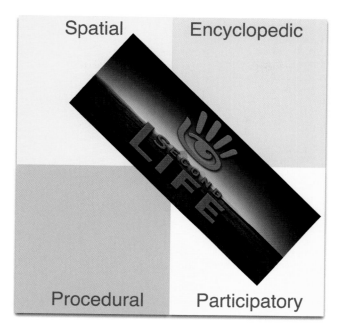

Figure 3.8

Second Life, founded by Linden Lab in 2003, became the first successful shared virtual social space for a mass audience, with participatory opportunities for constructing, buying, and selling artifacts within the virtual world.

Designers should first ask these questions of themselves in fantasy thought experiments and then use them to design surveys and conduct interviews, focus groups, and market research with real consumers. It is important not to limit our own ideas or the brainstorming of research subjects to functions that already exist or that we already know how to create: that is why the concept of the magic wand is useful. It brings to the surface unmet needs and wished-for powers that can become the basis of innovative features and conventions. The goal in eliciting and analyzing this information is not to design a specific artifact that will have all of these magical qualities, but *to more fully understand the potential design space.* The exercise helps us to expand our expressive palette by reframing the task beyond the most familiar legacy and digital conventions that we might otherwise limit ourselves to. It gives us insight into the long-term direction of innovation, providing a context for prioritizing goals and making design choices throughout the development process.

Affordance mapping is also a useful way to synthesize the results of competitive analysis, which is used to survey the features of all the products in a design domain. In addition to creating the standard chart that lists which applications have which

Figure 3.9
Brainstorming for a new project using the affordance grid to ask how the core activity might be served by a wide range of existing digital formats and genres.

features, one could take all the features and map them against the affordance grid to get an overview of the whole field that will also make clear what areas remain uncovered in the design space.

Although the affordance grid can help us to anticipate next-generation features, designers must resist the temptation to extend functionality just because it is possible. Good design is shaped by **constraints** as well as affordances: constraints of time, resources, screen space, physical form, and especially human attention. Sometimes mature applications, like a popular word processor or simulation game, grow less usable with each new release because increased functionality gets ahead of interaction design. Even in a single development cycle design teams can easily fall into patterns of "feature creep," adding functionality without first finishing a basic version of the artifact, delaying the project and confusing testers.

Shaping and Satisfying Interactors' Expectations

Users do not think in terms of abstract affordances, but they expect new digital artifacts to have features similar to other digital artifacts, and even to have magical new

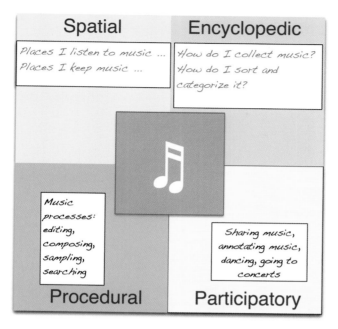

Figure 3.10
We can also use the affordance grid to brainstorm about the ways in which we perform the core
cultural activity at the heart of a design process, independent of any particular device or media
framework.

qualities based on the general kinds of things that they think computers are capable
of. In order to avoid potential confusions, the designer should attempt to anticipate
the interactor's expectations by imagining the interactor asking these four basic ques-
tions throughout the design process:

Procedural Question: What does it do?
Participatory Question: What can I do?
Spatial Question: Where am I in relation to the whole?
Encyclopedic Question: What are the boundaries to this domain?

The best way to answer such questions is to actively shape the expectations of
the interactor by drawing on familiar genres and conventions that can focus the
interactor's attention on productive actions. The more we can identify and create
standardized conventions of interaction the less confused the interactor will
be. Designers should be alert to their choice of conventions, avoiding the awkward
and ad hoc solution, such as "quick links" on a poorly organized website or
wordy instruction screens for an application that is not sufficiently self-explanatory.

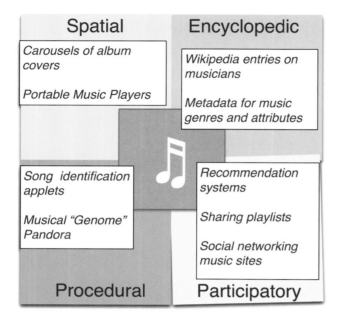

Figure 3.11
Using affordance mapping to generate an overview of existing applications.

The goal is to make the interaction easily learnable if it cannot be made immediately familiar.

Awkward strategies are sometimes unavoidable, but they should be recognized as symptomatic of an immature medium. As the medium matures, we collectively develop conventions to handle formerly awkward situations, often replacing indirect, multistep interaction patterns with **direct manipulation**. The examples in table 3.1 reflect the ongoing process of inventing and refining conventions that characterizes design in a new medium. Keeping in mind the four affordances can help us to focus that effort on specific areas within each project, looking for ways in which we can make the current application more coherent and thereby advance the expressiveness of the medium itself.

We can also tune up our awareness of the areas in which conventions are insufficient by noticing our own frustrations in digital environments and our own daydreams for magical functionalities. Whenever we use a digital resource or device that we have not used before, we can ask ourselves what our expectations are for each of the digital affordances and how well these expectations are met. For example:

Table 3.1

Answering the Four Questions with Immature and Mature Conventions

General User Question	Specific Question	Immature Solution	More Mature Convention	Why Better
What does it do?	What will happen if I click on this icon in a word processor?	Paper cheat sheet with icon labels and brief explanations.	Rollover text associated with the icon.	Information available in context and as needed.
What can I do?	How do I record a television program?	Consult newspaper listings to determine time and channel; enter time and channel using onscreen menu and remote, with help of manual.	Use remote to select program by name from onscreen menu.	Transmission codes (time and channel) eliminated, interactor's mental model simplified.
Where am I?	How do I find the movie listings in a newspaper site starting from the home page?	Provide "quick links" pull-down menu for frequently used resources buried in the site structure.	Put local listings with movie reviews under the Entertainment section of the site's hierarchical navigation system.	Logical use of space that reinforces the interactor's mental map of the categories of information covered by the site, as well as providing a memorable association for the location of the listings.
What are the boundaries?	How do I know which site I am on when I follow a link?	Links to pages inside and outside a website are displayed the same way and they all open in a single window.	Internal and external links are labeled and displayed differently, with external links opening in another window or tab.	Reinforces interactor's perception of a distinct, consistent site, part of but separate from the larger Web.

A new phone might
- not allow me to access all the features of an old address book (not encyclopedic enough);
- make it difficult to switch between dialing and looking at my calendar (failures of procedurality and participation);
- make me scroll through long lists or flip through multiple screens in order to find the right application (failure of spatializing information).

A new virtual community might
- provide poor tools for building assets (poor procedurality);
- make it hard to operate my avatar (poor participation);
- leave me confused about how to get from place to place (poor spatializing);
- provide too few choices of places to visit (not encyclopedic enough).

A new media player might not
- let me to open one application at a time (weaknesses in both procedurality and participation);
- play videos in a particular widely used format (not encyclopedic enough);
- make me scroll through screenfuls of applications to find the one I want (poor use of space).

Having the four categories in which to think about these common frustrations can help us to generalize our difficulties with particular devices so that we will recognize the same problem on other projects, and look for the media conventions that will provide solutions that can work across multiple applications.

Designing for Agency and Immersion

When we maximize the affordances of the medium in any one artifact we create satisfying experiences that it is useful to think of as **agency** and **immersion**.

As mentioned in the introduction, and as I proposed in chapter 3 of *Hamlet on the Holodeck* (1997), **interactivity** is rightly used to refer to the combination of procedural (computer processing) and participatory (human-directed) affordances of the digital medium. When these two affordances fit together well, they create the satisfying experience of agency. A highly interactive environment is one in which the machine puts a high degree of processing power into our hands and is highly responsive to our input. When the behavior of the computer is coherent and the application is designed so that a human interactor knows what to do and receives clear and immediate feedback on the result of their actions, the interactor experiences the pleasure of agency, of making something happen in a dynamically responsive world.

Figure 3.12

The Pac-Man arcade videogame (1980) offered the player multiple kinds of agency: moving Pac-Man, making the dots disappear, evading the ghosts, chasing the ghosts, navigating the maze, collecting fruit, completing the level.

Agency is therefore a more useful and specific design goal than interactivity. The designer creates agency by exploiting the interactive affordances of the medium, by shaping the rules by which the computer processes information and the conventions by which the interactor engages with the machine, so that human expectations and actions mesh well with computational expectations and actions. Agency is a concrete design goal, but it is not a property of an artifact. It is present or absent in the experience of the interactor (figure 3.12). Its opposite is powerlessness, confusion, or frustration (figure 3.13).

As with interactivity, there is a widespread sense that "new media" are immersive, but not much agreement on what **immersion** is or how to achieve it. Just as interactivity is often confused with a volume of activity, immersion is often confused with sensory stimulation. A high-resolution image on a very large screen or an enriched localized audio stream coming from a powerful speaker system may arrest our attention more fully and hold it longer than the same content delivered on a smaller screen and less powerful speakers, but we soon get used to increases in scale and intensity and learn to filter out stimulants that are merely very large or very loud. Immersion, like agency, cannot be a property of an artifact. Immersion is experiential and not a function of the size or volume of the stimulus, but of the engagement or distractibility of the interactor. An immersive environment is

Figure 3.13
Frustration of agency is the mark of poor design. This error message is the result of an overly rigid data-entry form that rejects phone numbers separated by spaces instead of dashes. A better system would supply the dashes on input, automatically constrain input within three separate boxes, or accept multiple conventions for representing a ten-digit number.

one that captivates and holds our interest because it feels expansive, detailed, and complete.

In digital environments, the experience of immersion is reinforced by the encyclopedic and spatial affordances of the medium, by its enormous capacity and its openness to navigation in simulated landscapes or information spaces. We can also become immersed in old media, in compelling stories that hold our attention to the page or the image, in rhythmic experiences that focus us on music or movement, in puzzles or games that take over our thinking, causing us to lose awareness of the world around us. Immersion is related to the experience of being completely and pleasurably absorbed in a challenging task, identified as **flow** (Csíkszentmihályi 1990), and it can be produced by a wide range of complex artifacts and challenging tasks. Digital environments can create all of these varieties of immersion, with the added sense of navigation of a landscape (like Second Life) or an information space (like Wikipedia) or a magically generative and renewing space of possibilities (like Tetris or the Spore creature editor) and a perception of the artifact as encyclopedic in its variety and extent.

Immersion is the experience produced by the pleasurable exploration of a limitless, consistent, familiar yet surprising environment. *As designers we create immersion by increasing scope, detail, and consistency while establishing clear boundaries and means of navigation.* These guidelines apply to information spaces such Wikipedia and virtual worlds such as Spore or Second Life. Immersion is created by rewarding exploration with consistent, detailed variation, and undermined by poorly defined boundaries, gaps in coverage, and confusion in navigation.

Agency and immersion are mutually reinforcing. When we engage with an immersive world and it responds to us as we expect it to, revealing deeper levels of content, greater detail in its coverage, we become more deeply immersed. In the context of

interactive narrative I have called this effect the **active creation of belief,** to emphasize that digital immersion is created not merely from what Coleridge called "suspension of disbelief" but also from testing out the imaginary world and seeing how responsive it can be and how deeply it is described. Developing each of the four affordances increases the potential expressive power of the other three.

DESIGN EXPLORATIONS: EXPLORATIONS FOR MAXIMIZING DIGITAL AFFORDANCES

Using the Affordance Grid

• Make a grid of the four affordances of the medium and write down at least five specific examples (such as specific websites, databases, game levels, or devices) that make particularly good use of each of them. Justify your choices. Do your examples in the same quadrant have any common features or conventions? Are there some examples that are good illustrations of multiple affordances?

• For one of these artifacts you placed on the affordance grid, identify the most promising areas of unexploited potential outside its current boundaries (e.g., how can a strongly encyclopedic application better exploit the procedural power of the computer?).

• Find an example of a software application that is at least five years old and has gone through multiple releases (for example, Microsoft Word, Adobe Photoshop, Intuit TurboTax, Maxis's SimCity). Compare a screen shot (or video or running version if available) of an earlier version with the current version. What features have been added? Is it easier or harder to perform the original functions now that the program has been expanded? Is the application making appropriate use of the four affordances of the medium? Is it displaying feature creep (or perhaps feature stampede!)?

• Create a comparative analysis chart for competing digital products in the same market space, listing all the features of each in a table that makes clear what features are matched and which are competitive advantages. Now take the same products and map them on the affordance grid. Are there areas that none of them are exploiting? Can you suggest product extensions in these areas?

• For a device that you use regularly, do a magic wand exercise, brainstorming what other functions you can imagine it performing within the four quadrants of the affordance grid. Be as imaginative as you like, assuming anything you wish for will be created with no effort, out of magical technology. Think very concretely about how the magical functions would ideally work.

After detailed brainstorming, take a break and then return to your formulations. Are there existing or conceivable technologies that could be applied to implement some of the desired functions? Are there impediments of compatibility preventing the wish from becoming a reality? What kinds of expertise would have to be brought together to make the magic wand product a real product?

II DESIGNING EXPRESSIVE PROCEDURES

The design of digital artifacts rests on our ability to assign symbolic meaning to electrical impulses by building up **abstraction layers**, from the **primitives** of the 00s and 11s of the machine code, applying the principles of **modularity** and **encapsulation.**

A key design goal for procedural systems is to increase human ability to think coherently about processes that have many **variables** that serve as **parameters**, modifying the way in which an action is performed. Designers should know how to represent complex, variable procedures using **flow charts, pseudocode,** and **state diagrams.**

Designers should recognize that the same process can be approached through more than one **algorithm** and that any fixed representation of a process, whether it is computer code or an earlier media genre such as a proverb, recipe, or automated mechanical device, reflects cultural biases and values and is subject to human error.

Designers should be conversant with the computational concepts used in **object-oriented** programming, in which objects are described separately from their **instantiation** and within more generalized **classes** from which they can **inherit** qualities and behaviors (**attributes** and **methods**).

Designers should know how to use **discrete time steps, feedback loops, resource allocation** structures, and focused **scenarios** to design **simulations** that afford modification and **replay,** so that interactors can increase their understanding of cause and effect within complex systems.

Humanist designers should be aware of what values they are serving and what assumptions they are making about the world when creating the cause-and-effect structures of computer programs and simulations. Wherever possible, they should make these assumptions visible to the interactor.

4 Computational Strategies of Representation

The Analytical Engine has no pretensions whatever to *originate* anything. It can do whatever we *know how to order* it to perform.
—Ada Lovelace (1843)

Computation as Symbol Manipulation

Designers need to understand the ways in which meaning is inscribed and encoded on electronic circuits, and the conceptual strategies by which software engineers represent the world. Computational concepts shape the fundamental structures of the digital medium, and no member of a design team can understand the plasticity of the medium without a conceptual understanding of computation, starting with the fact that the entire system is based on a very simple mechanism: an electrical switch that can be in either the on or off position. The interior of a computer can be thought of as composed of millions of such switches, each of which can change state in a very small fraction of a second. A computer program is a set of conditional rules, an executable script, for turning these switches on and off. Computers do only what they are explicitly instructed to do, and all of their instructions have to be translated into a changing **pattern** of on/off switches. We can imagine the inside of any computer-based device as filled with tiny circuits like Christmas lights, flashing on and off in rapidly changing patterns.

The power of computation rests on a **semiotic** connection similar to the way spoken language associates meaning with arbitrary vocalizations. Just as there is no reason why the sound "Ma" should mean "Mother"—or anything at all for that matter—there is no reason why a particular electrical state should hold meaning, or why one state should be assigned a value of 0, and another state should be assigned a value of 1. In both cases, there has been a cultural consensus—we (as English speakers) all agree to assign the meaning of "Mother" to the sound "Ma" and we (as programmers) agree that we will think of physical electrical switches, like vacuum tubes or silicon transistors, as abstract entities called *binary digits* or **bits** that

Figure 4.1
Vacuum tubes in a 1950s IBM mainframe computer, the technology that preceded the transistor, as a means of creating variations in electrical current for use in media appliances such as computers, radios, and televisions.

can be arranged in recognizable patterns, usually tracked in eight-bit groups, each of which is called a **byte**.

Everything symbolically represented within the machine—whether it is an urgent bank transfer or a thrilling video game or a mind-numbing game of solitaire—is stored as a pattern of on/off switches. A one-**megabyte** (1 Mb) file in any format is composed of eight million tiny electrical switches (bits), whether that file contains the text of a Pulitzer prize-winning book or a silly cat trick video or the initiation sequence for a nuclear weapon. The encyclopedic capacity and rapid speed of today's computers are the result of the successive miniaturization of these bits, from vacuum tubes to transistors to integrated circuits etched into the silicon (figures 4.1–4.3).

But the invention of the computer predates the invention of the electrical technologies on which it currently rests. The invention of the modern computer as a system of symbolic representation is credited to nineteenth-century mathematician Charles Babbage, who drew up plans for a calculating machine that would be programmable by removable cards, similar to the cards used by the French inventor and weaver Jacquard to produce variable and intricate textile patterns. Ada Lovelace, the daughter

Figure 4.2
A solid-state transistor, introduced in the 1950s, could replace multiple vacuum tubes, making for increasingly portable electronic devices, and increased computational capacity. Transistors are connected in electrical circuits hardwired to execute the primitive (i.e., foundational, building-block) commands of a computer system. For example, an Adder circuit transmits current in a pattern that can be interpreted as binary addition. Starting in the mid-1960s transistors were further miniaturized into integrated circuit chips.

of the English poet, Lord Byron, designed the first such set of cards, thereby becoming the world's first computer programmer. Babbage's "Analytical Engine" was never built, but Babbage and Lovelace developed such detailed plans for it that Lovelace came to understand that such a symbolic logic machine would be more than a mere calculator and "might act upon other things besides number, were objects found whose mutual fundamental relations could be expressed by those of the abstract science of operations." In particular, since she was trained in music as well as mathematics, she imagined a machine that could generate musical compositions: "Suppose, for instance, that the fundamental relations of pitched sounds in the science of harmony and of musical composition were susceptible of such expressions and adaptations, the engine might compose elaborate and scientific pieces of music of any degree of complexity or extent" (Lovelace 1843).

At the time that Lovelace was imagining such a machine, the most common form of automated sequence was the simple music box. Music boxes work by the action of a wheel with "pins" embedded in it and turned by a camshaft. The pins strike a keyboard called a "comb," producing tones in the appropriate sequence to form a melody. The physical layout of the pins on the wheel corresponds to a sequence of notes that is executed by the motion of the wheel. What Babbage envisioned for his Analytical Engine was more like a player piano: a machine that could execute fixed sequences

Figure 4.3
The Intel Itanium chip with two billion transistors, each only sixty-five nanometers wide, was announced in 2008, two years after the release of a one-billion-transistor chip, reflecting the company's continued aspiration to fulfill Moore's Law of 1965 which predicts that integrated circuits will double in capacity every two years. In 2010 Intel announced work on a new chip that would have transistors only two nanometers wide.

expressed on swappable cards. But Lovelace realized that such a machine could be programmed not with a particular tune, but with the rules of musical composition in symbolic representation. It could then apply those rules to generate new combinations. Lovelace was therefore the first person to understand the power of symbolic computation. *The conceptual leap from invariant, unisequential, hardwired mechanical processes like music boxes to dynamic, rule-based, multisequential, symbolically coded sequences is what makes the computer a medium of representation.*

It was not until the twentieth century that we had an inscription and transmission technology in the form of electrical current interpreted as bits that could hold such abstract symbols and execute the rules they contained. The state of any set of bits is unambiguous—they are each either on or off, 0 or 1—but the meaning of the bits can change depending on the type of **data** structure of which they are part. The same bit configuration can be interpreted as numbers, letters, pixels on a screen, or as any other kind of data, display, or abstract symbol. For example, consider the following byte:

0100 1010

Table 4.1

Binary, Hexadecimal, and Decimal (Conventional) Symbolic Representation

Binary	Hexadecimal	Decimal
0000	0	00
0001	1	01
0010	2	02
0011	3	03
0100	4	04
0101	5	05
0110	6	06
0111	7	07
1000	8	08
1001	9	09
1010	A	10
1011	B	11
1100	C	12
1101	D	13
1110	E	14
1111	F	15

Hexadecimals represent four bits in a single digit. In binary form a byte takes up eight separate bits; the same information can be summarized for humans in two hexadecimal digits.

We can interpret it as a conventional (i.e., base 10) number, one million one thousand and ten: 1,001,010. Or we can read it (as is customary for bits) as a binary (base 2) number, equivalent in quantity to the **hexadecimal** number 4A, or the decimal number 74 (table 4.1). Because it is a number, we can perform arithmetic on it. If we added 1 to it (0000 0001), for example we would get

0100 1011

which is equivalent in quantity to 75 in the decimal system.

But even though it is made up of 0s and 1s, the bit pattern 0100 1010 need not be read as a number. It can also be interpreted as the letter J, within the **ASCII** (American Standard Code for Information Interchange) system (table 4.2).

Or if we were to see the eight bits as part of an array representing one pixel per bit within a blue and red image, with 0 for blue and 1 for red, then 0100 1010 would represent the image shown in figure 4.4.

The bits could also represent true/false answers to a set of eight questions. In that case 0100 1010 might represent a complex set of knowledge such as:

```
Were you born in the South? NO (F)
Were you born in the Northeast? YES (T)
Were you born in Massachusetts? NO (F)
Were you born in Connecticut? NO (F)
Were you born in New York? YES (T)
Were you born upstate New York? NO (F)
Were you born in Queens? YES (T)
Were you born in the Bronx? NO (F)
```

Or `0100 1010` could represent items in a player's inventory within an adventure game:

```
Sword—
Dagger—TAKEN
Bread—
Book of spells—
Poison—TAKEN
Map—
Invisibility Cape—TAKEN
Candy—
```

Bits can also represent instructions to the computer. In fact, all computer instructions, no matter what programming language they originate in (such as Java, C++, PHP) end up being translated into machine code, or patterns of bits, usually in the form of one byte per instruction. For example, the instruction ADD might be written as 1111 0000. Such basic instructions are the **primitives,** or smallest building blocks, of all computer code.

The literal mindedness of computers is discouraging to novice programmers, but it is helpful to remember that the arbitrariness of the machinery, its ignorance of the world, is an **affordance** as well as a **constraint**: it allows us to employ these readily available, easily changed bits to mean anything we want them to. *As designers approaching the computer not merely as a tool for number crunching but as an expressive medium capable of many kinds of symbol processing, it is our job to expand the repertoire of meaningful qualities, ideas, and experiences that can be mapped onto those very simple but infinitely reconfigurable on/off switches.*

Abstraction of Processes into Flow Charts and Pseudocode

The principle strategy of representation in computer science is **abstraction**, a practice that underlies all representational media. Whenever we describe the world in any code we focus on part of it and not all of it, abstracting the thing we want to focus on away from the booming, buzzing chaos of our total experience. When the baby says "Mama" or "Dada" she is abstracting her parents away from the totality of sensation. When we use the word "mother" to refer to the category of people rather than to any

Table 4.2

ASCII (American Standard Code for Information Interchange) Representations for English Language Capital Letters

Letter	ASCII Code
A	0100 0001
B	0100 0010
C	0100 0011
D	0100 0100
E	0100 0101
F	0100 0110
G	0100 0111
H	0100 1000
I	0100 1001
J	0100 1010
K	0100 1011
L	0100 1100
M	0100 1101
N	0100 1110
O	0100 1111
P	0101 0000
Q	0101 0001
R	0101 0010
S	0101 0011
T	0101 0100
U	0101 0101
V	0101 0110
W	0101 0111
X	0101 1000
Y	0101 1001
Z	0101 1010

The Unicode standard is more inclusive; see <http://unicode.org>.

Figure 4.4

Pattern of pixels represented by the array of bits 0100 1010.

particular mother, we are abstracting in another way: generalizing from common elements in our experience to the general case that applies to all.

Computation, like language, rests on practices of abstraction. We find ways of identifying discrete items by giving them unique **labels**, addresses, descriptions; and we find ways of referring to multiple similar items with a single descriptor. Most important, since the computer is procedural we can specify a process once and then apply it iteratively to many similar items. For example, we refer to some people as "employees," a socially defined abstraction that identifies people by a single role and allows us to treat different members of this class in the same way. We are familiar with the abstract **genre** of representation called a "paycheck" based on a standardized transmission and inscription format (paper of a certain size, with fixed arrangement of fields for date, payee, amount, signature, routing number, bank account number, etc.). We can build on these socially established abstractions to tell the computer to issue "paychecks" to all "employees" following the same general rules (a procedural abstraction) for calculating and issuing each individual paycheck.

Computer code is a system for capturing similarity and variation in abstract terms. We capture variation of processes through conditional statements, and we capture variation in data by assigning parts of the data to different **fields** of a **database.** For example, our data about employees might be assigned to the general categories (fields) of first name, last name, address, hourly rate of pay, hours worked. Taken together the set of categories makes up an abstract representation of any employee. Any individual employee would be an **instance** of this abstract representation, and would have appropriate information populating each of the fields.

Programmers specify instructions in computer code, which is written so that it is unambiguous for a computer. It is very beneficial for designers to understand the syntax of programming languages, but the coding step can be separated from the conceptual work of deciding how a program should work. Computational processes can be specified in two human-readable formats that are precise but independent of the coding layer: **flow charts** and **pseudocode.** Designers should be able to create and read documents in both of these genres in order to have a common language with the other members of the design team and in order to think more clearly about the computational representation of processes. For example, the flow chart for paying an employee might look like figure 4.5.

Pseudocode captures the step-by-step logic of a process, the **algorithm** or abstract procedure, for performing it without worrying about the unforgiving syntax of any particular programming language. We can use pseudocode to describe the components of data structures like this:

```
Define Datastructures:
  timecard with name, hours, rate
  paycheck with name, pay
```

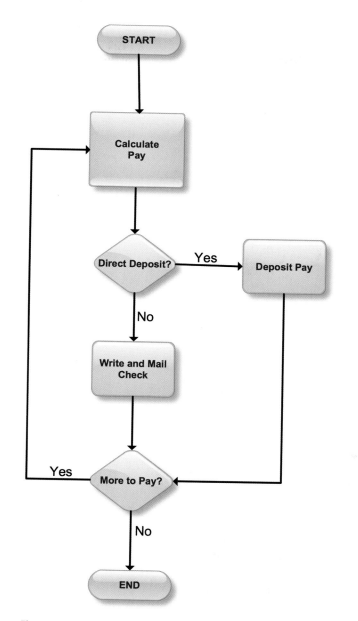

Figure 4.5

Flow chart for a program that calculates pay and either writes and mails a check or does a direct deposit. There are two decision points, shown as diamond shapes, and one **loop**, which iterates the same sequence until the program runs out of timecards. A flow chart is a useful way to display the logic of a conditional process.

We can incorporate aspects of programming syntax that are self-explanatory or commonly understood by team members. For example, a data field within a larger data object (like a name field on a timecard) is often referred to like this in programming syntax:

entity.attribute

So we can refer to fields in the timecard like this:

```
timecard.name
```

We can use pseudocode to specify instructions to the computer processor as a series of functions. In the case of the payroll program we need functions to read timecards, copy information, calculate pay, and print out paychecks:

```
READ next timecard
COPY timecard.name to paycheck.name
CALCULATE paycheck.pay = timecard.hours x timecard.rate
PRINT paycheck
```

Or if we were to write it closer to the actual code we might use the = sign without the "copy" or "calculate" command words:

```
READ next timecard
timecard.name = paycheck.name
paycheck.pay = timecard.hours x timecard.rate
PRINT paycheck
```

There are many correct ways to write out the same procedure in pseudocode. It is only important that it be self-consistent, logical, and readable by all the appropriate team members.

Let us assume that some employees have direct deposit of their pay. In that case we want to calculate the pay in the same way but we do not want to print the paycheck. Let us assume there is a separate **subroutine,** a process that handles direct deposit, called DEPOSIT. We would just have to change the last instruction like this:

```
COPY timecard.name to paycheck.name
CALCULATE paycheck.pay = timecard.hours x timecard.rate
DEPOSIT paycheck
```

To be efficient we want to combine both possibilities—PRINT and DEPOSIT— into a single program. To do that we have to add another field to our TIMECARD data structure:

timecard with name, hours, rate, directDeposit

The **variable** directDeposit can have a **value of true or false**. The pseudocode for processing either case could use the IF/THEN/ELSE structure that is a foundational convention of computer programming:

```
START
READ next timecard
COPY timecard.name to paycheck.name
CALCULATE paycheck.pay = timecard.hours x timecard.rate
IF directDeposit = true
THEN DEPOSIT paycheck
ELSE PRINT paycheck
END IF
```

Furthermore, we need an instruction that will allow us to repeat this process in a **loop** until there are no more timecards to read. To do that we can create another IF/THEN/ELSE statement, building up complexity of processing by nesting the original program within it:

```
START
READ next timecard
IF no more timecards
THEN QUIT
ELSE
  COPY timecard.name to paycheck.name
  CALCULATE paycheck.pay = timecard.hours x timecard.rate
  IF directDeposit = true
  THEN DEPOSIT paycheck
  ELSE PRINT paycheck
  END IF
END IF
LOOP BACK to "READ next timecard"
```

The ability to keep track of nested processes is important as the conditions proliferate, so we use indenting to indicate the **hierarchy**, and we end each IF/THEN/ELSE sequence with an END IF command to keep the logic clear. We can also simplify the structure by expressing the outer loop as a WHILE DO statement, which can be written in pseudocode like this:

```
WHILE any timecard is left in the stack
DO
    COPY timecard.name to paycheck.name
    CALCULATE paycheck.pay = timecard.hours x timecard.rate
    IF deposit = true
    THEN PRINT paycheck
```

```
    ELSE DEPOSIT paycheck
    END IF
END WHILE
QUIT
```

The instruction after the WHILE DO loop executes when the WHILE condition is no longer met. In this case, the program quits.

Conditional choices often have more than two possibilities, making it cumbersome to express them using IF/THEN/ELSE. Programming languages use case statements to express multiple conditions. The pseudocode for a CASE statement looks like this:

```
CASE
TODAY= Monday DO Monday_process
TODAY= Tuesday DO Tuesday_process
TODAY= Wednesday DO Wednesday_process
TODAY= Thursday DO Thursday_process
TODAY= Friday DO Friday_process
TODAY= Saturday DO Saturday_process
TODAY= Sunday DO Sunday_process
ELSE RETURN_ERROR
END CASE
```

Conditional instructions can be expressed in many ways, but the logic is the same. The computer is told to apply a test to some item, and to execute different instructions based on the results of this test. A computer program is usually made up of multiple such tests and a key part of computational abstraction is determining all the conditions that must be recognized and treated differently.

Part of the power of computational representation comes from our ability to abstract parts of a process as **variables**, as entities whose value will change during the execution of the code. For example, in the payroll example there were variables for:

- the name of the employee
- the number of hours worked
- the rate of pay
- the direct deposit indicator
- the amount of the paycheck

We were able to describe how to deal with these variable items by labeling them and referring to them by an abstract label, ignoring the **value** the variable might have in any particular instance.

The power of computing is the power of abstraction, of specifying how to handle many instances of something like an employee record in the same general way, with appropriate specific customizations. Thinking like a programmer means identifying

the appropriate generalizations and customizations necessary to perform a sequence of actions that accounts for all the likely variations of the target situation.

Faced with a large set of similar but different items and a system of complex processes, such as filing tax returns or registering students for classes or selling books over the Internet, programmers impose order by *abstracting away from the messy individual cases* to the appropriate level of generality. They do this by asking themselves questions like these:

- What are the most important categories of items in this domain?
- Within any category, what are the important qualities that all these items share?
- What actions have to be taken for every item in this category?
- How do these entities, attributes, and actions differ with individual cases?
- How do we decide which action to take in any individual case?

Since the answers to these questions will determine the representational structure of the digital artifact—how the processes in the real world are coded within the machine— they cannot be left to the programmers alone. *They must be part of the fundamental process of design.* Using pseudocode and flow charts, all team members can communicate and discuss these crucial abstractions. The more explicitly designers analyze such decisions, the better they will be able to anticipate the many variations that actual users will bring to the delivered system.

Scripting Behaviors

Human culture can be seen as a progression of ever more elaborate strategies for scripting individual and group behaviors and for developing uniform behaviors within larger and larger groups. Rhythmic clapping and movement—the rudiments of music and dance—can be thought of as programmed behaviors, sufficiently general and recognizable actions that can be replicated by a wide range of performers in a varied but uniform manner. Hunting, fishing, gathering and sharing food, religious **rituals**, weddings, funerals, technologies of tool-making, child care, clothing, cooking, agricultural festivals of sowing and harvesting all require the transmission and reproduction of patterns of behavior that incorporate conditional rules for appropriate variations based on the immediate context. Symbolic forms of representation allow us to describe shared patterns of behavior without acting them out in real time, so that they can be remembered and reproduced with greater accuracy and complexity.

For people living in an oral culture, proverbs are a suitably brief genre, inscribing and transmitting useful general rules for behavior and for understanding the world by coding them in familiar language with conventions like rhyme, rhythm, and metaphor to make them memorable without having to write them down, for example:

The early bird catches the worm.

A stitch in time saves nine.

Leaves of three, let it be. (For avoiding poison ivy.)

The race is not always to the swift.

Do unto others as you would have others do unto you.

In a culture that has a writing system, people can inscribe behavioral scripts in stone or place them on sacred scrolls so they can be read out regularly as a guide to shared rules of behavior:

For six days you shall labor and do all your work. But the seventh day is a Sabbath to the Lord your God; you shall not do any work. (Exodus 20:9–10)

You shall keep the festival of unleavened bread. For seven days you shall eat unleavened bread, as I commanded you, at the time appointed in the month of Abib; for in the month of Abib you came out from Egypt. (Exodus 34:18)

Writing fixes behavior with greater uniformity for more people over longer periods of time, especially when it is accompanied by ritualized enactments that recur at predictable intervals. Time-keeping media technologies are also important in scripting behaviors. Synchronizing our reading of where we are in the sequence of natural events—for example, the daily, monthly, and yearly rhythms of sun and moon—allows us to coordinate our cultural patterns, like eating meals or planting crops, with nature and with one another.

The invention of the printing press helped us to standardize our observations and performance of complex processes—like the experiments that are the foundation of the scientific method or the best methods for dairy farming—and to share our strategies for improving them. The Industrial Revolution transformed many processes that are foundational to human culture by automating them, leveraging smaller amounts of human effort for vastly greater productivity. Manufacture of clothing and shelter and transportation was transformed by using compressed air, waterpower, carbon-burning engines, and eventually electricity to perform tasks that were formerly done by hand.

The invention of recording technologies for images and sounds has expanded our ability to observe and document processes, allowing us to repeat and segment events that would otherwise be lost in time, as well as to preserve and distribute our recordings.

The computer has augmented all of these modes of synchronizing, standardizing, automating, and recording sequences of behavior. It has increased scripting by word of mouth by facilitating voice, text, and image transmission—the equivalent of proverbial wisdom transmission for ever-larger social networks. Computer networks have also increased the dissemination, retrieval, and refining of more complex written rules, from legal contracts to the demanding rituals of French cooking. They have increased our control

over mechanized processes, from automobiles to nuclear power plants to remote-controlled weaponry and even to telescopes and probes in space by allowing us to control them through automated conditional processes. And they have augmented our ability to observe and record events over time.

Computers have given us the ability to fix, share, and refine procedural knowledge. A recipe in a book is descriptive (or declarative) knowledge. A recipe enacted by an expert is procedural knowledge. A computer displaying coded instructions is imparting descriptive knowledge; a computer running those instructions as a set of actions is demonstrating procedural knowledge. When we read a set of instructions in a book we can imagine what will happen when they are executed. When we run a set of instructions on a computer, we can explore what will happen under multiple conditions. It is descriptive like a recipe in a book; but it is also procedural like a chef executing a recipe—or like 1,000 chefs performing 1,000 variations of the same recipe. *The power of procedural representation is a tremendous resource for design, a cultural power continuous with dances, proverbs, and rituals as well as with scientific experiments and mechanical engineering.*

Computer programmers think of the procedures for doing things as separate from the particular code with which the procedures are implemented and they refer to these more abstract procedures as algorithms. A key part of computational analysis is identifying the appropriate algorithm, the optimal sequence of instructions for performing a particular task or part of a task. Some algorithms are usable in multiple situations for the same kind of process, such as sorting a list, searching a database or archive, compressing files, or generating random numbers. The field of computer science is concerned with exploring the properties of algorithms and inventing new algorithms for processing **information**. The field of computer programming is concerned with applying and refining known algorithms for practical purposes. These algorithms are part of the cultural conventions that shape a particular software environment, although they may be hidden from the user or nonprogramming designer.

Mathematical formulas, like the ones for determining the area of geometrical shapes, are algorithms that always give the single correct answer, and that we therefore follow in precisely the same way each time we execute them. Much of computer science is concerned with mathematical precision in algorithms. But in daily life we generally make use of rougher algorithms called **heuristics**, sometimes called "rules of thumb." Heuristics tells us in a mostly reliable way how to get to an acceptably close-to-accurate answer, such as estimating relative distances on a map by comparing them to the size of our thumb. Often the most advanced computational solution to a problem—the standard algorithm—is only a rough heuristic rather than a more precise methodology because the computer only has partial information, the outcome of a process is basically unpredictable, or a more mathematically accurate answer would take too much processing power for current machines. The proverbs discussed

earlier in this chapter are heuristics that guide the thoughts and behavior of an individual toward the cultural norms and received wisdom of the larger group, without aiming for literal truth or mathematical accuracy. But a human being can compensate for the approximation of a proverb by not expecting " a stitch in time" to save exactly "nine" other stitches. Humans can also apply the same process description metaphorically, recognizing that other problems besides fabric tears are best taken care of before they get much bigger. Computer programs, on the other hand, need algorithms that explicitly state every condition they should be aware of and every action they should take. So human users need to be told how to gauge the reliability of the computer's methods, by designs that bring **visibility** to the underlying algorithms.

Although the algorithms on which computer programs are based are crucial parts of the structure of digital artifacts, they are often invisible to designers and interactors. Sometimes proprietary rights keep them invisible since the best search engine or recommendation system algorithm is a valuable invention in the marketplace. We also do not have many conventions for illustrating algorithms outside of mathematical notations. Algorithm visualization is a focus of research in information visualization (figure 4.6). It is useful as an aid to the teaching of computer science, and it should also be a focus for interaction designers. The more we understand about the way information is represented and processed within the machine, the greater our power to design it. And the better we can communicate the basis of the machine's decision making to the interactor, the greater the experience of agency.

Figure 4.6
A comparative visualization of two sorting algorithms in the form of an animation with robots representing the actions of the processor. From a video by <http://zutopedia.com>, available on YouTube.

State

Since computer environments are always changing, we speak of them as having **state**. It is useful to remember that when we talk about state as a powerful abstract concept it is grounded in the physical reality of the underlying machine code and the millions of electrical switches set to 0 or 1 in patterns that we can interpret as representing higher-level codes. Programs have state, and parts of programs can also have state. The state of a program is the state of all the bits in which it is instantiated. In early programming environments programmers made use of a "core dump," a printout with a 0 or 1 representing every bit in computer memory. When a program crashed—when it could not figure out how to execute an instruction because of a typo or logic error of some kind— the program displayed its state at the moment of failure as a long list of 0s and 1s formatted into bytes. Programmers would find the bytes that indicated the location of the machine code instruction being executed at the time of the crash and the values of the variables, translating them from bits into ASCII characters, binary numbers, or primitive instructions, in order to determine what went wrong. We glimpse this underlying layer in error messages, usually expressed not in 0s and 1s but in hexadecimals (figure 4.7). We can think of an executing program as always in flux but capable of being captured in such snapshots when we need to, such as when we want to save a dynamic environment like a game or a tax return editor and restore it at a later time.

Figure 4.7
System errors producing problem reports like this one provide end-users with a rare glimpse into the bit abstraction layer that underlies all digital representation.

Because computer applications are procedural, we do not have to reproduce the entire program and all the associated data structures to capture the state of a system. *We only have to capture the values of all the variables.* A "saved game" is not a bit-for-bit duplicate of the entire game; it is a file with the values of all the game variables. The master program can procedurally reproduce the desired state by reading this small data set and reloading these saved values into the appropriate variables. In a multiplayer world each player sharing the same virtual space has local copies of the large image files and the rules for generating the world, and the central server only needs to receive and send a limited number of variable values in a standard common format to keep everyone's picture of the state of the world up to date. An image editor or word processor is similarly able to undo changes because it can keep track of the previous states of a document without having to save multiple copies. *State is a useful concept for designers in any situation where users will want to save or share a procedural environment, or to undo/redo changes to a digital artifact.*

State can also belong to entities within a world constructed of code. For example, all the characters in a multiplayer world can have individual states consisting of variables, like strength or intelligence, and possessions, like food and weapons. State is also a powerful conceptual framework for thinking about conditional processes. Instead of regarding a process as a unidirectional **branching tree**, with processing proceeding from beginning to end, we can see it as an interconnected **network**, with each **node** representing a distinct state and the lines or paths between them showing the preconditions for moving from one state to another. For example, figure 4.8 shows a **state diagram** of a virtual dog. If he is hungry he can pass to one of two states:

sated if he is given a meal of food
cranky if a second mealtime passes while he is already in a hungry state

The sated dog can become *playful* in the presence of a playmate or *curious* in the presence of a scent. He may run away if he is cranky, but he can be distracted by curiosity. We can represent all of these states as nested if/then statements or as a multibranching flow chart, but it makes more sense to represent them in a state diagram.

Many objects in computational systems can be understood in terms of a state diagram, such as a cursor that can change to a point, hand, highlighter, brush, and so on, with different functionalities associated with each state. The concept of state can summarize multiple variables in a complex system. For example, Will Wright's original design for The Sims included motives such as hunger, hygiene, and entertainment that were summarized in an overall state of happiness of the character (figure 4.9).

State distinctions in real life and in virtual environments often reflect power relationships or special privileges. For example, credentials of various kinds (such as college degrees; birth, death, marriage, and divorce certificates; drivers licenses;

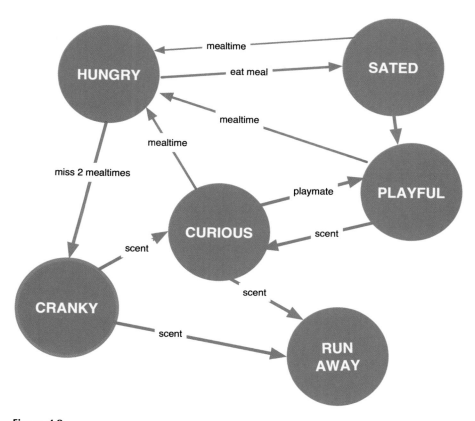

Figure 4.8
State diagram of a virtual dog. The hungry state occurs at time steps representing meal times. The conditions for advancing to the other five possible states are indicated on the arrows. Drawing a diagram like this can suggest new possibilities or refinements of behaviors, such as considering the conditions under which the dog can be distracted from crankiness by curiosity.

and visa and citizenship documents) can also be understood in terms of state, with preconditions officially monitored, legal rituals accompanying the state transitions, and state-specific constraints and affordances. A power-up in a platform video game is a similar kind of state transition. For example, in the Super Mario Brothers video game, the Mario figure can become huge enough to stomp on obstacles he has to jump over in his usual state (figure 4.10) or small enough to fly into tiny places to find hidden treasures. State distinctions can provide a useful framework for distinguishing between stages of a process, and sometimes a master state can affect multiple variables.

```
enum
{
        mHappyLife      =0,
        mHappyWeek      =1,
        mHappyDay       =2,
        mHappyNow       =3,

        mPhysical =4,
        mEnergy         =5,
        mComfort =6,
        mHunger         =7,
        mHygiene =8,
        mBladder =9,

        mMental         =10,
        mAlertness      =11,
        mStress         =12,
        mEnvironment=13,
        mSocial         =14,
        mEntertained=15
};

#define DAYTICKS  720      // 1 tick = 2 minutes game time
#define WEEKTICKS 5040
```

```
// calc and average happiness
// happy = mental + physical

    Motive[mHappyNow]  = (Motive[mPhysical]+Motive[mMental]) / 2;
    Motive[mHappyDay]  = ((Motive[mHappyDay] * (DAYTICKS-1)) + Motive[mHappyNow]) / DAYTICKS;
    Motive[mHappyWeek] = ((Motive[mHappyWeek] * (WEEKTICKS-1)) + Motive[mHappyNow]) / WEEKTICKS;
    Motive[mHappyLife] = ((Motive[mHappyLife] * 9) + Motive[mHappyWeek]) / 10;

    for (z = 0; z < 16; z++) {
        if (Motive[z] > 100)  Motive[z] = 100;      // check for over/under flow
        if (Motive[z] < -100) Motive[z] = -100;
        oldMotive[z] = Motive[z];                   // save set in oldMotives (for delta tests)
    }
}
```

Figure 4.9
Excerpts from Will Wright's early draft code for The Sims, showing values for computing physical
and mental motives and for combining multiple motives into a calculation of the character's
average state of happiness over multiple time steps.

Cyberspace is increasingly populated by complex dynamic systems composed of
thousands of variables, such as:

• vast exploratory game worlds with hundreds of thousands of players
• social networking sites with thousands of associated media players and interactive
games
• stock trading systems providing access to globally available securities
environmental monitoring systems
• Slide presentation systems that offer one-button changes of color scheme, format-
ting, and background for the same text content
• control systems for automated manufacturing processes

Figure 4.10
Video game character Mario undergoing a state-transforming power-up that increases his size and the range of actions available to him.

Each of these systems exists in a huge possibility space, making it increasingly difficult to keep track of the big picture, to know what variables to watch in order to understand the state of the system as a whole or to accurately track its individual parts. *We are creating complex digital environments faster than we are creating the means of conceptualizing and overseeing them.* The abstraction and visualization of the state of complex computational systems will therefore be an active area for design in the coming decades.

Modularity and Encapsulation

Modularity and **encapsulation** are key programming strategies for representing complex sequences of behavior by breaking them up into smaller parts that work independently but know how to exchange information with one another.

*The more modular a program, the better it can survive the inevitable changes of a development process, the more **extensible** it will be, and the more likely it will continue to be adaptable as new technologies emerge.* Modularity allows programmers to change part of a large system without affecting the other parts, while sharing important elements across the whole system as appropriate. One way to think of modularity is to imagine a software program as an organization with employees, like a storefront bakery. The bakery may have one group of employees to make the pastries, one to wait on customers, and another to work the cash register. Each group understands what a cupcake is and how

to pass it through the system, performing the appropriate actions at each stage. If the pastry chef is experimenting with a new cupcake recipe, it should not distract the other employees from doing their jobs. Similarly, a software program that supports Internet sales of baked goods might be written with a front-end module for customers, a back-end module for employees, and shared database for keeping track of inventory. Redesigning the appearance or navigation of the customer interface should not disrupt the underlying database or the data entry done by the employees.

One of the most useful applications of the strategy of modular design is the separation of the appearance of digital artifacts from their inner structure, of the user interface from the back end. For example:

• Databases that offer multiple views of the same data, such as graphs, pie charts, tables
• Slide presentation systems that offer one-button changes of color scheme, formatting, and background for the same text content
• Separation of display from structure with cascading style sheets in web environments
• Delivery of the same news and entertainment content on multiple-size screens and multiple hardware/software platforms

Modularity of design also allows developers to release expansion packs and level modifiers for games, by adding separate but compatible code onto an existing structure.

Modularity is a fundamental principle of software engineering. It can be implemented in many ways. For example, in the payroll program we might make a subroutine called PAYCALCULATOR that would be called by the main program. Here it is in pseudocode:

```
PAYCALCULATOR (hours, rate) // calling program, passing parameters
CALCULATE calculatedPay = hours x rate //plugging in values passed as
                                        parameters
RETURN (calculatedPay) //returning a value for calculatedPay
```

In the first line of the program we tell the subroutine PAYCALCULATOR what values to use to calculate the pay. When the program runs, the subroutine will receive two numbers separated by a comma. It will assume the first number represents a particular employee's hours and the second represents the employee's rate, and it will then plug these values into the equation hours x rate and come up with a new value, which it will send back to the program that called it in a variable called calculatedPay. In this example (hours, rate) and (calculatedPay) are variables that are passed as **parameters** between the master program and the subroutine.

Having made this subroutine, we can change the master program so that it does not have to know how the pay is calculated. The relevant portion would read like this:

```
COPY timecard.name = paycheck.name
CALL PAYCALCULATOR (hours, rate) to get (calculatedPay)
Copy calculatedPay = paycheck.pay
IF DIRECTdeposit = true
THEN DEPOSIT paycheck
ELSE PRINT paycheck
END IF
```

The formula for calculating the pay has been encapsulated in the subroutine.

In general, programmers try to divide up the functional components of a software system so they can be tested separately and modified without affecting the other components. This also allows multiple people (or subteams) to work on the same system. As long as all the developers have a common representation of the data structures they will be sharing and the parameters they will be passing, each subteam can develop its own piece of the larger system independently of one another. For example, to handle the complexity of a real corporate payroll program, the functions for figuring out pension deductions or income taxes or charitable contributions can be treated as separate modules from one another and from the module that calculates net pay. As with many aspects of digital systems, standardization allows for coordination among multiple contributors.

When the payroll program calls the CalculatePay subroutine by name it is taking advantage of the computational strategy of **encapsulation,** by which we hide the specific functional details of a module, drawing on it as if it were a **black box** known only by its name and the relevant protocols for sharing information. For example, we do not want to have to look at the binary machine code instruction for contacting the printer every time we want to print something. We encapsulate all of that within the PRINT command of a higher-level programming language or the PRINT menu item in a computer application. Encapsulation is sometimes spoken of as "information hiding" but it is better understood as standardizing the topmost level of an operation, so that other parts of the system can invoke the function without worrying about the details of how it is performed. Encapsulation reinforces modularity. By making one command PRINT for every printer we do not have to think about the individual print drivers for every operating system and every printer family each time we make an application. We just pass the PRINT command on to the system software and let the system find the appropriate device and driver.

Often design of a complex software system starts with the topmost level and black boxes the constituent processes, leaving the details unspecified while the big picture is sorted out. For example, if we are making a procedure for preparing breakfast, we want the top level, the most general part of the program, to make sense regardless of what we are cooking. It might look like this:

```
PLAN menu
LIST ingredients
GATHER ingredients
COOK meal
SET table
SERVE meal
```

In listing the general steps we do not have to think about the details of performing any of them. We have encapsulated the multistep process of cooking the meal into a single "Cook" command. Because these routines are modular, the team that does the cooking does not have to think about gathering the ingredients. Each part of the larger program can be designed independently as long as the coders know how to pass information (shopping lists, groceries, prepared food) from one module to another. Encapsulation helps us to keep track of a large sequence of instructions without getting overwhelmed by the details.

Within each module we would specify the actions in greater detail, continuing to look for opportunities to encapsulate further, building up complexity with multiple **abstraction layers**. At the level of gathering the ingredients, we can begin to think about what generalized actions (**functions**) we would perform regardless of what we are cooking. For example, we have to

```
GO to Refrigerator
OPEN Refrigerator
SELECT item
PLACE item on counter
GO to Pantry
OPEN Pantry
SELECT item
PLACE item on counter
```

We notice that there is some parallelism here. The Pantry and the Refrigerator are similar, and they belong to a category that could have other elements, such as ShoppingBag and BreadBox. All are FoodContainers. So we could save ourselves the trouble of making individual routines for each by making a generalized GATHER routine that would work for all of them, and that would also allow for other places besides the counter, as follows:

```
From [FoodContainer] select [Item] and Place [WorkLocation]
```

To identify components of any process requires brainstorming all the examples of specifics while constantly thinking about how to abstract the general case. Food preparation immediately brings to mind refrigerators and pantries, which in turn suggest the general category of FoodContainer. Once we think of FoodContainer, shopping bags and breadboxes come to mind. Once we generalize the container, we realize we

Table 4.3

The Open Systems Interconnection (OSI) Basic Reference Model

Layer	Function	Example of Components
7. Application	Provides network services to applications	File Transfer Protocol (FTP)
		Hypertext Transfer Protocol (HTTP)
6. Presentation	Standardizes and encrypts data to pass it between application and session layers	Multipurpose Internet Mail Extensions (MIME)
5. Session	Establishes connections between computers, ends sessions gracefully	Domain Name Server (DNS)
4. Transport	Transfers data between users, keeping track of segments of data and whether they transmitted correctly	Transmission Control Protocol (TCP)
3. Network	Routing of data chunks of varying lengths through one or more networks	Internet Protocol (IP)
2. Data Link	Arranges bits from the physical layer into logical sequences called frames	WiFi, Integrated Services Digital Network (ISDN)
1. Physical	Provides the standardized electrical and physical specifications for devices, such as pins, voltages, cables, adapters, creating the function of modulation—conversion of digital data from user equipment to signals that can be transmitted by a communications network	Modems, Coaxial Cable, Fiber Optic Cable

The OSI Basic Reference Model, describing the system of enabling technologies of the global information network, is a good example of the principle of encapsulation, which simplifies interaction in a nested hierarchy of functions by hiding information so that each level only sees what is relevant to its own process; for example, programs that are transferring files cannot see anything of the underlying hardware or radio waves, but they can rely on them working as needed because each component is following the official protocols for passing information up and down the hierarchy.

could also generalize the work location. Meanwhile other teams are thinking in more detail about the components of other parts of the process. The process of abstraction is iterative and collaborative. Although the advantage of modularity in development is information hiding, it is important for teams to establish clear standards and to remain in touch about shared structures. In 1999 NASA lost a $125 billion Mars orbiter because "one engineering team used metric units while another used English units for a key spacecraft operation" (CNN 1999).

Encapsulation is an important enabling strategy for the Internet (table 4.3), allowing a programming team to make significant changes to modules at any point in the hierarchy without having to worry about affecting or being affected by changes going on in the levels above and below, as long as the innovators observe the standard

protocols for passing information up and down the line. The reliability of the Internet, which it is easy to take for granted on a day-to-day basis, can be seen as a triumph of computational abstraction.

DESIGN EXPLORATIONS: COMPUTATIONAL STRATEGIES OF REPRESENTATION

Using Binary Codes for Symbolic Abstraction
• Make up a coding scheme that describes one of the following using only eight bits:
 • The politics of the members of your family
 • The most important qualities of items in your music collection
 • The factors that will determine whether a particular person (yourself, your roommate, your sibling, a famous person) will get married in the next three years
 • Evaluation criteria for something you are planning to buy
• Try the following exercises in abstracting fictional characters:
 • Identify the variables in a character design system for a popular character-based game (e.g., Dungeons & Dragons, World of Warcraft, The Sims). What are the traits that are represented in the system? How are these traits reflected in the character's behavior? What makes these traits suitable for a programmed environment—for example, are they easy to dramatize or quantify? What innovations in character design did the specific game introduce?
 • Using a character design system from an existing game, represent one or more fictional characters from another medium such as novels, films, or television. What preexisting media conventions is the game system based on? What kinds of characters would be easiest to represent within the system?
 • Using a character design system from an existing game, represent three people you know using the same variables. What would be left out? What moral, social, and cultural values are reflected in the abstraction system?
 • Invent a system that would capture a complex fictional character or a person that you know better than the existing game systems. What cultural values and media conventions can you draw upon to make your system? How would you create behaviors to illustrate the character traits you have invented? How would you differentiate between characters?
• Abstracting social identity: identify a website or networked mobile application that offers a questionnaire to match people romantically or to determine their chances of longevity or their carbon footprint or any other multifactor assessment.
 • Analyze the questions to determine what the underlying model of a person is. What kinds of activities do they expect people to engage in? What values do they expect them to have? What attributes or behaviors are not considered?

• Compare two or more such sites addressing the same or different goals. Are these questionnaires overlapping at all? Do they look at the same characteristics in different ways? Do they have the same model of a person or a relationship or a healthy life?

• How much confidence do you have in the analysis done by each of these sites? What features seem the most helpful? What suggestions do you have for how one or more of these sites might change their abstraction of a person to shape better questions and offer a more useful analysis?

Representing Choices and Iteration in a Flow Chart

• Flow charts are useful for representing branching processes based on conditional decisions that are repeated in a loop over multiple iterations, such as processing multiple timecards in a payroll program. Make a flow chart that represents a typical day in your life or the life of someone you know well, emphasizing routine decision points (e.g., what to wear, what to have for breakfast, whether to study or talk to a friend). In creating this flow chart:

 • Represent any repetitive pattern during the day as a loop (e.g., leave house—did I forget something?—if yes—reenter/retrieve/leave house— did I forget something?. . .).

 • Represent the whole day as part of an iterative loop of a week. How would the iterations differ from one another? How would you represent those differences?

 • Compare your flow chart to those of others in the class. What did you put in that others left out? What did you leave out that others put in?

 • Collaborate with others to make a more abstract and inclusive chart based on multiple individual decisions.

Representing Lived Experience as Abstract Pseudocode

• Using no more than ten verbs and twenty nouns, write a procedural description of a typical day in your life from waking to sleeping, as follows:

 • Framing the task: decide on the kinds of actions and objects you will ignore (e.g., personal hygiene or private matters) and what kinds of actions and objects you will particularly focus on. Will you emphasize comic or studious activities? Will you aim for the idiosyncratic or the generic?

 • Use pseudocode syntax and consider whether you need to specify items that are implicit in English syntax. For example, not just Dress but Dress(Clothing).

 • Compress the representation by generalizing—for example by writing Meal instead of Breakfast, Lunch, Dinner—and keep a separate list of the kinds of objects and behaviors that are encapsulated in the more abstract term.

 • Follow up with groups: compare your verbs with those of three other students. Could you represent your day using only their verbs?

• Working in groups of three, compress all of your actions and objects into no more than seven verbs and fifteen nouns. Wherever possible, generalize to create another abstraction layer. For example, if one person had BIKE to CAMPUS and another had DRIVE to CAMPUS, then create a top-level verb like TRAVEL.

• Compare results with other groups to see who captures the most specificity with the fewest verbs. How many abstraction levels would be necessary to combine all of the groups' lists into a single comprehensive vocabulary with only seven verbs and fifteen nouns at the top level?

• Advanced exercise: create pseudocode or running code for a program that generates randomized variants on a typical student day. Start with a representation of seven to ten actions arranged in chronological sequence and described at their most general level (e.g., EAT, TRAVEL, STUDY, FLIRT, etc.). Specify specific variants for each of these actions, either by substitute verbs (e.g., TRAVEL/DRIVE/BIKE) or nouns (PLACE/HOME/CAMPUS/CAFÉ). What rules would you need to make coherent sequences?

Thinking of Processes Algorithmically

• Look up sorting algorithms on the web or in a computer science textbook. How many ways can you find for putting a list into alphabetical order? How would you choose when to use one over another?

• One of the most common forms of sorting is the Bubble Sort, in which two items are compared and the lesser of the two is placed beneath the greater. In an existing list, one can sort through every pair in this manner and the highest value will "bubble up" to the top of the list. Draw a flow chart for a bubble sort. With a set of 500 unalphabetized words on index cards, follow your flow chart and sort them. Was it difficult to follow the flow-charted rules? If so, what would you have preferred to do?

• Implement the Bubble Sort algorithm in the programming language of your choice (or find an existing version) and test it with the same list of words. How is the computer performance different from the human performance?

Abstracting the State of Complex Systems

• Start any computer-based game, quit in the middle, and then restart it. Did the system duplicate the previous instantiation or were there differences between the original and restored version? What factors did the program have to keep track of in order to restore the game? How would you express these factors as a set of variables?

- Using yourself, someone you live or work with very closely, or a fictional person or celebrity you know from media reports, identify seven variables that taken together summarize your chosen person's overall state at a particular segment in time (it could be by month, week, day, time of day—whatever you consider most important to keep track of). The seven variables can be logical (e.g., true/false), qualitative (e.g., healthy/so-so/sick), or quantitative (e.g., net worth in dollars). Using these seven variables:
 - Make a chart indicating all the possible values of each of the variables.
 - Enter the values on index cards arranged in seven stacks or as a set of seven adjacent pull-down menus. This will allow you to experiment with different combinations of settings. How long would it take to manually look at every possible combination?
 - Are any of these variables causally linked or closely associated (e.g.: If a person's number of days-to-deadline for an important project are less than 5 then are their hours-of-sleep likely to be less than 8?)
 - Which combinations of variable settings are most worth keeping track of?
 - Based on this description of a person with variable states, identify some important actions that will change the value of variables or whose performance will change based on the value of variables. For example, will the result of taking an examination change if the person's hunger level is high? Draw a flow chart describing variant paths through a set of events based on decisions that change the state of variables. Or draw a state diagram for the character that describes how transitions are made from state to state.

Using Encapsulation to Abstract Behaviors as Discrete Modules

- Using pseudocode or a flow chart or another form of system diagramming, describe in at least seven modules with at least two abstraction levels the planning process for an event such as a wedding, family reunion, professional conference, or political demonstration. This can be done as a group exercise and the situation can be based on experience, fiction, or invention.
 - Preparation for creating the modules: describe the event, giving examples of similar real or fictional instances, and indicating the general requirements (e.g., a wedding similar to the one in the movie *Father of the Bride*).
 - Start with the top-level process. It may help to think of yourself as the chair of a committee and to think of each of the second-level modules as a set of related tasks assigned to a particular committee member.
 - What processes are named within the top-level process? If they are well chosen then they will fully describe the general tasks needed to accomplish the goal.

• Identify shared parameters and data structures, such as output from one module that is delivered to other modules as input (e.g., MakeGuestList would pass the GuestList to CreateInvitations and CreateSeatingPlan).

• Include other levels of encapsulations as needed (e.g., CreateInvitations might include a black box for ChooseStationer).

• What behaviors (e.g., CheckBudget, CheckStillEngaged), variables (e.g., UrgeToE-lope), or information structures (e.g., Budget, GuestList) would all the modules need to share?

5 Building Procedural Complexity

Every computer program is a model, hatched in the mind, of a real or mental process. These processes, arising from human experience and thought, are huge in number, intricate in detail, and at the time only partially understood . . . they continually evolve; we change them as our perception of the model deepens, enlarges, generalizes until it attains a . . . place within still another model with which we struggle. The source of the exhilaration associated with computer programming is the continual unfolding within the mind and on the computer of mechanisms expressed as programs and the explosion of perception they generate. If art interprets our dreams, the computer executes them in the guise of programs!
—Alan J. Perlis (1996)

Objects, Classes, Methods, Inheritance

One of the most important advances in computer science in the past thirty years was the movement toward **object-oriented programming.** While older programming languages separated data structures from procedures and emphasized central control programs with dependent subroutines, object-oriented systems provide a more integrated and decentralized model that allows designers to specify objects and behaviors at multiple levels of abstraction.

In an object-oriented environment, the programmer creates objects with attributes and behaviors (often called **methods**). For example, in an object-oriented role-playing game system, a warrior object might have fighting methods and a magician object might have spell-casting methods. This kind of abstraction is also a feature of cultural life in which, as Erving Goffman pointed out, we see ourselves and one another as playing roles with scripted interactions characteristic of those roles (Goffman 1967). For example, a teacher and a student have characteristic behaviors individually (lecturing, studying) and interactively (administering and taking tests). Machines can also be seen as objects with methods. For example, microwave ovens have pre-scripted methods for dealing with popcorn or potatoes.

Objects are specified not as individuals but as members of a **class**, and the individual object created when the program is executing is considered an **instance** of the general class or template for that object. **Instantiation** does not only belong to object-oriented environments. It is one of the most powerful features of the digital medium: the ability to describe something as a general template or rule set and then to create an unlimited number of copies with unlimited possible variations.

Objects within a class **inherit** all the attributes and methods of the class, but they can have different values attached to them. For example, an instance of a dragon object might have a variable indicating whether or not (T/F) it was fire breathing, which would also determine whether its fight method included fire-breathing attack as one of its functions.

Objects can also belong to subclasses that inherit attributes and methods from parent classes. For example, a knight class might be a child of the warrior class with fight methods that are parameterized using the sword subclass of the weapons object class and following the rules associated with the method for dueling. All warriors might have common attributes such as health, strength, and weapons proficiency, and common methods such as challenge, fight, and retreat. These common attributes and methods would only have to be specified once to apply to all warrior subclasses, with appropriate parameters to differentiate a dragon warrior from a knight warrior. Objects can inherit from multiple classes, so that the knights might inherit methods from the courtly lover class that would allow them to recite poetry and choose a beloved, as well as to perform the behaviors appropriate to warriors.

Object-oriented concepts are well suited to representing our increasingly parameterized view of the world—our sense that the way things are is just one version of the many ways they might be.

Substitution Systems

As systems become more complex, they become more difficult to represent as flow charts of branching trees. Consider for example the case of a narrative environment in which multiple events are possible at any time, some of them based on much earlier choices and events, some of them based on immediate actions. It is easy to imagine such a world but difficult to build it, and especially hard to understand while building it all the possible combinations of events the system will enable. **Substitution systems**, like the one that is the basis of human language, are good ways of approaching this level of complexity.

We can think of language as composed of standardized slots that can be filled in with a large range of content. For example, a simplified **template** for an English sentence might look like this:

Subject/Noun | Verb | Object/Noun

We can say an infinite number of things and still be understood by following this word order, substituting particular nouns and verbs for the appropriate slot in the template. The rules for which nouns and verbs go in which slots, for how they are spelled, for what they mean, and for which of the many variations of this simple template will be used (with or without adjectives, adverbs, embedded clauses, etc.) are enormously complicated, but the organizing format that makes meaning possible is a simple substitution system.

Similarly, substitution systems of various kinds provide the structure for many predigital and digital media formats and genres. A few examples:

- The rhyme scheme in a ballad
- Print templates for marriage licenses, paychecks, birth certificates
- The organization of popular music concerts into sets and of songs into sets
- Layout schemes for magazines and newspapers
- The organization of talk shows into slots per guest, and of reality contest shows into slots for contestants and episodic challenges
- Pull-down menu choices on a computer application or web form
- Avatar creation and choice of weapons in video games (figure 5.1)

In all of these media genres, the **schema** of a substitution system allows the creators to produce multiple versions in a more efficient manner and it allows the consumer to anticipate the information and therefore take it in more efficiently.

In computer-based environments we can build up complexity by shaping multiple interconnected substitution systems and writing complex rules for assembling the elements, creating not just a uniform template but a proceduralized substitution system.

The elements of such a proceduralized substitution system can be dynamically generated based on multiple **parameters**. For example, the experimental interactive drama Façade (2005a) is a story game based on a visit by the player to a couple who are in a troubled marriage (figure 5.2). The visit can end in many ways, all of them variations on the couple reconciling, separating, or turning their anger on the player's character. The story is composed of fifteen dramatic beats arranged in a substitution system that draws on twenty-seven possible beats in multiple possible combinations. Each beat is also a set of substitution systems made up of ten to one hundred segments of joint dialog, which can also be varied in multiple ways. In addition there are many "mix-ins" of possible actions, similar to the chopped nuts or broken chocolate candies and other treats that ice cream parlors offer as "mix-ins" to your choice of ice cream flavor. The use of the term "mix-ins" is in fact a programming pun associated with the **artificial intelligence** term of a "flavor system," a kind of parameterized variant structure that is similar to object classes. But the flavors and mix-ins in Façade are many orders of magnitude larger than those of an ice cream parlor, and many times

Figure 5.1
World of Warcraft character builder is a multipart substitution system.

PlayerArrives, TripGreetsPlayer, PlayerEntersTripGetsGrace, GraceGreetsPlayer, ArgueOverRedecorating, ExplainDating-Anniversary, ArgueOverItalyVacation, FixDrinksArgument, PhoneCallFromParents, TransitionToTension2, GraceStorms-ToKitchen, PlayerFollowsGraceToKitchen, GraceReturns-FromKitchen, TripStormsToKitchen, PlayerFollowsTripTo-Kitchen, TripReturnsFromKitchen, TripReenactsProposal, BigBlowupCrisis, PostCrisis, TherapyGame, Revelations-Buildup, Revelations, EndingNoRevelations, Ending-SelfRevelationsOnly, EndingRelationshipRevelationsOnly, EndingBothNotFullySelfAware, EndingBothSelfAware

Figure 5.2
Façade (2005), an experimental drama by Michael Mateas and Andrew Stern that generates thousands of possible variations of a dramatic story, based on fifteen of the twenty-seven highly parameterized beats listed here. The interactor confronts a quarrelsome couple in a visit that results in varying degrees of mutual revelation and self-awareness.

more than could be drawn as a branching structure or enumerated as a list of possibilities, because they are procedurally determined, based on multiple factors including the input of the player in game gestures and free text dialog that is parsed and interpreted by the system.

Creating variation in a digital system is not hard, but keeping track of the variation is very challenging. In the case of Façade there are a number of strategies for selecting and composing the beats, including a relatively fixed order for the beginning and end of the encounter and a "drama manager" who seeks to create a pattern of rising tension and resolution. There is also an architecture that allows the author to specify preconditions and postconditions for each beat: variables that control when a beat is eligible for selection and what aspects of the story change after it has been played. For example, an escalation in insults between the husband and wife would raise tension variables and might make it more likely that the next beat selected will focus on the revelation of a wounding secret. The result is an multilayered story system capable of generating thousands of possible dramatic sequences, while remaining consistent and coherent, because all of the variation occurs within a fixed set of possible substitutions (Mateas and Stern 2003, 2005b).

Simulations of Complex Systems

A system is a set of processes and actors that work together in an integrated manner. Knowledge in many fields—such as biology, economics, organizational management, civil engineering, and history—is increasingly understood in terms of complex interrelated systems. In the past thirty years it has become commonplace to think of the earth itself as a single complex ecosystem that we must learn to take collective responsibility for managing. Systems can be natural, human made, or mixed. They can be open (subject to input from other systems, like the ecology of the oceans) or closed (like a game of checkers). The development of computational methods has made it easier for us to think about systems because we can mimic them in **simulations.**

A simulation is a model that changes in ways that imitate the changes observed, assumed, predicted, or proposed in the original system. Simulations do not necessarily involve computers. For example, live-action simulation games are a standard part of training for emergencies and dangerous situations such as natural disasters, medical rescues, diplomatic crises, or military actions. Computer simulations allow for complex mathematical modeling and for detailed observation of results. Most important, computer simulations allow us to introduce time into the description of events and to observe the results of system interactions over large and small time spans. Computer models are most often built to compute effects in **discrete time steps** so that the state of the model can be recalculated all through the process, and appropriate actions can be triggered by small changes in state.

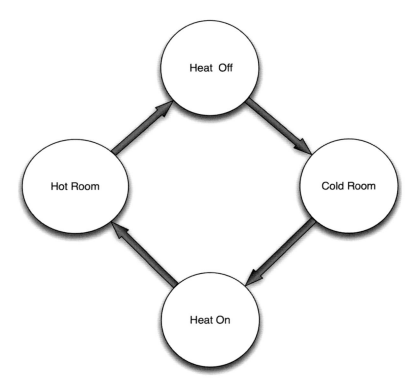

Figure 5.3
Feedback loop for a thermostat, the classic illustration of a self-regulating system.

System models often include **feedback loops,** which are characteristic of systems in the real world and purposely built into many automated systems. The canonical example of a feedback loop is a household thermostat: when the thermostat senses cold air in the room, it will signal the heating system to increase the heat, which will cause the temperature in the room to rise, which in turn will signal the thermostat to turn off the heat. When the heat is turned off it will cause the temperature in the room to fall, which will eventually cause the thermostat to turn the heat back on (figure 5.3). The feedback loop keeps the system in homeostasis, self-regulating equilibrium, never allowing the room to get too hot or too cold. Ecological and biological systems are often described as containing feedback loops. For example, predator and prey species create a feedback loop that regulates population growth: a decrease in predators leads to an increase in prey, which leads to an increase in predators, which leads to a decrease in prey, which leads to a decrease in predators, and so on. When feedback loops lead to spiraling bad effects, as in the accelerating deterioration of a

neighborhood from crime, they are called vicious cycles. When feedback loops lead to good effects, they are called virtuous circles. For example, compound interest payments create a virtuous circle, building up the principle, which leads to more interest, which leads to more principle, and so on. Feedback loops can be an important component of modeling systems; however, most real-world systems are not closed loops, but rather are open to variation from multiple sources.

Simulations are useful because they can be repeated with variable assumptions, providing us with a way of juxtaposing alternate outcomes. Financial simulations offer alternate assessments of the marketplace, and can generate numbers that can be easily compared. They can help us to think about the future, to analyze a situation that we don't understand by trying out alternate ways of reproducing it, or they can help novices to learn well-understood systems by providing a working model that can be examined under multiple circumstances. Simulations are also a useful way of providing training on dangerous systems without real-world risks.

Computers are suited to simulating complex systems because they can model a world of interacting objects, changing variables, and measured time-steps. As we understand more and more of the world in terms of interconnected systems, computers become more and more important in keeping track of our knowledge and testing out our hypotheses about how things work. Simulations are most often used as specialist tools, however, and designers have not yet had many opportunities to craft complex simulations for the nonspecialist. However, as programming skills become more common and computers become more powerful, the opportunities for the design of simulations should increase.

The most active design community in making simulations for a mass audience has been game designers. Computer simulations can be thought of as a game without a winning condition. Urban planners used simulations for decades before Will Wright adopted their algorithms for his genre-creating game SimCity (1989), which is one of the most widely used computer simulations in the world (figure 5.4). SimCity works as a **resource allocation** simulation based on time steps. The player is in sole control of the online world, in the role of an all-powerful mayor who must make decisions about infrastructure, such as where to create zoning for home or work, when to raise or lower taxes, where to put an electrical plant, and how much of a fixed budget to spend on education. The strategy of the player is constrained by limited resources, such as space and money. The game calculates the effects of the player's decisions, which it demonstrates concretely by the visible growth of the city—houses and factories spring up—and the reactions of the unseen citizens, which are reflected in newspaper headlines and in occasional cheers of approval or howls of discontent (Wright 1989).

One of the most important elements in simulation design is establishing the boundaries of the world, both physical and conceptual. SimCity has a clear physical

Figure 5.4
Screenshot from SimCity 2000, one of the many re-releases of the classic 1989 simulation game created by Will Wright. The city grows automatically as time progresses, based on decisions made by the player and the game's own programmed rules about the patterns of urban growth and decay.

boundary of a single city. The gameworld simulates many aspects of the technical, economic, and organizational life of a city including the electrical grid, the relationship of industry to job growth, the role of the police and fire departments, and the effect of greenspace on the happiness of the citizenry, but it also leaves out large aspects of actual cities, such as the ethnic politics of the inhabitants, the regional traditions that determine which industries dominate the local economy, and how much corruption is tolerated in city officials. SimCity presents at city planning as basically a top-down engineering task, relying as much as possible on quantifiable relationships (factories create a certain number of jobs, requiring housing located nearby; more housing requires more commercial areas nearby; if taxes are too high, the citizens will leave; if fire stations are not close enough, buildings will burn).

SimCity represents the cultural milieu only in terms of generic civic buildings, such as sports arenas or libraries, without distinguishing the rich human flavor and tone of the city—the many things that make our experience of San Francisco so different

from our experience of Chicago. Because the abstraction level is clear, players form the appropriate expectations for what they can do and what kinds of things can happen within the simulated world.

Of course not all computational systems are models of the actual world. We can also set up cause-and-effect situations that model fanciful thought experiments or represent purely mathematical relationships. The computer can offer us worlds where gravity and time behave differently or where dead people and vanished places are brought back to life. The advantage of the computer as a modeling environment is that we can fiddle with the rules of the model and the input we give it to find out how the model will behave under different conditions—without the effort and serious consequences of making things in the actual world. In a scientific simulation, like a model of an ecosystem, we can keep some values constant, like the initial population of a pond, and change others, like the mean temperature of the water, to juxtapose the results over multiple runs. In a military or economic simulation we could retry the same situation with varying strategies and tactics.

Simulation design often requires trade-offs between complexity of the model and readability of the results. Chains of cause and effect are easier to follow when the variant conditions are clear and outcomes are readable and easily distinguished, as they are in the popular casual games based on small-business simulations where profitability provides a readable score (figure 5.5). But more complex systems cannot be summed up in a single quantifiable outcome.

Sometimes changes in a complex system occur as a result of multiple *preconditions* being met. For example, a simulated creature in a virtual ecosystem may continue to eat, grow, and live, but it may not reproduce until certain preconditions exist, such as sufficient nourishment over a specified period of time, absence of nearby predators, and availability of a suitable mate. Mating would lead to local and global *postconditions* such as an increase in the species population count, an expansion in the territory claimed by the creature's herd, and a decrease in the likelihood of species extinction, as well as the immediate consequence of the appearance of new instances of baby creatures. These causal relationships may be clear at the coding level, but they may not be clear to the person running the situation without explicit features, such as a set of interface meters that explicitly keeps track of the factors that lead to reproduction.

Virtual models allow us to explore real-world systems in a safe environment that is more controllable than actual ecosystems, global finances, or spaceflight. *The model should be procedurally manipulable at three different levels:*

• First, the design team should be able to test and change the underlying model of the world, and to add new objects and methods without having to completely rewrite the code.

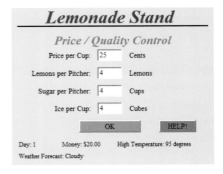

Figure 5.5
The Lemonade Stand simulation game is a popular casual game that is also used educationally.
Depending on the game variation played, the player can be asked to allocate money for quantity
of ingredients, sweetness of recipe, paper goods, advertising, staffing, rent, and to make decisions
about location. The game usually works in one-day time steps with weather forecasts and perhaps
some other random events that drive traffic up or down. There are many variants for different
businesses, and the "tycoon" variation involves the opportunity to build multiple locations.
Screenshots on the left from the Yahoo Games version of Lemonade Tycoon; upper right: iPhone
app Lemonade Stand; lower right: <http://lemonadestandgame.com> web-based game.

• Second, the model should include a way of creating multiple **scenarios,** based on
different assumptions and focusing different aspects of the underlying simulation.
• Third, the interactor should be able to change parameters within a scenario, and to
replay a scenario with a clear indication of what factors are held constant across runs.

In addition, designers should be aware of the danger of misrepresenting the world and
making unreliable predictions based on computational models. Of course, human
beings are tragically capable of acting from incomplete and biased assumptions
about the world with or without help from computers. But computers give an aura of
authority to information, particularly when it is quantitatively presented. *At a*

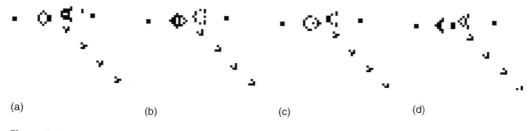

(a) (b) (c) (d)

Figure 5.6
A sequence of images in the emerging pattern called a "glider gun" produced by a computer implementation of Conway's mathematical Game of Life. <http://en.wikipedia.org/wiki/ File:Gospers_glider_gun.gif>.

minimum, we should always make clear the assumptions on which digital simulations rest. For simulations as for simpler forms of information processing, the old programmer's proverb remains true: **GIGO** ("garbage in, garbage out"). Passing bad data or bad ideas through a computer does not make them into good ideas, but it can give them a dangerous credibility.

Emergence

One of the most striking truths about the world that has become clearer with computer modeling is that complex large-scale behaviors can emerge from simpler small-scale behaviors. John Conway's Game of Life (1970), a procedural representation of a mathematical construct known as a "cellular automaton" has provided a dramatic illustration of this principle (Gardner 1970). A cellular automaton can be thought of as an infinite grid made up of identical squares (cells), like a checkerboard, each of which contains a token that can be in a limited number of states. There are rules for how each token changes state at each **time step**, based on the states of the eight surrounding cells. In the case of Conway's experiment, the tokens are binary—they can only be in one of two states, black or white, like the tokens in the board game Othello. The sequence can begin with a few tokens in any configuration, some of which yield surprisingly coherent patterns when combined with simple rules. Running Conway's simulation one can see **emergent behaviors**, such as the movement of a chevron-like pattern, similar to a flock of geese, across the board. We call these behaviors emergent because they happen without any top-down planning, and would not be immediately predictable from the rule set without running the simulation. A complex global pattern arises as a result of many individual entities acting independently of one another, and according to a very simple set of local rules. If each cell is considered an independent agent, similar to a goose flying in formation, it need not have any idea

of the overall pattern in order to play its appropriate role in creating it. The pattern arises from collective but independent action.

Emergence is a feature of complex systems, and the term most properly refers to bottom-up patterns like Conway's. We tend to think of emergence as something unpredictable that lies beyond the actions or knowledge of the designer. But as Conway's Game of Life so elegantly shows, there are *algorithms that predictably produce the same "emergent" behaviors on every run.* Emergence is also used more loosely to refer to the mere unpredictability of complex systems, or to the unforeseen adaptations that users, particularly large communities of users, make of the affordances of systems. Designers should also be aware that complex systems would indeed produce unpredictable effects, when they become too complicated for us to think through all the possibilities. This kind of emergence is not necessarily a good thing. Although **emergent,** like **interactive, intuitive,** and **immersive,** is sometimes used as an imprecise praise word *it is important to remember that mere unpredictability is not a worthy design goal.*

Emergence has always been a feature of human systems and human culture, so it is not surprising that environments that combine complex programming with tens of thousands of people show behaviors that go beyond the expectations of the design team. The first graphical multiplayer online community, Lucasfilm's Habitat exhibited some disruptive emergent player behavior, such as ways of manipulating the rules to get unlimited supplies of money or to take game weapons away from the producers. It also exhibited constructive emergent behavior such as the growth of virtual towns where player-vs.-player killing was not allowed (Morningstar and Farmer 1991). In fact, social organization—partying, gossiping, flirting, making friends, and establishing leaders, followers, and common interest groups—is a fundamental emergent behavior of human culture, and so we should not be surprised when it reproduces itself in cyberspace. But we should ask what particular features of an environment (such as real-time chat utilities) allow social organization to emerge.

Although programmers and system designers often speak of emergence as a positive value, the goal of design is to create intentional effects through conscious choices and to provide affordances for behaviors we want to encourage—not to hope for something useful to "emerge" from a structure that even the designers do not understand. It is a fallacy of naive technological optimism to expect emergence to produce desirable results. But it is always worth being alert for emergent effects, based on an understanding that the more complicated we make our systems, the less we can predict the full range of their behavior.

Computational Procedures Reflect Cultural Values

Just as novels, poems, plays, movies, paintings, TV shows, and comic books reflect the values of the people who create them and the cultures in which they flourish, computer programs are based on the assumptions, prejudices, and judgments of the people

who make them. Sometimes these values are conscious, sometimes they are unconscious, just as in other media. Game designer and theorist Ian Bogost has coined the phrase "procedural rhetoric" to refer to the ways in which interactive systems, and especially games and simulations, embody cultural values (Bogost 2007). Game rhetoric can be subtle and implicit, as in SimCity's uncritical use of standard urban planning algorithms (Starr 1994; Friedman 1999) and its omission, for example, of predatory mortgage brokers or impassioned community activists. The values can be as conventional and explicit as in Grand Theft Auto's delight in fast cars and violence against women (Jones 1997), or Civilization's emphasis on military conquest (Meier 1991). Simulation games can also be explicitly persuasive. For example the award-winning student game Darfur Is Dying (Ruiz, York, et al. 2006) arouses sympathy for the plight of African refugees trapped by hostile armed militias by placing the interactor in the role of a young child or unarmed woman trying to avoid being murdered or raped while foraging for water for their family. The values of the project are encoded in the appealing portrayal of the victims, the use of water gathering, which is an immediately understandable human need as the central game mechanic, and the procedural recreation of the difficulty of the task (figure 5.7).

Figure 5.7
Screenshot from the serious game Darfur Is Dying (2007). The situation dramatized in the game is put in context by news articles and activism sites that are linked to the game. <http://www.darfurisdying.com>.

Game designer and theorist Gonzalo Frasca adopts familiar simulation and game motifs to express in interactive form viewpoints that might otherwise be conveyed in an editorial cartoon. His Kabul Kaboom! (2001) and September 12th (2003) are both responses to the U.S. "War on Terrorism." In Kabul Kaboom! the interactor is placed in the role of a child, who is visually portrayed as a character from Picasso's celebrated antiwar painting Guernica about the victims of fascist bombing in Spain. In Frasca's piece, the child is assaulted by bombs and food rations raining down from U.S. planes, and unlike the spaceships in similar arcade games, there is no way of shooting back and very little ability to evade the onslaught. In September 12th, the interactor has only a gun sight and the ability to pull the trigger. In the player's crosshairs is the street grid of a city with low-rise buildings and palm trees in which some of the figures walking around are wearing turbans and seem to be carrying weapons. If you shoot at any of them you are likely to miss your target however carefully you aim, and your actions only cause the potential terrorists to multiply. In Frasca's third "newsgame," Madrid (2004) the interactor is invited to play a game similar to the classic arcade game Whack-a-Mole, but the object is the opposite of playful violence: instead of whacking moles that reappear elsewhere as fast as you clobber them, the player must light and relight flickering candles held by an international group of people representing the site of political violence (figure 5.8). The task is difficult but possible (or so I

Figure 5.8
Gonzalo Frasca's Madrid (2004) news game. The object of this casual game is to get all the candles lit simultaneously.

Figure 5.9
The message you see if you quit Madrid without getting all the candles lit.

am told—I have never succeeded in getting all the candles burning at once). If you give up performing this symbolic action you receive a simple message in Spanish and English: "You have to keep trying" (figure 5.9) (Frasca 2001, 2003, 2004).

In all of these examples, the designer's values are encoded in the kinds of behaviors written into the rules of the simulated, abstracted worlds. The game-like interaction is meant to entice the interactor into performing actions that are symbolic as well as mimetic—representing states of mind as well as actions in the world—and result in an insight about the world similar to that gained by a well-told story, a pointed political cartoon, an aptly chosen **metaphor**.

Procedural environments can also lead us into new behaviors, both emotionally and cognitively. I have written elsewhere about how I began to pet the dogs of my friends after playing for a while with an appealing computer pet. The behavior of the digital puppy, which performed cute cartoonish actions, induced new behaviors in me that, to my surprise, carried over into the actual world (Murray 1997). Multiplayer environments offer the opportunity to practice social behaviors with automated characters and real people mediated through avatars. Violent video games, like other forms of violent play, function for some players as rehearsal and training for actual violence, whether socially sanctioned military actions or criminal actions. They also serve, like

other violent play including football and hockey, to sublimate and provide a safe outlet for violent impulses.

Seymour Papert, educational theorist and inventor of the LOGO educational programming system, advocated the application of the procedural power of the computer to learning through the creation of explorable simulations called **microworlds**. A microworld is a rule-based environment that models system of relationships, such as gravity and the laws of physics, or electromagnetism. The student learns the domain by playing with the world, and most of all by actively constructing things within the microworld. The learning involved is experiential, because *the knowledge is embodied in the rules by which the world behaves*. We try something and notice what happens, and this leads us to form hypotheses about how the world works, which we test by trying out some other actions. (Papert 1980)

In the 1980s when he proposed the creation of microworlds, Papert was primarily thinking of mathematical environments, and later he extended those ideas to the building of robots in collaboration with the Lego toy company. But as the expressive power of the computer has grown, designers have been creating moral and cultural microworlds as well, worlds that allow people to explore solutions to intractable problems or to imagine the world as it could or should be. For example, The PeaceMaker game (Brown et al. 2007) models the dispute between the Israelis and Palestinians as a strategy game, like Civilization—but it is concerned with strategies for peacemaking rather than for the victory of one side over another (figure 5.10). Although the player assumes the role of the leader of the Palestinians or the Israelis, they cannot take a narrowly aggressive approach. In order to succeed at the game the player must confront the complexity of the situation and think constructively about satisfying divergent interests. A key challenge for designers of simulations and microworlds is finding ways to make the underlying assumptions of the world clear to players. PeaceMaker uses references to actual news events to bolster its claims to be presenting the world as it is.

Other games emphasize the satirical nature of their presentation of the world. For example Ian Bogost's game Oil God (2006) invites the player to act in the role of a demon oil baron whose goal is to double oil prices in five years by inflicting disasters on an oil-producing region (portrayed in a toy model), including economic chaos, wars, and arbitrary changes of government (figure 5.11). Oil God is a casual game that can be played in a few minutes, while PeaceMaker is a much larger simulation that rewards a substantial time commitment. On the surface they appeal to opposite impulses: altruism versus greed. But both games engage large political realities that affect millions of lives as the object of discrete game moves. Both represent a world similar to the one we see reflected in news reports and our everyday experiences, a world where people die from the same causes as they do in the actual world, as if it were a strategy system in which we can trace the effects of decisions and replay situations to try alternate approaches.

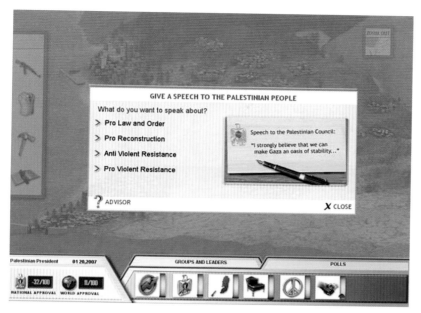

Figure 5.10
One of many strategic choices offered to the player for achieving the goal of resolving the conflict between the Israelis and the Palestinians, in PeaceMaker (ImpactGames 2006) (<http://www.peacemakergame.com>).

The genre of the simulation game is one of the most important areas for design in the coming decade. A few of the conventions have become sufficiently firm that they provide a scaffold for new work. For example, the simulation usually puts the player in either the role of a god or demi-god, someone with more power than a single human being usually has. In SimCity, for example, one plays the mayor, but with dictatorial powers to allocate budget and dictate zoning. Decisions are usually turn-based with the player's turn amounting to an allocation of resources or a change in some asset, followed by the program recalculating the state of the game and then responding to the player's actions. Action in the game is divided into time steps, with the game either clocking off changes continuously, or moving forward only in response to the player's turn. Often the game employs a mixed control, with time progressing in normal mode, but stopping when the player calls up the resource allocation choices.

On the one hand, because the computer creates reality by executing rules *it increases the player's sense of the reality of the world to have changes occur that are initiated by the computer.* On the other hand, because the digital medium is participatory as well as

Figure 5.11
Oil God (Persuasive Games 2006), a satiric strategy game designed by Ian Bogost, with a model of the oil futures market. The Hand of God credits allow the Oil God to inflict wars and other disasters on the countries in the game.

procedural, *players need to feel that their own actions have had a clear effect on the world,* and that the automatically unfolding events leave room for the player's actions. In this way a simulation game is different from an analytical simulation, which may offer participation only at the beginning of a run, allowing the player to set up the initial conditions, set the world in motion, and watch the consequences. Although some battlefield and sports simulations work in that way, the trend in computing in general is toward more continuous action on the part of the user, and simulation design is likely to follow the same trend, becoming more participatory and using more of the conventions of games to capture the cause and effect relationships in complex systems.

Although a simulation can be presented as a neutral, accurate representation of reality, abstraction always involves interpretation, prioritizing some values over others. For example, the simulation game Civilization abstracts the entire history of the world as a competition between autocratic empires, driven by aggressive settlement, military victory, and technological development. Within the world of the game, imperialism is a practical strategy and technology is the driving force of history. A game based, for

example, on Jared Diamond's (1999) view of cultural development would run on a very different set of rules, emphasizing geographical factors, such as the spread of technical and cultural inventions across similar climate zones, and the role of contagious diseases in shaping the course of civilizations.

As designers of simulations, we choose what parts of a system we model and the degree of detail with which we instantiate it. The Sims game models a social household and includes tremendous detail in furnishings and a representation of time as twenty-four-hour cycles including sleeping hours. The characters must be taken to the toilet and made to wash their hands afterward, though the graphics do not display their naked bodies or the details of their elimination. They report to work and the model includes whether they are late or not and what mood they are in (which affects their job performance), but not (in the earliest versions of the game) what they do when they get there. The conversations between characters are abstracted into "Simlish," a gibberish audio with recognizable emotional tones augmented by icons in dialog bubbles that indicate the topic being discussed. The same situation might have been abstracted in many other ways offering more or less detail in personal hygiene, more or less time compression, more or less realism in the conversations, narrower or wider selection of topics, or more or less furniture choices.

The procedural design of the Sims reflects conventional bourgeois American values. Cleanliness, industrious pursuit of learning, and punctuality are reinforced with game rewards and with negative consequences for neglect. The implicit game goals are career success, establishing a marriage and family life, and accumulating possessions. The cause-and-effect logic of the underlying code reinforces these priorities. For example, socializing with friends is valuable because it puts you in a good mood for greater career success, and buying material goods is beneficial because it makes you more popular with other Sims.

Design problems never have a single right solution. Just as a physics simulation game reflects the rules of the physical world, social simulation games reflect cultural assumptions about the rules of the social world and about human motivations and rewards. It is the job of the designer to be aware of these assumptions and to make conscious choices informed by an understanding of how values that shape our embodied behaviors are reflected and reinforced by the behavior of the virtual systems we invent.

DESIGN EXPLORATIONS: STRATEGIES FOR PROCEDURAL COMPLEXITY

Abstracting the World into Objects and Methods
• Using pseudocode, create a generic class for items sold on Amazon.com or any other site selling multiple kinds of merchandise.

- What attributes do all the items have in common (e.g., price)?
- What attributes do some but not all have (e.g., clothing size)?
- Identify at least five important distinct subclasses, indicating how their attributes and methods would differ from one another.
- Using pseudocode, create a system to keep track of college registration and grades:
 - Describe a student object and the attributes and methods associated with it, from the registrar's perspective.
 - Describe an instructor object and the attributes and methods associated with it, from the registrar's perspective.
 - Describe a course object, including the attributes and methods associated with, from the registrar's perspective. What other objects would it have to interact with? What data objects and variables would have to be standardized to allow professors and students to share a common representation of a course?
 - Indicate any other abstractions a functioning registration system might need to keep track of.
- Using pseudocode, make a set of classes to describe all the characters in a single fantasy universe that you know well, chosen from any fictional source (books, movies, television programs):
 - What is the highest-level class?
 - What methods are common to all the characters?
 - How many levels of subclasses do you need?
 - What methods and attributes belong at each level of the **hierarchy**?

Creating Simulation scenarios

- Play with any online cellular automata program based on Conway's Game of Life and identify two or three initial configurations that lead to emergent self-organizing sustained behaviors.
 - Change one cell in the original configuration and note the difference it makes to the display of emergent patterns.
 - Does changing some cells lead to greater effects than changing others?
 - Advanced exercise: create your own cellular automaton. The Processing programming language is a good place to start; see the chapter on Simulate 1 Biology in Reas and Fry 2007.
- Breakup simulation: using pseudocode, storyboards, flowcharts, state diagrams, and/or any other useful representation of your choice, create a design for a story/game system that simulates a marriage (or similarly intense two-person partnership) that could possibly end in a breakup. Assume that the interactor will be able to choose which character to play, and will be encouraged to replay with different choices and/or from the other point of view.

- Make each member of the couple a separate object, with methods of communicating that reflect their individual motives and values.
- Limit their actions to DISCUSS (specify topics) and MAKE GESTURE (specify gestures). Make up a list of no more than sixteen topics the couple could talk about, as well as no more than eight positive gestures, and no more than eight negative gestures that the two partners could make.
- Indicate preconditions and postconditions for each topic and gesture.
- Decide if you will make gestures and topics repeatable, and if so what will be the effect of repetition?
- What shared variables, objects, or methods would be helpful in making this interaction coherent?
- How will you indicate the effect of different choices?
- How will you create contrasting outcomes and parallel moments to make replay more dramatic?
- Spend four hours playing a simulation game such as Civilization, Sim City, Spore, or another similar game of your choosing.
 - What are the assumptions behind the game about history, society, science, or human behavior?
 - How clear are these assumptions to the novice player?
 - What would a game based on different assumptions about the world look like?
- Research and identify a group of insects that displays emergent social organization from independent simple behaviors. How would you design a computer program that imitated the insects' behavior?

Expressing Cultural Values in Procedural Abstractions

- Play a "serious game" or a "persuasive game" meant to educate or affect attitudes about a real-world problem.
 - Note your attitudes about and knowledge of the domain before and after playing.
 - Did the rules of the game, rather than just the explanatory content, reinforce learning or attitude change? If so, how?
 - How would you improve on the rules to make them more effective? How would you apply the game's most effective design strategies to the design of other games with similar goals?
 - Analyze the implicit values in a game with which you are very familiar.
 - What kinds of actions does it reward?
 - What ideas of fairness does it reflect?
 - What motivation does it assume in the players?
 - If there are characters portrayed as "enemies," do they look like any actual people or categories of people? Do they resemble characters in movies or TV? What visual and behavioral characteristics mark them as evil?

- Are there choices that pose moral dilemmas? How are they resolved? Which moral choices lead to a winning condition? Which lead to a happy ending?
- Analyze the implicit values behind a software tool that you are very familiar with, like a media player or editor.
 - What activities does the software tool assume are important?
 - What related activities does it ignore?
 - How does it define the attributes of the media objects or information it processes? What is emphasized and what is left out?
 - How important is sharing of information, maintaining privacy, protecting copyright, generating an income stream, etc., to the design of the tool?

III SPATIAL DESIGN STRATEGIES

Every digital project involves spatializing in some form, including maps, information spaces, locations in the real world, virtual places. In all of these environments, designers should focus on providing **agency** in **navigation** by clearly indicating the current location of the **interactor**, the relationship among the elements that are within the digital site, and the extent and location of boundaries.

Designers should consider a broad range of spatial conventions including those relating to **containers** such as lists, tables, and virtual file folders, and **landscapes** composed of continuously navigable **space** and discreet, recognizable **places**. Designers should draw on the existing possibilities of geographical and abstract **maps**, including the spatial mapping of temporal phenomena through interactive **timelines** and animations, while also looking for new ways to express relationships through space, including emerging conventions for location-specific information and 3D displays.

Libraries are an enduring model of spatial organization that combines elements of the container (catalog, shelf, book) and the landscape (stacks arranged to reflect a taxonomy of knowledge). Libraries exemplify the crucial information-organization principle of **collocation** that puts like things near one another, providing **intellectual access** to items in the collection according to what they are about. For digital collections, designers can maximize collocation because the same object can appear in multiple places, unlike a single copy of a physical book.

Standardized conventions of labeling are the foundation of coherent collocation and navigation of information spaces.

Designers should participate in the collective task of designing global digital archives that unite the functions of the catalog and the library and that are maximized for sharing resources through common conventions of **labeling** and **classification.** Designers should impose order on complex aggregations of information by **chunking** it into

meaningful units, creating **hierarchies** when possible, and limiting the number of elements that human beings are expected to focus on by remembering the "magical number seven" (Miller 1956). Humanist designers should be aware that systems of classification reflect cultural biases and values and will always be in need of revision and expansion.

6 Defining and Navigating Spaces and Places

Space lies open; it suggests the future and invites action. On the negative side, space and freedom are a threat. . . . Open space has no trodden paths and signposts. It has no fixed pattern of established human meaning; it is like a blank sheet on which meaning may be imposed. Enclosed and humanized space is place. Compared to space, place is a calm center of established values. Human beings require both space and place.
—Yi-Fu Tuan ([1976] 2001)

Media of representation focus our attention with fixed formats and genres, made up of culturally established conventions that allow us to take in new information by expressing it in familiar patterns. New media use old conventions in new ways and they also create new conventions, allowing them to support new cognitive patterns. This chapter provides an introduction to the spatial conventions that are of particular relevance to the design of digital artifacts.

Lists, Tables, and other Containers

Spatial organization has been exploited from time immemorial for the creation of media genres that focus our attention and extend our memory. Tally sticks, which represent events or resources by notches carved in wood, are among the oldest and most enduring recording media, dating from prehistory and used as an official accounting method in England up through the beginning of the nineteenth century. The **list** and the **table** are among the oldest artifacts of written culture, and remain everyday staples of information organization. The written list exploits the vertical arrangement and grouping of items and the table exploits the two-dimensional organization of items and attributes. The list remains valuable in the menus that dominate interface design, and the bullets that dominate presentation environments. The table provides the basis of the records that make up relational databases, the cells of electronic spreadsheets, and the graphic design grids that shape most web pages.

Figure 6.1
Accordion directory listings (left) and column displays (right) provide access to nested containers at different levels of the hierarchy. The accordion display allows simultaneous expansion of multiple non-nested branches.

All of these ancient genres are examples of spatial containers for aggregating information. The **container** is an enduring strategy for organizing physical objects in space and has long been used as means of ordering information. Containers turn separate pieces of information into a single unit. For example, the ancient forerunner of the written document was the clay envelop that contained pebble-size clay tokens meant to symbolize a transaction, like a sale of cattle. Similarly, we create a single unit when we put multiple articles into a single online encyclopedia or multiple music tracks onto a single CD or multiple files on a terabyte backup disk. Virtual containers such as files, folders, and windows are the basis of the desktop graphical user interface (GUI). As we work with larger numbers of information sources and aggregate them from more diverse sources we develop new container conventions, building **complexity** by nesting them inside one another (figures 6.1–6.3).

Containers can be used just to hold items in no particular order, like many photograph boxes, jump drives, and real and virtual desktops. But they also let us sort information into categories, and to label them as a unit. We still speak of "pigeonholing" something as placing it in a tight category, after the pigeonhole filing structure built for scrolled documents in Victorian desks. And the virtue of twentieth-century file cabinets (still very much in evidence today, despite efforts to create the "paperless" office) is their affordance of sorting paper records into labeled paper folders that can then be aggregated into labeled hanging folders and further sorted into labeled drawers.

Containers are valued for their capacity and portability, and for how well they lend themselves to retrieval of their contents. The digital medium has expanded our repertoire of

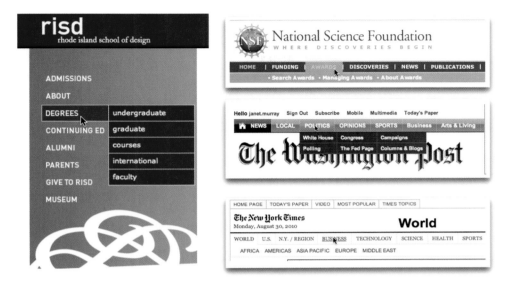

Figure 6.2
Rollover submenus (as in the RISD, NSF, and *Washington Post* examples) work best at only one level of hierarchy. Without the rollover display (as in the *New York Times* example) the browsing interactor can only see the contents of the current container (the World) and cannot preview other categories (such as Business).

virtual containers, from the earliest internal computer registers that held a few bytes of information, to the kilobytes of early floppy disks of removable memory, to today's multigigabyte thumb drives and the invisible, weightless data "cloud" that contains our information on the ubiquitous networked servers of cyberspace. Media applications adopt container conventions from older formats, such as the photo "album" and the record "album cover." As the digital medium grows we will need more conventions to help us form the correct mental model for where an item is, what it is stored with, and what larger entity we go to in order to retrieve it.

The invention of the World Wide Web can be seen as replacing the container model of file folders with the landscape model of the browser. We no longer go to a file folder to retrieve a file by downloading a copy of it and hoping it will be readable by the software on our machine (as in the earlier File Transfer Protocol or FTP system); instead, we view the file immediately through the window of our web browser, just by going to the "site" where it is located. Changing our mental model of a global information resource, from huge stacks of folders stored in hierarchical drawers all over the world (which would be another accurate way of describing the information

Figure 6.3
The iPad is a container for applications, like Flipboard, which is a container for online content drawn from diverse, personally selected sites, reformatted as conventional magazine pages. The Flipboard Contents screen is a grid that provides a glimpse of what is inside each of the contained pieces.

on the web) to an interlinked web of places within a common landscape, makes it easier to remember where things are and how we get to them. But the landscape model alone is inadequate for keeping track of our simultaneous interest in multiple sites. When we visit a space in the physical world we leave the place we are in; similarly, browsers at first replaced one page with another when interactors clicked on a link. But web surfers were not only in a landscape but also in the container world of the GUI desktop where they expected to have multiple windows open. So browsers were extended to include multiple windows, and when switching among multiple windows became too cumbersome, designers abstracted a key element of the file folder container by creating the new convention of browser tabs (figure 6.4). It is possible that we will eventually need containers for the tabs as well (figure 6.5) or we may see access to networked information broken up with specialized forms of browsers, like the applets on a mobile device, handling subsets of what we now see as the general category of "website."

Figure 6.4

Tabs in a browser are an abstract representation of a print-era media convention (the tabs on paper file folders), located within an abstract container we call a "window," which can itself be one of several windows within the abstract container known as a "desktop." These container conventions help us to get control of multiple processes and pieces of information, and to switch the focus of our attention without confusion.

Figure 6.5

Shiftbrowse is an experimental browser developed by Abhishek Gupta at Georgia Tech that expands the tab structure by adding a metacontainer into which one can place multiple tabs related to the same task, topic, work session, or other "context."

Landscapes

Landscapes are a fundamental organizing framework for human beings. The ability to distinguish the visual features of landscapes, like rolling hills and branching trees, seems to be innate to human beings, favored by evolution for its survival value. In fact, recent research has connected the shapes of every human alphabet to the contours of the natural world, explaining why reading occupies a particular area of the brain. We repurposed our landscape instinct for the recognition of letters (Dehaene 2009). We also use our sense of navigating a landscape to help us cope with large information spaces, like cyberspace, or the the World Wide Web. We talk about mastering a "domain" or an "expanse" of knowledge, getting "the lay of the land" in a new situation, "surveying the field" of alternates, "crossing a boundary," becoming unnerved by "edgy" artworks, and recognizing "landmark" achievements. It is not surprising that we bring the same spatial metaphors to our experience of digital artifacts, which offer such a large capacity of storage space and support many forms of spatial navigation.

As we noted earlier, the creation of the illusion of space within the machine is not dependent upon visual elements since it can be achieved in purely text-based environments, such as interactive fiction games where the user types in "N" for north and then sees a paragraph of text describing what is at this new more northerly location. *The illusion of navigable space is created by the consistency of the rules by which the space is programmed, and the consistency of the interface for navigation.* Although the space may not exist apart from these rules, it takes form in the user's mind as a mental map, a set of expectations and relationships. Concepts drawn from architecture and urban studies such as landmarking, pathfinding, nodes, zones, edges, and boundaries (Lynch 1960) are relevant to the design of digital spaces, and we recognize this connection to the built environment by calling the profession concerned with organizing digital resources "information architecture" (figure 6.6).

We are still learning how best to navigate virtual spaces, and that includes learning from necessary mistakes. One common pitfall of spatial design is the creation of too-

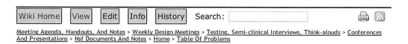

Figure 6.6
Path-marking breadcrumbs, like those dropped by Hansel and Gretel in the fairy tale, allow you to retrace your steps, but as digital markers they also let you skip to any point in the chain. Breadcrumbs are useful for environments that lack top-down persistent navigation menus, like a wiki that evolves dynamically based on a changing project and multiple contributors.

literal spaces that require tedious traversal by the user. The infamous Microsoft Bob interface (figure 12.9), briefly introduced in 1995, annoyed users by situating them in a cartoonish house, and requiring them to move from room to room to perform standard tasks. Many multiplayer games and online virtual environments are similarly frustrating because the distances between interesting areas take too much time to traverse and the relationship of one area to another is difficult to understand. Successful open world games combine freedom to explore a large and detailed space with density of incidents. For example, the single-player open-world game Red Dead Redemption (2010) does not attempt to literally reproduce the geography of the American West and Mexico where it is set. Instead, it creates distinct adventure zones and climate zones, and it reinforces the sense of place by building in incidents even in the necessary interludes of solitary travel through desolate terrain (figure 6.7).

In any virtual environment the interactor must be reminded where they are in relationship to the whole. Since we know that people orient themselves by zones and landmarks it is important to group like elements into visually distinct larger areas, using landmarks to make them more memorable and visible from a distance. In three-dimensional worlds the landmarks can be tall buildings or mountains (figure 6.8).

Figure 6.7
Designers of Red Dead Redemption (Rockstar Games 2010) populated the spaces between population centers with predatory animals and people who appear and challenge the player or one another in procedurally generated, unpredictable configurations, with the goal of making the empty space into a more differentiated landscape of memorable places (Onyett 2009).

Figure 6.8

A gallery of places in Second Life, including (counterclockwise from upper left) a museum based on an actual Frank Lloyd Wright building, an art gallery for virtual objects, an evocative landscape with a name (Runestone) from fantasy fiction, and a **sandbox**—that is, a place for playing with technology to learn how it works—located on a virtual sandy beach. They all have highly noticeable visual features that set them apart and reinforce the sense of place.

In information spaces they can be labels that are visible on a persistent menu bar (figure 6.9).

Another emerging design challenge in three-dimensional environments is establishing clear conventions for point of view. The navigating interactor may be limited to a first-person point of view in which their own presence is not visible in the landscape except as a hand or gunsight, or to a third-person viewpoint in which the player-controlled avatar or game character is visible but the camera is placed slightly behind him. Designers can also allow the interactor to separate camera placement from character control in order to alternate between a narrower point of view and a god-like overview of the larger action. Some games take control of the camera away from the

Figure 6.9
Landmark places within the BBC Archive, which contains many thousands of hours of television and radio programs as well as memos, scripts, and other text documents and still images. Navigation is through multiple portals, some visual and some alphabetical text listings. The yellow ARCHIVE **navigation bar** (with divisions for Home, Collections, Subjects, Programmes, People, and Meet the Experts) serves as a landmark and brand for the entire section, separating it from the BBC site **nav bar** above it, in black and white.

player, switching camera angles automatically in order to capture emerging action. Each of these strategies poses its own design challenges, but the success of any of them depends on *communicating a coherent model of the world to the interactor through consistent, redundant cues to proximities and landmarks.*

Filmmaking has mature conventions for establishing point of view and ensuring spatial continuity. For example, two people conversing with one another are usually shot over the shoulder of one of them, in pairs of shot/reverse shot, always keeping to the 180-degree rule so that right and left are not reversed. Locations are usually presented in establishing shots that give the outside of a building, for example, followed by cuts to an interior office. Filmmakers understand that they do not have to build a complete model of a dramatic space; the exterior shot is often thousands of miles away from the set used for the interiors. The space is built up in the mind of the viewer. Virtual spaces, which are cheaper to build than movie sets, must be continuous if they are to be navigated by the interactor, but this may result in too-literal and undramatic spaces. Digital media designers can draw on film conventions, but

they must adapt them for interactivity. For example, the view of a location from the distance can serve the same dramatic purpose as an establishing shot, and the approach to the place can be speeded up with animation to preserve the sense of continuity while providing **dramatic compression** to the player's experience. As more people are drawn to 3D navigable worlds for games, social networking, and other purposes, we will need to expand and refine existing conventions of representation to make navigable virtual spaces in interactive environments as memorable and coherent as filmic spaces and to allow for fluid and coherent points of view (Nitsche 2008).

Maps

Maps are an ancient strategy for organizing knowledge about spaces in the world. Maps identify the separate elements of a space, establishing boundaries and proximities and associating names with places. They mimic the shape of the geographical features they describe, abstracting rivers and countries and continents into iconic images. We do not think of our view from an airplane or a satellite photo when we think of "America" or "Chile" or "France": we think of the shape of the country on a standard map. Mapping something focuses shared attention on it, validating its existence in social and cultural terms. When a town is very small we speak of it as "not even on the map" meaning not in the awareness of people thinking about a region. When a fictional world becomes very detailed it is often the subject of obsessive mapping, as is the case with Faulkner's Yoknapatawpha County, Tolkien's Middle Earth, and the mysterious island that is the location of J. J. Abrams's television series *Lost*. Mapping makes a place real and allows us to hold a shared concept of it. The original players of Zork (Blank, Lebling, and Anderson 1977), the text-based adventure game built on an architecture of connected rooms navigated by geographical commands, created a mental image of the game world that combined the spatial relationships and the sense of adventure inherent in the fantasy world (figure 6.10).

Computer-based maps can accommodate enormous detail, which can be displayed in multiple configurations and granularity. A street map can be combined with a tourist site map or a highway map, with aerial or satellite photographs, and with street-level still photographs or live webcams. Maps can include information on earthquake faults, elevation above sea level, population density, neighborhood stores, crime statistics, driving instructions, or the location of friends. As maps become more and more digital, they are changing from a static, abstract representation of boundaries, proximities, and labels to become dynamic models and detailed surveillance systems of the areas they represent (figures 6.11–6.14).

We can also express other kinds of relationships as abstract maps. For example, it is useful to map participatory structures as social networks, identifying individual

Figure 6.10

A fan-drawn map of the text-based adventure game Zork.

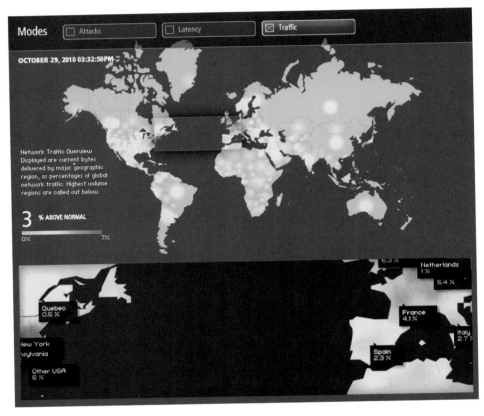

Figure 6.11
Akamai's map of real-time network use information. The upper map gives an overview with navigation to areas of focus, which are displayed in detail in the lower window.

actors as nodes and looking for ties between them. Drawing maps of social networks can help to identify points of connection between individuals, and to locate key individuals who are at the center of multiple connection paths (figure 6.15).

Places versus Spaces

A virtual space becomes more real as the interactor has experiences within it. The geographer Yi-Fu Tuan distinguishes between **space** and **place**. We understand space experientially, through our real or imagined movement from one place to another. Tuan sees places as the pausing points that capture our attention within a space. Places are discrete abstractions in the larger continuous expanse of space. We endow public

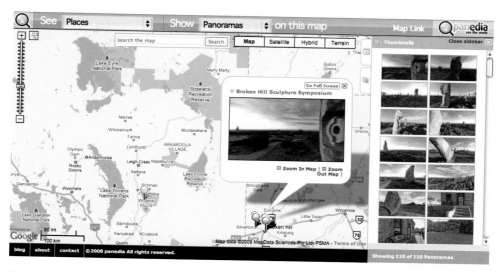

Figure 6.12
Google Maps mash-up that links panoramic images to places on the map, from <http://maps.panedia.com>.

Figure 6.13
Google Maps mash-up that links surveillance videos to the location of bank robberies. From <http://bandittracker.com/map>. For more Google map mash-ups see <http://mashable.com/2009/01/08/google-maps-mashups-tools>.

Published: April 2, 2010
Tracking Taxi Flow Across the City
Information from millions of taxi trips provides a telling record of the city's vital signs. The map shows the average number of pickups for different times of the day and days of week, Jan. – March, 2009. ☐ Comments (43) | Related Article »

Note. Blocks that have fewer than one cab ride every two hours on average are not included in the data.
By MATTHEW BLOCH, FORD FESSENDEN and SHAN CARTER | Send Feedback
Source: Sense Networks

☐ TWITTER
☐ COMMENTS (43)

Figure 6.14
New York Times website infographic "Tracking Taxi Flow Across the City," a zoomable map that can play automatically or be manually navigated to show the changes in taxi availability over the course of a week. (The map excludes blocks that average "fewer than one cab ride every two hours," and seems also to exclude the private car services that serve the outer boroughs, which limits the display to Manhattan and a few flickers of Queens airport traffic.)

spaces with value by naming them and using them collectively. Individually, we find places memorable because of our direct experiences of them. In Tuan's words, "What begins as undifferentiated space becomes place as we get to know it better and endow it with value" (Tuan [1976] 2001). The same thing that is true of real-world spaces is true of virtual spaces. Each time we retrieve a particular word-processing command from its pull-down menu we reinforce our sense of its location. When we have a conversation in a virtual plaza or kill a particularly nasty monster in a virtual dungeon, the place becomes anchored in memory by the emotions and memories associated with it. Navigating to a place can itself be a rich experience if it is framed as an exploration and rewarded with surprising discoveries.

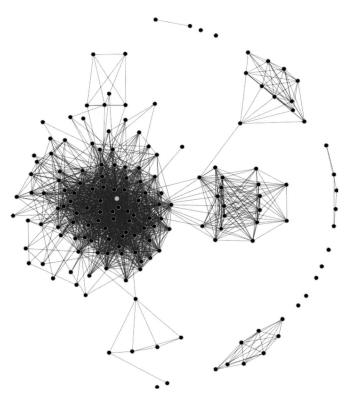

Figure 6.15
A social network diagram, with the most densely connected nodes at the center. A node may be
a person, group, or institution.

Game designers have made good use of the pleasures of exploratory navigation and
discovery. Text-based games like Adventure (Crowther and Woods 1976) and Zork
(Blank, Lebling, and Anderson 1977) initiated the genre of the quest through a chal-
lenging landscape full of hidden dangers and treasures. The framework was reinvented
for consol video games (e.g., the original 1980s Nintendo Zelda series), and then
expanded through the 1990s and 2000s as graphics capacity improved, with works
such as the puzzle-driven 2D fantasy world Myst (1993), the groundbreaking 3D
Legend of Zelda: Ocarina of Time (1998), and the open-world 3D urban adventure
Grand Theft Auto III (2001). Each of these innovative games was successful in large
part because of its linking of gameplay to the exploration of a detailed and extensive
landscape (figures 6.16–19).

Figure 6.16
Myst (1993), designed by Robyn and Rand Miller, makes good use of visible landmarks seen from
a distance that lure the player down a path toward a mysterious destination. The game was built
on top of HyperCard and offered only 2D images and limited navigation, but the rich visuals
and meticulous, cinematic sound design reinforced the experience of immersion in the fantasy
world, helping to make this a best-selling game.

Websites also create a sense of place, using consistency of style sheets to unite the
page displays, and including the home page as a landmark to which other pages are
all related. When the space is well designed the organization is reinforced through the
experience of navigation. Each time I go to a page I get a concrete experience of the
relationship of one topic to another. Designers can reinforce the experience of an
information space, and make it more memorable, by using clear labels and a naviga-
tion pattern that follows a logical information hierarchy. Creating a separate "site
map" (figure 6.20) is a poor substitute for creating a navigation menu that provides a
clear, logical, and memorable map of the site organization.

As computational environments move beyond the two-dimensional screen, design-
ers are experimenting with placing virtual objects in real space. Augmented reality
applications superimpose images and text on places in the actual world using GPS and
special viewing devices, like a cell phone camera or head-mounted display, in order
to recreate historical events, for example, or provide tourist information in multiple
languages. As we move into a world of "ubiquitous computing," we are increasingly

Figure 6.17

The Legend of Zelda (1986) was created by Shigeru Miyamoto, who also designed the Mario games. Where Mario jumped through a scrolling linear world, Link, the hero of the Zelda series, could move at will through a large graphical world. Gameplay involved figuring out where to go next to fulfill the quests.

Figure 6.18

Nintendo's Zelda: The Ocarina of Time (1998) provided one of the first experiences of free movement through a detailed, three-dimensionally portrayed world. The player controls the protagonist, Link, who is seen in third-person point of view. The map (lower-right overlay) orients the player to their place in the larger landscape.

Figure 6.19
Grand Theft Auto III (Rockstar Games, 2001) presents an open-world urban landscape based on
New York City, in which the player can choose to explore or to perform missions that lead up
the ladder of success as an urban criminal.

surrounded by wireless, location-based, and sensor technologies and devices that
actively sense our presence, calculate our location, and communicate with one another
with and without our conscious intervention. We spy on distant cities with webcams,
track our cars and one another by their GPS location, monitor the baby and the nanny
from our mobile phones, receive step-by-step or turn-by-turn directions on demand,
and make ourselves available for bombardment by location-based advertisements as
we walk around a city. Every electronic object is a potential contributor to a global
mapping operation capable of photographing or annotating every corner of the globe.
The result is that we are asked to pay attention simultaneously to multiple spaces, real
and virtual, and to multiple layers of information within each of them. Designers have
yet to sort out how we should move through this multilayered space that is converg-
ing with our actual landscape, and what kind of compasses and communicators—
combining the function of map mash-ups, text messages, cameras, head-mounted
virtual reality displays, writing tablets, media players, and travel assistants—we will
need to navigate it.

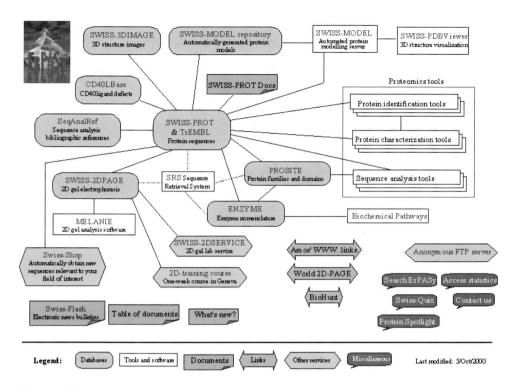

Figure 6.20
Site maps such as this are a poor substitute for a logical hierarchy presented as a persistent navigation menu. This example is dated 2000 and is no longer in use by the organization. Site maps are a good example of an interim convention that was widely adopted at one time but faded as sites became better organized and hierarchical navigation menus more standardized.

Virtual reality researchers are also growing more skillful at creating environments that immerse the interactor in simulated experiences that look and sound, and sometimes even feel and smell, close to the experience of being in an actual physical place. Such virtual reality installations are currently used for phobia treatments and military training, and they are potentially useful for museum and entertainment installations (figures 6.21, 6.22). *The challenge for the designer is finding the right degree of realism and abstraction that allows users to suspend disbelief, as they do when watching a play or a film, without confusion of the real and the illusory.* Like any representational structure, virtual reality environments select some of the elements of an actual or imagined place or event, while creating the impression of a complete environment. The interactor must be able to move around or look around enough to reinforce their belief in the

Figure 6.21
Virtual Iraq is a virtual reality environment originally developed at the University of Southern California and used to treat American soldiers with combat-related posttraumatic stress disorder (PTSD) by recreating a sense of being back in the place where they experienced the trauma and encouraging them to talk about their experiences.

virtual world, but must have a limited scope of action in order to make the experience coherent.

Even before the advent of the World Wide Web, people were using the Internet for shared meeting spaces, first as text-based chat rooms and then as graphic spaces for social purposes, education, and collaborative work. Virtual meetings of any kind require ways of making up for the affordances of actual presence. The most successful versions are the high-end dedicated facilities, with closely symmetrical meeting spaces and spatialized sound that literally reproduce the experience of sharing a table, while also providing additional displays for shared documents. The advantage of this model is that the rich social cues such as eye contact, fidgeting, and nodding are as visible as if the participants were sharing a real space (figure 6.23). But dedicated rooms are an expensive way of providing virtual contact. More common methods include an audio feed and either avatars or video images of participants, with the emphasis on sharing the same virtual desktop. The shared desktop is a serviceable substitute for global travel, especially for delivering and attending presentations, but less successful for group discussions, which work better in multiwindow video chats. Text chat windows, on the other hand, remain useful for informal, shorter conversations, and provide some of the same sense of real-time connection at much lower bandwidth,

Figure 6.22
Virtusphere is a ten-foot sphere that rotates around a player whose movements are tracked and coordinated with the images and sounds in his head-mounted display. Devices like this are attempts to solve the problem of creating virtual space that can be traversed while containing the movements of the player in the real world (promotional image from <http://www.virtusphere.com>).

and with less intrusiveness than telephoning. This changing array of social spaces requires the elaboration of appropriate social rituals to maintain politeness and to manage participation.

From a cultural perspective our concept of a place is made up of more than just its geography and signage. We associate places with things that have happened there, personally, to others, and historically. We respond emotionally and socially to the landscape and architecture. Places in the real world can be cozy, welcoming, majestic,

Figure 6.23
Cisco TelePresence room uses spatialized sound and matched furniture to create the illusion of
a single conference room with multiple site participants. Such rooms are now created as public
facilities, rented by the meeting, similar to a twentieth-century public phone booth or to third-
party telephone conference hosting.

menacing, intriguing; they can reinforce feelings of poverty, wealth, gender, and age,
making some people feel more at home than others. Virtual spaces can be equally
distinctive, memorable, evocative, and equally welcoming or forbidding depending
on how well they are organized and what kinds of interaction they support.

Abstract Space

It is always appropriate to ask of any project whether it is maximizing the use of space.
For three-dimensional landscapes and for large navigable information resources, the
spatial aspects are quite clear. But space can also be exploited in other contexts, such
as the creation of abstract spatialized information graphics. Just as the written list and
multicolumn table allowed us to keep track of more information and more complex
relationships, interactive graphics can similarly advance our ability to retrieve and
analyze structured data.

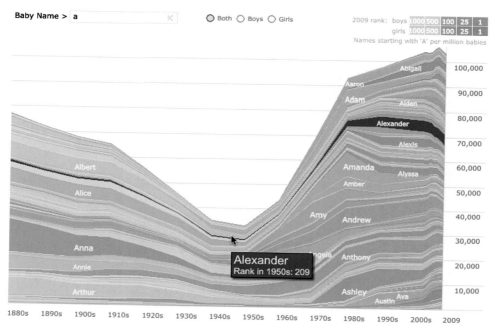

Figure 6.24

The Baby Name Voyager (2005) designed by Martin Wattenberg is a classic of web-based information design, showing trends in male and female names since the 1880s.

Spatial design is particularly powerful when it is the service of strong information organization. The computationally intense field of information visualization exploits the processing power of the computer to present dynamic views of complex information resources that make it easier to gain an overview, to navigate, and to focus on meaningful relationships among multiple items. Information visualization provides carefully constructed displays in which size, color, proximity, and containers all have meaning in characterizing attributes of the information.

Such displays can allow users to zoom in and out and to **filter** the information in multiple ways. For example:

• Timelines can focus attention on dynamic changes in multiple elements over time, displaying specific events within the context of longer-term trends (figures 6.24, 6.25).
• **Treemaps** visualize items within a hierarchy so that they can be understood in overview, with size, color, and proximity conveying readily scanned information, and with additional information available interactively by zooming in on details or observing changes in the patterns while clicking through **time steps** or changing parameters in a filter (figures 6.26, 6.27, figure 8.5).

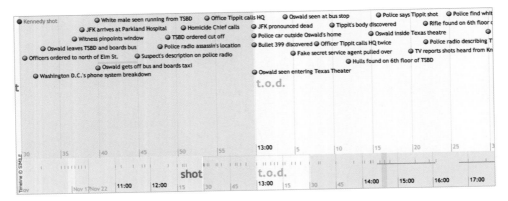

Figure 6.25
A **timeline** created with the SIMILE web widget, created at MIT, shows detail on the events of a segment of time (shaded area) within the context of the larger-grained sequence.

- Hyperbolic maps arrange a hierarchy or network as a sphere, with items that are farther away seeming smaller, but easily dragged into the center, causing all the items to recenter around the new focus of interest (Lamping et al. 1995). Hyperbolic maps can also often be zoomed in and out for closer detail or wider perspective (figure 6.28, 6.29).
- Circular visualizations allow designers to create a zoomable, filterable overview of a dense linked network of information (Krzywinski 2004), such as a relational database or an archive of political debates (figures 6.30, 6.31).

New technologies of inscription and transmission expand our ability to exploit spatial organization. With the growth of wireless networks and the proliferation of mobile devices, location-specific information and services are becoming increasingly common in new consumer categories. Gestural interfaces for videogames are allowing us to think of the space between the interactor and the device as a site for inscribing commands that can be detected and interpreted by a camera. 3D screens have added another dimension of navigation, an improvement that is primarily aimed at immersive game and entertainment experiences, but which may also prove to be helpful for exploring information spaces.

Spatial design can help us to sort out information and to get control of large quantities of data; it can offer us navigable landscapes composed of memorable places and information resources whose navigation patterns reinforce our understanding of the knowledge structure. As with all interactive design, the key to success is giving the interactor **agency** over the environment by setting up expectations that can be acted on and appropriately rewarded.

Figure 6.26

"One Million Items Treemap" summarizing one million files in a directory, created by Jean-Daniel Fekete and Catherine Plaisant, University of Maryland. Each rectangle corresponds to a file or directory. The size of each rectangle is determined by the file's or the directory's size, color represents file type (blue for text, green for images, and red for executables, etc.). Deeply nested directories appear darker. Careful examination of the high-resolution display reveals patterns such as duplicate directories and unused space, and the display can be explored with specialized filtering and overview tools. See <http://www.cs.umd.edu/hcil/millionvis> (Fekete and Plaisant, 2002).

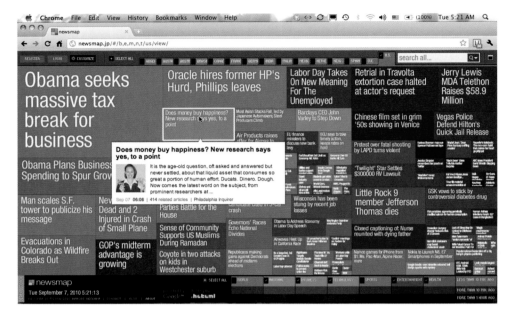

Figure 6.27
Newsmap is a treemap display of stories appearing on Google News, with color indicating topic and size indicating quantity of coverage. The map can be filtered by country, topic, and time, and details are displayed by clicking on a box. Created by Marcos Westcamp in 2004.

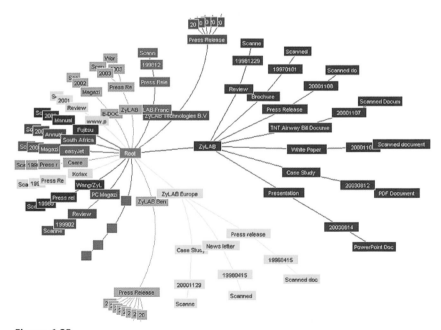

Figure 6.28
A hyperbolic map that can be used for navigating a large document archive or website. From <http://www.zylab.com/Technology/data_visualization.html>.

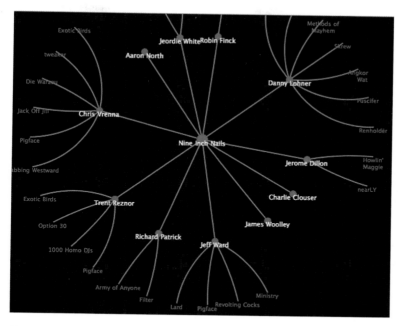

Figure 6.29
A demonstration hyperbolic map drawn with the JavaScript InfoVis Toolkit (<http://thejit.org>).

Figure 6.30
A visualization of the relationship between tables (shared keys) in a relational database, created with the Schemaball software system by Martin Krzwinski.

Naming Names
Names used by major presidential candidates in the series of Democratic and Republican debates leading up to the Iowa caucuses.

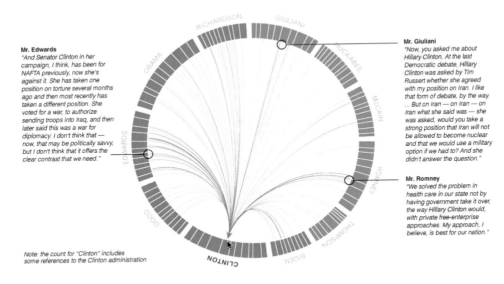

Mr. Edwards
"And Senator Clinton in her campaign, I think, has been for NAFTA previously, now she's against it. She has taken one position on torture several months ago and then most recently has taken a different position. She voted for a war, to authorize sending troops into Iraq, and then later said this was a war for diplomacy. I don't think that — now, that may be politically savvy, but I don't think that it offers the clear contrast that we need."

Mr. Giuliani
"Now, you asked me about Hillary Clinton. At the last Democratic debate, Hillary Clinton was asked by Tim Russert whether she agreed with my position on Iran. I like that form of debate, by the way. ... But on Iran — on Iran — on Iran what she said was — she was asked, would you take a strong position that Iran will not be allowed to become nuclear and that we would use a military option if we had to? And she didn't answer the question."

Mr. Romney
"We solved the problem in health care in our state not by having government take it over, the way Hillary Clinton would, with private free-enterprise approaches. My approach, I believe, is best for our nation."

Note: the count for "Clinton" includes some references to the Clinton administration

Figure 6.31
"Naming Names," *New York Times*. A radial visualization of the references of U.S. presidential candidates to one another during the 2007 Democratic and Republican debates. The interactor can focus the graph on particular candidates (names in outermost right, Democrats in blue, Republicans in red). Segments of the circle represent individual debate appearances, and are sized according to the word length of the candidate's answers.

DESIGN EXPLORATIONS: SPATIAL ORGANIZATION

Creating Navigable Spaces
• The classic text adventure game genre (e.g., Adventure, Zork) is built on a room-based architecture in which players progress from room to room by solving puzzles. Play one of these games (they are reproduced on the web) and make a diagram of the space based on your play.
 • How does the purely textual representation create the experience of being in a particular space?
 • How important is the navigation?
 • How important is the content of the space?
 • How does the quest story suit the spatial organization?
 • Could the same structure serve a mystery story or a romantic story? If so, how? If not, why not?

• After playing Adventure or Zork: create a consistent navigable space using only text and programming code.

> • Design a "room" architecture, creating at least five indoor and five outdoor areas as if they were separate rooms connected to one another by North, South, East, West, Up, Down commands.
>
> • Draw a complete map of the space before you implement it. Think about some rooms as "nodes" leading in multiple directions, and about groups (or pairs) of rooms forming clusters (like bedrooms/living area or the west wing/east wing of a house). Differentiate the spaces with clear labels.
>
> • The directional commands can be either typed in or chosen from a menu or directional buttons, etc. (You may use any programming language, HTML, or one of the authoring environments for interactive fiction, such as Inform or TADS.)
>
> • Note that the space should be consistent for the purposes of navigation. A minimal implementation of your space should produce results like this:
>
>> You are in the Living Room
>> Interactor: go north
>> You are in the Dining Room
>> Interactor: go south
>> You are in the Living Room
>> Etc.

Creating Memorable Places

• Make your navigable, logically programmed space into a more particularized place by adding at least one object in each of the rooms. The objects should be things that afford actions by the interactor. For example, a chair should afford sitting down, like this:

> You are in the Living Room. There is a chair here.
> Interactor: sit down
> You are in the Living Room, sitting in the chair.

• Add to your navigable, furnished place a narrative or game to lure the interactor from one room to the next. You may want to make some of the rooms hidden, or lock the doors between them and hide the keys. The goal is to create memorable experiences located in particular places, and to turn some rooms into more memorable landmarks so that other rooms will be remembered by their proximity to the more important ones. (Use a storyboard or flow chart for the most important elements of your plan if there is not enough time to specify or program the whole thing.)

Analyzing Real Spaces and Places

• Think of the last time you were lost. What confused you about the space you were in? How did you figure out where you were? Did you use landmarks to orient yourself?

Did you refer to a map? Are there elements in the spatial layout of this place that do not make sense to you? If so, how would you change them?

• Analyze the elements of a familiar real-world place, making clear what natural, built, or cultural elements in the environment cause you to feel negatively or positively. Do the other people in the space seem to feel the same way?

• After doing the previous exercise analyze a familiar virtual environment.

 • How easy or hard is it to find one's way in this world?

 • What design choices on the part of the creators make the virtual world easy or hard to navigate?

 • What design choices make it welcoming or not welcoming?

 • What elements of the space lure you to explore it?

 • Is this virtual world an improvement over reality, an extension of reality, or perhaps just a neutral alternative to the everyday physical world?

 • How do the designers signal that you are entering or leaving the virtual world? How do they mark off distinct areas within the larger virtual world?

Using Abstract Spaces to Visualize Information Resources

• Design or create a visualization that summarizes the state of any complex system based on available streaming digital information, and information visualization techniques (suggestion: consult IBM's Many Eyes website <http://manyeyes.alphaworks. ibm.com> or similar information visualization resources, or search for recent videos of research projects in information visualization).

7 The Library Model for Collocating Information

Walking through library stacks . . . and browsing, a user may suddenly come across just the right book and credit this luck to serendipity. But such a finding would be serendipitous only if the books were shelved in random order, whereas in fact they are ordered according to a rigorous system of semantic relationships, which like an invisible hand guides the seeker to his "lucky" find.
—Elaine Svenonius (2001)

Aggregating Information, Preserving Knowledge

Many of our knowledge organization structures are rooted in the creation of the library as a physical repository for written documents. The organizing principle of the library is **collocation**—placing like things together—in ever-finer categories of resemblance. This chapter examines the labeling and classifying conventions that have supported the physical collocation of handwritten manuscripts and printed books, and the ways in which these conventions and practices are changing as we redefine collocation of information for the digital age.

Human culture has been preserving and collecting information records for at least five thousand years. An Egyptian tomb of the third millennia B.C. identifies the deceased as a scribe in the "House of Books," which probably refers to repositories of papyrus rolls. Sumerians of the same period were keeping detailed city records on clay tablets written in cuneiform, binding together multitablet records with leather straps and storing them on shelves in baskets and boxes with labels identifying subject and contents. By the eighth century B.C. a body of written work had developed in several language groups in the Mideast, and the Assyrians had established a "House of Tablets" where scholars copied, sorted, and preserved 25,000 tablets worth of written culture, including financial and diplomatic records and texts of poetry, history, and astrology (Casson 2001). The formats of writing were also becoming standardized around this time, with the Greeks extending the efficient phonetic alphabet of the Semites to include vowel sounds, leading to wider dissemination of full and partial literacy, and more written documents.

By the late fourth century B.C., substantial written texts had become important as a means of disseminating learning. Plato had a library associated with his school, as did his successor Aristotle, who is believed to have created a system of organization for his unusually large and comprehensive collection. Aristotle's pupil, the emperor Alexander, included a royal library in the plans he drew up for Alexandria, and under the Ptolemy dynasty it became the greatest library in the Hellenic world, drawing on texts from across the region, starting in the third century B.C. In addition to the aggregation of the texts themselves, the massive copying, translating, collating, and cataloging efforts supported by the Alexandria library helped to preserve and promulgate knowledge.

In the second century B.C. another great library was founded in the Greek city of Pergamon (now in Turkey), which is credited with refining the production of animal hide (i.e., parchment, or *pergamenon* in Greek) as an inscription material for books. Libraries were built in private homes in the times of the Roman republic, and the Roman emperors planned and built monumental libraries, imitating the models of Alexandria and Pergamon. Roman libraries preserved knowledge from the past, developed systems of numbering shelves and stacking and retrieving volumes of scrolls and codices, fostered publication by providing copies of texts for duplication and sale by scribes, and at least some of the libraries allowed citizens to borrow books and remove them from the premises. The Romans are also credited with the invention of the **codex** format of bound pages similar to modern books, which was based on wooden frames for wax tablets, and which made writing more portable and efficient by using both sides of the writing surface. The codex was also the first random access technology, since the segmentation into stacked pages made it much easier to access information in the middle of a text than it was in a long rolled document. At the same time, the Chinese were also producing books and are credited with creating the first systematic library catalog during the Han dynasty (206 B.C.–220 A.D.), written on silk scrolls, as well as with the invention of paper (Casson 2001).

In short, library making—the collection and preservation of media artifacts—has been part of human culture from the time of the earliest known inscription technologies, making possible more complex systems of education and more comprehensive forms of government record keeping by expanding the circle of people sharing attention with one another, and the number of organized objects on which they could focus.

Before the invention of the printing press, the preservation and dissemination of knowledge required painstaking hand production of texts, and so it was hard for individuals to own them. The growth of universities led to the wide-scale copying of manuscripts, but they were often borrowed, one section at a time, from the booksellers of the Middle Ages. Because the transmission space between the writer and the reader was occupied by a line of human intermediaries, some of whom may not have

understood what they were copying, the texts were far from uniform and open to many opportunities for distortion and error (Eisenstein 1979).

The invention of printing in 1455 made book production more uniform as well as more efficient. It became increasingly possible for *multiple people, even those who were geographically distant from one another, to focus attention on the same text,* and to be aware that others were sharing in the common activity of reading and thinking. Research libraries were founded at the major European universities, and wealthy private individuals also began to collect books. As literacy grew in Europe and the New World, libraries changed from the treasured collections of the privileged few in the seventeenth century, to subscription establishments for a growing urban middle class in the eighteenth century, to free public institutions located in local communities by the end of the nineteenth century.

For the past two hundred years, libraries have been emblematic of participatory democracy, particularly in the United States. Benjamin Franklin established the first American subscription library, which later became the basis for the first Library of Congress, and he later founded the first free public library with a gift of books to the town of Franklin, Massachusetts. Thomas Jefferson signed the legislation establishing and funding the Library of Congress; and after the British burned it in 1814, it was replenished with the purchase of Jefferson's treasured personal library, a collection that he had arranged according to his own subject-based cataloging system.

Though media formats have changed over the long sweep of human history from scratches on clay tablets to electronic bits traveling over radio waves, many of the core design goals for knowledge collections are the same now as they were in the ancient world, such as:

- To find, acquire, and shelter the artifacts (collection, preservation)
- To keep track of what is in the collection (create a catalog, label with names)
- To sort items within the collection to keep like things together (classification)
- To keep track of where things are so they can be retrieved (unique addresses)

The aggregation of any media format carries its own difficulties in preservation. Clay tablets are heavy and easily shattered; stacks of papyrus scrolls can tumble easily and are hard to browse without opening; early celluloid film stock is highly flammable; vinyl records are easily warped or scratched; analog recording tape becomes brittle with use. Digital technologies eliminate many of these physical hazards and sometimes provide support for preservation. Creating a digital facsimile of a Shakespeare folio, for example, can help to preserve the original while still making the information on the page available to scholars worldwide.

But digital copies are also subject to destruction and they can become completely unreadable when the hardware and software platforms—the technologies of inscription and transmission—become obsolete. Preserving material in digital environments

usually means creating multiple copies in physically as well as electronically distinct locations and migrating the copies from an older to a newer system to yet another as platforms change. Preserving a fifteenth-century book involves keeping it in a temperature- and moisture-controlled room and opening it as little as possible. But to preserve an artifact made of bits rather than atoms it is important to move it quite regularly and to update the conventions with which it is formatted and annotated.

In changing a digital artifact from one format to another it is important not to lose information. For example, we might have a video file that has annotations associated with it indexed by time code. We will want to keep the annotations and make sure that they are appropriately linked to the new version, which may have a shorter or longer credit sequence and may measure duration in frame numbers. Or if there is close captioning on a video file, we should preserve it in a separate file if it cannot be accommodated in the new format. Any structure that has been added to a digital file is a resource to be preserved because it can serve as a way of accessing meaningful segments of the file. Visual files should be stored at the highest possible resolution so that we do not lose information by diminishing the number of bits we have describing an image.

The Catalog and the Shelf

Any collection of information has to keep track of the items it contains. Early library catalogs were linear lists, making it hard to add individual items between other items without recopying the whole. In the nineteenth century, libraries started keeping track of their collections on index cards, a way of segmenting information so it could be added to and reordered.

When libraries moved from card catalogs to digital record keeping in the twentieth century, they established standardized formats that transferred the index card information into data fields. The MAchine-Readable Cataloging—or MARC—format allows all U.S. libraries to list their books in the same way (see <http:// www.loc.gov/marc>) and to create union catalogs that unite the holdings of physically separate libraries into a common database, facilitating interlibrary loans. MARC brought the advantages of uniformity, but its awkward abbreviations—created for an era of much lower-capacity computer tape—make for records that are not easily human-readable (figures 7.1, 7.2).

In the 1970s MARC was an innovative approach. By the 1990s, projects such as the American Memory Project, and its successor, the National Digital Library Program, were moving the Library of Congress from the model of a unified catalog to a vision of unified access to the documents themselves:

A digital library is more than a database, and the future National Digital Library will be much more than a universal union catalog. We envision the National Digital Library as a set of

010 tag	marks the **Library of Congress Control Number** (LCCN)	
020 tag	marks the **International Standard Book Number** (ISBN)	
100 tag	marks a **personal name main entry** (author)	
245 tag	marks the **title information** (which includes the title, other title information, and the statement of responsibility)	
250 tag	marks the **edition**	
260 tag	marks the **publication information**	
300 tag	marks the **physical description** (often referred to as the "collation" when describing books)	
490 tag	marks the **series statement**	
520 tag	marks the **annotation or summary note**	
650 tag	marks a **topical subject heading**	
700 tag	marks a **personal name added entry** (joint author, editor, or illustrator)	

Figure 7.1

A partial listing of MARC (MAchine Readable Cataloging) fields from *Understanding MARC Bibiographic: Machine Readable Cataloging,* Library of Congress, <http://www.loc.gov/marc/umb>. When books are scanned for digital archives, they should be linked to the authoritative metadata in the catalog description to avoid a "trainwreck" of misinformation (Nunberg 2009).

MARC Tags			Sample Content
100	1#	$a	Arnosky, Jim.
245	10	$a	Raccoons and ripe corn /
		$c	Jim Arnosky.
250	##	$a	1st ed.
260	##	$a	New York :
		$b	Lothrop, Lee & Shepard Books
		$c	c1987.
300	##	$a	25 p. :
		$c	26 cm.
520	##	$a	Hungry raccoons feast at night in a field of ripe corn
650	#1	$a	Raccoons.
900	##	$a	599.74 ARN
901	##	$a	8009
903	##	$a	$15.00

Figure 7.2

MARC record fields example from *Understanding MARC Bibiographic: Machine Readable Cataloging,* Library of Congress, <http://www.loc.gov/marc/umb>.

MODS Top Level Elements:

titleInfo
name
typeOfResource
genre
originInfo
language
physicalDescription
abstract
tableOfContents
targetAudience

note
subject
classification
relatedItem
identifier
location
accessCondition
part
extension
recordInfo

Figure 7.3
Metadata Object Description Schema (MODS) top-level elements. MODS is a more flexible cata-
loging system than MARC, based on **XML** and a structured document model. MODS can describe
software, archive websites, and digitize books as well as legacy media artifacts.

distributed repositories of managed content and a set of interfaces (some of which will resemble
traditional catalogs) to that content. Some interfaces may offer comprehensive access to the
entire resource, while others will be specialized by content, by intended audience, or by primary
purpose. Some interfaces will be closely tied to a particular repository, while others will provide
access to a selection of content from distributed repositories. (Library of Congress 1997)

Creation of a digital library has led to new cataloging format, MODS (Metadata Object
Description Standard), which replaces the numeric codes of the MARC format with
human-readable element labels and is meant to provide a common description for
many kinds of media objects, not just books (figures 7.3, 7.4).

In the atom-based information systems of the predigital era, libraries and archives
were separate and had different cataloging procedures. Libraries dealt with standard-
ized, published print materials (as well as some published records and tapes); archives
dealt with documents that were more individual, usually unpublished, and often
arranged in collections associated with individual individuals or institutions, such as
Abraham Lincoln's letters or the records of a government agency. Documents in a
digital library include artifacts of both kinds; they may be video or audio or photo-
graphic artifacts, or even objects needing to be documented in three dimensions.
They might be rare or fragile artifacts that would otherwise be available to very few
researchers for fear of physical deterioration. For example, the Duke Papyrus Archive

typeOfResource
 Enumerated values:
 text
 cartographic
 notated music
 sound recording-musical
 sound recording-nonmusical
 sound recording
 still image
 moving image
 three dimensional object
 software, multimedia
 mixed material
 Attributes:
 collection (yes)
 manuscript (yes)
 displayLabel
 usage (primary)
 altRepGroup
 Subelements:
 [none]

Figure 7.4
Details of the MODS top-level element "3. typeOfResource."

(available at <http://scriptorium.lib.duke.edu/papyrus>) displays over a thousand high-resolution images of ancient papyri; the ESPRIT archive aggregates over a thousand examples of prehistoric slate engravings from the Iberian peninsula (<http://research2.its.uiowa.edu/iberian>). When we move multiple collections of such artifacts into digital form and offer them in a single networked resource, with standardized cataloging, we dramatically augment the power of all the contributing archives for knowledge distribution. A single person can compare artifacts from different collections based on common intellectual criteria, without regard to where they might be physically located. *The attention of the individual is maximized,* facilitating observations that might not be possible by physically visiting each archive or requesting facsimile images by mail. At the same time, *the circle of shared attention is widened.* More people can see the same sets of objects, expanding the possibilities for developing and sharing expertise, and for elaborating and refining expert analysis (figure 7.5).

The library model is the most developed model we have of a vast, nonquantitative information resource, but it does not take us far enough in thinking about aggregations of digital information. It is limited by its appropriateness to the physical form of the book, and by the traditional separation between information about the object (the paper or computer-based catalog) and the objects themselves. In a digital archive, however, we can scan in a book and throw away the postage meters. We can make a

Catalogue Record

```
Title: Magical handbook, [2--]
Subject: Magic --Egypt --Handbooks, manuals, etc. --Early works to 1800.
         Magic, Ancient --30 B.C.-640 A.D.
         Aphrodite (Greek deity)
         Aphrodisiacs --Egypt --30 B.C.-640 A.D.
         Charms --Egypt --30 B.C.-640 A.D.
         Subliterary papyri --Egypt --30 B.C.-640 A.D.
Material: 1 item : papyrus, reconstructed from several fragments,
          mounted in glass ; 15 cm.
Note: Actual dimensions of item are 14.8 x 10.2 cm.
      54 lines.
      Written along the fibers on the recto; written across
      the fibers on the verso.
      Margin of 1 cm. on the recto; left margin of 1 cm. on the verso.
      P.Duk.inv. 729 was formerly P.Duk.inv. LK76 2.
      Leaf of a papyrus codex with a magical handbook from
      Egypt. Has instructions for various spells including
      a love-charm that details the preparation of a potion
      and mentions Aphrodite, a charm to force silence
      on a person, a love charm or binding spell containing
      magical symbols, and a hymn to the sun (Helios) to
      accompany any request. The hymn identifies the sun
      with, among other things, Harpokrates, Yahweh, Abrasax,
      Hephaistos and Mithras.
      In Greek.
      Descriptive database available in repository.
```

Figure 7.5
Magical Handbook fragment and its catalog entry in MARC archival and mManuscript control format, from the online Duke Papyrus Archive (<http://scriptorium.lib.duke.edu/papyrus>).

catalog that is also a library shelf: a list of books that is directly linked to the books themselves. A single book can then be positioned on multiple virtual shelves and can be accessed by many readers at the same time. Because it is made of bits rather than atoms it is not limited to being in one place at a time.

The arrangement that is closest to uniting the catalog and the library shelf is the electronic bookstore linked to a proprietary hardware or software book reader. For any book in such a collection, the reader can instantaneously access the text of the book from its online (sales) catalog description. The marketing for ebooks features this novelty of immediate access as a primary attraction (figure 7.6). But the books that are delivered are odd hybrids of print and electronic affordances. Although one might expect that reproducing books in electronic form would make them better organized, so far the main advantage has been in portability. Devices that deliver electronic books can contain much more information than a comparable size and weight in printed books, but they may introduce new difficulties in legibility, page formatting, and annotation.

The process of moving any highly valued, proprietary media form from one format to another is often fraught with economic, political, and social considerations that complicate the design task. *But once a legacy artifact is remediated into digital form it raises the full range of procedural, participatory, encyclopedic, and spatial expectations in its users.* For example, if a hyperlink appears in a book or newspaper read on a networked electronic reader, users expect it to be clickable and they are frustrated if they cannot access the referenced website.

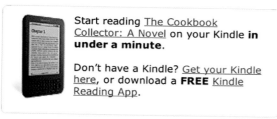

Figure 7.6

Amazon.com entices customers to buy its electronic reader and ebooks with the promise of instant gratification: "Start reading . . . in under a minute."

The Association for Computing Machinery (ACM), the organization that supports research in computer science and related fields including human–computer interaction, has taken a radical and comprehensive approach to electronic publication, offering all its journals in digital form and linking articles not only to their parent journals, other articles by the same author, and cited articles, but also to online articles that cite the current one, and to other articles read by the scholars who read the current one. Since authors have unique identifiers, the system also generates a list of collaborators—people who have published with the current author on other articles. By making visible these intellectual connections and professional

Figure 7.7
ACM Digital Library entry leads not just to the article but also to the network of investigation it belongs to, including articles it references and articles that cite it.

networks, the ACM digital library is providing a new expressive format for colloca-tion. The citation trails point both backward and forward from any point in the chain, and the collaboration trails point off in parallel directions, and up and down chains of mentorship. A novice is therefore able to get a rich overview of a field using a single relevant article as a point of entry. The ACM digital library is providing the same core function that the library shelf used to provide for a knowledge domain that is growing at a pace much faster than library acquisition cycles can match (figure 7.7).

The trend toward digital publication and retrieval is likely to increase in coming years, shifting the tasks of the librarian to the digital sphere. The participatory nature of the medium, which the ACM has been exploiting so well, will allow the distribu-tion of some of the annotation and cataloging tasks to the community of expert readers, with the librarian shaping the environment and providing editorial control over automated and contributed content. The pace of change may have more to do with changing the social rituals that create authority than with demonstrating the efficiency of knowledge dissemination. Since articles in electronic journals will be

more accessible they may come to be cited more often, building traditions of prestige that over time may eclipse the time-honored rituals of print.

Labels as Identifiers, Descriptors, and Pointers

The Sumerians stored their clay tablets in larger information **containers**—on shelves and in baskets. The same format of a clay tablet with cuneiform writing might hold a myth cycle or the record of a commercial transaction. To keep the tablets organized, the Sumerian librarians attached a smaller tablet or **tag** to the main tablet as a label. The clay tags of the Sumerians are the earliest surviving ancestors of the paper labels on record albums or DVDs, and the file names and web addresses that we attach to our electronic containers, telling us whether we are dealing with baby pictures or stock market quotes. Large information structures in any medium are organized around containers and tags. The tags identify and differentiate the chunks of information within a common container.

Like clay tablets, manuscripts, and books, and like their paper antecedents, electronic files and folders have names to differentiate them from one another. Names are an important form of tag, and they can serve as both identifiers and **descriptors**. For example, instead of saying something like "Tolstoy's lengthy narrative about the Napoleonic period in Russia," I can point to it more efficiently by its title, *War and Peace*. A book title can be a device for **encapsulation**, like the name of a programming procedure, allowing us to refer to the argument or story as a whole in a shorthand way without having to enumerate everything between the covers. Names can have cultural and historical connotations like Primrose Cottage or Philadelphia (City of Brotherly Love) or New York, whose relevance may no longer be apparent (no primroses, no noticeable brotherly love, no memory of an older York).

As identifiers, book titles like geographical names are meant to be unique to the object described, but they often are not—a problem that gets more and more difficult as the world gets smaller and more crowded with named objects. When we decide collectively to make a set of names standardized and unambiguous we establish a **nomenclature.** Examples of nomenclatures include botanical names, street names, and website domain names. But standard names are not necessary unique names. If human beings labeled places in the physical world around us with the precision required by computers there would not be seventy-one streets with the word "Peachtree" in their name in Atlanta, or more than thirty cities called Springfield in the United States to vie for the honor of being designated Homer Simpson's home town. Since nomenclatures often have to be built on existing labels they frequently include numbering systems such as ZIP codes to **disambiguate** them.

But numbered identifiers can also be confusing. Numbering systems are easiest to remember when they conform to observable patterns, such as a north–south/east–west

Figure 7.8
Map of Queens, New York, shows a numbering system that confusingly includes a 45th Ave, 45th
Rd, and 45th Dr.

Figure 7.9
MIT campus map shows a numbering system that begins logically with the buildings surrounding
the main quad, but breaks down as the campus grows. The visitor to campus generally arrives
at "Building 7" (numbered 7 on the map).

grid as in Manhattan. When numbers are arranged in more complicated patterns as
in the borough of Queens, New York (figure 7.8) or the campus of MIT (figure 7.9) in
Cambridge, Massachusetts, they may be logically unambiguous but still quite confus-
ing to ordinary human attention. Numbering systems are ideal for computer labels,
however, and can sometimes acquire the semantic charge of words. For example, ZIP
codes of American neighborhoods are sometimes used as a shorthand for a real estate
market, and by association acquire the connotations associated with the values and

behaviors of the people who live there, as in the TV show *Beverly Hills 90210*, usually referred to by the number alone.

Nomenclatures can be organized into one or more **namespaces,** sets of words that are used consistently to create unique identifiers and to apply like names for like objects. For example, we can agree that the namespace for a room full of computers will be green vegetables, and then assign them names arbitrarily but sticking to the limited set of choices such as Pea, Green Bean, Spinach, Broccoli, and so on. The problem with creating organizational namespaces from arbitrary categories in the real world is that, unlike numbers, you can run out of them. If you have more machines than there are green vegetables you have to start to use yellow ones, creating a question in users' minds about whether the difference in names denotes a meaningful distinction (do the green machines use less energy?). Namespaces for computers, such as Tolkien characters, ski resorts, or movie stars, are sometimes fancifully unrelated to the technical objects they denote, but they may have complex cultural connotations, making them part of the shared social identity of the organization. Designers should be aware that such choices are never neutral and may have undesirable associations for some members of the community if they are drawn from the larger culture rather than from a local frame of reference (such as the industry, service function, or educational field the computers support). Computational namespaces like domain names are logically constructed based on rules for assembling discrete alphanumeric semantic elements. Like postal codes or street names or the names in library catalogs, domain names and other shared computational nomenclatures require authorizing institutions to establish rules and regulate usage.

Identifying and descriptive labels are forms of **metadata,** which is important for searching and retrieving items in an archive. The fields in the MARC record include metadata that describe the physical book (such as number of pages) and the content of the book (such as subject terms like "Raccoons" in figure 7.2). Descriptive labels are also important, as we will see in chapter 9, in defining meaningful segments within **structured documents**.

Classification Schemes

Whether they are identifiers or descriptors or both, labels are most useful when they are human-readable, open-ended, and part of a meaningful **classification** schema. A classification schema is *a nomenclature that sorts information into knowledge-based categories*. Classification lies at the root of much cultural activity, but the more we know or observe, the harder it can be to sort things into fixed categories. The Argentine fabulist Jorge Luis Borges made this point with characteristic playfulness in this fanciful classification scheme, which he attributes to an imaginary emperor:

Borges's Emperor's Classification of Animals

a. those that belong to the emperor
b. embalmed ones
c. those that are trained
d. suckling pigs
e. mermaids
f. fabulous ones
g. stray dogs
h. those that are included in this classification
i. those that tremble as if they were mad
j. innumerable ones
k. those drawn with a very fine camel's hair brush
l. others
m. those that have just broken a flower vase
n. those that resemble flies from a distance (Borges 1975)

Borges's categories are dramatically compelling and seem to be based on very specific observation and engagement with particular animals. The qualities he identifies are significant distinctions. They are placed in a sequence with orderly alphabetical identifiers. His categories are certainly comprehensive since they include both "those that are included in this list" and "others." But this is an absurd classification system not merely because the classes are idiosyncratic, overlapping, and nonsensical ("innumerable ones"?), but also because they are brilliantly incommensurable: describing wildly different attributes that do not compare with one another. As Bowker and Star point out in *Sorting Things Out,* Borges's whimsical characterizations of animals is a good illustration of the difference between assigning things to categories and sorting them according to a logical classification scheme (Bowker and Star 1999).

A classification system of any kind—from the top-level links of a website to the Library of Congress Subject List—is an organized way of slicing up the world. To be successful the categories should be consistent, *recognizable* and *distinct* from one another; the system as a whole should be *complete* with everything within the domain finding a place within it; the categories should be reasonably *symmetrical*: that is, they should display a *consistent level of subcategorization*; and the system should be *open-ended* to accommodate new categories reflecting new knowledge or perspectives on the same domain. Of course these qualities are not fully achievable by any known system: they are not specifications but goals, and systems aim for them but always fall short (Bowker and Star 1999).

The effectiveness of classification systems should be tested both by those who enter information into the system and those retrieve the information. Classifiers should be able to assign new items to the right category or categories without

ambiguity and without having to read through a list of every identifier in alphabetical (nonsemantic) order to find the right one. Ideally, a classification schema should be a hierarchy that can be traversed as a decision tree: Is this item animal, vegetable or mineral? If animal, is it fish or foul or mammal? Each decision should lead deeper down the hierarchy. However, life is analog and items in a taxonomy often overlap categories or fall outside of established classes. Some things are neither fish nor foul, not quite chemistry and not quite physics, not quite tragedy and not quite comedy. It is always challenging to try to fit the messy objects of the **lifeworld**, where the objects, qualities, and events we share are experienced directly, into consistent logical categories.

Any classification scheme must be tested with multiple real-world practitioners and should be put to the test of extending it with potential additions to the collection. One common way to formulate and test classification schemes is with *card sorting*, writing down all the items, or a subset of representative items on separate index cards and asking multiple stakeholders to sort them into categories. The categories may be given to them or they may be asked to invent their own. It is particularly useful to test organizational schemes for the navigation of complex websites with diverse users performing a representative range of tasks. Even after they are deployed, classification schemes should allow for refinement and revision as collections grow and perspectives change.

Classification schemes are effective if they provide a basis for the reliable retrieval of information. Seekers of information should be able to use the classification terms as search terms, and to find *all* that is relevant and *only* what is relevant. Failures in retrieval can usually be traced to the messiness of human language, which employs the same word to mean different things and many words to mean same thing. Library science addresses this problem by creating **controlled vocabularies,** lists of words that are administered by a central authority and designed to cover an entire field of reference. Controlled vocabularies that serve as a basis for classification schemas have a **thesaurus** associated with them that lists all the approved terms and provides guidance for cases where ordinary language has multiple synonyms such as substituting "agriculture" for "farming" or "physician" for "medical doctor."

To make it possible to retrieve information, information structures need address spaces. An address space is a kind of controlled vocabulary in which places are assigned unique labels, whether in numbers or letters or words or some combination of all three. Ideally, addresses should be classification labels—where something is located should reflect what it is, so knowing one will tell you something about the other. Shelves of libraries are a controlled address space, with individual books receiving unique codes within this space based on subject, date, and author (figure 7.10). For example, for the book

Wallace Martin, *Recent Theories of Narrative*

LC Control No.: 85022401
LCCN Permalink: http://lccn.loc.gov/85022401
Type of Material: Book (Print, Microform, Electronic, etc.)
Personal Name: Martin, *Wallace.*
MainTitle: Recent theories of *narrative* / Wallace *Martin.*
Published/Created: Ithaca: Cornell University Press, 1986.
Description: 242 p. : ill. ; 23 cm.
ISBN: 0801417716 (hard: alk. paper)
0801493552 (pbk. : alk. paper)

CALL NUMBER: PN212 .M37 1986
Copy 1
-- Request in: Jefferson or Adams Building Reading Rooms
-- Status: Not Charged

CALL NUMBER: PN212 .M37 1986 FT MEADE
Copy 2
-- Request in: Jefferson or Adams Building Reading Rooms - STORED OFFSITE

Figure 7.10
Library of Congress catalog information including call number, physical location, ISBN, and the LC Control No., which refers to the original cataloging system established in 1898. See Library of Congress online catalog, <http://catalog.loc.gov>.

the Library of Congress assigns the call number

PN212 M37 1986

The value in the date field "1986," the year of publication, is the only part of this code that is immediately human-readable. The rest of the signifiers can be decoded in this way:

P is the class of Language and Literature
PN is the subclass of Literature (General)
M is the first initial of the author's last name
212 is a subclass of PN, within the range (172–239) assigned to "Literature/Authorship/ Technique, Literary Composition, etc."

It is significant that at the finest level indicated on the Library of Congress Classification Outline (<www.loc.gov/catdir/cpso/lcco/lcco_p.pdf>) for PN 212, the designers of the classification system are forced to throw up their hands by resorting to "etc." In fact theories of narrative are not currently understood as a subclass of "authorship,"

but would probably fit more appropriately into PN 45–57: Literature/ Theory. Philosophy. Esthetics. Classification schema aim for consistency but knowledge expands and categories often become ambiguous or obsolete with time.

Systems of identification are starting to converge as they all move into digital representation. Alongside traditional library systems of labeling is a newer, commercially driven identification system of unique International Standard Book Numbers (ISBNs). The thirteen-digit ISBN number contains four three-digit fields that label the object as a book, identify country, publisher, and specific title, as well as one more check digit that validates the number. Publishers purchase blocks of ISBNs and assign them to unique volumes without regard to the contents of the book. The system was initiated in 1966 in Britain and certified by the International Standards Organization in 1970 as a ten-digit system, but by 2007 it became necessary to add three additional digits in order not to run out of numbers. Libraries now add the ISBN codes to their records of their holdings. But unlike the Library of Congress system, ISBN codes are not helpful for browsing groups of books because the numbers are not based on the informational content. Instead, ISBN codes are optimized to provide a unique identifier in a uniform format (same number of digits in the same bar code representation) that makes it easier to retrieve a box of books from a warehouse shelf and to ship the right book to the right buyer. But the ubiquity and consistency of the ISBN have made it the basis of some networked bibliography systems, such as Zotero.

The codes of the Library of Congress point to a logical place on a shelf that remains the same in relation to the rest of the library holdings, even if the physical shelves are moved. In this regard they are unlike ISBNs, but very like **Universal Resource Locators (URLs)** that point to web pages. Similarly, the URL <http://www.gatech.edu> will point to Georgia Tech's website regardless of whether the site moves to a different server or the server moves to a different building. But unlike the ISBN or the call number, both of which can be stamped on the physical book, the URL is not permanently associated with the information it locates.

Media objects within a digital library object need persistent identifiers that can be used to locate them, even when they change URLs, and that can identify the same object when it is duplicated at multiple URLs (just as ISBN and LOC codes identify multiple copies of the same book). The **Digital Object Identifier (DOI)** system serves this purpose by functioning like the lifelong email address provided to some college students on graduation, which can be updated to point to changing current accounts (see <http://www.doi.org>). As long as the rightsholder updates the appropriate records, the DOI will always lead to the correct media object. DOIs can be assigned to any digital object, such as a web page, music file, or video sequence. They can also be assigned to any abstract entity that can be claimed as intellectual property. For example, one could assign a single DOI to an article that has been reprinted in multiple

places or a song that has been recorded by many artists or a book that exists in text and audio versions. Attaching a unique identifier to an abstract entity, independent of its material representation, could significantly expand our understanding of what it is that we are collecting in digital archives. It reflects the reality that naming something creates it as a focus of shared attention, creating meaning where it was not visible before.

At the most basic level everything in a digital archive is a collection of bits, and the name of any collection of bits always resolves in a pointer to a virtual address, a place in computer memory where those switches are located. The information structures we build on top of those pointers are basically other pointers. *The job of the designer is to create pointers to information that are unambiguous for the machine and meaningful for the human who is storing and retrieving the information.* Doing this usually means creating tables of some kind in which the human-meaningful name is translated into the machine-logical address. When the systems work well they function like memorable web addresses or well-sorted library shelves. When they work badly it is because a human being is being asked to remember a computer-friendly code or a computer is being asked to understand ambiguous human-friendly codes (figure 7.11).

Figure 7.11
Georgia Aquarium provides location-specific educational information, taking advantage of the cell phones that its visitors already carry. In order to receive the information, the visitor enters two separate transmission codes, a nine-digit telephone number and then a location number (here: 510, in black circle at upper left). Mobile devices with scanners make such location-specific information retrieval more transparent, by allowing designers to hide the lookup codes. The designers should be able to use the same underlying information structure of location-indexed media files as transmission technologies change, perhaps upgrading from audio to video as available bandwidth increases.

Information Organization as a Taxonomy of Knowledge

The library cataloging system is a **taxonomy** of every subject of human knowledge that can be described in print, a byproduct of its intended function, which is to sort vast holdings into searchable smaller units and to assign a unique place on the shelf for everything that comes into the collection.

With the growth of print culture in the nineteenth century and the spreading of literacy, libraries became public institutions and schemas were devised to organize knowledge in standard ways. The most successful early **schema** was the Dewey Decimal Classification (DDC) system, devised by Melvil Dewey in 1876, currently in its twenty-second revision, and still the most widely used system in the world, which divides all of human knowledge into ten top-level classes, and allows for expansion by the addition of decimal places (see figure 7.12). Because numbers have intrinsic sequence, the DDC provides librarians with a reliable way to shelve and retrieve books from unique locations.

The small number of classes and top-down assignment have made it difficult to add the many areas of knowledge. Technology and Science are particularly crowded categories, leaving "Nuclear Engineering," for example, to be elbowed in under "Mechanical Engineering," and "Computer Science" stranded in the 000 category which was originally assigned to "Generalities." The coding system finds new places on the shelves for these new knowledge containers but it does not reflect our changing epistemological structures. The numbering system has lost its descriptive power as a map of human knowledge, and now functions as an arbitrary transmission code, like telephone numbers, a way of assigning unique shelf addresses, but confusing collocations. Like giving a home a name such as "Primrose Cottage" instead of a street

Dewey Decimal System Top-Level Categories
000 – Computer science, information, and general works
100 – Philosophy and psychology
200 – Religion
300 – Social sciences
400 – Language
500 – Science
600 – Technology
700 – Arts and recreation
800 – Literature
900 – History and geography

Figure 7.12
The Dewey Decimal System places all of human knowledge in the form of books to be shelved, in ten top-level categories. It is successful in placing every book in a particular place on the shelf and in assuring that books shelved near one another are related in content.

Library of Congress Classification System
A GENERAL WORKS
B PHILOSOPHY. PSYCHOLOGY. RELIGION
C AUXILIARY SCIENCES OF HISTORY
D HISTORY: GENERAL AND OLD WORLD
E HISTORY: AMERICA
F HISTORY: AMERICA
G GEOGRAPHY. ANTHROPOLOGY. RECREATION
H SOCIAL SCIENCES
J POLITICAL SCIENCE
K LAW
L EDUCATION
M MUSIC AND BOOKS ON MUSIC
N FINE ARTS
P LANGUAGE AND LITERATURE
Q SCIENCE
R MEDICINE
S AGRICULTURE
T TECHNOLOGY
U MILITARY SCIENCE
V NAVAL SCIENCE
Z BIBLIOGRAPHY. LIBRARY SCIENCE. INFORMATION RESOURCES (GENERAL)

Figure 7.13

The Library of Congress Classification System has twenty-one top-level categories, including two assigned to American history, reflecting its primary mission of accounting for everything in its own collection.

address, we are creating confusing identifiers that resemble descriptors but are not reliable as descriptors.

The main rival to the Dewey system in the United States is the Library of Congress (LOC) Classification system (figure 7.13). It was invented in the early twentieth century in response to the limitations of the Dewey system, which could not account for all the volumes in the LOC's existing collection. The LOC Classification is divided into twenty-one top-level categories, which are assigned alphabetical labels. All of the categories are administered by domain specialists, who attempt to adapt and expand the classification system to reflect changing knowledge; however, as we have seen, the system is more successful at assigning unique identifiers than it is at assigning reliable intellectual descriptors.

The growth of networked digital resources presents many classification problems similar to the problem of the Dewey Decimal and LOC systems, where users would like to use classification schemes as a guide to unfamiliar content, but the domains are so large and ill formed that they resist assignment. For example, what classification scheme would best describe all the books on Amazon.com or all the films and TV shows on Netflix.com or all the videos on YouTube? How would we sort all the museums of the world so that they can be browsed in a way that furthers our under-standing of the range and shared qualities of institutions? How would we sort all the artifacts within those museums so that we could see all the works of a single artist or compare separately held versions of the same document or artifact?

Since taxonomies are so difficult to create and so hard to sustain, new and growing areas of services and information—which includes almost everything in digital media—

AOL A-Z

Editors' picks in **bold**

A	G	Q
Access Numbers	Gadling	Queersighted
Account Security Question	**Games**	**R**
Account Updates	Game Daily	
Address Book	Gardening	**Radio**
AIM	Gay and Lesbian	Real Estate
Android Apps	GNN	Recipe Finder
Antivirus Protection	Golf	Reference Center
AOL.com		Refinancing
AOL Desktop 9.6	**H**	RentedSpaces
AOLbyPhone		ReputationDefender
AOL Computer Checkup	Hairstyles	Retirement
AOL Desktop for Mac	**Health**	Ringtones
AOL SafeSocial	Health Encyclopedia	
AOL Safety Toolbar	**Help**	**S**
Asylum	Hockey	
Atlas	Holidash	SafeCentral
Autoblog	Home	**SafeSocial**
Autos	Home Improvement	Safety & Security
Away Message	Home Values	SafetyClicks
	Horoscopes	SciFi Squad
B	Horror Squad	Scores
Banking	Hot Searches	**Search**
Baseball	Hotels	Search and Recover
Basketball		Seed
Beta	**I**	Sessions
Better Guard	ID Vault	Settings
Big Download	Indie Wire	ShelterPop
	Inside Movies	Shopping
	Instant Messages	Shortcuts.com

Figure 7.14
AOL Portal Services, excerpt from the alphabetical listing.

often require multiple iterations of an organizational structure, as items that have to be covered and the relationships among them keep changing and expanding. Most information-rich websites outgrow their original structure. When outlier pages grow too numerous, it is best to rethink the whole site rather than to keep adding on inconsistent sections or "quick links" to hidden material. For larger sites in transitional phases the minimal rule should be to *use scrupulously consistent nomenclature, and to aim for standardization with similar websites for the most frequently used categories of information.* Lack of a clear taxonomy of the kinds of services, tasks, and information offered by a digital environment of any kind can lead to a proliferation of labels, buttons, and menus, and to web pages with inconsistent and confusing names. One sign of an area that has outstripped its designers' ability to provide order is a reliance on alphabetical listings, like the portal sites in figures 7.14 and 7.15. Attempting to create a taxonomy for such lists can reveal weaknesses and strengths in the organization itself and help to clarify its mission.

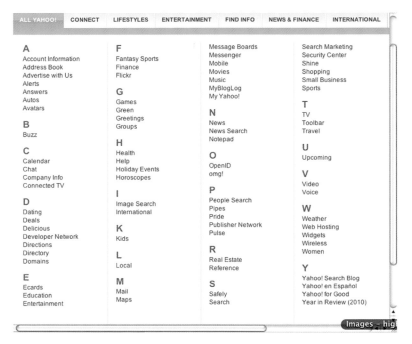

Figure 7.15
Yahoo Web Everything, excerpt from the alphabetical listing.

Designing for Navigation with Appropriate Labels

One of the chief aims of any classification system is collocation, which as noted earlier means grouping intellectually similar items near one another. A library shelf is a highly organized grouping of similar items, giving us an overview of a domain of knowledge merely from browsing the appropriate shelves in a well-stocked collection. Similarly, *the navigational menu of a well-labeled website should provide an overview of the knowledge it contains.* Actually navigating the site should reinforce the interactor's understanding, supporting the creation of a spatialized mental representation that integrates the web design with the abstract information structure. For example, if we find the works of Carl Jung in the psychology section of a library or web encyclopedia, we reinforce our knowledge that Jung's work was in psychology.

The proliferation of information in digital form has made it hard to create well-labeled, well-segmented information resources. Instead we often find endless lists and nested lists that force the interactor to navigate through many things they are not interested in to find the things that do interest them. News sites are particularly challenged in their presentation of content (figure 7.16) since human events do not fall

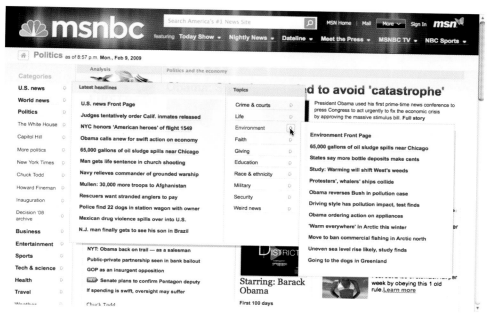

Figure 7.16
News sites often rely on scrolling lists and nested lists that place information in multiple broad categories.

into neat categories. The starting points for online organization of news are the broad categories inherited from daily newspaper sections (National, International, Style, Business, etc.). These have been supplemented online with summary pages devoted to persistent topics like individual countries, but the topics covered by newspapers are so numerous they have to be arranged in alphabetical listings (figure 7.17). Newspapers have also drawn on the participatory behavior of readers to do some of the organizing for them, by providing lists of "Most Emailed" articles or "Most Popular" topics.

Other large information resources provide specialized overviews for different categories of browsers. For example the Library of Congress provides separate points of entry for Kids/Families, Librarians, Researchers, Teachers, and others (figure 7.18).

Expandable menu trees can allow users to jump up, down, and across branches of a large information space, going from one page to any other page with fewer intermediate page loads (figure 7.19). Organization of long lists of items into discreet categories can be accomplished by a top-down method, imposing a relevant existing taxonomy, such as the organizational chart of an institution, upon the information; or organization can be discovered from the bottom up by starting with the individual items and sorting them to see what categories emerge. Users and stakeholders can be

A

Browse the list below to find topic pages about people, places, organizations, and subjects. Each topic page collects all the news, reference and archival information, photos, graphics, audio and video files published about the person on NYTimes.com.

Names of New York Times reporters are shown in italics. Visit a reporter's page to search an archive of the reporter's work or to send an e-mail.

A Good Appetite, by Melissa Clark	Allen, Paul	Appiah, Kwame Anthony
A M Castle & Company	Allen, Ray	Appier, Kevin
A Power Energy Generation Systems Ltd.	Allen, Robert E.	Apple Inc.
A. Schulman Inc.	Allen, Thad W.	Apple Valley Bank & Trust Company
A.C. Milan	Allen, Tim	Apple, Fiona
A.C. Moore Arts & Crafts Inc.	Allen, Will	*Apple, R. W. Jr.*
A.O. Smith Corp.	Allen, William J	Applebee's International, Inc.
A.T. Cross Company	Allen, William T.	*Applebome, Peter*
A123 SYSTEMS INC.	Allen, Woody	Appleby, Stuart
AAA Energy Inc.	Allenby, Robert	Applegate, Christina
AAG Holding Company Inc.	Allende Gossens, Salvador	Apples
Aaliyah	Allende, Isabel	Applewhite, Marshall Herff
Aamaxan Transport Group Inc.	Allende, Salvador	Appliance Recycling Centers of America Inc.
Aaon Inc.	Allergan Inc.	Applied Biosystems Group
AAR Corp.	Allergy Research Group Inc.	Applied Digital Solutions Inc.
Aaron Rents Inc.	Allete Inc.	Applied DNA Sciences Inc.
Aaron, Hank	Alley, Kirstie	Applied Energetics Inc.
AARP	Alliance Bancorp Inc.	Applied Industrial Technologies Inc.
Aastrom Biosciences Inc.	Alliance Bancshares California	Applied Materials Inc.
AB andT Financial Corporation	Alliance Bankshares Corp.	Applied Micro Circuits Corp.
Abacha, Sani	Alliance Data Systems Corp.	Applied NeuroSolutions Inc.
Abas, Nasir	Alliance Fiber Optic Products Inc.	Applied Signal Technology Inc.
Abashidze, Aslan	Alliance Financial Corp.	Appointments and Executive Changes
Abate, Catherine M.	Alliance for Downtown New York	Appraisals and Valuation
Abaxis Inc.	Alliance Healthcard Inc.	Approach Resources Inc.
Abazias Inc.	Alliance Holdings GP LP	Aprecia Inc.
ABB Ltd.	Alliance Imaging Inc.	Apria Healthcare Group Inc.
Abba	Alliance One International Inc.	April Fool's Day
Abbado, Claudio	Alliance Pharmaceutical Corp.	APT Satellite Holdings Ltd.
Abbas, Abu	Alliance Recovery Corp.	AptarGroup Inc.
Abbas, Mahmoud	Alliance Resource Partners LP	Apted, Michael
Abbey, Edward	AllianceBernstein Holding LP	Aqua America Inc.
Abbott Laboratories	Alliant Energy Corporation	Aquamer Medical Corporation
Abbott, Jim	Alliant Techsystems Inc.	
Abd-el-Kader	Allianz SE	
	Allied Capital Corp.	
	Allied Defense Group Inc, The	

Figure 7.17
New York Times Topics list serves as an index to a very varied range of entities, and is only organized alphabetically (<http://topics.nytimes.com>).

helpful in the process of arriving at an appropriate taxonomy through focused interviews and card-sorting exercises, in which representative labels are placed on separate index cards or sticky notes and multiple subjects are separately asked to categorize them. However the arrangement is achieved, it must be tested against the existing items, the expectations of representative users, and against the designer's best predictions of how the archive or website is likely to grow.

In creating a hierarchical menu structure it is useful to remember the principle of the "Magical Number 7," or more precisely the range of between five and nine items identified by cognitive scientist George Miller in 1956 as the limit of short-term

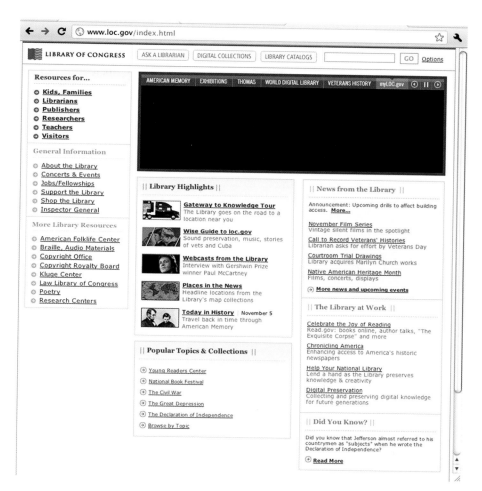

Figure 7.18

The Library of Congress offers top-level access to six distinct entry points offering "Resources for" Kids, Families, Librarians, Publishers, Researchers (this page), Teachers, Visitors.

Figure 7.19

The expandable navigation bar of <http://washtingtonpost.com> allows a reader to browse and move directly to subtopics within the information tree from anywhere on the site.

working memory (Miller 1956). Miller thought of memory as an information **channel**, and five-to-nine bits of information as the bandwidth of the channel. He noticed a range of experiments that supported a limit in this range for accurate memory or for perception. For example, human beings can easily recognize one to six dots on a single die face, but we need two dice with separate patterns to reliably distinguish numbers higher than six. Miller identified subgrouping, or **chunking,** as one of the key strategies for increasing human cognitive capacity. Telephone numbers reflect this constraint; in the United States they have nine digits, chunked into units of three and four digits for better memorizing. Miller also identified the **recoding** of information into fewer chunks with more information per chunk as one of the fundamental cognitive strategies by which we engage with the world; he identified language, narrative, and images as pervasive forms of recoding. Just as we build up complexity in a computer system by combining **encapsulated** processes and identifying abstract **classes,** we build up our conceptual complexity by chunking information into nested containers.

Miller also pointed out that we can increase our cognitive and organizing capacity by adding another dimension to information, such as rhythm, rhyme, or color. By creating well-chunked lists and nested menus we make meaningful, logical divisions more memorable by wedding conceptual divisions to spatial features. *Since navigation of a space adds the dimension of enactment to spatial organization, interactive environments can further reinforce our understanding of a domain, when chunking and navigation reflect well-formed categories arranged in coherent hierarchies.*

The "rule of 7" and the conventions for visually clustering and semantically chunking information provide powerful organizing strategies that can change an unwieldy list into a memorable, coherent set of choices. For example, *if an application program menu or tool palette has more than nine choices, they should be sorted into meaningful subgroups and separated visually.* Such chunking of menu choices is the equivalent of creating landmarks for spatial navigation, and adds to the learnability and transparency of the interface. But limiting items by number and dividing them into groups only works if the labels are meaningful, and the categories are distinct and memorable.

Good information design hides information as well as revealing it. It does not list everything in alphabetical order at the same level. It nests information in meaningful hierarchies. The designer should attempt to create the most efficient abstraction of the domain, building up complexity by resting broader informational topics on a hierarchy of well-organized smaller ones, while remembering that in digital spaces, unlike physical library shelves, the same information can belong to multiple hierarchies. Wikipedia, for example, includes summary sections for more complex topics with hyperlinks that trace topics up and down the relevant hierarchies and also across the network to associated nodes (figure 7.20). Although some articles do a better job than others at presenting a topic or surveying a field, the structure as a whole encour-

Analytic philosophy

From Wikipedia, the free encyclopedia
(Redirected from Analytical philosophy)

Analytic philosophy (sometimes **analytical philosophy**) is a generic term for a style of philosophy that came to dominate English-speaking countries in the 20th century. In the United States, United Kingdom, Canada, Scandinavia, Australia, and New Zealand, the overwhelming majority of university philosophy departments identify themselves as "analytic" departments.[1][2][3] Analytic philosophy is sometimes understood in contrast to other philosophical movements, such as continental philosophy, Thomism, or Marxism.[2][4]

The term "analytic philosophy" can refer to

(a) a broad philosophical tradition[5][6] characterized by an emphasis on clarity and argument (often achieved via modern formal logic and analysis of language) and a respect for the natural sciences.[7][8]

(b) the narrower set of developments in early 20th-century philosophy that were the historical antecedents of the broad sense: e.g., the work of Bertrand Russell, Ludwig Wittgenstein, G.E. Moore, Gottlob Frege, and the logical positivists. In this narrow sense, analytic philosophy is identified with specific philosophical commitments (many of which are rejected by contemporary analytic philosophers), such as:[9]

- the positivist view that there are no specifically philosophical truths and that the object of philosophy is the logical clarification of thoughts. This may be contrasted with the traditional foundationalism which views philosophy as a special sort of science—the highest one—which investigates the fundamental reasons and principles of everything.[10] As a result, many analytic philosophers have considered their inquiries as continuous with, or subordinate to, those of the natural sciences.[11]

- the view that the logical clarification of thoughts can only be achieved by analysis of the logical form of philosophical propositions.[12] The logical form of a proposition is a way of representing it (often using the formal grammar and symbolism of a logical system) to display its similarity with all other propositions of the same type. However, analytic philosophers disagree widely about the correct logical form of ordinary language.[13]

- the rejection of sweeping philosophical systems in favour of close attention to detail,[14] common sense, or ordinary language.[15]

Philosophy	
(Plato, Confucius, Avicenna)	
Branches	[show]
Eras	[show]
Traditions	[show]
Philosophers	[show]
Literature	[show]
Lists	[show]
Portal	
	v · d · e

Contents [hide]

1 History
 1.1 Origins: Frege, Russell and Whitehead
 1.2 Ideal language analysis
 1.3 Logical positivism
 1.4 Ordinary language analysis
 1.5 1960 and beyond
2 Contemporary analytic philosophy
 2.1 Philosophy of mind and cognitive science
 2.2 Ethics in analytic philosophy
 2.3 Analytic philosophy of religion
 2.4 Political philosophy
 2.4.1 Liberalism

Figure 7.20
Wikipedia page on analytic philosophy provides a definition, and table of contents (partially seen here) as well as an introductory overview of the topic. Hyperlinks within the summary lead to related topics like Aristotle and subtopics like positivism.

ages good information organization by providing templates that chunk information into focused modules.

Information in digital form can be chunked, retrieved, and labeled with much more flexibility than information printed on pages and bound into books. Though the library model provides foundational principles and traditions for labeling, sorting, and collocating information, the methods of information architecture must be drawn from established and emerging digital models, as we will see in chapters 8 and 9.

DESIGN EXPLORATIONS: COLLOCATION IN THE EMERGING DIGITAL LIBRARY

Using Knowledge Networks

• Create a collection of text files, video clips, audio clips, or all of these by your favorite author or performer. Identify each entry by a unique name and date. Where would you look to find reliable lists of their works? Where would you look to find reliable copies of their works? Who created the information resources you are consulting? What authority do they have for making the list? How would you check its accuracy?

• Choose a single information source such as an online catalog of a research library, the ACM Digital Library, Google Scholar, Google Books, or Wikipedia to answer this question: What do we mean by "boundary object" and what are the most important works in which it is discussed? Be sure to identify the first such work and the most recent. If you can, collect physical or electronic copies of the sources. Compare your results with those of other students. What sources are most reliable for this task? How many of them are necessary to collect copies of the original sources?

Becoming Aware of the Cultural Associations of Familiar Nomenclatures

• Examine any list of names that has been applied to a new or rapidly expanding domain, such the earliest-founded colonies and cities of the United States, objects discovered in space, recently discovered species of plants or insects, rock bands, sports teams. What strategies have been used to come up with names for them? Could you write a computer program (or a procedure in **pseudocode**) that would generate names similar to existing ones? What do the choices of names suggest or reveal about the cultural context of the groups that chose them?

• In a cultural domain with which you are familiar, find examples of numbering schemes that have acquired cultural meaning beyond the arbitrary assignment of a unique identifier (for example: telephone exchanges, postal codes, sports jersey numbers).

• Compare three websites from similar information-oriented organizations such as three universities, three museums, or three government agencies.

 • What are the top-level categories on each site? How do they reflect the priorities of each institution? Do they seem to reflect the interests or concerns of those who visit the sites?

 • Compare the organization of the three sites in performing a specific task. For example: how many levels do you have to click through on each of the university sites in order to find the current tuition rate? How easy is it to discover when spring break is going to fall this year? Where would you look to discover the level of support for women's sports or which instructors will be teaching freshman English next year?

- Identify the elements on each site that convey the personality of the individual institution. Mock up the content of one of the institutions using the design elements and information organization of another institution. What connotations change when the presentation changes in this way?
- Design a generic website for a university, museum, government agency, or other institution based on your analysis of existing sites. Make the top-level categories as specific and inclusive as possible. Can you sort all the second-level items from three existing sites into your categories? Are there items that fit in more than one category?

Creating Consistent Classification Schemas

- Create a classification system for a list of recorded music, using descriptive, distinct category labels and a consistent structure of subcategorization.
 - Write down the ten most recently played songs on your music player (or choose them from a popular music site. Combine your list with the list of four other students for a total of forty diverse selections.
 - Create a catalog format with fields that include the important information about each song. Put the information about each song on a separate index card (or electronic equivalent, such as a database record or spreadsheet file), so that you have forty consistently formatted cards.
 - Using the information on the cards, or other categories that you invent for the task, sort the cards so that every song is in at least one category. Photograph or otherwise record your sort.
 - Compare your sort with those of others. How well does each sorting scheme do at collocating like items?
 - Next, agree on a single list of categories. If necessary, allow a song to be listed in multiple categories.
 - Add forty songs from another group of students or another online source (such as a "recently played" or "favorites" list). How does your schema have to change to accommodate these new entries? Do you have to add new top-level categories or just make existing ones deeper? Do you have to change the names of some of the categories to make clearer distinctions?
 - Ask people who did not participate in the sort but who are familiar with some of the songs to look them up in your categories. Did they find them where they expected them to be?
 - Do your categories work as a classification schema? Justify your answer, remembering that the categories should be *recognizable* and *distinct,* and applied *consistently*; they should create a fairly *symmetrical hierarchy* and provide *complete* coverage of the domain. What practices made it harder or easier to create a suitably descriptive classification scheme?

Creating Labels for Knowledge Navigation

• Navigation of a well-labeled information resource should give a reasonable overview of the information domain. There were originally only three Internet top-level domains: .net, .com, and .org. Without looking up the actual current categories and without using the web, write down all of the current top-level domains that you are aware of.

 • What other domains can you think of that should exist?
 • Can you group these domains into groups or into a logical hierarchy?
 • If you were to redesign the domain nomenclature from scratch, what labels would you use?

• Create a top-level classification scheme for five to nine topics pertaining to poorly sorted information. Take at least thirty items chosen from a larger list of descriptive labels, such as the web portal topics shown (in part) for AOL or Yahoo (figures 7.14, 7.15).

 • Sort your list to find resemblances among items.
 • Create a set of top-level categories that is at least three and no more than nine items long. Place all thirty items in one of these top-level categories.
 • Determine if your items are symmetrically sorted. If not, would the categories be more symmetrical if you added more items from the original list? Adjust your categories so that you have confidence that each one will be filled and nothing in the master list will be left out.
 • Start with the category with the most items and create subcategories, placing no more than nine subcategories under each of the top-level categories.
 • Repeat until there are no more than ten items in any subcategory at the bottom of the tree, and no subcategory is empty.
 • Examine all your labels. Are they all the same part of speech (noun, verb, adjective)? Are the labels at the same level similar to one another? Is each label name used only once in the organizational structure?
 • Choose another thirty items and attempt to sort them into your categories. Change your categories as necessary to accommodate them. Are there some items that should be listed under multiple headings?
 • Test your schema by making a collapsible menu and inviting other students to find items located at the lowest level. Do they go down the correct tree the first time? If not, how would you change your navigational labels to make the right path more apparent?

IV DESIGNING ENCYCLOPEDIC RESOURCES

The main goal of information design is to increase the scope and organization of our shared focus on **information**: to give more people greater control over a wider range and a finer level of detail within any area of human knowledge.

Good information design should emulate a well-designed **database** in segmenting information into **semantic units** so that meaningful **chunks** can be accessed at multiple levels of **granularity** and aggregated in multiple **templates**. Sorting and segmenting information into the **tables** of a **database** requires making the similarities and differences among items more apparent, producing new knowledge and fresh insights into familiar domains. Well-segmented information is **multisequential,** providing multiple coherent paths through the information space.

Large databases pose an important problem for information designers, who must give the interactor **agency** by providing an overview, zoom, filter, and details on demands (Shneiderman 1992a).

Humanist designers should be aware that no information organization can eliminate the ambiguity of the actual world of human experience, and they should look for opportunities to create **boundary objects** that can unite disparate user groups in common schemas of representation.

Good information design should take advantage of the standards and **conventions** of networked **structured documents**, including **tagging** content with meaningful **metadata** so that it can be shared with a coordinated group of **distributed knowledge** workers and be made available for automated processes. In particular, designers should familiarize themselves with the emerging standards associated with the long-term efforts to create a **Semantic Web** and should look for appropriate opportunities to make use of XML, document **schemas**, and **ontologies** to create robust information resources that can be shared across applications and read by machines as well as humans.

Humanist designers should also recognize the trade-offs in imposing standardized vocabularies and models, and the importance of creating systems that are open to multiple viewpoints and changing configurations of knowledge.

8 The Database Model: Strategies for Segmentation and Juxtaposition of Information

From the single image that represents the "cultural unit" of a previous period, we move to a database of images.

—Lev Manovich (2001)

Semantic Segmentation

Finding information is not just a matter of appropriate and unambiguous labeling: it is also important to attach labels at the appropriate level of **granularity**. It is not helpful if a 1,000-page history of World War II is labeled as containing information about Franklin D. Roosevelt unless there is an index to indicate on what pages he is mentioned. In a conventional library, the cataloger is only concerned with book-sized items, and leaves the creation of the index, if any, to the publisher of each individual book. In an open networked resource like the World Wide Web, the indexing and cataloging tasks are greatly magnified, with information associated with individual pages and parts of pages rather than with a site as a whole. Similarly, the growth of time-based digital media such as audio and video files has increased the desire for access at finer granularity than the complete program or the whole album or even an entire song. We want to point to a particular frame or musical phrase, and we want to find it quickly. *The key task for the designer is to provide access to semantically segmented information, to information that is chunked into meaningful units.*

A **semantic unit** of information can be a word, a sentence, a paragraph, a chapter; it can be an image or part of an image; or it can be a combination of words and images, like an illustration with a caption attached. **Semantic segmentation** can take the form of hierarchies of nested units from the smallest to largest granularity (word, sentence, paragraph, chapter) or it can include overlapping chunks (like dialog and shot divisions in a film). In the digital medium we do not have to choose a single method of segmentation. We can employ multiple methods and use them separately or together. Legacy media provide a wide range of segmentation **conventions**, most of

which reflect the **constraints** and **affordances** of predigital **inscription** materials and **transmission** technologies. *When we decide which segmentation conventions to employ for digital archives, we should be guided by the principle of retaining information.* Legacy segmentation conventions based on physical format that also have semantic value include:

A single shot in a film
A paragraph in an essay or narrative
A single slide in a PowerPoint presentation
A scene in a play
A headline in a news story

Physical segmentation conventions that do not have intrinsic semantic value include:

Page numbers in a book or magazine
Time code in an audio or video clip
Floor numbers in an open stack library collection

Physical segmentation can be useful for referencing the original legacy artifact, however, and sometimes physical placement carries important cultural meaning. For example, it makes a difference if a newspaper story is on page one, and even where on page one it is placed (above the fold and to the right makes it more important than lower and to the left). The page numbers for a magazine or journal article, however, are usually without semantic value. Physical segmentation information can serve as an indication of duration or extent. In a **unisequential** (linear) medium it is useful to know that we are on page 255 of a 450-page book or thirty minutes into a ninety-minute film. But **multisequential** artifacts may need other kinds of duration conventions, such as lists of all the linked pages in a **hypertext** space, color-coded to indicate which ones have been previously visited. In translating materials from legacy formats, it is important not to lose any vital information associated with segmentation, such as page numbers of a rare book, but not to be limited to the original segmentation scheme in presenting the digital version.

Chunking of information is not just a matter of dividing up pies, it also involves **recoding**, by nesting information in larger and larger **containers**, like Russian dolls that nest inside one another. We routinely use **encapsulation** as a cognitive strategy, grouping things into larger categories without enumerating the contents, as a way of building up larger knowledge units. For example, it is easier to remember the group [Victorian novelists] and then the individual members of that group and then the individual names of each of their novels than it is to try to remember an unordered list of individual Victorian novels. Similarly, when we design information archives we should look for ways to segment complex information and encapsulate it in

hierarchies in order to be able to process and retrieve it more easily and at different levels of granularity.

Granularity of segments is an important design decision, and in general we should provide access to information at multiple granularities. The smaller the granularity, the more precise the control we can exercise over the information. Expert users generally need very fine granularity of access. In watching a film, the home viewer may be content with divisions into perhaps twenty DVD "chapters," but a cinephile may want access to one of the 200 scenes or the 1,000 shots that make up the movie. Even among expert users, different purposes dictate different segmentation schemas. For a Shakespeare play, for example, scholars may need to annotate and retrieve chunks by line number, by phrase, by word, but actors may see the play as divided by character entrances and exits or by dramatic beat. *It is part of the designer's analysis to understand how users currently access information and also how they would prefer to access it if offered greater flexibility.* Providing access at multiple levels of granularity allows the user to choose how best to retrieve and display the material.

In a multimedia digital archive, segmentation issues often arise in connecting related objects in different media formats. If semantic metadata has been attached to the information at the appropriate granularity the interactor will be able to collocate the relevant chunks without scrolling through irrelevant text or swiping through irrelevant video. If a science program or news show deals with multiple subjects, we want to be able to find only the segment we need without browsing through an entire show. If there are portraits of famous people in a collection of images we want to be able to search on a single person's name and find only that person's portraits rather than the whole set. When we are labeling a segment for browsing we should remember that the goal is to provide **intellectual access**—retrieval by subject labels. It is much more useful to know that a particular artifact refers to the Szechuan region of China, than to know whether it is a video segment, a jpg map, or a text file.

Just as segmentation and precision of retrieval is important, it is equally important that each segment preserve the context of the whole. We may not want to be distracted by multiple segments of a science show or multiple news stories when we are looking up a particular topic, but we want to be able to take advantage of the collocations in the original presentation environment, of the context in which the segment of information was conveyed. *We should therefore be able to trace our way back to the larger information unit from any segmented piece of it.* This is as true of a song within an album, a paragraph within an essay, an article within a newspaper, as it is of a shot within a scene, or a single scene within a film.

The model for the arrangement of segmented information in multiple views within the digital medium is the **database**. **Data** is information that has been structured in a standardized way that allows for machine processing. A database is an information structure that is made up of individual **records**, all segmented, labeled, and formatted

in the same way. The separate segments of a database record are called **fields**. Records and fields are semantic segments—they correspond to meaningful chunks of information. The content of the fields of a record in a database is information that has been structured into separate attributes and **values.** For example, the attribute of the "Street Name" field in a database of Contacts might have the value of "Main Street" in one record and "Peachtree Street" in another. When we make a database we describe a group of like items in terms of shared attributes with varying values: shirts of different sizes and colors, students with different courses and grades.

The conceptual basis of the database is the table of information in which columns represent fields and rows represent records. There are three kinds of databases:

Flat File
Relational
Object Oriented

Flat File Database

A flat file database is structured as a single table in vertical columns of categories and horizontal rows of instances. It is called a "flat file" because the entire structure can be represented by these two dimensions. We could represent the whole of any flat file database on a single linear sheet of paper, though it might be very wide and very long. Each horizontal row is a separate "record" and each record contains "fields." When the records lie one underneath the other the fields line up in columns.

For example, here is a flat file representation for the Three Bears household:

Table 8.1

The Three Bears and Their Possessions

Character	Porridge	Chair	Bed
Papa Bear	Hot	Big	Hard
Mama Bear	Cold	Medium	Soft
Baby Bear	Medium	Small	Medium

Each bear's preferences in porridge, chairs, and beds, as detailed in the familiar fairy tale, are laid out for comparison. We can take in the salient information very quickly in this format, allowing us to focus our attention and share the information much more efficiently than we could do in spoken or written sentences. In fact, if we add one more character, we can plainly see the pattern of similarity that forms a repeated motif in the story:

Table 8.2

The Four Characters in Relationship to the Bears' Possessions

Character	Porridge	Chairs	Beds
Papa Bear	Hot	Big	Hard
Mama Bear	Cold	Medium	Soft
Baby Bear	Medium	Small	Medium
Goldilocks	Medium	Small	Medium

But we can see that the underlying conceptual abstraction has lost clarity now. The distinction between bears and humans is crucial to the plot, so it should be another attribute/value—another column—in our representation of the world of the story, and our labels have to change accordingly:

Table 8.3

The Four Characters Differentiated by Species

Character	Species	Porridge	Chair	Bed
Papa Bear	Bear	Hot	Big	Hard
Mama Bear	Bear	Cold	Medium	Soft
Baby Bear	Bear	Medium	Small	Medium
Goldilocks	Human	Medium	Small	Medium

There is another important distinction that we have not yet captured in our abstract representation of the story world. The porridge, chair, and bed attributes in the bears' records represent actual porridge, chairs, and beds that belong to them. For Goldilocks, it represents only what she would prefer. Therefore, we could split the Porridge, Chair, and Bed columns into two columns, for ownership and preference:

Table 8.4

Ownership Differentiated from Preference

Character	Species	Owns Porridge	Prefers Porridge	Owns Chair	Prefers Chair	Owns Bed	Prefers Bed
Papa Bear	Bear	Hot		Big		Hard	
Mama Bear	Bear	Cold		Medium		Soft	
Baby Bear	Bear	Medium		Small		Medium	
Goldilocks	Human		Medium		Small		Medium

Displaying the information this way makes clear that the characters are not described symmetrically. We could infer that the Mama Bear likes her chair medium, but does she really like her porridge cold? Maybe it is cold because she was busy serving others and did not get to eat hers when it was hot. Maybe her bed is soft because it is an older one than Papa Bear's. Also, what is Goldilocks's home life like? Does it feature hot porridge and soft beds? And where do we record what Goldilocks was up to in that house? Putting information into tabular form makes symmetrical comparisons immediately graspable (such as whose chair, porridge, and bed Goldilocks will want), makes clear some gaps in our knowledge (like what Goldilocks' own bed is like), and obscures other information completely (like what Goldilocks was doing in the cottage). Although I have chosen a whimsical example, the issues that it raises are common to the tabular abstraction of any domain.

Ordinarily the kinds of information we think of as populating a database are already symmetrical and abstracted into easily identifiable categories. For example, an address book is one of the most widespread forms of databases. It inherits several longstanding systems of organization, such as assigning first and last names to individuals, assigning names to streets and numbers to buildings within streets, assigning names to cities, states, and countries, and assigning unique numerical identifiers in the form of ZIP codes, area codes, telephone numbers. Without these labels, nomenclatures, and tax-onomies we could not point to one another with any degree of reliability. Because these labeling systems had already been conventionalized into the standard print genres of address and phone books, they were easily translated into digital form (figure 8.1).

Figure 8.1
Flat file database: An entry from the Palm system Address book with separate fields for First Name, Last Name, Prefix, Nickname, and Title.

Flat file databases include some information that has to be entered separately for each record (such as a person's name) and some that is drawn from a limited set of possibilities (such as U.S. states). Both of these kinds of fields are attribute/value fields, but for states we can create a **value list** that makes it harder for the person entering the data to mistype or to create an entry the machine will find ambiguous, like NewY instead of the standardized NY for New York. Fields can constrain the format of entered data; a name field can accept letters and not numbers; a ZIP code field will only accept five or nine numbers. *These constraints make the data less ambiguous for the machine by limiting the expressiveness of the individual.* I might prefer writing NYC for friends who live in New York, leaving out the state and emphasizing the city where I grew up, but the computer can't rely on contextual knowledge (like knowing what state NYC is in). Making a database often involves making contextual knowledge explicit, since context is based on human embodied experience and cannot be inferred by machines.

Semantic segmentation is crucial to the usefulness of a database schema. Designers must separate composite information like a phone number, address, or date into separate, explicitly labeled parts (area code and local number, city and state, month, date, year). *The finer grained an information structure, the more powerful it will be for accessing information.* In a well-segmented contact list we can find the person whose name we don't remember whom we met at a conference three months ago, and who works for CNN. Or we can aggregate the information, collocating the records of all the people we know in Seattle, or all the ones who are employed by Microsoft, no matter where they work. The more standardized the information fields, the easier it is to automate fine-grained information collection, as with a business card reader that recognizes name, title, address, and email fields.

Unlike paper index cards or handwritten tables of information, electronic databases allow us to search and process the data. Databases can distinguish between letters and numbers, alphabetizing a column of names or adding up a column of figures. A spreadsheet, such as is produced in a software package like Excel, is a specialized kind of database that can store formulas in its fields as well as numbers and letters. When we look at the specialized flat file known as a spreadsheet we think not of records and fields but of **cells** arranged in rows and columns that can contain mathematical formulae, allowing them to perform operations such as totaling the figures above or to the left or figuring percentages of figures elsewhere. Each cell of the spreadsheet has a unique label created by combining its row number and column letter. By writing the formulas with abstract cell labels we make them into **variables**. Changing the number in one cell changes the calculated value in other cells. A spreadsheet can therefore offer a **parameterized** environment, allowing the user to explore different strategies and possibilities.

Flat files can also contain specialized fields that act as containers that store or point to external documents or **temporal media** files or segments. Video and film logs are

used by the producers of television news shows and feature-length movies to keep track of all the footage they shoot, which may amount to thirty to a hundred times as much material as will actually reach the screen. TV news shows are frequently called upon to find archival footage to give context to a breaking news story. In the predigital framework, the film or video footage is offline on a reel or a tape kept on an indexed shelf, and the database refers to it with a pointer to the reel or tape number and time code for the segment. In filmmaking, a placard is inserted into the recording stream to identify every shot by scene, shot, date, and take number. Digital workstations are now the norm for postproduction of television and movies, and are increasingly used for production and delivery, which means that semantic segmentation and labeling can be integrated into the production process. Since the moving-image segments produced for commercial television and film are often repurposed, for promos, games, and ancillary products, segmentation and indexing schema are growing areas of interest. Semantic segmentation and indexing are also increasingly desirable for personal video, as the amount of recorded moving images grows, and digital cameras include tagging as part of the recording process.

Among the most intensively used database applications for video are the systems created for competitive team sports. Football coaches at the college and pro level use systems that capture multiple views of games and practice sessions, segment the video by play, and allow for hundreds of annotations from controlled vocabularies. Coaches can call up information about their own team and about games played by other teams with precision and in real time, immediately after a practice session or years after a particular game. These complex systems require not just flat files, but also relational databases that have separate tables for information on individual players, teams, plays, and games (figure 8.2).

Database structure can also be used for artistic expression. Glorianna Davenport and Lev Manovich (figure 8.3), among others, have created experimental pieces that emphasize the recombinatory power of semantically segmented sequences of moving images (Davenport, Smith, and Pincever 1991; Manovich 2003).

Relational Databases

Relational databases allow us to capture data about complex systems using multiple tables that point to one another. Segmenting information into separate tables lets us keep information in different categories, and eliminates the awkwardness of incommensurable categories. For example, we could put our friend Goldilocks into her own People table and capture information about her preferences without worrying about making it symmetrical with the information about the possessions of the Bears (tables 8.5 and 8.6).

Table 8.5

People and Their Preferences

Character	Chair	Porridge	Bed
Goldilocks	Medium	Medium	Medium

Table 8.6

Bears and Their Possessions

Character	Chair	Porridge	Bed
Papa Bear	High	Hot	Hard
Mama Bear	Low	Cold	Soft
Baby Bear	Medium	Medium	Medium

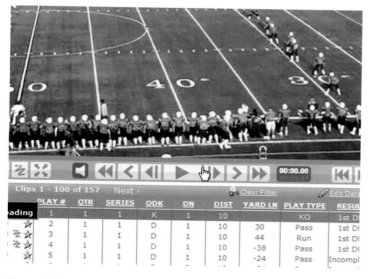

Figure 8.2

Database system for annotating video of football games. As information technology has become more widely available, high-end systems created for professional and leading college sports teams have been adapted for high school teams. Source: <http://www.hudl.com>.

Figure 8.3
Screenshot from Lev Manovich's experimental *Soft Cinema: Navigating the Database* (2005), a collection of films that are generated procedurally from a database of segments.

Classification with multiple tables can make us aware of other abstract categories that help us organize complex information about the world. For example, we might make another table of Households and Intruders, drawing from a wider range of fairy tales set in forests (tables 8.7 and 8.8).

Table 8.7

Householders

Householder	Vulnerable?	Why?
Papa Bear	Yes	Absent
Grandma	Yes	Old
Little Pig 1	Yes	Straw house
Little Pig 2	Yes	Wood house
Little Pig 3	No	Brick house

Table 8.8

Intruders

Intruder	Consumed	Not consumed	Regurgitated
Goldilocks	Porridge		
Wicked Wolf	Grandma	Little Red Riding Hood	Grandma
Big Bad Wolf	Little Pig 1, Little Pig 2	Little Pig 3	

Separating the information into tables lets us keep track of elements and attributes within different contexts: Papa Bear's absence is separate from his preferences, for example.

In order to relate information from one table to another, we establish standardized shared elements, such as unique numerical keys associated with each of the stories (table 8.9) and each of the characters (table 8.10), and we could relate the two by using the first two digits of each character number to indicate which story it belongs to.

Table 8.9

Assigning Unique Keys to Stories

Key	Story
01	Goldilocks and 3 Bears
02	Little Red Riding Hood
03	Three Little Pigs

Table 8.10
Assigning Unique Keys to Characters

Key	Character
0101	Goldilocks
0102	Papa Bear
0103	Mama Bear
0104	Baby Bear
0201	Little Red Riding Hood
0202	Wicked Wolf
0203	Grandma
0204	Hunter
0205	Mother
0301	Big Bad Wolf
0302	Little Pig 1
0303	Little Pig 2
0304	Little Pig 3

We would then use the uniform numerical keys instead of the much messier though more meaningful character names inside our database, since this will speed up processing and ensure accuracy: "Little" Red Riding Hood and "Little" Pig 1, 2, or 3 might all come up on a simple text match of the first six letters, but using our numerical keys it would only take two numbers to differentiate them (table 8.11 and table 8.12).

Table 8.11
Householders Indexed by Key

Householder	Vulnerable?	Why?
0102	Yes	Absent
0203	Yes	Old
0302	Yes	Straw house
0303	Yes	Wood house
0304	No	Brick house

Table 8.12

Intruders Indexed by Key

Intruder	Consumed	Not Consumed	Regurgitated
0101	Porridge		
0202	0203	0201	0203
0301	0302, 0303	0304	

Structuring relational databases is a specialized skill, involving technical knowledge of specific systems. Not every designer will be an expert in this area, but all designers should understand the ways in which information is segmented, sorted, and combined through databases since there are always trade-offs and cultural inflection points in any system of representation.

Information is entered and retrieved from a relational database through database management systems or more directly through a specialized code, the Structured Query Language (SQL, pronounced "sequel"). In general, the interfaces to databases are cumbersome and frustrating, created at too great a distance from the users of the information, and requiring expert intermediaries to create, change, or even access. Queries to databases often require knowledge of the structure of the tables, including explicit commands (known as **joins**) to relate the contents of one table to the contents of another. To compensate for the difficulty of accessing data, programmers often create custom queries to cover the most likely needs of end-users. But end-users may not be good informants for the programmers since they may limit their expectations to what is possible in their current system. *There is a need for designers to be more active in shaping these custom interfaces so that the end-user is appropriately supported in performing the core task and not limited to reproducing the constraints of legacy processes.* Designers can use techniques such as task analysis, **think-aloud protocols**, and paper prototyping with the end-users, and can actively propose novel kinds of searches to discover the core questions that the end-users bring to the information archive. These core questions may be different from the set of current queries. Identifying these core questions may lead designers to interview and observe a wider set of potential end-users than those currently engaged in querying the archive, since those who might most benefit from a more accessible information resource may have been discouraged by the difficulty of accessing the current archive. Sometimes the least technical people in an organization are the ones with the best understanding of what sort of questions need answering. Designers should therefore take care to identify an appropriately representative user group.

Once development of a database access system is under way, designers should conduct multiple **formative evaluations** with this representative group, since

Select CRN

ⓘ Please enter the CRN you wish to access, or select a different term from the menu.

CRN: | Master's Project - 51262 |
Master's Project - 51262
Master's Thesis - 51263
(Submit) Teaching Assistantship - 51264
Research Assistantship - 51265
Project Studio - 51671
Doctoral Thesis - 54216 [Enter Section Identifier (CRN) Directly]
Special Problems - 54878
RELEASE PhD Qualifying Prep - 55166
Special Problems - 56320

Figure 8.4
A flawed database query template makes this online system for entering final grades unnecessarily confusing and time consuming. Courses must be retrieved by "CRN" numbers, a unique identifier used by the database but meaningless to instructors. This transmission code should be hidden and the familiar course number should be displayed in its place. In addition, search results include courses for which no students are currently registered, creating multiple extra steps that could have been avoided by adding another table lookup to the query.

end-users often articulate their needs most clearly when actively engaged in using an interactive prototype, especially if they are performing a task they are genuinely invested in. The risk of ignoring the design process is that the system will duplicate or introduce new difficulties into legacy processes. The wrong querying structure can mean that common tasks will take multiple frustrating steps to accomplish when they could be done in one well-designed query. This is too often the case in existing systems. For example, consider a system for entering grades at a university that does not allow the instructor to enter semester and course number or to specify final versus midterm grades in a single query on a single screen. The system also does not filter out courses that have no registered students. This means that the end-of-semester work of every instructor includes frustrating, unnecessary, repeated actions that distract from the task at hand (figure 8.4). The waste of time is considerably worse for the thousands of people who are forced to use such poorly designed database-query systems every working day.

In addition to providing templates for searches, another common solution to the opacity of query languages is to offer static views of search results for common queries. Such views are important building blocks of information design, but they often limit understanding. For example, a standard database system for earthquake damage analysis by government planners allows users to explore the consequences of possible earthquakes. Users can specify a location and magnitude and receive as a report a

map-based plotting that shows nonfatal casualties or deaths or property damage, but it is not possible to request a single report displaying all three categories of information. Database systems often hold data that would be much more useful if displayed with greater flexibility.

The appropriate display of information within relational databases is an important area for design innovation. Instead of rigid templates and static views, we should be moving to more open and powerful querying systems, free from the transmission codes of SQLs. *Designers should look for ways to give end-users increasing access to the procedural power of the computer, allowing them to ask multiple questions based on multiple parameters of their own choosing, and to compare the results through meaningful views and juxtapositions.*

Navigating and Visualizing Large Databases

Databases have now grown so big that it can seem impossible to offer users an overview of their contents or to allow them to browse through them without becoming overwhelmed. Ben Shneiderman has suggested one useful approach to this challenge: visual displays offering overview, zoom, filters, and details on demand (OZFD) (Shneiderman 1992a). *Overviews* establish the scope and main categories of a large database and provide the context for all of the semantic segments and filterable attributes; *zooming* provides access to semantic segments of information at varying levels of granularity, and keeps the user oriented to the relationship between levels; *filters* allow users to limit the kinds of information they zoom in and out on based on **attributes** or **facets**, eliminating the need for multistep queries; providing *details on demand* allows users to call up the finest levels of granularity when needed without cluttering the interface.

Treemaps as shown in the examples in chapter 6 (figures 6.26, 6.27) and in figure 8.5 are one example of an OZFD approach to presenting a large amount of mostly quantitative information in a compressed space (Shneiderman1992b, Shneiderman and Plaisant 2009). For example, the state of the stock market has long been reported as a simple list (an instantly updated stock ticker), a table (in daily print-based newspapers), or a line graph of summary values like the Dow Jones Industrial Average over various time periods. The SmartMoney.com's Map of the Market presents the same information interactively, making overall trends and specific details more immediately readable and retrievable on demand. The display (figure 8.5) offers an overview of about six hundred individual stocks, arranged by market sectors (Energy, Financial, Health Care, etc.), following the practice of professional analysts. It reports the most salient quality—is the market up or down in the past fifteen minutes?—by color-coding, and it includes a knob for adjusting the color contrast from the conventional green/red to blue/yellow for the color-blind. Size is also semantic, with larger boxes

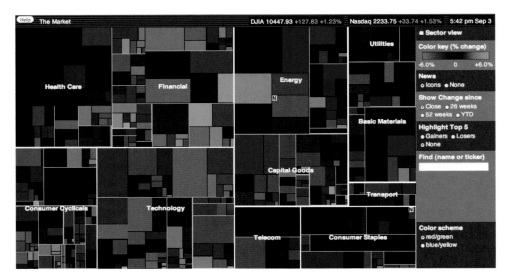

Figure 8.5
The SmartMoney Map of the Market (1998), a treemap visualization of a complex, dynamic, relational database. The control panel is at the right, and the interactor can also drill down within the sectors to an individual company by navigating the blocks. The map, created by Martin Wattenberg, obeys Ben Shneiderman's principles of overview, zoom, filter, and details on demand. Available at <http://www.smartmoney.com/map-of-the-market>.

for bigger companies and sectors. (The placement and proximities of each sector on the screen is not semantic but it is consistent from day to day and year to year.) The display can be filtered by time and performance, and zoomed in and out to see subsectors and more details about individual stocks, each of which has an appropriately sized rectangle representation that changes color and size individually. The map therefore shows at a glance the overall performance of the market, automatically highlighting the performance of sectors and individual stocks that are doing significantly better or worse than others. The control panel allows for recontextualization of the information in different time spans, which is an important variable for the domain: a stock, sector, or even the whole market may be up over the past two months but down over the past two years. The treemap presentation reveals changes in value over time and relative performance of one sector against another with very few clicks and page reloads.

The translation of market structure to visual structure makes the information much more accessible than ticker tapes or newspaper tables, or than similar multigraph efforts of other news sites. But the arrangement like any information display emphasizes some things and hides other. The display does not cover every stock traded in New York, let alone internationally. The placement of company rectangles within a

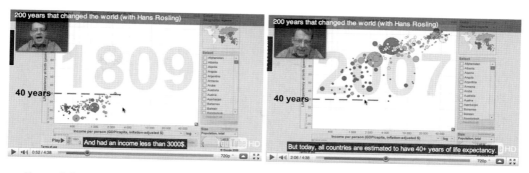

Figure 8.6

Hans Rosling uses bubble animation visualizations to explain complex economic changes over time. The video is available on YouTube, and software is available for exploration at <http://www.gapminder.org>.

sector is not semantic and it can visually call attention to contrasts and similarities in the performance of particular companies or sectors that happen to have been placed next to one another for the purposes of a tidy display, but may not be semantically related. As with any encyclopedic resource, the implicit claim of comprehensive coverage should be examined. Like other stock market summaries it does not track or represent factors important to other constituencies beside traders, such as executive compensation, location of headquarters, or carbon footprint. Along with other materials associated with the Market Map, it encourages a view of the market that connects vigilance over short-term changes with successful investment.

Databases often contain information about changes over time. In print media these changes are presented in graphs with time along the x (or horizontal) axis, plotted against one other factor on the y (or vertical axis). Hans Rosling, the founder of gapminder.org has introduced animated interfaces to large international databases, plotting two changing economic or social factors on the x- and y-axis, while displaying temporal changes in animation. His visualizations of the information in databases maintained by the United Nations and the Organization for Economic Co-operation and Development (OECD) produce dramatic graphs of rising and falling health and income, with multiple countries represented as bubbles on the same graph, differentiated by color, displayed in sizes proportional to their economies, and often linked to a geographical map. This approach can clarify complex changes, capturing the elation of rising standards of living and the poignancy of decline. The interactor can navigate the information by country, region, and time period, discovering new connections and creating their own animations (figure 8.6).

The exploration of visual strategies for displaying large databases is a growing area of public participation as well as a focus of design research. The World Wide Web has

Figure 8.7
Guardian.co.uk, the website of the *Guardian* newspaper, makes large government databases available to its readers and invites them to submit visualizations.

served as a platform for making large data sets available, and developers are producing sharable tools for visualizing data, which are being used by researchers, citizen groups, and curious individuals (figure 8.7). The availability of these tools provides an opportunity for designers to increase their data skills and to develop model applications of the technology that make complex relationships understandable. Although many visualization applications produce only static displays rather than interactive filtering and zooming interfaces, the availability of these rich information sources will raise expectations and create demand for datasets that are not merely chartable but dynamically explorable.

From Tables to Objects

Object-oriented databases are an emerging organizational structure based on **object-oriented programming** techniques, but still too poorly and inconsistently implemented to be a true standard. In addition to data, object-oriented databases would allow the user to define procedures: complex rules that relate items within the database to one another and determine not just what attributes they have but also how they behave. We can think of an object-oriented database as having the same relationship to a flat or relational database as an electronic spreadsheet (like those created in Excel) has to a table of figures created in a simple word processor. Along with symbols the

spreadsheet contains logical relationships, allowing us to command a complex abstract structure of variables and formulas rather than just a grid of numbers. Similarly, when we move an ordinary database, with rows of items and columns of attributes and values, into an object-oriented world, we gain the power to describe the items algorithmically, as dynamic procedures.

In an object-oriented database, the basic units of organization are object classes and objects, rather than tables and records. Classes of objects inherit attributes (qualities) from one another. For example, one could have a class of news stories, all of which have the quality of date, time, and place. Objects inherit the attributes of their class but they can also have variant attributes that belong to subclasses or individual objects. A news story might belong to the subclass of text article, which would give it the attribute of a byline; or it might belong to the subclass of video, which would give it the attributes of producer and reporter. Objects also have methods, which are pieces of programming code. A text news story might have a display method that formatted columns on a page, while a video news story might have compression and playback methods suitable for moving images and audio tracks. But both objects would inherit the same news story template for assigning the story to a date, time, and place. Object-oriented databases can be part of object-oriented programming environments, like Java. They may turn out to be particularly well suited to multimedia applications since they allow the designer to associate different behaviors with different media formats while also sharing other attributes and behaviors across media formats.

Relational databases are cumbersome because it is hard to write the queries that relate one table of attributes to another. For example, it takes explicit knowledge of the design of multiple internal tables to ask if Papa Bear is both absent and fond of a hard bed. An object-oriented database might allow us to perform the same tasks more efficiently, while opening up more powerful ways of exploring rich collections of parameterized data. Returning to our fairy-tale world, for example, the three bears might each be an instance of the class of BEAR, and Goldilocks would be an instance of the class PEOPLE. BEARS and PEOPLE might share methods for EATING, SITTING, SLEEPING. Having the story in an object-oriented database opens the possibility for variants in behavior, such as instantiating a Goldilocks who hates porridge, or who respects the property rights of bears. Traditional databases force all data into uniform formats. Object-oriented structures can be more tolerant of one-of-a-kind items, allowing them to share some qualities and methods with the class(es) they instantiate, while possessing other attributes that belong only to themselves. Such a design may be increasingly useful in our shared, networked media-rich environment in which contributions come from and are distributed to many people in many different formats, simultaneously increasing the demands for standardization and customization.

The Persistence of Ambiguity

Databases take discrete items of information and format them in consistent ways for automated processing. Because databases require uniformity they are systems that encourage us to look at the world in terms of expected values, often expressed numerically, since numbers are more uniform than words, or constrained to a predetermined attribute/value list, whether for T-shirt colors or ethnic identity. Anything that falls outside of these expected values may simply become invisible. *Life is analog and indeterminate but data structures are discrete and standardized, forcing category choices that do not fix the shape of our lived experience.* Is my profession "educator" or "researcher" or "writer" or "designer"? Is my grandmother's last name the one she had in Russia or the one the immigration officials changed it to when she came through Ellis Island? Race, ethnicity, religion, and marital status are increasingly contested cultural categories, evoking personal answers that fit more appropriately into a narrative than a checkbox (figure 8.8). The database wants simplified, unambiguous answers, but human experience is never simple and always contextualized. And our contexts and values are inevitably subject to change.

Classification schemes are always open to cultural challenges, even those we think of as grounded in physical realities. Classifications, like words themselves, ultimately rest on consensual associations, on shared contexts and practices that form *communities of interpretation*, rather than on absolute, objective distinctions. Cultures differ tremendously in the classification of experience, even such immediate and physiologically anchored experiences as tastes. For many years western culture assumed that human taste receptors could identify four distinct flavors: sweet, salty, sour, bitter. But Japanese culture includes a fifth flavor known as *umami*, or savoriness, the quality of monosodium glutamate in Asian foods and of glutamates in meats and cheeses. For westerners, learning the new category can change the tasting experience, even in retrospect.

Culture influences classification processes, and classification processes can lead to social and cultural changes. As Bowker and Star have pointed out, the decision to validate nursing care by assigning it appropriate hospital billing codes has complex consequences. A billing code for administering medication is straightforward, but what about the nurse's ingenuity in engaging a patient socially to allay anxiety? If we make joking with patients to relieve anxiety a billable commodity, then some parts of nursing care become more visible, but the human experience of the joke will be changed (Bowker and Star 1999).

Classification systems often reflect economic and power relationships, and they can be the subject of political, legal, and economic disputes. Areas of a city are subject to classification by zone for the purposes of development, as SimCity players well know, often to the dismay of the people who live there. Insurance companies

8. Is Person 1 of Hispanic, Latino, or Spanish origin?

☐ **No,** not of Hispanic, Latino, or Spanish origin
☐ Yes, Mexican, Mexican Am., Chicano
☐ Yes, Puerto Rican
☐ Yes, Cuban
☐ Yes, another Hispanic, Latino, or Spanish origin — *Print origin, for example, Argentinean, Colombian, Dominican, Nicaraguan, Salvadoran, Spaniard, and so on.* ↘

| |

9. What is Person 1's race? *Mark* ☒ *one or more boxes.*

☐ White
☐ Black, African Am., or Negro
☐ American Indian or Alaska Native — *Print name of enrolled or principal tribe.* ↘

| |

☐ Asian Indian ☐ Japanese ☐ Native Hawaiian
☐ Chinese ☐ Korean ☐ Guamanian or Chamorro
☐ Filipino ☐ Vietnamese ☐ Samoan
☐ Other Asian — *Print race, for example, Hmong, Laotian, Thai, Pakistani, Cambodian, and so on.* ↘ ☐ Other Pacific Islander — *Print race, for example, Fijian, Tongan, and so on.* ↘

| |

☐ Some other race — *Print race.* ↘

| |

Figure 8.8

Questions from the 2010 U.S. Census form. Ethnic and racial groups are culturally and politically determined categories, with vague boundaries and shifting definitions, whose members differ in their self-descriptions.

classify medical procedures and property damages in ways that limit their liability, and sometimes outrage policyholders who expected a needed operation or disaster recovery to be covered. Citizenship is a classification system that is politically defined, carries enormous personal consequences, and is enforced, at times at gunpoint. Information technology has been used in the service of repressive and even murderous classification systems. Census data collected in 1933 with the help of IBM machines helped Hitler to identify the Jewish and gypsy populations of Europe, and punch-card technology kept track of their extermination in the concentration camps (Black 2001). National identity cards were an important part of enforcing apartheid in South Africa and genocide in Rwanda. Although these are extreme examples, they

are important reminders of the human consequences of classification schemes. Whoever determines the classification rules or administers the classification process is exercising power and affecting how the classified domain is seen, understood, treated, and experienced by those inside and outside of it. Segmenting and labeling information is therefore often a political task, and even a small change in a data structure or a web navigation system can reveal areas of contested meaning and conflicting interests.

Since labeling and classifying are such foundational and politically charged activities, the information designer is often called upon to bridge divergent interest groups or communities of practice. One way to think of this activity is to frame it as a task of recognizing, refining, or creating **boundary objects**. A boundary object is any cultural artifact or practice that has one structure but different meanings for different groups of people (Bowker and Star 1999). For example, an Ivy League diploma can signify disciplined intelligence to one group, upper-class affiliation to another, and professional credentialing to a third, yet all three will recognize the same social and cultural practices for earning and verifying it.

A large database or IT system can also be seen as a boundary object. The designer's job therefore is to identify common categories that will work across diverse groups of stakeholders, from sales people to creative teams to lawyers, so that they can share information and contribute to common records, while seeing the world very differently from one another. To do this the designer must understand how each group constructs the common enterprise and come up with a design for a shared resource that will be meaningful to all while not imposing one group's framework on the whole organization. For example, when a large movie studio sought to unify its database system it discovered that many in-house groups made use of still images taken from a single frame of a motion picture, but they stored them in multiple incompatible systems and referred to them with different names depending on whether the images were being used by production continuity, postproduction editing, marketing, publicity, or licensing. The hardest part of designing a unified system was not the underlying representation of a film as a set of single frames, but the superstructure by which those frames could be retrieved, tracked, and incorporated in these divergent work processes. Tasks like these have been described as the work of brokers, who must be careful not to ally with any particular faction while advocating for and facilitating the creation of a single representation that fits into each of the divergent mental models (Pawlowski, Robey, and Raveb 2000).

The tools of information design may be used to critique rather support the status quo. For example, Josh On's website They Rule (On 2004) uses seemingly neutral data about the membership of corporate boards of directors to generate images of the networks of interlocking directorships that link one company to another, and often to academic institutions, presidential cabinet members, and Washington, D.C., think

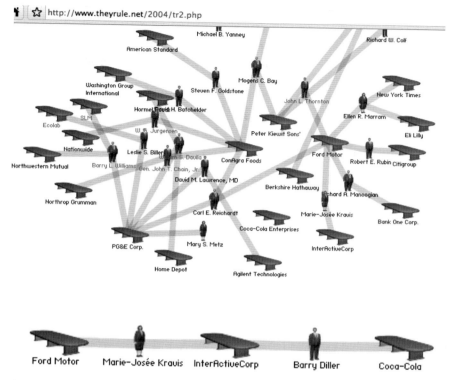

Figure 8.9

Two ways of visualizing and exploring corporate connections on the They Rule website created by Josh On (2004): (top) by following links from companies to directors and directors to companies to build a network; or (bottom) by asking the application to generate the links between two entities (here, the Ford Motor Company and Coca-Cola, which are connected through only one other company).

tanks. The site can also be used to generate connection paths, showing that seemingly disparate companies can be connected through their boards of directors in just a few steps. In conjunction with the explicitly anticorporate designer's notes, the intentionally impersonal iconography reinforces a sense of corporate directors as an illicit oligarchy, hiding in plain sight (figure 8.9).

Although the information sciences (as well as many fundamental cultural structures and cognitive strategies) rely on shared classifications and standardization of terms, all such systems may be flawed because of the arbitrary nature of language itself. Many contemporary humanists would agree with Wittgenstein (1958) that the verbal categories we take as absolutes really point to very divergent things that have only a "family

resemblance" to one another. Wittgenstein's example was the category of "games" that he declared meaninglessly broad since it contains such disparate examples as Ring Round Rosey and chess. How then do we organize items that are only mingling together in vaguely similar clumps, rather than neatly sorted onto hierarchical, sharply differentiated trees? One strategy, proposed by Eleanor Rosch as a model of how the mind works, is **prototype theory.** Rosch's research established, for example, that people consider "chair" and "sofa" to be better examples (i.e., **prototypes**) of the category "furniture" than "mirror" or "wastebasket" (Rosch 1975). Prototype theory suggests that we can elicit this kind of conceptual framework from particular communities of practices, by asking them to identify best examples of confusing categories (like "checkers" or "baseball"). Using prototype theory to organize a domain we would not ask subjects to sort cards into separate stacks, but rather to spread them out across a continuous space according to degrees of resemblance (Does soccer go near checkers or baseball or Ring Round Rosey or off in its own corner? How about Scrabble?). Prototype theory is particularly useful for exploring large collections of similar items (like mobile devices or websites) that may not yet belong to fixed media genres. *Focusing on prototypical examples allows us to identify shared attributes without having to commit ourselves to a single taxonomy for a diverse set of items.*

The advent of the computer has increased our ability to collect and manipulate data, but it has yet to increase our awareness of the complex processes by which we choose to measure and name some things but not others. The proliferation of cheap, rapid computational systems has meant that we can create bigger and bigger databases, providing increasingly uniform access to increasingly disparate information. It makes it more and more likely that we will find ourselves assigned a numerical identification so that our personal **attributes** and **values**—as students, employees, consumers, taxpayers, international travelers, mortgage holders, and so on—can be represented and cross-referenced in uniquely labeled, lifeless relational database records. Sorting experience into uniform database tables lets us see larger patterns, but it also removes us from the detail of the narrative layer, which is much closer to lived experience.

As information designers we have to take advantage of existing media conventions and cultural abstractions in order to focus our shared attention on the same information. But we should resist the urge to move prematurely from messy, ambiguous experience of the **lifeworld** into overly neat cliché. Once more we need to remember the old programmer's adage of "garbage in, garbage out" **(GIGO)**: we do not get any useful output from a computer, no matter how brilliantly complex the programming, if we feed it incomplete or overly simplistic data. It is the designer's job to expand the structures of data abstraction to contain new knowledge about the world, not to merely recycle legacy categories. We have to make an extra effort to discover the data that we are not collecting, the questions that we are not asking,

the categories that are messier than our existing models. We can never eliminate bias or distortion from a dataset, or invent a perfect system of categorization, but we can do our best to make our assumptions clear and to be open to revising our classification schemes and data structures as our knowledge and understanding change over time.

DESIGN EXPLORATIONS: THE DATABASE MODEL

Creating Semantic Segmentation schemes
• For a favorite movie, television show, or recorded sports event that you have watched more than once, make a list of all the key elements that are most memorable to you (e.g., a character, scene, shot, line of dialog, action sequence, romantic tone, sports play, performance by a single player, attitude of a group or individual).
 • How would you segment the entire temporal unit (the two hours of the movie, the half hour of the TV show, the duration of the sports event) so that it reflected existing media segmentation conventions (such as the divisions between commercial breaks, titles, credits)?
 • How would you find the memorable elements that you have listed within the structure of conventional media segments?
 • Create a new system of semantic segmentation that would provide **intellectual access** to the memorable elements you most value (for example, dividing the telecast of a football game by plays).

Creating Meaningful Attribute Fields in a Database
• Make a flat file table of all the regular characters in your favorite TV sitcom (or other fictional art or entertainment with nine or fewer regular cast members).
 • How would you describe them using the same fields but different attributes?
 • What are the most important points of difference and resemblance?
 • Are some of the attributes quantifiable by existing measures (e.g., estimated age, income level, I.Q.)?
 • Are some attributes quantifiable by scales (e.g., attractiveness, foolishness)?
 • Are some of them limited to a known set of values?
 • Sort the table by the attributes. Does alphabetical or numerical order provide a meaningful organization? Are there other groupings that would be more meaningful, perhaps based on multiple attributes?
 • Compare your table with that of others. Can you design a generic sitcom character record structure that would accommodate all of the attributes identified by members of the group?
• Make a flat file of all the recurring characters in a complex TV or live drama, or a film or print fictional series with at least fifteen recurring characters (e.g., *The Wire*,

The Sopranos, and *Lost* TV series; the *Star Wars* movies; the novel *War and Peace;* or a Shakespeare play), using the same fields to describe each of them.
 • What groups do these characters fit into?
 • What attributes are most important in describing them?
 • What quantitative attributes describe them?
 • What qualitative attributes have a limited value set (e.g., Mafia families, law enforcement agencies, planets of origin)?
 • Which attributes change over the course of the story?
 • Compare your table with those of other group members. Can you design a generic dramatic character record structure that would accommodate all of the attributes identified by members of the group?
• Brainstorm a diverse list of twenty-five foods that might go into a salad. Imagine that each of these is represented by a record in a common flat file database, which would also be open for new items to be added.
 • What would the attribute fields be if you wanted to combine the ingredients to make visually beautiful salads?
 • What would the attribute fields be if you wanted to make healthy salads (be specific in your personal definition of healthy)?
 • Determine your own set of salad goals and attribute fields based on your own taste, drawing as much or as little as you like on the two previous attribute sets.
 • Using pseudocode or a flow chart write a rule set or decision tree that would access your salad ingredient database in order to assemble multiple pleasing salad combinations.

Using Data Visualization Tools
• On the ManyEyes website (<http://www-958.ibm.com/software/data/cognos/many-eyes>) or a similar resource for visualization strategies and software, compare two visualizations of the same data set.
 • Which provides the best display by Shneiderman's criteria of overview, zoom, filtering, and details on demand?
 • How would you improve them to address any deficiencies?
• On the same website, choose a single tool or visualization strategy and apply it two or more data sets. How was it suitable or not suitable for each of them?

Becoming More Aware of the Cultural Values Implicit in Informational Resources
• Find three quantitative charts on the same general issue from current news sources (e.g., election results, ecological disaster and recovery efforts, the state of the financial system, pending legislation).
 • What labeled elements of the domain and what attributes and values are the charts based on?

- What parts of the domain have not been counted and have been rendered invisible?
- How would you modify the display of They Rule (<http://www.theyrule.net>), using the same data, to celebrate rather than call into question the activities of people serving on multiple boards?
- Two private exercises follow, *not to be shared,* on values and labeling:
 - Create a coding system to rate the activities of your friends and family on the attributes, actions, products, and services that are most important to you. Use as your model a hospital billing system, but assign credits and demerits instead of prices. For example, your partner making you breakfast would earn credits whereas crashing your car would earn demerits. Would you ever show this system to any of the people involved? To other people? Is this kind of scoring a useful basis for thinking about relationships?
 - Now make a similar coding system for your own behavior, using multiple tables for the different people or interest groups you interact with. What earns their favor or disfavor? How would you feel if you were being scored in this way? Would you or someone you know find it helpful?
 - This part can be shared if you choose: Based on the two private exercises, do you think there are some kinds of information that definitely should not be expressed in quantitative form? Why or why not?

Working with Boundary Objects

- Social networking sites as boundary objects: sites like MySpace or Facebook or LinkedIn are examples of boundary objects that are used by many diverse communities of practice, from teenagers or seniors looking for social connections to public relations firms bringing attention to entertainment media to professionals connecting with one another. Choose three distinctly different kinds of users from any social networking site and consider:
 - How does the category of "friend" or similar linking mechanism function the same and differently in each of the three groups? How are people connected to one another?
 - How are updating conventions like blog posts or a status line used by each of your groups? In what way are the uses similar? How do they diverge?
 - Do your groups intersect at any point (e.g., parents monitoring children; corporations posting to personal pages)? What is the effect of these intersections?
 - Suppose that the three groups were on different sites with divergent conventions. How would the linking mechanisms, blog posts, status lines, or (if you like) some other convention(s) change if customized for only one kind of user?

Using Prototype Theory to Map a Domain

• Make a list of at least twenty-five objects within an ambiguous category or emerging genre of diverse digital objects such as websites, video games, mobile phone applications, input devices. Make two copies of the list: one that is fixed and linear, and another that is made up of movable objects, one per item, such as index cards or bubbles on a concept mapping program.

 • Choose three of the objects as representative prototypes—best examples—of diverging aspects of the domain.

 • Draw a diagram, placing these three objects spatially in a way that represents their relationship to one another. For example, they might be in an equilateral triangle or points along a line. Leave room for the other objects on your list to fit on the same diagram.

 • Look over the remaining items and place them one by one on your diagram, taking care to mark their proximity to each of the landmark prototypes.

 • Compare your diagram to those of other individuals or groups. Do their prototypical examples make sense to you and vice versa? What qualities have been important for each group?

 • Can you create a unified representation that includes all the items listed by both groups? Can you use all the prototypical examples or do you have to eliminate or combine some or invent new ones? How does the landscape change when the prototypes change?

• Compare an information organization based on prototypes with one designed as a hierarchy. Collect the titles of 100 songs from everyone in class without identifying who supplied which item. Arrange the collected list in a database with whatever metadata are already attached to the items. Sort them alphabetically by title (or in any way that randomizes the genres of music) and take the first fifty items as your Test Set.

 • Stage 1: Divide into two groups, H and P.

 • Group H: Create a hierarchical representation of categories of music that includes everything in the items in the Test Set.

 • Group P: Create a prototype diagram organizing the Test Set based on exemplary prototypes and outliers, with proximity used to indicate the degree of resemblance (e.g., How far is selection X from Johnny Cash and from Edith Piaf?). Indicate the attributes shared by items that are near one another.

 • Both groups: You may add items to the list to make the classification clearer or to provide better examples of exemplars and proximities, but you must account for all the original Test Set items.

 • Be sure to provide clear descriptors for the hierarchical categories (Group H) and for the shared attributes that create the landscape of prototypes (Group P).

- Refine the original database as you make up your chart to accommodate the distinctions you are making with appropriate attribute fields.
 - Your end product is a hierarchy or prototype chart and a revised database.
- Stage 2: Reconvene and compare Group H's and Group P's organizations.
 - How closely do the organizational schemas resemble one another?
 - How closely do the associated databases resemble one another?
 - What distinctions or resemblances are better captured by one or the other approach?
 - Could the songs that were added beyond the Test Set by each of the groups fit into the schema of the other group?
- Stage 3: Work separately to refine your schema, using as many of the remaining fifty items as possible. Compare the refined diagrams and consider together the common difficulties of organizing the domain, and the advantages and disadvantages of each approach.

9 The Structured Document Model: Using Standardized Metadata to Share Knowledge

Wholly new forms of encyclopedias will appear, ready made with a mesh of associative trails running through them.
—Vannevar Bush (1945)

Whatever digital artifact we are designing—whether it is a marketing and retail space for a toy seller or a repository for data about stars at the farthest reaches of the cosmos—we can approach the task as an opportunity to advance the **encyclopedic** potential of the medium. The aggregation of media archives in digital form offers a historic challenge to the designer to turn an exponential increase in our **inscription** and **transmission** capacity into a comparable increase in human knowledge by inventing and refining more powerful **conventions** of information organization.

Structured Documents Are the Basis of the World Wide Web

Databases are now a crucial part of web design. A large retail site like Amazon.com is generated dynamically from items stored in relational databases. The basic information for a book description is entered only once, and can then be pulled up in whole or in part on multiple pages that are assembled as they are needed. If anything needs to be altered, it is altered only once, and then every instance of the book description will incorporate those changes. Similarly, college course catalogs, which used to be print items, released every few years and often out of date, are now routinely kept as databases and published on the web. Information about individual courses can be accessed in multiple contexts, and descriptions of programs can be kept up to date by maintaining the database entry. But the web does not display information in the form of database reports; it displays them as **structured documents**.

A structured document is a text, image, video, or audio file, or combination thereof that has labeled (tagged) sections, similar to database fields whose contents can be referenced by those semantic **tags**. The World Wide Web is a collection of loosely structured documents that is growing more organized over time through the adoption

of standards for tagging media containers. Just as the much copied proverbs, spells, and sales slips that formed the pasted-together rolls of papyrus eventually grew into the organizational complexity of the modern library and database, so the scraps of information we are currently creating and retrieving over the web may someday be transformed by similar advances in organization and aggregation into a more coherent repository of knowledge. As with earlier advances in knowledge aggregation, greater organization of our burgeoning networked resources will result from the basic activities of labeling, classifying, and establishing intellectual access at multiple levels of semantic segmentation.

The World Wide Web is the result of five centuries of print culture. By the 1940s, and with the heightened emphasis on knowledge systems that came from the development of the university/military/industrial complex, it became apparent to some that the library system could no longer keep pace with an exponential knowledge explosion and the growing demand for faster access to information for commercial and political purposes. In 1945, Vannevar Bush, director of the U.S. Office of Scientific Research and Development during World War II, published a visionary essay called "As We May Think," in which he imagined a futuristic workspace based on photo-images of books that could be called up at will, annotated, and linked. He called this imaginary machine the **memex** because of its role as an extension of human memory. Here is Bush's classic description of how it would operate:

The owner of the memex, let us say, is interested in the origin and properties of the bow and arrow. He has dozens of pertinent books and articles in his memex. First he runs through an encyclopedia, finds an interesting but sketchy article. . . . Next, in a history, he finds another pertinent item and he ties the two together. Thus he goes building a trail of many items. Occasionally he inserts a comment of his own, either linking it into the main trail, or joining it by a side trail to a particular item.

And the trails do not fade. (Bush 1945)

To explore this new frontier of knowledge, Bush called for "a new profession of trail blazers, those who find delight in the task of establishing useful trails through the enormous mass of the common record."

Bush's model combines the American myth of exploring uncharted wilderness with the scientist's paradigm of collective mapping and individual trailblazing. His model assumes an active, almost restless search for knowledge. Bush's scientist is not expected to follow or forge a straight line. There are side trails as well as main trails creating a space of intersecting experts, mapping a common landscape of knowledge. Isaac Newton's famous celebration of the contribution of scientific trailblazers is similarly geographical: "If I have seen further it is by standing on the shoulders of giants" (letter to Robert Hooke, 1676). But Newton's **metaphor** implies a fixed position and a top-down view on a fixed geography of knowledge. Bush imagines knowledge as a forest

to be traversed, with multiple pioneers at ground level, moving in different directions, to create a dynamic, collaborative network of human understanding. After five centuries of print culture, the landscape is too big to be surveyed whole by any one person.

Bush's model of a web of knowledge was picked up in the 1960s by Ted Nelson as the networked desktop computer terminal was becoming available, and higher-level programming languages were expanding the range of business and technical applications from payrolls to space flight. Ted Nelson coined the term "hypertext," and proposed using computers as "literary machines," envisioning vast digital libraries that connected texts to one another.

Nelson was the first person to think and write extensively about how texts could change in digital form by taking advantage of the capacity and processing power of the machine. He envisioned a system with a highly complex structure in which any document could reference and include any part of any other document, and he remained an advocate for this architecture even after the worldwide adoption of HTML, continuing to work on his lifelong project of an ideal system called Xanadu. For Nelson, hypertext should always associate every part of a document with a single originating instance, and automatically link all other instances of and excerpts from that document back to its original, a feature he calls **transclusion**. In a system with transclusion all instances and excerpts of a single document would change whenever the originating author saves changes to the originating file. His notion is an application of the concept of modularity, similar to the way the same **function** can be called by different programs; or the same externally stored image can be displayed in multiple **HTML (HyperText Markup Language)** pages just by naming them within a shared **protocol** (like a programming language or **URL**). Nelson and others have argued that such a system is the best way to resolve the problem of authorship, allowing clear attribution of all copied materials and supporting **micropayments** to authors (Nelson 1974a, 1974b, 1987, 1992, 2007) (figure 9.1).

By the end of the 1980s several hypertext systems had been created, which used "hot words" and "buttons" to link pieces of information together, causing the user to jump from one note card-like segment of information to another by clicking on the "hot" word. These systems were widely used in educational environments, but they were incompatible with one another, and were mostly stand-alone rather than networked systems. The most successful such system was Apple Computer's HyperCard, which employed the format of a stack of index cards, and allowed consumers rather than professionals to create links. The wide use of HyperCard in schools helped prepare the way for the networked hypertext of the 1990s, and inspired the wiki structure of networked, collaborative hypermedia, exemplified by Wikipedia. It is significant that it was based on the familiar convention of the index card, invented at the end of the eighteenth century and used most widely in library cataloging systems.

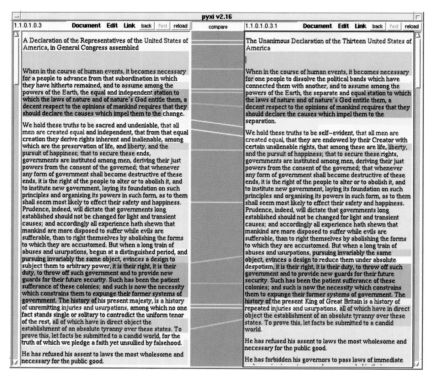

Figure 9.1

Ted Nelson's Xanadu system displaying multiple versions of the text of the Declaration of Independence. The system is based on a vision of hypertext as a complex conversation among documents with multiple appropriations and recontextualizing of the same texts. See <http://www.xanadu.com.au>.

Networked hypertext became a unifying global format for the inscription and transmission of information largely because of the ingenuity and social principles of Tim Berners-Lee, who developed the **HyperText Markup Language (HTML)** while working as a researcher at the CERN physics laboratory in Switzerland in the 1980s, and created the world's first HTML website in August 1991. Berners-Lee wanted to make it easier for researchers to share documents loaded on servers, which was then done with the file transfer protocol (FTP). To FTP a file required specialized software and the file itself was not viewable until it was opened in whatever software had created it. There were passwords involved in each transaction and the transferred files might not display properly on the recipient's machine. Berners-Lee's standardized **markup language** and system of net addresses (the URL, or universal resource locator) made it easier to find the right document on the right machine and to display it in

readable form on any platform. Most importantly, HTML included a tagging convention for turning any part of the document into a **link**, eliminating the need for securing and typing in a URL for every file you wanted to view, and providing a uniform transmission code for hypertext.

One of the crucial elements in a hypertext system is that it eliminates one or more layers of distracting transmission code. In a library we have to translate our request into a call number and the call number into a location on a shelf. In a book index we have to translate our interest area into possible key words, look up variants of the key words in an index, follow the index pointer to a particular page and search the page for the related material. In a hypertext system the indexed key words are the pointers and the URL is hidden in the source code. The link is a powerful new kind of label, unique to computational environments: it can function as an identifier, descriptor, address, and as a means of directly retrieving the information it identifies, describes, and points to.

Because of the organizing power of the link, the value of hyperlinked information rests on the quality of the words and images used as pointers, the semantic descriptor that is enclosed within the linking tag and displayed as an underlined or colored link. These labels that we apply to URLs are taking the place of the library catalog and shelving system. But the catalog and shelving system are professionalized classification practices with over a century of information design behind them. By contrast a link in a hypertext system may or may not be under editorial control, and is part of an open, universally available, information structure with only a few decades worth of practice behind it. Among the clearest symptoms of this immaturity is the persistence of "Links" (See figures 9.2, 9.3) as a section of a website. This was understandable given the novelty of hyperlinks, but "Links" is no more descriptive than "Names" or "Addresses" or "Books." A link is merely a pointer; the user needs to know what kinds of things are being pointed to under this heading.

HTML also included other kinds of tags besides links, directing the browser how to display the information. Some tags indicated elements directly, such as the horizontal rule tag; some gave formatting instructions, such as the tags for italics or bold text or a bulleted or numbered list; and some gave formatting instructions less directly through structural labels, such as heading1 or heading2. The information was presented as a document structured by the tags.

Berners-Lee could have turned his invention into another proprietary hypertext system. Instead he made a profound design choice: he decided that HTML should be free and standard, transforming the practice of information sharing on the Internet from file transfers, email discussion lists, and proprietary bulletin boards into a World Wide Web that has instantiated Vannevar Bush's vision of linked information trails, and profoundly transformed our ability to experience shared attention with one another.

GNU's Who

Speakers

ThankGNUs

GNU Art

GNU Fun

Music & Songs

Free Software Jobs

Links

Figure 9.2
Many early websites included "Links" as a category in the navigation menu, which made more sense in a time of fewer websites and weaker search engines. "Links" here leads to a page with the more descriptive title "Links to Other Free Software Sites."

Figure 9.3
Vague umbrella labels like About and Links and the need for a Site Map separate from the navigation menus are signs that the information in the site has not been sorted systematically.

Making Meaning with Metadata

Structured documents, like HTML pages, gain their structure by using **metadata** tags to segment and label chunks of media. Metadata (the term is the same for singular and plural) is data about data, keywords attached to a text or visual document. Metadata in the form of sets of descriptors attached to a media objects (such as books, movies, photographs, watercolors, or digital files of any kind) can describe the structure, use, ownership, or content of the object. HTML is primarily a set of metadata tags that describe the logical structure governing the presentation or display of a document. For example, metadata tag "h1" can be attached to a chunk of text to indicate that the enclosed phrase should be displayed as a top-level heading. Associated style

sheets can describe the **attributes** of an h1 tag (such as color, size), allowing the designer to deal with logical structure and presentation in separate **abstraction layers**, each with their own appropriate metadata tags.

Metadata are often in the form of **attributes** and **values**, like the **fields** in a **database** or library catalog. Digital metadata are searchable, allowing users to find objects based on multiple descriptors, to filter information by **facets**, and to group objects together in multiple different arrangements. A single digital photo with metadata attached to it may appear in answer to three separate queries, such as "birthday," "candles," or "baby." A song may be found by its own name or the name of the singer or the writer or the year of its recording. The addition of metadata tags to web documents was an important part of the change in the early 2000s to the more organized and participatory environment popularly referred to as Web 2.0.

Metadata can be *assigned* or *derived*. The Library of Congress Classification is an example of assigned metadata. Any work that comes into the library must be assigned a place within this structure. Assigned descriptors are usually part of a hierarchical world, and the assignment of descriptors to items can be thought of as an intellectually top-down operation, starting with a preexisting tree, and settling each item as a unique leaf on its appropriate branch, like a book on a shelf. The social process is also top-down in that the administrators of the archive control the choice of descriptors. The Dublin Core is an example of a more limited set of descriptors for cataloging digital artifacts, with only fifteen "core" elements in the original specification (figure 9.8), but it requires a complex committee structure to administer the specification and coordinate it with other nomenclatures (see <http://dublincore.org>). Establishing the social structure to decide on and enforce uniform metadata conventions is a crucial aspect of information design.

Derived descriptors are more open ended. They resemble the words in an index. They are not normalized as assigned terms are, but are used as they appear in the original artifact. Derived descriptions are sometimes drawn from specific fields in a document like article abstracts in a scholarly journal or closed captions in a television program. We can automate the process of creating metadata from an electronic text by creating a concordance (a list of all the words in the work), eliminating common words, and looking for frequently used words or phrases. This is a bottom-up process, and closer to the original text, but subject to inconsistencies and (if automated) misinterpretations of context.

Until the advent of the Internet, tagging was either informal and private or formal and controlled by official organizations. An individual might have an index of their collection of recorded music on a set of index cards with private notes on the salient characteristics of each record or tape, but no one else would be likely to use the system. Librarians, on the other hand, practiced uniform systems of **categorization** because they were representing an authority structure and a fixed order. But on the Internet,

everyone can attach their own descriptors to items and then share them with the world. Media aggregation sites encourage users to share their images, music, audio recordings, and videos with one another and they provide an open tagging system in which objects are categorized by a social process. Tagging is now a widely practiced, unregulated and semiregulated activity in many media sharing environments, and even in text messages. The social utility Twitter was the first to introduce metadata tags for instant messages in 2009. The enthusiastic adoption of metadata for messages limited to 140 characters is striking evidence of the importance of shared tagging systems for navigating the expanding information stream (figure 9.4).

The advantage of social tagging is in the distributed labor model that leverages the work of many people, each of whom only tags a small number of items, to organize a vast collection of existing materials or to bring together like things very rapidly, as in coverage of a emerging event, like a natural disaster. Furthermore, the assignment of objects to categories benefits from the collective thinking that takes place when many people have offered labels. If someone has already created tags for "vacation" and "beach" then we can just pick them off a list and know that our tagged photos will be collocated with other people's beach vacation shots.

Social tagging poses the challenge of how to provide overviews of such uneven and unpredictably tagged inventories. A popular early approach is the **tag cloud**; a non-symmetrical (and therefore cloudlike) display of tags assembled though the procedural power of the computer, mapping size to frequency or sometimes recency. Some sites offer multiple tag clouds, selecting by popularity, date, place, or related subjects. Tag clouds leverage the distributed effort of markup to make the information self-organizing, and to create an automatically updating overview and navigation system. The drawback of such democratic participatory tagging is that the tags are not used consistently. Without an editor to enforce standard names, information may not be appropriately classified, and will therefore not be appropriated collocated (figure 9.5).

Much of the self-organizing and emergent structures of the web take advantage of this informal, ambiguous tagging, often called **folksonomies**, because unlike **taxonomies**, they are created not by professionals but by just plain folks, without regulation or regard to consistency. A taxonomy of information is a clear hierarchy that avoids repetition and ambiguity. For example, an official taxonomy of U.S. cities would take the form of a hierarchy of states, with abbreviations (NYC, N.Y., NY) recognized as synonymous with full names (New York). But in a folksonomy NYC, NY, and Big Apple would be separate labels and Lexington might refer to a New York subway line, a Manhattan street, a town in Massachusetts, or a city in Kentucky. Taxonomies aim for complete representation of a domain and have to be created from a top-down perspective. folksonomies are created bottom up, from example to example without regard

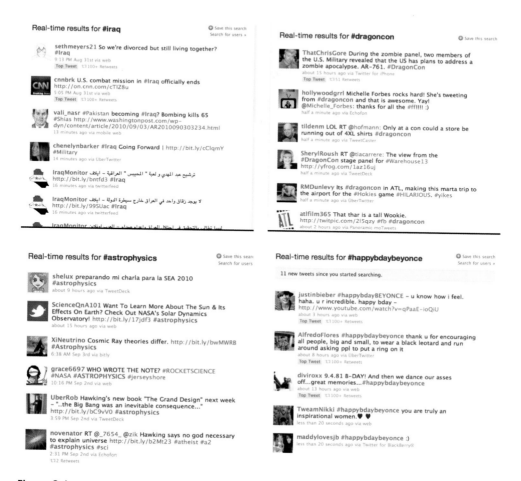

Figure 9.4

Hash tags on twitter.com allow aggregation of user-defined topics.

for the overview. Folksonomies work best when they can leverage shared cultural **patterns** with predictable labels, such as social rituals (like birthday parties or graduations), mass activities (like sports, elections), controlled name spaces (like movies, tourist attractions, famous people), mass media topics (like breaking news, celebrity gossip, or ephemeral political buzzwords. Folksonomies can display a consistency and coverage similar to controlled vocabularies when they are employed with regularity and focus by specialized communities that make use of suggested shared tags. It is significant that many popular categories on delicious.com are technical terms such as "linux" and "javascript" (figure 9.6).

All time most popular tags

06 africa amsterdam animals architecture art asia august australia autumn baby
barcelona beach berlin birthday black blackandwhite blue boston bw
california cameraphone camping canada canon car cat cats chicago
china christmas church city clouds color concert d50 day dc december dog
england europe fall family festival film florida flower flowers food
france friends fun garden geotagged germany girl graffiti green halloween
hawaii hiking holiday home honeymoon hongkong house india ireland island italy
japan july kids la lake landscape light live london losangeles macro me mexico
mountain mountains museum music nature new newyork newyorkcity newzealand night
nikon nyc ocean paris park party people portrait red river roadtrip rock rome
san sanfrancisco scotland sea seattle show sky snow spain spring street
summer sun sunset sydney taiwan texas thailand tokyo toronto travel tree
trees trip uk urban usa vacation vancouver washington water wedding
white winter yellow york zoo

Figure 9.5
The most popular Flickr.com tags for July 2007 include three variants of New York City: newyork, newyorkcity, and nyc.

Tag Cloud: Popular

KEY: green tags are tags you have in common with everyone else. Sort: Alphabetically | By size

.net 2008 3d advertising ajax and animation api apple architecture art article articles artist audio
blog blogging blogs book books browser business car cms code collaboration comics community
computer converter cooking cool css culture data database design Design desktop development
diy documentation download downloads drupal ebooks economics education electronics email
entertainment environment fashion fic film finance firefox flash flex flickr food forum free freeware
fun funny gallery game games geek google government graphics green guide hardware health
history home hosting house howto html humor icons illustration images imported information
inspiration interactive interesting internet iphone japan java javascript jobs jquery kids language
learning library linux list lists literature mac magazine management maps marketing math media
microsoft mobile money movie movies mp3 music network networking news online opensource
osx people phone photo photography photos photoshop php plugin podcast politics portfolio privacy
productivity programming psychology python radio rails realestate recipe recipes reference religion
research resources reviews rss ruby rubyonrails school science search security seo shop shopping
social socialnetworking software statistics streaming teaching tech technology tips todo tool tools
toread travel tutorial tutorials tv twitter typography ubuntu usability video videos vim visualization
web web2.0 webdesign webdev wiki wikipedia windows wishlist wordpress work writing youtube

Figure 9.6
Popular tags on delicious.com, which allows users to store and share their bookmarked web pages and encourages uniform tagging by making suggestions based on other users' tags for the same item.

There are advantages and disadvantages to the top-down and bottom-up approaches to metadata and designers must weigh the trade-offs for particular applications. Wherever there are controlled vocabularies it is important to use them and to scaffold their use by distributed contributors by offering menus with the approved list of values. But it is also important to remain open to newly relevant indexing terms and to a range of interest groups.

Information designers can maximize intellectual access to information by combining the efficiency and flexibility of controlled vocabulary descriptions with free text fields and socially derived descriptors (see figure 9.7, figure 9.8, figure 9.9).

Searching the Web with Metadata and Social Networks

As the World Wide Web has grown, the user has been faced with increasing information overload, and the creator of information has developed an increased risk of invisibility, of posting information that no one finds. **Search engines** are the means for addressing this problem, for leading information seekers to the appropriate information providers. Search engines are discovery agents, helping people to find things they did not know were out there, creating the equivalent of the library shelf by collocating the relevant results from disparate sources in a single list.

Search engines are computer programs that read and index web pages, and then match the indexed terms with words or phrases entered into a text box. Search engines employ some basic strategies for identifying what text on a page is worth indexing. The more structured the document the easier it is to index. Text identified as headers or as menu items are taken as more important than body text. In addition the HTML <meta> tag allows the user to create metadata labels that are explicitly intended to guide searching.

There are many problems that make it difficult to create web search engines that produce reliable results, including the quantity of information, its dynamic nature, and the lack of consistently applied metadata labels. No current search engine is completely successful in finding all the relevant information and not listing any irrelevant information. The dominant search engine for the period of dramatic growth in web content, starting in 1998, was (and continues to be) Google. One important reason for Google's early success was the company's understanding of the structure of hypertext as a reflection of social structure. The Google search algorithm analyzes links, scoring sites on the number and reliability of the pages that point to it, and associating the text of links with the pages that they point to. The Google inventors *used the content of the link tag as derived metadata about the page it linked to* because they realized that the word(s) someone uses to describe a page she is linking to can be a significant descriptor for that page. Google also ranked pages based on the reliability and reputation of the pages that linked to it. Although the results of a Google search

Leader/00-23	*****cgm##22*****#a#4500
001	<control number>
003	<control number identifier>
005	19920513133548.3
007/00-22	mr#bf##dnnartnnac198607
007/00-22	mr#bf##dnnbdtnnac198607
007/00-22	mr#bf##dnnaetnnac198607
008/00-39	870505s1918####xxu055############ml####d
017	##$aLP12321$bU.S. Copyright Office
040	##$a[organization code]$c[organization code]$eamim
245	00$aM'liss /$cPickford Film Corp.; supervised and directed by Marshall A. Neilan; photoplay by Frances Marion.
257	##$aU.S.
260	##$aUnited States:$bArtcraft Pictures Corporation,$c1918.
300	##$a5 reels of 5 on 2 (1988 ft.):$bsi., b&w ;$c16 mm.$3ref. print
300	##$a5 reels of 5 on 2 (1988 ft.):$bsi., b&w ;$c16 mm.$3dupe neg.
300	##$a5 reels of 5 on 2 (1988 ft.):$bsi., b&w ;$c16 mm.$3arch pos.
500	##$aCopyright: Famous Players-Lasky Corp.; 18Apr18; LP12321.
500	##$aOriginally released in 35 mm.
500	##$aBased on a story by Bret Harte.
508	##$aPhotographed by Walter Stradling; art director, Wilfred Buckland.
510	4#$aNew York times film reviews,$c5-6-18.
510	4#$aVariety film reviews,$c5-10-18.
510	4#$aMoving picture world,$cv. 36.l, p. 894, 897, 1043.
511	1#$aMary Pickford (M'liss), Theodore Roberts (Bummer Smith), Thomas Meighan (Charles Gray), Charles Ogle (Yuba Bill), Tully Marshall (Judge Joshua McSnaggley), Monty Blue (Mexican Joe), Val Paul (Jim Peterson), Winnifred Greenwood (Clara Peterson).
520	##$aA western comedy-melodrama set in the mining town, Red Gulch, Calif. about the untamed daughter (Mary Pickford) of the town drunk (Theodore Roberts) who falls in love with the new schoolteacher (Thomas Meighan) who is accused of murdering her father and the situations that occur during his murder trial.
541	##$3ref print$dReceived: 8-20-80 from LC film lab;$cgift;$aPickford (Mary) Collection.
541	##$3dupe neg$dReceived: 11-20-79 from LC film lab;$cgift;$aPickford (Mary) Collection.
541	##$3arch pos$dReceived: ca. 1958 from USDA film lab;$cgift, copied from 35 mm nitrate on loan;$aPickford (Mary) Collection.
650	#0$aFrontier and pioneer life$zWest (U.S.)$vDrama.
650	#0$aTrials (Murder)$vDrama.
700	1#$aNeilan, Marshall A.,$d1891-1958,$edirection.
700	1#$aMarion, Frances,$d1888-1973,$ewriting.
700	1#$aPickford, Mary,$d1893-$ecast.
700	1#$aRoberts, Theodore,$d1861-1928,$ecast.
700	1#$aMarshall, Tully,$d1864-1943,$ecast.
700	1#$aMeighan, Thomas,$d1879-1936,$ecast.
710	2#$aArtcraft Pictures Corporation.
710	2#$aPickford Film Corp.
710	2#$aFamous Players-Lasky Corporation.
710	2#$aPickford (Mary) Collection (Library of Congress)$5DLC

Figure 9.7
The MARC record describing a feature film includes assigned descriptors metadata for genre and free text descriptors for the plot summary.

Title
Creator
Subject
Description
Publisher
Contributor
Date
Type:
Collection, Dataset, Event, Image, Interactive Resource, MovingImage, Physical Object, Service, Software, Sound, StillImage, Text
Format
Identifier
Source
Relation
Coverage
Rights
Language

Figure 9.8

Dublin Core Metadata Element Set 1.1. The 15 top-level elements of the Dublin Core Metadata Set Version 1.1, a simplified abstract representation meant to apply to any networked resource, and the assigned vocabulary list for the Type element. The Description element can be composed of derived descriptors from a table of contents or abstract, or it can be created by free text entry.

were still a too lengthy list with too many irrelevant items, Google searches generally were much better than other early approaches, which relied on free text search alone or on the hands-on indexing of human catalogers. *Google's innovation was derived from the inventors' understanding of the semantic information embedded in the tagging structure.*

One of the important impediments to searches is the computer's ignorance of context, which makes it unable to distinguish among very different uses of the same term (such as a computer virus versus a human virus). In information design we call the clarification of such distinctions **disambiguation**. Human language and naming conventions are imprecise and require multiple strategies in spoken and written language to avoid ambiguity. Human conversation includes regular requests for clarification and redundant statements to reinforce meaning. Librarians have many procedures for handling ambiguity, such as establishing name authority to make sure we can tell one "John Smith" from another. But computer programs often do not ask for clarification because they do not know that they are confused. One "John Smith" or **ASCII** string for "virus" looks the same as another to a text-matching program.

Disambiguation has been an active area of technological and design innovation. For example, typing the word "force" into the Wikipedia home page search engine takes one straight to the physics-based Force page, which also contains this note:

See also Force (disambiguation).

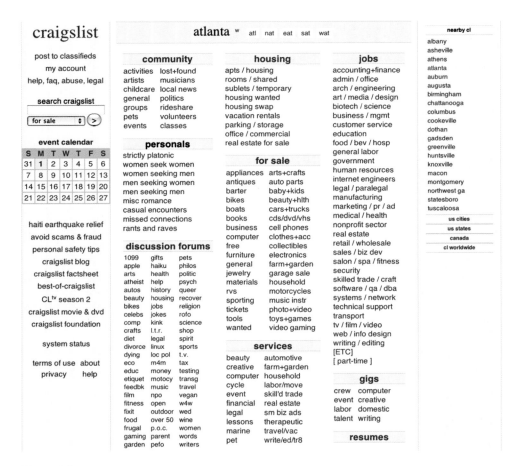

Figure 9.9
Craigslist.org uses assigned metadata for places and categories of listings, but also allows free text search on the headings and listings text provided by contributors.

The disambiguation page (figure 9.10) lists multiple meanings in several distinct categories including multiple subcategories under science and sports, but also includes the familiar, popular culture context of the *Star Wars* movies. Since 2008, web search engines have tried to provide the same explicit disambiguation through query refinement (figure 9.11) and contextual grouping of search results (figures 9.12–9.14).

Because the digital medium is participatory, automated popularity indexes can provide rough social correctives to the often-misleading results of automated text search. Like commercial sites that create inferred recommendation systems by telling

Force (disambiguation)

From Wikipedia, the free encyclopedia

Force is what causes mass to accelerate or become deformed.

Force may also refer to:

In **science**:

* Forcing (mathematics), a proof-technique of set theory
* Brute force method, proof by exhaustion in mathematics
* Fundamental force, an interaction between particles that cannot be explained by other interactions

In **sports**:

* Force play, a situation in baseball where the runner is compelled to advance to the next base
* Georgia Force, an Arena Football League team
* San Antonio Force, an Arena Football League team that played the 1992 season only
* Western Force, an Australian rugby union team in the Super 14
* FORCE (Formula One Race Car Engineering), a division of the Haas Lola Formula One team

In **other uses**:

* Force (Star Wars), mystical energy in the Star Wars universe
* Force (cereal), a wheat flake cereal
* Force (comics), a character in the Marvel Comics Iron Man titles
* Force (law), unlawful violence or lawful compulsion
* Force, Italy, a municipality in Ascoli Piceno, Italy
* Force or Europe, a Swedish band
* In some contexts, "force" may be used as a synonym for coercion

See also

[edit]

* Armed forces (disambiguation)
* The Force (disambiguation)
* GeForce a PC graphics chipset
* nForce, a computer motherboard chipset
* High Force, a waterfall on the River Tees, England
* Major Force a fictional character in the DC Comics universe.

Figure 9.10
Wikipedia disambiguation page distinguishes entries on "force" by context categories (accessed November 1, 2010).

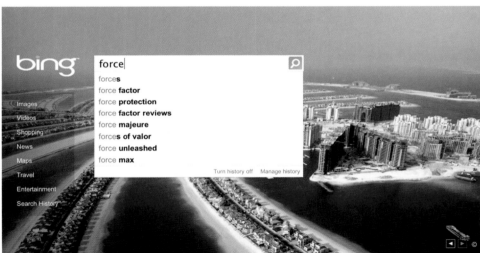

Figure 9.11

Query refinement has been the focus of active competition and innovation among search engines. These three results (from November 2010) attempt to anticipate the unstated or partially stated focus of queries by providing the user with a choice of common search terms and explictly disambiguated contexts.

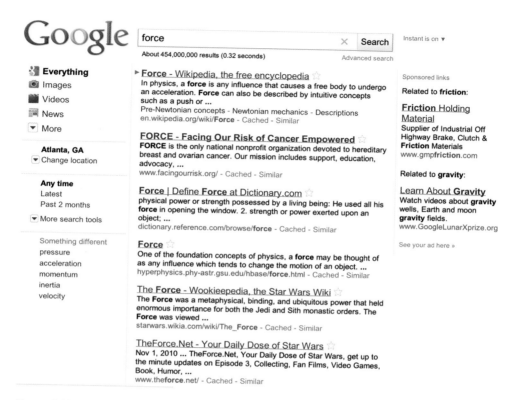

Figure 9.12

The Google search results page (accessed November 1, 2010) covers three major uses of the term "Force" (physics, cancer activism, Star Wars) and includes other physics terms under the vague category of "Something Different" in the left-hand column.

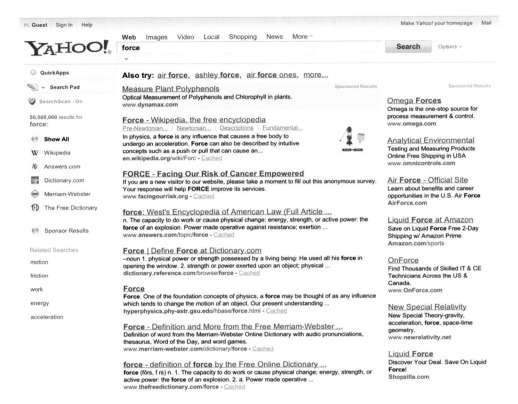

Figure 9.13

The Yahoo search results for "Force" (accessed November 1, 2010) offers alternate contexts across the top and physics terms under "Related Searches" to the left.

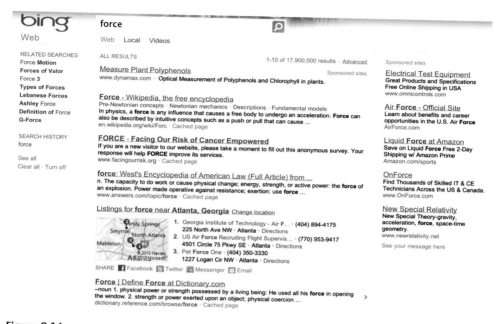

Figure 9.14

Microsoft's Bing search engine (accessed November 1, 2010) offers "Related Searches" that range from physics and military terms to a celebrity drag car racer, and it groups customized local results (based on implicit surveillance of my location) into a subcategory.

customers what others have bought, search engines refine their page rankings through "click analysis": by watching which pages users select when presented with a menu of choices and measuring how long they stay with the selection before returning to the same search page, taking selection and sustained viewing as an indication of relevancy. As the amount of available information increases, popularity has become a key index of importance. Some economists claim that large groups of people, from diverse points of view, making independent judgments can achieve the "wisdom of crowds" and networked resources offer a good opportunity to create such aggregations (Surowiecki 2004). But popularity rankings are also useful when the information seeker has a reason to trust or identify with the individual or group whose judgments are available, making for more explicit and reliable criteria of judgment. Information designers can offer both kinds of rankings, as well as conventional editorial judgments. For example, the *New York Times,* whose front page in print remains a key measure of relevancy and importance, also offers online readers a list of its most popular items (figure 9.15), and allows them to follow the recommendations and ratings of other readers or to find articles through social networks (figure 9.16).

MOST POPULAR

E-MAILED	BLOGGED	SEARCHED	VIEWED

1. The Vanishing Mind: Money Woes Can Be Early Clue to Alzheimer's
2. Essay: Why Sisterly Chats Make People Happier
3. Frank Rich: The Grand Old Plot Against the Tea Party
4. Paul Krugman: Mugged by the Moralizers
5. Europe's Plagues Came From China, Study Finds
6. Nicholas D. Kristof: Give Obama a Break
7. Maureen Dowd: Can the Dude Abide?
8. Thomas L. Friedman: It's Morning in India
9. Op-Ed Contributor: The 150-Year War
10. Op-Ed Contributor: How the Banks Put the Economy Underwater

Go to Complete List »

Figure 9.15
The *New York Times* online offers several popularity lists.

Searching the World Wide Web is frustrating because of the extent and variety of documents. Designers will be increasingly called upon to work with more uniform collections of networked resources in **structured archives**. A structured archive is a set of digital artifacts that have been semantically segmented and indexed with controlled metadata. One of the most promising approaches for integrating searching and browsing of structured archives is the strategy of faceted search. Facets are categories of metadata that describe some aspect of the search domain, such as the author, year, country of origin, and so on. Facets are assigned to objects in a collection, and users are given the choice of searching by one or more of them. Once a search is completed, facets can be added or changed, providing a way to **filter** search results. A **facet** can be arranged in hierarchical or flat structure, and the searcher can address one or more facets independent of the others. As a result, faceted searches of structured archives indexed by metadata can lead to a faster, more precise match to a search query.

The Flamenco system (figure 9.17) under development at the University of Berkeley under the direction of Marti Hearst is an example of a faceted search engine (Hearst 2006). It treats each set of descriptors in an archive of Nobel Prize winners as a separate facet. The interactor can filter the results by year, country, or gender, constructing a

Lost the Remote? Another Reason to Use an App

By JOSHUA BRUSTEIN
Published: October 31, 2010

The standard TV remote control, lost so many times beneath sofa cushions, may soon be lost to history.

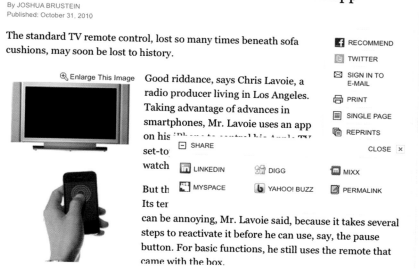

Good riddance, says Chris Lavoie, a radio producer living in Los Angeles. Taking advantage of advances in smartphones, Mr. Lavoie uses an app on his iPhone to control his Apple TV set-top

watch

But th

Its ter

can be annoying, Mr. Lavoie said, because it takes several steps to reactivate it before he can use, say, the pause button. For basic functions, he still uses the remote that came with the box.

Figure 9.16

The Share Tools feature on nytimes.com provides multiple forms of recommendation systems, including external social networking sites.

Figure 9.17

The Flamenco search engine demonstrates faceted search on an archive of Nobel Prize winners. The user has retrieved all the winners of the literature category from the 1920s and is about to eliminate the literature descriptor, allowing her to browse through winners in multiple categories. See <http://orange.sims.berkeley.edu/cgi-bin/flamenco.cgi/nobel/Flamenco> (Hearst 2006).

custom query that will create the equivalent of a customized library shelf. Such systems are useful for novices because the explicit facet and value lists provide an overview of the contents of the archive and its intellectual structure. The ability to present the same object in multiple contexts is also a benefit in thinking about complex subjects, by surfacing relationships that would not otherwise have been noticed.

Structured Wikis and the Social Creation of Knowledge

Vannevar Bush's vision of an information space was one in which experts provided knowledge in a distributed manner. Many people in multiple locations could contribute to making coherent paths for the sake of the larger community. Digital media afford this **distributed** knowledge creation by networking people together and providing data structures that can associate one chunk of information with another.

From the 1980s early users of the Internet took advantage of the rapid transmission of text to create active networks of email, bulletin boards, and newsgroups. As their names suggest, each of these systems was built in emulation of earlier paper-based systems. Email is a one-to-one form of persistent messaging. It is a more immediate way of sending memos and personal messages than letter writing, and it has eliminated the need for laborious handwriting, stenography, Dictaphone transcription, and rote typing, with tedious paper-based error correction. The ease of transmission has made for flatter hierarchies and easier distant collaborations, and the persistence of digital files has opened up many treasure troves for criminal investigators. Electronic bulletin boards, often run by administrators who own and operate the hosting machine, allowed many-to-many communications among a cooperating group whose shared focus was analogous to a local community around a single physical bulletin board. Newsgroups combine the functions of both email and bulletin boards, aggregating people with similar professional, civic, or recreational interests, who essentially coedit a newsletter online. Often these groups have a central administrator who serves as editor in chief and decides what gets promulgated to the rest of the participants. Because of their underlying paper-based conceptual format, these forms of communication have limited structural elements. They can be searched by content or header field, and they can be organized by date or sender. The strongest digital convention that has arisen from these practices is the **thread**, the common subject line that unites a set of responses. But threads are a slender connector for following complicated lines of arguments or prolonged conversations.

A related development, which has replaced bulletin boards and expanded community creation on the web is the **blog**. Blogs (a portmanteau of "web" and "logs") and blog-like social networking sites (such as Facebook) are based in the tradition of online journal keeping. The basic structure of the blog is the long chronological list,

Figure 9.18

Blogs share an ease of posting to the web but vary widely in professionalism and organization. Most reflect the viewpoint of a strong individual writer or editor, or an aggregation of similarly focused individuals.

since it is optimized for rapid updating rather than for archiving content. Like wikis, blogs offered a refinement on the inscription technology of HTML by allowing noncoders to write directly to the World Wide Web. Blogs provide a reliable framework for sharing text, images, video, and hosting conversations, and are used for the same wide range of functions—research, socializing, journalism, commerce, community building—as the rest of the web. Blogs are too diverse and informally structured to be considered a genre (figure 9.18), but they do display recognizable conventions, such as

• brief, essay-like posts that can be as informal as a group email to friends or as formal as a journalist's column
• live blogging of events: continuous posting, similar to the radio or television commentary of a live sports event, usually in text
• aggregation of announcements, news, and other time-sensitive information
• conversational exchanges within or across sites, including conventions of cross-linking and comment posting
• polls, popularity lists, tickers, and graphs of live data
• personal travel journals
• fan sites and gossip aggregators
• professional identity centers for an individual or group

Although all blogs and chronological/strongest currently resemble one another in their two- or three-column scrolling structure, their point of similarity is the ease of inscription and transmission, and so blog formats are likely diverge as more specialized variations and refinements arise.

Wikis, like blogs, are a format for facilitating participation, but they emphasize group coordination and the creation of persistent resources. Ward Cunningham invented the Wiki in 1994 as a means of quick, collective website building, similar to the generation of HyperCard stacks. Cunningham instanced "observable" process and "convergent," commonly edited pages as key design principles (see <http://c2.com/cgi/wiki?WikiDesignPrinciples>). The new format, by making HTML document creation more **transparent** and the process of creation more **visible**, provided the scaffolding for convening collaborative communities of writers/readers/editors.

For wikis to work the participating community must be self-sustaining, self-editing, and self-policing. It is not surprising that this strategy works for web resources created for small groups with common interests. It has been much more surprising that larger groups could create a reasonably reliable information source. This has been the case with the Wikipedia, which was founded in 2001 by Jimmy Wales as a volunteer-driven, online editable encyclopedia. By 2010 it claimed over 85,000 active contributors, 14 million articles in 260 languages and was one of the most visited sites on the World Wide Web. It is therefore considerably larger than the previous category leader, the *Encyclopedia Britannica*, founded in the eighteenth century, with 120,000 articles in its 2007 online version. It also employs less than half the paid staff of the *Britannica*, which has 100 paid editorial workers and 3,000 paid experts. Wikipedia identifies over 1,700 administrators for the 3 million articles published in the English edition but only a few dozen paid employees.

Wikipedia is uneven in its coverage and its contributors are usually anonymous with uncertain credentials, but on the whole it is a practical and highly useful resource (Giles 2005), directly or indirectly benefitting from many other more conventional

information structures such as authored books and articles, libraries, university degree programs, other encyclopedias, and increasingly, other more specialized websites. Wikipedia is energized by the allure of a global community and by the encyclopedic impulse, which somehow motivates millions of hours of unpaid labor contributed by professionals, graduate students, and information junkies, including those serving as editors in their specialty areas. Although vandalism has been a problem, it has not been devastating as many predicted it would be, because page changes trigger alerts to editors, who pay particular attention to known controversial topics (Viégas 2004). In 2010 participation in the site showed significant signs of decline, which may be an indication that the economic model is not viable over the long run.

The information design model, however, is an achievement in itself. The contributions of so many unpaid authors are made coherent by the top-down organization of the wiki page as a structured document. *Wikipedia is a triumph of information design, expressed in transparent editing tools that support clearly articulated formatting and genre conventions.* One key organizational strategy is the separation of discussions about an article's content from the article itself (figure 9.19). This allows contributors to focus on the collectively written article as separate from the personalities and judgments of the contributors.

Another important strategy is the documentation of uniform standards, policies, and templates for the creation of entries, the organization of the site, and rituals of participation. *The distributed creation of knowledge resources requires agreement on the standards, formats, and genre conventions in which the knowledge is exchanged* (figure 9.20). For Wikipedia, these standards are explicitly spelled out and they build on the genre

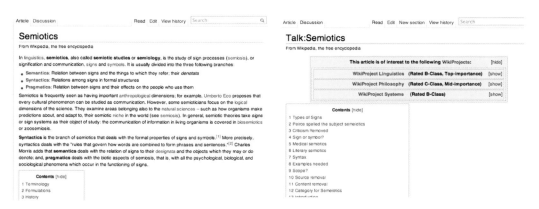

Figure 9.19
Wikipedia fosters collaborative, distributed creation of an information resource by separating discussion about changes from the content of the article itself.

v · d · e	Wikipedia principles	[show]
v · d · e	Key Wikipedia policies and guidelines	[hide]
Overview	**Policies and guidelines** · List of policies · List of guidelines	
Project-wide principles	What Wikipedia is not · Editing policy · Consensus · Dispute resolution · Ignore all rules	
Article standards policies	Neutral point of view · Verifiability · No original research · Biographies of living persons · Article titles · Deletion	
Behavioral policies	Child protection · Civility · Edit warring · No personal attacks · No legal threats · Ownership of articles · Sock-puppetry	
Behavioral guidelines	Assume good faith · Etiquette · Do not disrupt Wikipedia to illustrate a point · Please do not bite the newcomers · Gaming the system	
Classification guidelines	Categories, lists, and navigation templates · Categorization · Template namespace	
Content guidelines	Conflict of interest · Do not include copies of primary sources · Disambiguation · Do not create hoaxes · Notability · Patent nonsense · Identifying reliable sources	
Editing guidelines	Article size · Be bold · Hatnotes · Signatures · Talk page guidelines · User pages · Subpages	
Style conventions	Manual of Style · Manual of Style (accessibility) · Manual of Style (layout) · Manual of Style (lists) · Manual of Style (linking)	

Categories: Wikipedia policy | Wikipedia policies and guidelines | Wikipedia administration | Wikipedia procedural policy

Figure 9.20
Wikipedia rests on carefully elaborated policies and guidelines that shape information design, content creation, and collaborative behaviors.

conventions of print culture as a common context. Among the most important principles and practices affirmed by the editors are:

- Neutral Point of View
- No Original Research
- Verifiability
- Conformity to Encyclopedia as a Genre
- Civility

The editors devote a long section to "What Wikipedia is Not," a list that includes a dictionary, a directory, a soapbox, a guidebook, a battleground, and an indiscriminate collection of information. Wikipedia is also not a paper encyclopedia, and therefore it has not one but multiple tables of contents, and knowledge taxonomies including:

Topics: <http://en.wikipedia.org/wiki/Lists_of_topics>
Portals: <http://en.wikipedia.org/wiki/Portal:List_of_portals>
Projects: <http://en.wikipedia.org/wiki/Wikipedia:WikiProject_Council/Directory>
Reference Desk: <http://en.wikipedia.org/wiki/Wikipedia:Reference_desk>

The Wikipedia example makes clear that distributed creation of an information resource requires explicit, detailed information design, including standardized templates and guidelines for content creation, and explicit rituals for collaboration.

XML and the Semantic Web

Structured documents depend on metadata to build complexity and flexibility in the same way that databases depend on tables and fields. As we saw in chapter 7, libraries have established reliable, shared methods for labeling books by employing

controlled vocabularies, and **thesauruses** that provide guidance for the labeling of items. The World Wide Web has created a global information structure that is like a library in its comprehensiveness, but a library in which items are jumbled together, with very poor labeling, and a vast expanse of virtual space to search through. Furthermore, there is no centralized library staff to catalog it all.

Tim Berners-Lee, the inventor of the HTML protocol that is the basis for the World Wide Web, has offered a vision of the future of the web as a much more highly organized network of structured documents. The organization he founded, the World Wide Web Consortium or W3C (<http://www.W3C.org>) is attempting to build an information infrastructure that will lead to the creation of a **Semantic Web**, in which meaning is encoded in a way that is friendly to humans and to machines, so that it can be searched, retrieved, and processed with greater reliability. The key to the W3C approach is the annotation of information with *standardized metadata in standardized structured documents*. Their aim is to move information from the hidden, proprietary, idiosyncratic organization of thousands of databases and millions of irregularly formed web pages into a single comprehensive, shared information format. Although this seems like a radical vision it is similar to the process that has created knowledge resources in previous media technologies.

As the amount of information we generate increases, we must put more effort into formatting and sorting in order to keep track of it. If we have one clay tablet we just have to remember where it is and then point it out to others when they ask for it. If we have twenty tablets we have to place them in a memorable way that will make sense to everyone who is likely to look for any one of them. If we have 20,000 clay tablets we need shelves and baskets and labels. If we have 200,000 books then we need a classification system for shelving them that leads us through the taxonomy of knowledge to the right part of the right shelf.

The process is similar for the data we place in larger information containers. If we have a census operation for a small town we can keep our tables on a papyrus roll in a locally invented order. If we have a census for the entire United States in the twenty-first century, we will want to use a computer and a uniform system of database tables, so we can pull things out city by city, or county by county, or across cities and counties by age or gender or two-person household.

With the World Wide Web we have created a global information repository with items generated from millions of individual points, in multiple categories of knowledge and human expression. We have reached a new level of complexity, an increase of many orders of magnitude, perhaps equivalent to the explosion in print culture following the invention of the printing press, but happening much faster than the four centuries it took from the invention of the printing press to the invention of the Dewey Decimal system. *It is as if we are called upon to simultaneously reinvent the tablet, the book, and the library.*

How do we get from our current too-diverse docuverse to a coherent semantic web? We do not have to invent a single document format for everything on the web or impose a single order on all web creators, but we do need a way to encourage the use of common document formats and metadata sets. The W3C created **XML** (Extensible Markup Language) for this purpose. XML is a metalanguage, a language for defining other markup languages. It provides a structure for defining common tags and document formats for sharing information. Unlike HTML, XML does not have any fixed set of tags. Instead, users can define all the elements in their document in whatever words they please. More important, they can define templates for families of like documents by establishing standardized XML **schemas.**

Perhaps the most familiar XML document is the RSS feed, which stands for Really Simple Syndication, and is the basis of podcasts and news feeds that pipe information directly to users. If networked information on the web is similar to a global array of bulletin boards, RSS turns it into a global broadcasting system in which millions of people have millions of choices of channels. RSS began as a text standard and was extended to include temporal (audio and moving image) media (figure 9.21). Podcasting and blog syndication works because RSS provides an accessible standard for the information, written in XML. Although XML was intended to foster wider sharing of information, it can also be used as the basis for proprietary schemas, such as a music format that only runs on one manufacturer's devices.

In addition to schemas, the W3C has released specifications for a Resource Description Language (RDF) and an **Ontology** Web Language (OWL). Both are based on our ability to use a label as a pointer to a location that serves as a container for other information. In this case the World Wide Web is the location, and unchanging web

Sample RSS Elements
Channel
 Title
 Description
 URL Link
Item
 Title
 Description
 URL Link
 Author
 Category
 Global Unique Identifier (guid)
 Publication Date

Figure 9.21
RSS elements standardize podcasts, providing universal access to create and receive them and facilitating aggregation of individually chosen feeds in RSS readers.

pointers—called Universal Resource Identifiers (URIs) serve as unique names for containers of information. An RDF is a set of three such pointers to two entities and the relationship between them. For example an RDF for a ZIP code document might look like this:

```
(field 5 in database A) [subject]
(is a field of type) [relationship]
(zip code) [object]
```

Part of the power of the RDF is its modularity, its abstraction of the three elements into web addresses so that the content of any one of them can change without changing the relationship among them. For example, if ZIP codes change from nine to thirteen digits the RDF does not have to change since it just points to the site on which ZIP code formats are specified and to the site of a particular set of ZIPf codes. RDF is a way of abstracting any relationship so that it can be expressed in terms that a computer can understand and act on appropriately. OWL builds on the architecture by specifying kinds of relationships (such as X IS A FIELD OF TYPE Y, X IS EQUAL TO Y).

In principle, we could use such a Semantic Web architecture to describe any set of complex relationships among entities that are represented by structured web documents. In the vision of Tim Berners-Lee, schemas, RDFs, web ontologies, and shared standardized rule sets will structure XML documents into a a future web environment in which computers will know not only how to display a document (as in HTML), *but also what knowledge category each segment of the document belongs to, and how to process it appropriately.* The plan for the Semantic Web assumes that this information will be as well formed as data in a database, or objects in a programming language, allowing it to be exchanged across applications and processed according to abstractly specified methods.

Many domains on the public web and in private networks already share information. For example, application programs for making bibliographies know how to retrieve and read entries from research libraries like the Library of Congress and paste the information into documents within another vendor's word processor. Calendar programs and address books also exchange information through standardized formats. Business to business applications rely on standardized representation of inventory items to coordinate orders, shipping, and billing through complex manufacturing and delivery chains.

But the vision of the Semantic Web goes far beyond this level of interchange, imagining automated processes, which function as **agents** taking data from diverse parts of the web and accomplishing complicated tasks on our behalf, because they can rely on standardized metadata to identify useful bits of information. Here is part of the scenario offered by Berners-Lee and his collaborators in his 2001 *Scientific American*

article on the Semantic Web. It involves a brother and sister caring for the medical needs of their elderly mother, with italics from the original article indicating the items that the authors expect to be tagged online with standardized metadata, and therefore available for computational processing:

At the doctor's office, Lucy instructed her Semantic Web agent through her handheld Web browser. The agent promptly retrieved information about Mom's *prescribed treatment* from the doctor's agent, looked up several lists of providers, and checked for the ones *in-plan* for Mom's insurance within a *20-mile radius* of her *home* and with a rating of *excellent* or *very good* on trusted rating services. It then began trying to find a match between available *appointment times* . . . and Pete's and Lucy's busy schedules. (Berners-Lee, Hendler, and Lassila 2001)

In this idealized scenario the brother and sister are able to find excellent care for their mother and to avoid disruption to their "busy schedules." At the cultural level the story conforms to the ideal servant fantasy we will be looking at in chapter 12, and it seems to have been designed to popularize the idea of the web by appealing to the workaholic information technology (IT) community. This makes it somewhat less persuasive as a story set in the lifeworld of illness, overwork, filial guilt, and sibling conflict (all of which have been abstracted away but are still evoked by the connotations of the scenario). But the logic of the computer processing is quite persuasive, since we could well imagine an insurance table of prescribed treatments, a map utility that calculates distances, web retrieval of the home address of everyone in the family, a social network utility that ranks service providers, and a calendar application that sets up appointment times based on intersections in multiple calendars. What is harder to imagine than the computer processing is the human cooperation necessary to establish all the common standards necessary to achieve this transaction.

How well the vision of the Semantic Web is realized will depend on how cooperative the diverse information-producing communities will be. In a 2006 follow-up article entitled "The Semantic Web Revisited," Berners-Lee and two other collaborators survey how much progress has been made toward achieving these goals. They express continued excitement in the potential of the RDF and the OWL system, to provide the basis of structures that could lead to new businesses and new knowledge. But they also express disappointment at the slow adoption of RDFs, which they attribute to the difficulty of imposing standards on existing communities. They complain that scientists are using **URIs** for information formats (like zip files) that must be downloaded to be read, and they are using naming conventions that are not consistent with URI standards. They locate the problem not in the technology but in the social organization: "A process is needed that routinely gives URIs to such objects and entrusts their management to individuals and communities who care about consistent and explicit reference methods" (Berners-Lee, Shadbolt, and Hall 2006).

Even for the master wizards of the web working with the highly organized scientific community, the human context of information proves to be much messier than they had hoped. In 2007, Berners-Lee suggested abandoning the name Semantic Web in favor of Giant Global Graph (GGG), in order to emphasize the potential for achieving a transformative organizational structure comparable to the Internet (in networking computation) and the World Wide Web (in networking documents). The GGG would allow us to share not just documents, but also "the things they are about," by segmenting and labeling them as shared structured data (Berners-Lee 2007).

Although the most ambitious goals of the W3C for a Semantic Web or GGG are still largely in the realm of research, the abstraction, standardization, and segmentation of documents and the formulation of semantic metadata will be important elements in digital design for decades to come. The need for a greater semantic organization and standardization is clear: the U.S. government alone is reported to have 60,000 distinct document types, and even a relatively stable field of knowledge like art history is facing a crisis in which there is concern that the amount of articles written about particular works of art is more than any researcher can reasonably expect to read (Elkins 1999). We have long outgrown the organizational power of the library and the database; we are not yet in control of the existing web, and yet access to digital inscription and transmission is growing every year.

Designers should welcome every opportunity to create and use standardized document structures to increase the power of our focused attention, and create meaningful organization. Every time we create a document (including media files such as text, images, moving images, and sound) for the web, we should consider how it could be semantically segmented with metadata tags. Every time we create a data structure for a software system, we can consider how it might be made into a sharable XML file. Existing documents can be analyzed to create generic schema for semantic segmentation. Doing this may not lead to Berners-Lee's ideal Semantic Web or Gigantic Global Graph, but it will lead to a more semantically organized web and bring us closer to turning the exponential increase in documents into a corresponding gain in knowledge and understanding.

DESIGN EXPLORATIONS: DOCUMENTS STRUCTURED WITH METADATA

Using Metadata to Structure Documents and Shared Resources
• Using cascading style sheets or similar abstractions of formatting from logical structure, reformat an existing website's content in the style of a different genre of website. For example, take content from a gossip site or family vacation blog and redisplay it in the format of the *New York Times* website. What difference does it make to change the display of the information? What meanings are implicit in formatting and font choices?

• Choose a set of twenty-five related items indexed by metadata on a site for sharing media artifacts or structured information, such as images on Flickr, bibliography entries on Zotero, or pointers to web pages on delicious.com.
 • List all the labels that have been applied to all the items in your sample.
 • Where did the metadata come from?
 • Which tags are assigned top down from an authority source?
 • Which ones belong to a controlled vocabulary?
 • Which are from taxonomies of knowledge?
 • Which terms are applied bottom up?
 • Are there any tags that are synonyms for the same idea among the items in your sample?
 • Does the application allow for any free text search or derived descriptors?
 • Does it suggest tags to contributors?
 • Does it provide templates for contributors?
 • What new tags or templates would you like to add to the system?
 • What new features would you like to add to the tagging interface?

Using Metadata to Create More Successful Searches

• Play the Google image labeler game for a total of at least five times (each game is two minutes): <http://images.google.com/imagelabeler>. The site will match you up with a partner, and you can play anonymously as a "guest." Record your answers and your partner's answers, using a screen capture program if necessary.
 • What strategies did you use to come up with labels?
 • How many of your labels matched your partner's labels?
 • Check the original context of the images after you play. How well did the labels either of you chose match the original context of the images?
 • If you were to enter any of the label words into an image search engine, would you be expecting images like the ones you labeled? If not, what would you be expecting instead?
 • After exploring the original context of the images and considering the labels you and your partner generated, can you come up with a better set of labels for each of the images?
• Play Guess-the-google for at least ten minutes and keep track of how many times you guess correctly: <http://grant.robinson.name/projects/guess-the-google>. What cues in the images determined a correct guess? How important were familiar icons or text elements?
• Using the Google Book Project, Flickr, YouTube, or any similar repository of a large number of digital artifacts in any media format, create your own mini-archive of twenty-five items on a subject of interest to you.

- What facets can you identify in this domain?
- What facets would your items already have associated with them that may not be directly relevant to the domain?
- What bibliographic records or other research sources already exist for your items and your domain (e.g., Wikipedia pages, online film databases, Library of Congress catalog, etc.)?
- What would be an appropriate level of granularity for tagging (for example, if it is an archive of books should the tags point to the whole book? particular pages? one or more paragraphs?)?
- How would you (ideally) make use of genre features such as book indexes or subtitles of films to create derived metadata?
- What controlled vocabularies are relevant to your domain?
- Mock up a faceted search sequence that assumes an ideal tagging and retrieval system for your mini-archive.
- Although they are an efficient way to catalog emerging information resources, folksonomies that lack editorial control can lead to redundancy, ambiguity, and inefficient retrieval. Analyze the "most popular" or "most recent" **tag cloud** of a media repository site with a large user base (or use one of the tag cloud illustrations from this chapter).
 - Identify the obvious ambiguities and redundancies.
 - Attempt to make a knowledge taxonomy using the existing tags. What tags would you have to add? What hierarchical categories would you create? What tags are the hardest to fit in?
 - Compare taxonomies with other members of your class or group. What top-level categories worked best? What was the source of these categories?
 - After making the taxonomy, take a random sample of twenty-five items from the same site without searching on any of the tags you used, and choosing from at least five distinct contributors.
 - Can you label every one of these randomly chosen items using your taxonomy?
 - Can you do so by adding new tags in your existing categories?
 - How consistent is the system after you have modified it to include these new items?

Exploring Wikipedia as an Information Structure

Wikipedia can provide a model for the use of information design conventions such as templates, segmentation, controlled vocabularies, social rituals, and explicit style guides for structuring contributions from a vast distributed pool of contributors in order to create a remarkably uniform information resource.

- Divide into three teams and take an hour to gather information on the cross bow. Answer the following questions: What made the crossbow successful? How was this weapon used? When was it invented and by whom?

- Team A: use only the print resources of the campus library.
- Team B: use only the World Wide Web without using Wikipedia.
- Team C: use only Wikipedia.

After presenting the results, decide as a group: What are the advantages and disadvantages of each method of gathering information? What did each lack that was present in one or more of the other resources?

- Choosing whichever strategies were the most useful in the previous exercise, do the same process for the baby carriage, frying pan, and the automobile.
 - Is there an equal amount of information available for these nonmilitary objects as there was for the crossbow?
 - Which had the most information?
 - What cultural attitudes may have determined the amount of information available?
 - What is the largest category of information represented in the Wikipedia (or other online resource)? What motivates the creation of this information? How is the information validated?
- Find an area of Wikipedia that is part of an existing "Project" (<http://en.wikipedia.org/wiki/Project>) and has clear guidelines associated with it. Add one article to your chosen Project area.
 - What questions did you have while doing this exercise? Were you able to answer them?
 - Where did you find the information you added? How did you know it was not already part of Wikipedia?
 - How did you know it was accurate?
 - How did you know how to format your article?
 - Was it reviewed by other contributors?
 - Was it edited or changed?
 - If you discussed any part of the article with others, where did you hold this discussion? How was it structured?

Using Standardized Semantic Structures

- Identify the appropriate XML metadata vocabularies and document formats for the following: a person's street address in any country, syndication of a radio program across the web, and a customer's phone number and credit card information. Who designed and established these standards?
- Write a list of five media artifacts you personally consumed (read, watched, listened to, interacted with) in the past week. Can you identify for each of these artifacts a specific XML-based document format that enabled its transmission and structured its presentation? What was the effect of the standardized markup? Who created and agreed to adopt the standard?

- Using the current W3C standards (<http://www.w3c.org>) create an abstract schema for an existing print document.
- Working in groups, create an **ontology** of a popular sport, using RDF, OWL, or a simpler **pseudocode** of your own invention.
 - Collective Brainstorming Stage:
 - Agree on a controlled vocabulary, and identify the level of abstraction at which you will describe elements of your domain. (Do not make it so detailed that it is impossible to finish, but make it detailed enough that you could distinguish your sport from a similar one.)
 - Separate names of things from actions. Identify the most important adjectives that go with the most important objects and actions.
 - Identify the most important state variables you would have to keep track of (e.g., innings, outs, runs, positions on the field).
 - Modular Design Stage:
 - After this period of collective brainstorming, divide into subgroups, assigning distinct modules of the ontology to each subgroup.
 - Does making the ontology raise questions about competing definitions of the same terms, or competing rule sets for the game?
 - Are there canonical sources available for settling these disputes or do they reflect informal practices?
 - How much does your ontology reflect culturally specific practices?
 - How much coordination among subgroups is necessary to make a consistent ontology?
 - Assessment Stage:
 - How successful was the collaboration? What strategies worked best for creating a consistent organization? What factors worked against consistency?
 - Are there other related domains (e.g., hot dog sales, sports injuries, soccer brawls, free-agent bidding) that would have to be modeled in order to have a more complete representation of the game?
 - How would you decide on the boundaries of your ontology?
 - How would you coordinate with multiple groups making ontologies for multiple games?

V SCRIPTING INTERACTION

Digital media innovation for the past half century has been concerned with establishing **rituals** and **conventions** for sharing focus between human beings and computers, implicitly and explicitly relying on a few basic models of interaction: the **tool, machine, companion**, and **game models**. Digital media designers must understand the strengths and weaknesses of these models in order to apply them mindfully and to expand our repertoire of strategies for meaningful engagement.

Good interaction design should emulate good tool design in creating **transparent** systems that can be mastered with a **gentle slope** learning curve and used not just for rote tasks but also for customized expression and virtuosity.

Good interaction design should emulate good machine design by making automated processes **visible** and under human control.

Good interaction design should recognize the pervasive fantasy of an intelligent companion that computers evoke, and should avoid triggering fantasies of a magical mind-reading servant, aiming instead at creating the experience of a reliable, polite helper, always under the explicit direction of the human **interactor**.

Humanist designers should recognize games as building blocks of culture and look for opportunities to use the game model of interaction to create interaction **mechanics** that enlarge the circle of shared attention and the possibilities for symbolic representation in all digital genres. Designers should recognize and reject the use of game patterns as reductive generalizations that trivialize human experience. Designers should use the expressive power of games to expand our cognitive abilities and to encourage more focused and flexible thinking about complex situations.

10 The Tool Model: Augmenting the Expressive Power of the Hand

Successful interaction design requires a shift from seeing the machinery to seeing the lives of the people using it. In this human dimension, the relevant factors become hard to quantify, hard to even identify.

—Terry Winograd, "From Computing Machinery to Interaction Design" (1997)

Interactivity refers to the maximizing of two affordances of the digital medium, the **procedural** and the **participatory**, in the satisfying experience of **agency.** Previous parts of this book have surveyed ways to *script the computer* in order to represent processes, spaces, and semantically structured information. Part V focuses on ways to *script the interactor*, by identifying four key models that shape human expectations of digital artifacts: the tool, the machine, the companion, and the game. For each of these models we will examine established and emerging design conventions that exploit the affordances of digital media to expand our cultural repertoire for capturing and sharing meaning.

Pointing, Grabbing, and Expressive Gestures

We participate in digital environments first of all by bringing to them a sense of what a computer is. Our simplest model for working with digital environments is the model of the **tool**—something that fits in the hand, whose value lies in its instrumentality, its usefulness in performing an action that the hand could not otherwise do so well.

A tool is not necessarily something that we make. It can be a found object with the right affordances for the job, such as a rolled leaf poked through a hole in the bark of the tree by a hungry chimp in search of termites, or a shard of river rock used by early humans to skin an animal. A tool can be manufactured by skilled craftspeople, such as a quill pen, or by industrial machinery, such as an aluminum knitting needle. Through their own physical affordances and the strategies we invent for employing them, tools allow us to perform beyond the limits of our own strength and dexterity. The industrial age greatly extended our repertoire of tools by taking advantage of a

wider range of materials. Magnifying lenses and paper clips, cuticle scissors and cork-screws, ballpoint pens and steering wheels are all highly sophisticated in manufacture and optimized for postindustrial uses, but they function in the same way as flint, twigs, and bone in focusing and augmenting the force of our hands in the service of a specific task.

Although we often see tools as separate external entities, they are best understood as extensions of the hand. In fact, the human hand with its opposable thumb can be thought of as our first and most powerful tool. The hand allows us to grasp, move, manipulate, and reshape objects; to sense heat and cold, texture, contours, and motion; to communicate with visible gestures (pointing, waving, opening and closing fist and fingers, shaking hands) and auditory means (clapping, snapping, thumping); and of course to touch, caress, or strike other sentient creatures. *Aside from the face, the hand is the most emotionally expressive part of the human body, providing us with a repertoire of signals from handshakes to obscenities that mediate our social relationships.* American Indians used such hand signals to communicate across spoken language groups, and the sign language of the deaf richly exploits hand gestures as a syntactical medium of inscription, a transmission code that carries representational messages as precise and expressive as spoken language. Sign language has lately been adopted for use by parents and infants and it has opened a pathway for understanding a baby's desires (Food! More!) and for assigning names to compelling items in their environment (Cat! Ball! Car!) before the child is able to articulate words.

Products made with hand tools are appealing to us because they have a direct connection with the physical body of the maker: the potter, sculptor, painter, carpenter, cook, or seamstress. Handwritten letters, manuscripts of books, autographs of famous people gain value beyond the words on the page reproduced by other means. We see the traces of the hand in the effects of the tools, and we take special pleasure in creating and perceiving those traces. In English, we refer to products created through the expert use of tools as "handicraft," and we use the word "handy" to refer to skillfulness and welcome availability. Other languages make similar connections. We find hand tools appealing because we are hardwired to enjoy using our hands for a mixture of utilitarian and expressive purposes.

The computer can be thought of as just one more set of tools, one more way of augmenting the power of our hands. Engagement with digital environments is usually made through our hands: we nudge a mouse or trackball, we move our fingers across a touch pad, we press down on the keys of a virtual or actual keyboard, we poke at a touchscreen, we jiggle a joystick. *Much of what we do on the computer is an extension of pointing.* Navigating by moving the mouse, entering letters and numbers on a keyboard, clicking on screen-based buttons and icons are all extensions of our ability to isolate an item from the visual field and point at it. The iconized pointer or cursor

(whether a finger, an arrow, a vertical line "insertion point," or an image of a pointing hand) is a crucial building block of the digital environment because it acts as our surrogate hand in the virtual world. In fact we can think of pointing as a participatory *primitive, a necessary substructure for all of the interactor's actions.* As we discussed in part I, human babies begin to point at around nine months old, displaying their characteristically human ability to focus on what other people are thinking about, and to share the **joint attentional scenes** that cognitive scientists believe to be the basis of symbolic communication (Tomasello 2001).

Similarly, one might say that the era of interaction begins with the invention of **transparent** pointing technologies (like the mouse) and the conventions (like highlight and clicking/double-clicking) for sharing a common focus of attention with the machine as the basis of issuing commands. When an interactor is confused or frustrated by a set of software tools it is often because the necessary shared focus has not been established. The **WIMP** (Windows, Icons, Menus, Pointing device) desktop interface has had many decades to establish and refine its conventions of pointing and commanding. Mobile phones, social networking environments, graphical virtual worlds, interactive maps and GPS devices, and interactive television are much more recent configurations, and still struggling to establish pointing rituals that are as efficient as the manipulation of files and folders with the mouse-driven cursor on the virtual desktop. One important impediment is the poor fit between human fingers and the miniature buttons on remote controls and the miniature real and virtual keyboards on mobile devices.

As media converge into multifunctional digital devices, pointing devices from television, music players, cameras, slide projectors, game consoles, and desktop computing are also converging. We are making increasing demands on the hand by proliferating devices and expanding the functionality of each individual device. One result is a miniaturization of buttons, often accompanied by poor labeling, which can make it difficult to identify, isolate, and depress the appropriate selection. Designers seem to expect the hand to adapt to the device (figure 10.1) rather than the other way around (figure 10.2). Power users, and especially younger and more dexterous consumers, have been willing to develop specialized manual skills like multitap or thumb typing in exchange for access to the augmented communication networks of the mobile world. But devices that offer simpler direct pointing affordances attract a wider range of potential users (figure 10.3).

The graphical user interface (GUI) has made pointing into an almost magically powerful action, recalling the fantasized omnipotence of infancy when pointing could deliver food or toys through the actions of the parent. Fairytales represent this sense of magical pointing in the figure of a magic wand, and manual technologies—such a joystick game controllers, datagloves, fingertip sensors, or the wand-like Wii remote—especially when they are new, can evoke this sense of magical access. Applications that

Figure 10.1
The size of the buttons on remote controls are confusing to most users, and particularly challenging for the elderly whose fingers lack force, steadiness, and accuracy.

Figure 10.2
This remote is closer to what they would all look like if they had been originally designed for elderly fingers.

Figure 10.3

The Apple iPad, introduced in spring 2010, attracted many first-time computer owners with its touchscreen interface and sub-notepad size, particularly those who wanted access to Internet media files without having to use a computer.

play on the conventions of magic by making things appear and disappear, or grow larger or smaller, with a flick of the fingers, can be particularly satisfying.

The video game industry exploits our pleasure in manipulating digitally displayed objects through the action of our hands. The experimental edge of such expressive interaction eliminates the input device altogether. For example, in Camille Utterback and Romy Achituv's landmark art piece, *Text Rain* (1999), you (the interactor) stand in front of a screen on which your own image appears as in a mirror, but silhouetted and joined with images of gracefully falling letters. By stretching out your arms, and moving your hands, you can capture and rearrange the letters and words as they fall, breaking apart their original poetic words and phrases and creating fluid new combinations. The falling objects have appealing buoyancy, responding like air balloons to the force and direction in which they are flicked or pushed or bounced (figure 10.4). A similar sense of magical potency over text objects is used for dramatic effect in Steven Spielberg's futuristic film *Minority Report* (2002), where the police investigator played by Tom Cruise navigates a vast information array by waving his arms and pointing both hands at a transparent wall screen that reads his gestures without the use of any pointing device (figure 10.5).

In mixed reality environments, where digital objects are superimposed on or embedded in real-world objects, the interactor is often given a simple physical tool,

Figure 10.4
Text Rain (1999), an art installation by Camille Utterback and Romy Achituv that entices interactors to play with responsive bouncing letters.

Figure 10.5
Steven Spielberg's futuristic film *Minority Report* (2002) showed Tom Cruise using a gestural interface to navigate a dense information space. The technology was based in part on gestural work done at the MIT Media Lab by John Underkoffle and interface designs by Dale Herigstad of Schematic.

Figure 10.6

Augmented Alice, a research project in augmented reality. The interactor, wearing a head-mounted display, sees the virtual characters sitting at the same table, and has an actual teacup (empty, but equipped with motion sensing) that matches the cups held by the virtual characters (Moreno, Bolter, and MacIntyre. 2001).

which can act as an interface to the digital world. For example, in a mixed reality installation of the Mad Hatter's tea party, created at Georgia Tech, the interactor is placed at a real table with a real though empty tea cup, suggestive of a child playing tea party. Wearing a head-mounted display, the interactor sees the (digital video) characters from the story as if they were sitting at the same table. The teacup is an input device, which can be used to throw tea at another character. By lifting it and aiming the invisible tea the interactor triggers the video segment in which the character is drenched in tea and responds angrily (figure 10.6) (Moreno, Bolter, and MacIntyre 2001). The same strategy would work with procedurally generated characters, which might be able to receive the tea on different parts of the body with dynamically calculated splatter patterns reflecting the force and rotational positioning of the cup. This is a dramatically satisfying action, giving the interactor a strong sense of agency, but there are only so many things one can do with a teacup. Furthermore, the presence of the characters in the same space raises questions about what other actions might be possible: can you point at them accusingly, shake a fist, raise a hand in a "Stop that!" gesture? Can you get out of your seat and grab the Mad Hatter by the throat? The teacup acts as a **threshold object** to connect the interactor with the imaginary world, and to script specific behaviors that have agency within that world (Murray 1997). But placing the virtual object seemingly within reach raises our level of expectation, which can lead to frustration and loss of immersion when we discover the limits of our agency. The challenge for designers in engaging the hand is to establish the consistent boundaries between what can and cannot be grabbed.

The computer magnifies and challenges the pointing power of the hand but it can also eradicate the hand altogether. The life-changing power of the computer as a prosthetic device rests on the ways in which it has abstracted pointing away from the hand and made it possible to point with eye movements, mouth movements, or even

Figure 10.7
IRISCOM system (2009) allows people with limited mobility to control a computer by mapping the movement of the cursor to eye movements captured by a digital camera.

with brainwaves themselves (figures 10.7–10.9). The manipulation of external objects by merely thinking about them or looking at them is a magic beyond the magic of the hand, the realization of the fantasy of controlling the external world merely by the power of our thoughts and desires. Part of the appeal of computational environments is their power to elicit this fantasy.

Digital tools act on information rather than on the physical world: they change the state of bits inside the machine, a change that is reflected by the output display. These changes are hard for users to model, and so designers reach for concrete analogies. Early graphical interfaces relied heavily on images of pointing fingers and grasping hands. These have largely been replaced with arrows, showing that the use of the pointing cursor as an extension of the hand has become transparent. We no longer need to be reminded of the convention.

Current applications rely on iconized hand tools such as pencils, pens, brushes, paint buckets, highlighting pens, erasers, scissors, and magnifying glasses. These metaphorical tools work something like the actual object, abstracting a key affordance of the thing they imitate, but they do not behave exactly as we would expect the physical object to behave, because bits do not behave the same way as atoms.

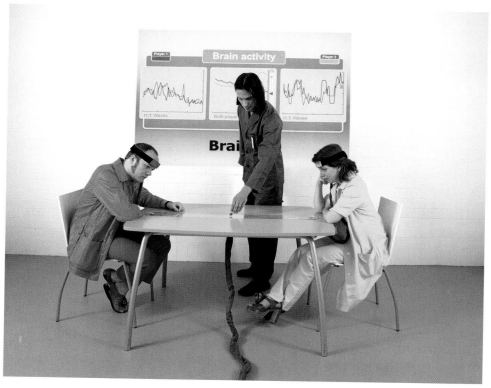

Figure 10.8
Brain Ball (2000), Interactive Institute, Sweden. Two players compete to move a ball toward them by generating brainwaves characteristic of relaxation.

Users often bring expectations from legacy processes into the digital world. We live in the **analog** world of atoms not bits, and we are more comfortable with analog processes, because they reflect the familiar, immediately understandable messiness of our minds and hands. Erasing a line on a computer screen means switching each byte representing it from on to off, and thereby changing the state of each pixel by which it is displayed. Digital erasure leaves behind no trace of the hand or the tool that performed the act, no messy borders, no half-erased but still visible marks, and no bits of eraser rubber clinging to the surface. Erasing a line on a piece of paper with a rubber eraser leaves a smudge, and graphic designers do not want to sacrifice the expressive possibilities of smudging. The unfamiliar efficiency of the digital medium has led to the creation of virtual tools that precisely simulate the effects produced by the inefficiency of analog tools: the smudge tool in Photoshop, for example, does just that, allowing the user to partially eradicate and blend part of an image. It is iconized by

Figure 10.9
In Mindflex Game (2009), a commercial product, the player controls the movements of a ball
(through the action of the fans that position it) by generating the appropriate brainwaves.

a finger, and modified by setting the level of pressure with which the area is smudged.
The action simulates finger painting. For those who want the computer display to
respond more directly to the pressure of the hand, there are pressure-sensitive input
devices, one of which is a stylus with a digital eraser at one end in direct imitation of
a pencil. Smudge tools and pressure-sensitive styluses are necessary because human
beings crave analog effects produced by analog means.

Unlike analog tools, digital tools can operate in the same way at significantly dif-
ferent scales. We need a different pair of scissors to cut embroidery thread than to
trim a hedge, but we can use the same digital scissors to cut out a single letter or
100,000 words. This greater range of effect means that we have to be careful to *specify
the scope of action* that we want in any use of a tool. Because their scope is potentially
enormous and because digital actions can be parameterized so easily, *digital tools elicit
encyclopedic expectations for a large repertoire of variant effects.* One of the design chal-
lenges of application software is how to provide this expansive range of choices
without overwhelming and confusing the user. For example, Photoshop groups its
tools into a menu with variant related tools in submenus; it places a control panel
with parameters for the selected tool in a separate pane (figure 10.10).

The complexity of digital tools is somewhat offset by another digital affordance—
reversibility. The effects of digital tools should always be undoable. Interactors should
always be allowed to undo the last action, with a command that is specific: not just
"undo" but also "undo typing" or "undo formatting." Undo commands should

Figure 10.10
Selecting a tool in Photoshop involves selecting from variants in the tool palette (e.g., Brush Tool, Pencil Tool) and then adjusting its settings in the control panel at the top of the window (e.g., Brush size, Mode, Opacity).

themselves be undoable, with paired "redo" choices. It is desirable to allow the user to undo multiple steps, not just the last one, and to cancel anything that has not yet been completed. Undo interfaces should have a history feature, allowing the interactor to step backward through decisions. Wherever possible, undoing should be independent of the order in which an action was performed, allowing the interactor to change one of a sequence of commands without changing the effect of subsequent commands unless they are directly dependent upon it. For example, Photoshop provides a history of actions performed on an image and allows the user to undo an action taken anywhere in the sequence without undoing the ones that came after it. *The more complicated the toolset, the greater the need for fine-grained access to reversibility.*

Because we are so familiar with physical hand tools and because icon toolbars make good use of our ability to select from a range of choices by pointing, application programs tend to turn as many actions as possible into iconized tools. Sometimes the icon is the metaphorical physical tool (such as a scissors for cutting text); sometimes it is a visual **abstraction** of the desired result (such as icons for the Align Text Left, Align Text Center, Align Text Right, and Justify commands); and sometimes it is a metaphorical representation of an abstract process, (such as the counterclockwise circular arrow that means "undo"). Other icons are less specific. For example, the magnifying glass has been used within the same word processor icon bar for three different metaphorical functions: search, print preview, and document map—and in other common applications, like Adobe Acrobat, for zooming. The proliferation and inconsistent use of icons makes them hard to differentiate and remember. Grouping the tools visually and labeling them by function is helpful. *But the congestion of*

Figure 10.11
Some of the available iconized tools and tool palettes in Microsoft Word 2008.

application toolbars makes clear that as programs increase in functionality they are outgrowing the model of the tool (figure 10.11).

Efficiency, Learnability, Transparency

The **tool model** helps us to focus on key design goals that apply to any digital environment, and are particularly relevant for programs or artifacts that are used instrumentally, as a means for accomplishing a task. Good tools display:

• Efficiency: They allow us to perform tasks in the most immediate and direct manner without unnecessary intermediate steps or delayed results.
• Learnability: Their function and manner of use is obvious and easily demonstrated; they can be used for simple tasks in a simple manner, and complex uses can be mastered incrementally with practice.
• Transparency: The user can focus on the task and not on the functioning of the tool.

The earliest digital tools in the graphical user interface prototypes developed at Xerox PARC supported these design goals through the affordance that Ben Shneiderman later identified as **direct manipulation**. According to Shneiderman direct manipulation is characterized by three specific design practices:

1. Continuous representation of the objects and actions of interest with meaningful visual metaphors
2. Physical actions (or presses of labeled buttons) instead of complex command syntax
3. Rapid, incremental, reversible operations whose effect on the object of interest is visible immediately. (Shneiderman 1992a, 205)

Direct manipulation systems tie visible results to users' direct actions, making them easy to learn. The first instances of direct manipulation, such as the file and folder system, were a clear improvement over the command line interface. When they were embodied in the Macintosh interface they led to the wide adoption of the personal computer as a household item for personal use rather than merely a work tool. They also led to the development of graphic design application programs and a new kind of training of design professionals.

But the representation of objects and actions by visual metaphors can sometimes interfere with efficiency and create confusion. Dragging files into the trash requires unnecessarily traversing physical space on the screen. Direct manipulation sometimes requires disconcerting actions. The classic Macintosh operating system required users to place images of floppy disks in the trash in order to eject them, dangerously confusing destruction of data with removing durable media. In later versions of the operating system the trash icon changes to an EJECT icon—an improvement, but still not ideal. Direct manipulation is not served by a too-literal reproduction of the physical world or by needlessly physical representations of virtual actions. For frequently performed actions command keys can be more "direct" than metaphorical actions, as long as the result of the command is immediately observable and reversible. **Contextual menus** attached to the object that is the target of the action can also provide the experience of direct action without requiring awkward physical manipulations (figures 10.12, 10.13). *The important consideration is not whether the interface affords direct manipulation of a physical representation, but whether it communicates a clear model and supports interactor's experience of agency.*

Efficiency, learnability, and transparency are interrelated values. For most tools in the physical or virtual world, we must go through a period of trial and error and often a period of training in order to put them to best use. Hand tools, such as a hammer, have clearly perceived affordances based on their shape and how they feel in our hands; it would be hard to hold a hammer by its head instead of its handle, so simply picking it up starts the process of learning how to use it. Computer objects like plugs and floppy disks can be made to fit into receptacles in only one orientation, making it impossible and therefore nonintuitive to try to force them in incorrectly. The shape of the computer mouse invites the hand and the immediate **feedback** of seeing the cursor move as it is jiggled teaches us how it works. *The tools are successful because their affordances are so readable, scripting the interactor with appropriate expectations and behaviors.*

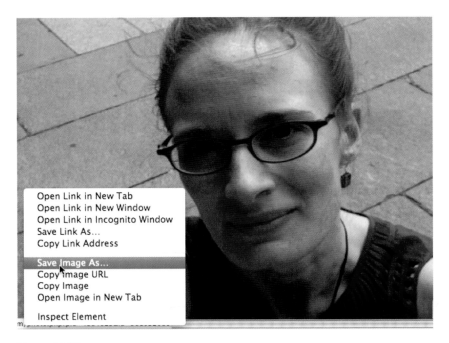

Figure 10.12
A contextual menu in a web browser understands that you have clicked on an image within the web page and offers appropriate choices.

Figure 10.13
A contextual menu from The Sims offers choices relevant to the object selected, in this case the door to a neighbor's house.

The complexity of contemporary digital applications makes them hard to learn and easy to misuse. *The aim of design should be a* **gentle slope system** *in which users can do simple things in simple ways and gradually add to their repertoire of actions.* Adjustable tool bars allow choices to be added incrementally, removing the clutter of mysterious icons from the novice's field of view. The strategy is similar to the practice in video game design of training the player on simpler levels before introducing more challenging ones. But the trend in application design has been to proliferate tools rather than to devote attention to presenting them in a learnable progression.

Mastery of a digital environment need not involve absolute recall but only the ability to be *reminded of things in context*. As Donald Norman has pointed out (1998), we cannot make everything immediately obvious to users, but we can aim to make things that only need to be explained once (182). Learning can be incorporated into the tool itself because we can associate text, video, animations, diagrams, labels, instructions, warning sounds, frequently asked questions, or any other media object that can provide guidance and instruction. The convention of providing context-sensitive help is a significant improvement over the legacy approach of a linear manual. We can find what we need when we need it, through rollover text or help buttons linked to specific tasks. Labeling is often the best way to make a tool's function clear, and it is increasingly necessary as interfaces become more cluttered. Labeling fails when the name does not reflect the function for first-time users (e.g., the Marquee Tool in Photoshop, which selects areas of an image), or the nomenclature is not standardized (e.g., the Contacts button in a calendar program overlaps the Address book feature; a program has both Search and Find commands). Tutorials and help screens can explain tools; animations demonstrating their use are particularly valuable. But the best way to learn a tool is to have a safe and structured way of trying it out so that repeated feedback with reversible results can reinforce the kinetic action of applying the tool. Some programs, such as games, provide **sandbox** areas for this kind of experimentation.

To make a tool learnable, its visual representation and label should reflect a consistent abstraction of the overall process. Much of the confusion of using tools lies in competing models of the task, tool, and product. For example, Photoshop abstracts the process of image making as masking, layering, burning, dodging, painting, lassoing, and even magic. Each of these metaphorical processes assumes a different kind of physicality for the underlying product and a different kind of activity on the part of the creator. Some of these abstractions come from the complexity of visual perception and some of them from the complexity of legacy processes such as photography and painting. Some of them, like lassoing and especially magic are clumsy attempts to find appropriate new labels for actions that are only possible in digital environments. All of these tools may follow Ben Shneiderman's guidelines for direct

manipulation, but each of them must be learned individually. The task is made harder from the lack of a common abstraction of the process.

In suites of tools, there should be a consistent abstraction of the overall process and especially of the material being manipulated. The abstraction should be as free as possible from legacy conventions that do not correspond to digital affordances (like "dodging" in Photoshop), and should provide for manipulation at multiple levels of granularity. For example, in a word processor it is appropriate that we not turn virtual pages but scroll up and down through a seamless text. Direct manipulation of the scroll bar or text area makes it clear that progress is from top to bottom of the screen and the position of the scroll bubble makes clear where in the text we are in relation to the whole. This is a consistent abstraction that is easily learnable, memorable, and efficient, and creates the kind of transparency that allows us to focus on the task instead of the mechanics of interaction. It would be much less transparent (and farther from the underlying bit structure) to represent the document as a stack of papers. Similarly, the concept of layering in image manipulation programs is a simple and powerful abstraction based on a familiar physical metaphor, and reflecting the efficient, modular organization of the underlying bits. Organizing an image into layers allows us to change some parts while leaving others intact, and to create duplicate versions of elements of an image to compare by turning visibility on and off layer by layer. Presenting text as a continuous top to bottom scroll and images as manipulable layers allows us to point to the part of the text or image we want to manipulate with our tools, while retaining a larger sense of context. Both of these presentations work because they communicate a concrete model of the artifact that is not literally faithful to the legacy versions, but that reinforces the digital structures that make them available for manipulation.

Expressivity and Virtuosity

In addition to the design goals of efficiency, learnability, and transparency, digital tools can also foster

• Expressivity: Good tools allow the user an appropriate degree of choice, inflection, and individual adjustment, supporting the development of expertise, craftsmanship, and technique.

The precision and scope of digital tools are turned into expressive power when the user is able to apply them with craft-specific technique and task-specific discretion. Digital tools are now the norm in the creation and transmission of words, images and sounds for art and entertainment, because they exploit the malleability and control that results from changing media from analog signals into bits. Words can be copied, pasted, erased, and reentered with ease; images can be changed dot by dot

instead of area by area; whole orchestras can be synthesized at will. The unprecedented manipulative power of digital tools makes them desirable to users, and increases the demand for more specialized functions: outliners and specialty fonts, filters that imitate brushwork, animations controlled by if/then statements, and tools that merge media types into a single presentation format. The novelty and potency of these new tools makes users tolerant of a high degree of awkwardness and difficulty in learning them.

In the long run, however, we demand tools that are easy to use as well as powerful. Although writers once put up with ink-blotting quills, leaky fountain pens, and pencils that had to be laboriously sharpened with penknives, they eagerly embraced ball-points, electric pencil sharpeners, and typewriters once they were invented. Similarly, users would gladly desert the cumbersome interfaces of current image and text-editing applications if they are offered more elegantly designed applications that offer a similar level of control with a more gradual learning curve.

The precision and repeatability of digital actions make digital tools ideal for activities that require standardized results such as color matching, geographical positioning, or closely synchronized behaviors. But standardization can be also dehumanizing, removing the traces of the human hand and obliterating individual effects. Digital reproduction is the antithesis of the "aura" that Walter Benjamin celebrated as part of the essential value of a work of art: its singularity and connection to its maker creates a sense of presence impossible to achieve through mechanical or electrical reproduction (Benjamin 1968). *The remedy for the dehumanization of standardized digital processes is the creation of tools that maximize individual choice and expression.*

To create these new expressive digital tools, we will have to expand our model of the digital tool, thinking of it as not merely efficient but also expressive. *Efficient use* involves getting a known task done in the simplest way with the least effort and time. *Expressive use* involves accomplishing an improvised, novel, or personalized task with the widest appropriate range of choices and discretionary options. Expressive use requires both mastery and technique: the ability to inflect the tool in subtle ways to increase its utility. A pocketknife can be used with expertise to carve wayfinding markings in tree trunks. This is an efficient, instrumental use of the tool. A pocketknife can also be used to whittle figures of animals. This is an expressive use of the tool, which allows for individual variation and meaningful differences in form. In mathematical contexts we talk of expressiveness as capturing complex relationships through symbolic means. In artistic contexts we talk of expressiveness as conveying emotion, sharp observation, or complexity of form. A computational tool can offer all of these forms of expression, both by mimicking analog tools and by allowing access to new expressive forms.

The expressive use of a tool is not merely a matter of efficient mechanical skill and familiarity, but also involves the attainment of technique. *Technique is the graceful*

fitting of the tool to the result, maximizing its expressiveness with carefully adjusted and coordinated choices, often involving manipulations that require specialized skills. Technique is both science and art, both perceptual and mechanical. We admire it not only for the difficulty of attainment but also for the fitness of the result. The computer is sometimes criticized for eroding technique because it makes complex actions available with a lower level of kinetic mastery and with much less knowledge of materials. Typefaces, for example, are a sophisticated design element, and they used to be hard to come by and to manipulate. Access to the tools was tied with training in their appropriate use. When the computer made multiple typefaces available to those without graphic design training the result was a new kind of visual clutter. By putting sophisticated tools in the hands of those who have very little knowledge of their correct use, the computer can sometimes short circuit the attainment of technique. *The challenge for designers is to scaffold the attainment of technique without sabotaging the novice with too much power.*

When we focus on the expressive power of the computer we often invoke the model of the musical instrument. A musical instrument is expressive by virtue of its physical affordances, and the learned mastery of the performer. The tool itself requires attention before it can become transparent in use. We must practice the instrument and fit our hands to its keys, strings, or buttons; fit our breathing to its apertures; learn to hold the right posture; bear the weight in the right places. Skill at a musical instrument is a matter of fitting the kinetic ability of the player to the affordances of the machine. Musical instruments require more than mere pointing, they require coordinating many expressive affordances of the human body with the affordances of the tool. Computer input devices can require similar degrees of practice but they rarely offer comparable expressiveness at the same level of transparency as a skilled musician. A computer keyboard or touchpad can become an extension of our hands just as a piano keyboard or drumstick does, but it does not register changes in pressure and tempo. A game controller is much more sensitive, affords virtuoso demonstrations of skill, and can be tied to emotionally charged actions, although games are often limited by formulaic situations and a lack of scope for original performance (figure 10.14).

The conventions of musical instruments have been directly helpful in shaping digital interfaces. Keyboarding of various kinds and especially *chording*—the simultaneous use of multiple fingers to expand the range of expressive choices—has been a staple of utilitarian and playful digital input systems. Musicians have a hard time learning to play their instruments, but there is a payoff in mastering the complex range of expressive possibilities, because more control leads to a richer product. In electronic environments, game controllers demand virtuoso control similar to musicianship. The game controller offers considerable versatility of action, calling for

Figure 10.14

The SONY DUALSHOCK3 wireless controller with pressure and motion sensing and feedback vibration, making (according to its maker) "Each hit, crash and explosion . . . more realistic when the user feels the rumble right in the palm of their hand."

movement in space and complex chording of buttons. Part of the pleasure of games is this demand for complex signaling and hand-eye coordination. The demand on dexterity taps into the biological connection between the hand and emotional expressiveness. Video game controllers have turned manual dexterity and rapid pointing reflexes into a competitive sport. The popularity of video games has revealed a surprising enthusiasm for mastering very complicated combinations of multifinger controller sequences for the purposes of simulated battle and vehicle navigation. But the expressive vocabulary of games has been limited, because commercial gameplay is so much focused on vehicles and weapons. There are signs that this is changing, however, and the coming decades may see an exploration of manual dexterity for increasingly expressive uses (figure 10.15), including controlling information spaces and navigating virtual worlds.

Our ability to map fine motor actions with our fingers onto representational worlds underlies our use of many tools: the embroidery needle, the carving knife, the paintbrush, the knitting needle. Facility at one helps to build up aptitude for others. A computer-phobic neighbor was surprised to find she was enjoying her grandson's video games until she realized that she found them easy to play because of her lifelong dedication to the piano. Computer games like musical performance draw on our pleasure in mapping hand movements to complex actions. The pleasure we find in mastering such skills and in finding expression in the movement of our fingers allows us to learn new keyboard arrangements such as the joystick game controller, the arrow key-driven PC game control, the one-handed twiddler keyboard used in experimental devices (figure 10.16), the thumb-operated PDA, or the quickly learned Wii game controller.

Figure 10.15
In the PlayStation video game Heavy Rain (2010), game pad actions mimic in-game actions. For example, climbing up a muddy, slippery hill hand over hand requires similarly challenging finger positioning.

Figure 10.16
Twiddler one-handed chorded keyboard used in wearable computing applications.

Figure 10.17
Multitouch iPad screen allows navigation of photo archives with pinch and zoom.

The effort of learning complex hand skills can be pleasurable in itself, especially when it is tied to emotionally compelling representational effects, such as rapidly appearing and disappearing colorful objects or the sounds of an explosion. Chording effects performed in a rapid manner within a responsive environment can provide the kind of difficult but achievable challenge that leads to the pleasurable absorption in a task, which Mihály Csíkszentmihályi (1990) identified as **flow**. As we gain speed and accuracy, mastery of the controller feels like an extension of our physical prowess. Some virtuosos gameplay Super Mario without looking at the screen. They have internalized the sequence, rhythms, and timing of the gameplay, in the same way that a dancer memorizes a choreographed dance.

A growing area of design is extending pointing to increasingly sensitive full surfaces, including some that are sensitive to multiple simultaneous points of contact. Touch-sensitive screens and trackpads are elaborating new mimetic fingering techniques, such as the two-finger pinch to zoom, or rapid left-to-right flicking to indicate deletion (figure 10.17). Multitouch screens and multitouch tables (horizontal screens, sometimes with associated coded or sensor-equipped objects) allow rapid sorting of images,

Figure 10.18
Multitouch wall-mounted screen, from Perceptive Pixel.

more detailed zooming of dense information spaces such as data-rich maps, and collaborative work or multiplayer gaming with simultaneous updating of the shared desktop or game board (figures 10.18, 10.19).

As gesture-based consumer devices like Microsoft's Kinect become more common, the range of expression that can be brought to digital applications will increase. Researchers at MIT are experimenting with wearable sensors linked to cameras and projectors that can recognize iconic gestures like snapping a photograph (figure 10.20). As such devices become more available hand gestures to simulate flying, walking, reaching, and grabbing may be particularly useful primitives in creating expressive applications. For example, in the experimental *Egg's Journey* installation (figure 10.21), the interactor is in the role of an egg reaching for one of a number of showering sperm. Grabbing any one of them produces a cartoon image of the possible child that would result from the pairing (<http://synlab.gatech.edu>). The interaction is direct and simple, leading to an experience of agency within a very complex representational world. Experiments like this remind us that the expressive possibilities for engagement with the virtual extend far beyond the familiar point-to-shoot conventions of commercial gaming.

The inclusion of cameras on cells phones has increased the expressive possibilities of pointing. Capturing a barcode or a book cover in the real world can provide access to all the information about that place. Looking at a place through the camera lens (in combination with GPS information) can produce an overlay of information or a related coupon. Similarly, GPS technology can turn the simple act of visiting a place into a kind of pointing, allowing you to display your image on a map so friends can

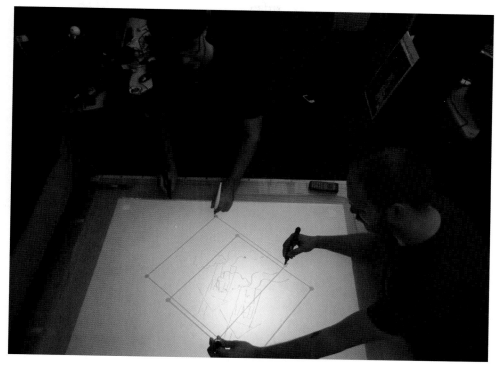

Figure 10.19

Two students copy a sketch for independent editing using SketchTop, a collaborative sketching application for a multitouch tabletop computer, designed in Ali Mazalek's Synlab at Georgia Tech. One student touches and holds two of the corners while the other pulls the copy out from under the page by dragging a third corner.

see where you are, or to claim an actual place within a social networking game as if it were a square on a Monopoly game board.

The next decades will bring an increase in possibilities for hand control, challenging designers to invent new gestural conventions and new gesture-driven device genres that will be as efficient, learnable, and transparent as the WIMP interface, and as expressive as the modern orchestra or rock and roll band.

Many digital artifacts function as tools in that they are used as instruments for achieving other aims, like the creation of a text or the retrieval of a video or the operation of remote telescope, and all digital artifacts have some tool-like elements, such as clickable icons or pull-down menus. Therefore, *the values we apply to tool design should be applied to any digital artifact, especially the value of transparency, which allows us to focus our attention not on the tool, but on the demands of the task at hand.*

Figure 10.20
Pranav Mistry of Pattie Maes's MIT Sixth Sense Group demonstrates a gestural interface to a digital system that includes a camera and colored markings on fingertips.

Figure 10.21
In Ozge Samanci's whimsical installation piece, *Egg's Journey* (2007), the interactor's hand and arm gestures are captured and mapped onto a mirroring animated character positioned inside an ovum surrounded by sperm. Grabbing a particular sperm produces an image of the possible child resulting from the combination.

DESIGN EXPLORATIONS: THE TOOL MODEL

Extending the Function of Our Hands

• Focus on an activity you enjoy that involves the use of unpowered hand tools, such as carpentry, cooking, drawing, cleaning, home repair, musical performance, sports:
 • What tools do you find particularly handy for this pursuit?
 • What tools have caused you injury or frustration?
 • What design qualities do these artifacts possess?
 • Are any nonfunctional qualities of the tools important to you?
 • Are there cultural associations prompted by the tools such as feelings of affinity with others who use it?

• For a physical or digital tool that required time to learn:
 • Describe how you went about learning it. Did you have expectations of how it would work before you used it? Did the shape of the tool or other physical qualities influence your expectations? Did the tool perform as expected?
 • Was the correct means of employing the tool apparent from trial and error? If not, what else was necessary?
 • How did the difficulty of the learning process contribute to your satisfaction or lack of satisfaction?
 • When you try to use the tool after a period in which you have not practiced with it, do you know immediately what to do? Do you refer to written instructions or other aids to recall how to use it?
 • When you are using the tool are you focusing on the tool itself, on your technique in using it, or on the effect of the tool on whatever you are using it for?

• When might you or someone you know do any of the following:
 • Use your hands to perform a task that others would use a tool for?
 • Use an improvised tool instead of a conventional tool to perform a task?
 • Use an unpowered tool instead of a powered tool?
 • What criteria are you applying for choosing the right tool for the job at hand?

• Attempt to use an unfamiliar hand tool for a familiar activity, for example, chopsticks or an oversized or undersized fork or spoon for eating or a calligraphy pen for writing; or if you know ping pong, try tennis or billiards; or switch from a cricket bat to baseball or softball.
 • How do your hands behave?
 • Does familiarity with one behavior help or hinder you from learning an alternate method?
 • What assumptions and expectations do you bring to using the new tool based on your internalized, kinetic knowledge of the familiar tool?
 • Is your knowledge of the familiar tool in your head or in your hands? Can you describe in words how to use it or do you have to demonstrate?

Using Pointing Conventions

• Using Google Scholar or the ACM Library or any similar collection of analytical writing, search one or more essays for the word "point" or its derivative forms (points, pointing, etc.) and find examples of at least five ways that language builds on this physical action as a metaphor for focusing attention.

• List all the times you use an electronic touch device that is built into a physical structure, such as an elevator button, microwave, or ATM.

 • What feedback does the device give you to let you know it has received your touch?

 • Have you ever been confused or irritated when using any of these devices? Why?

 • Have you seen children using the device? How do they react? What appeals to them or frustrates them about it?

• Use the computer for a pleasurable leisure activity, such as a virtual environment, social environment, or video game.

 • Notice every time you point at something.

 • Is pointing tied to another action (such as opening, grabbing, shooting)?

 • Is selecting separate from acting?

 • Is pointing too time consuming?

 • It is purposely challenging, as in a game?

 • How transparent is the act of pointing accurately?

 • How difficult was it to learn?

• Use the computer for a complicated visual task like editing a photograph or creating a 3D model.

 • Does the software allow you to point to the part of the image that you want?

 • Does it provide feedback on what you have pointed to?

 • Can you adjust the granularity?

 • How tactile is the experience?

 • How would you prefer to perform this task if you had an ideal, magical technology to support it?

 • How would you describe the design goals for such a perfectly tactile technology to a group of wizard inventors?

 • What would it take to create such a tool in the actual world?

Exploiting the expressive power of pointing

• Choose a memorable image from painting and/or fictional films that focuses the viewer's attention on a gesture of pointing or the touch of a finger (e.g., Michelangelo's *Creation of Man*, or the alien's finger in the film *ET*).

 • What ideas, spoken dialog, emotions, or concepts are contained within the gesture? How does the artist frame, compose, and contextualize the hand to convey these meanings?

• Design or create an interactive artifact that invites the interactor to enact a similar touch.
• Pretend that you have a magic wand that could change something that is happening in your daily life in a way that would make things easier or be more to your liking.
 • What would you change?
 • What gestures would you use to effect this change?
 • Design or create a mock-up or prototype for a digital artifact that invites the interactor to perform the magical effect you have fantasized.

Connecting the Real and the Virtual with Threshold Objects
• Teleoperator environments let us perform actions from a distance, such as directing a robot to pick up rocks in space or repositioning a web camera. Choose a teleoperator environment available over the Internet and spend some time exploring it.
 • How responsive is it? How immediate is the feedback? How appropriate is the input device to the action you are performing?
 • How would you design an ideal input device for performing the same task? How important is it to have visual, auditory, or **haptic** feedback for the process?
• Choose a fictional world that was very real to you as a child. Imagine you can enter that world, as if it were a movie screen you could step into with the help of a magic threshold object that physically exists in both the real world and the target world (e.g., Dorothy's ruby slippers that take her back home to Kansas from Oz when she clicks them together).
 • Design the threshold object that would let you act within the fantasy world. How would you summon it? What would you do to direct it? What would be the first sign that you had successfully entered the imaginary world?
 • How would you implement your design in a virtual reality environment?

Making Digital Tools Learnable and Transparent
• Examine all the tools in a common image-processing application tool palette.
 • What is the physical metaphor behind each tool?
 • Which are derived from chemical processes?
 • Which are derived from printing?
 • List all the legacy (predigital) media formats that are referenced by the labels of tools and menu commands.
 • Which tools do you use the most?
• Design a minimal set of tools for manipulating images.
 • Sort them into seven or fewer categories with seven or fewer items in each category. Compare result with others.
 • Collectively create the smallest possible set of tools with the most functionality.

• Design an iconized tool that acts on an image or text segment in a way that reinforces direct manipulation with clear feedback. (It can produce a whimsical or surprising effect, such as a writing tool with a horror movie font.) Communicate cause and effect clearly so that tool is quickly learnable by trial and error.
 • Your design should be documented with a state diagram if the tool has state, and a flow chart for uses of the tool with storyboard illustration.
 • Implement your tool if possible and observe users with it.
 • What expectations did they bring to the tool? Did the tool fulfill their expectations?

Supporting Expert Practice

• For an activity with which you are familiar, find an example of a tool that is essentially the same for novices and experts.
 • Is it easy or hard to learn how to use the tool?
 • What is the difference in skill between different kinds of users?
 • What kinds of practices lead to the acquisition of higher skill levels?
 • Could the more skillful practice be automated? Why or why not?
• For an activity with which you are familiar, find an example of a nonpowered hand tool used by experts above your level of skill (e.g., specialized kitchen tools, high-end sports equipment).
 • How does this object feel in your hand? If you can find an expert (or perhaps a salesperson) ask them what affordances the tool has that might not be apparent to you.
 • How does an expert use it differently?
• Find an example of a power tool that has a nonpowered basis (e.g., tooth brush, screwdriver, egg beater) and use each of them in turn to perform the same task.
 • How much control over the process do you have with each?
 • What is your emotional reaction to each?
 • What are the cultural connotations of each—who would use them and in what context?
 • Invent a story about a person who prefers one to the other. What else would you expect such a person to prefer?
• Create a storyboard or a set of animations that documents the design of a new interactive virtual tool. (It can be based on a tool you investigated in one of the previous explorations.) Your virtual tool can perform either a literal task (such as a virtual knife whittling virtual wood) or a metaphorical task or (a virtual knife cutting waste out of the U.S. health care system).
 • What input device (e.g., mouse, stylus, joystick, touchscreen, accelerometer) would work best with your virtual tool?

- How would you provide immediate feedback on the workings of the tool? What sensory information is crucial to success (visual, auditory, haptic)?
- What existing conventions for similar tools are useful for providing sensory feedback?
- How would a novice use your tool?
- How would an expert use it?
- How would you support the acquiring of technique from novice to expert?
- If possible, implement your tool and test it with users doing think-aloud reporting.
 - Does the tool work as you expected it to?
 - Do the users understand how to use it?
 - Does it become transparent with practice?
 - Can they achieve expertise with it?

11 The Machine Model: Visibility and Control as Design Goals

Machine: An apparatus . . . so devised that the result of its operation is not dependent on the strength or manipulative skill of the workman.
—*Oxford English Dictionary*, second edition (1989)

A **tool** is a simple device, customized to a single purpose, operating under our control and responsive to our direction, whose effects are immediately visible to us. A **machine** is a complex device, designed to perform scripted actions in exactly the same way. Machines are independent of our control once set in motion, although some machines—like vacuum cleaners, automobiles, or nuclear power plants—require alert and skilled operation by human beings to monitor and direct their complex actions. Digital **artifacts** are like other physical machines in that they perform scripted sequences of actions, but as highly **interactive** devices they can include extensive human direction. When we think of a digital artifact as a tool we emphasize the design values of **transparency** and skilled expression. When we think of a digital artifact as a machine we emphasize the design values of **visibility** (of its operations) and control.

Designing for Visibility

The model for interaction with a machine is the **black box,** the hidden processor that receives **input** from the user, performs unseen operations on it, and returns the result as **output**. An automobile receives gasoline and produces motion; a vacuum cleaner receives electricity and creates suction. How they produce these results is hidden in the black box. We don't need to know how they work as long as they get us where we want to go and continue to suck up the dust motes. Machines often begin as automated versions of hand-controlled artifacts, like the electric drill or can opener. The vacuum cleaner is an automated broom, the automobile a "horseless carriage." Over the longer sweep of history we can see a progression from human hand, to hand tool, to mechanical device, to electrical device, to **computer**-controlled process. For example, consider the age-old activity of spinning thread: Bits of animal hide, wool,

or plant fiber are first twisted by hand into larger and stronger cords; then a found rock or twig is used for more organized winding; then a handmade spinet is created for the explicit purpose of turning fiber into yarn, with refinement of the design over time and adaptations for thicker and finer cords; eventually the single spinet for twirling fabric fibers into thread is made more efficient by being attached to a spinning wheel; then, in the eighteenth century, the single spinning wheel is made more efficient with the invention of the spinning jenny that allows manual control of eight spindles; with the advent of electricity, spinning is further automated, with the process elaborated into a multimachine assembly line. Currently, thread is spun in giant arrays of computer-controlled machines that have over a thousand spindles each. Each step increases the amount we can produce and distances the process further from direct contact with human fingers.

Until the industrial revolution, machines were largely powered by human or animal strength. But with the invention of the steam engine in the late eighteenth century, processes could be more completely automated, replacing manually produced piece-work of many kinds with more uniform and prolific factory output. As the *Oxford English Dictionary* definition opening this chapter suggests, a large part of the value of a machine is its substitution of reliable mechanization for potentially faulty human control. Tools *augment* human effort; machines *replace* human effort. Machines literally take processes *out of our hands* and put them in black boxes out of sight and out of our direct control.

As we have seen in part II, it is a helpful part of **modular** design practice to think of computational procedures as black boxes (figure 11.1), allowing the design team to hide the details of how something is done in order to focus higher- level system components. As interactors we are also familiar with black box input/output mechanical devices like vending machines, which let us focus on our end goals without having to manage the intermediate steps. The customer approaches a large metal box, puts some money in a slot, and the money disappears inside. The customer presses a button, mysterious interior noises are heard, and the soda bottle pops out from some other part of the device.

Early computer systems worked in a similarly mechanical way. Stacks of punch cards went into a system of large, noisy processors, and some time later reams of

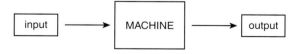

Figure 11.1
A machine receives input and produces output. Its processing is often hidden, making it a **black box**.

printouts came out the other end. For such a system, an important design goal was input predictability, since any error in entering data on a card or specifying the sequence of computer commands would bring the processor to a halt, and require a time-consuming, paper-based debugging process, followed by another visit to the basement computer room with a revised set of punch cards. The aim of designers was to take the human out of the system—to mechanize processes as much as possible in order to reduce the chance of human error.

But automated systems contain human errors that can be harder to spot, can do more damage in a shorter period of time, and can prove more complicated to correct than direct human errors. Here are three particularly notorious examples that designers should remember:

• In the 1980s, several cancer patients died as a result of lethal radiation dosages administered by the Therac-25 machine, which substituted faulty software safety checks for hardware constraints that would have made it physically impossible to deliver a lethal dosage (Leveson and Turner 1993).
• On January 15, 1990, 144 AT&T long-distance switches failed because a mistake in a single line of computer code set off a chain reaction that propagated itself each time any individual node would shut down and try to reset itself. The error took nine hours to diagnose, leaving 60,000 people without telephone service and causing 70 million failed telephone calls (<http://www.phworld.org/history/attcrash.htm>, accessed February 21, 2011>).
• The European rocket system Ariane 5 was destroyed during its launch on June 4, 1996, because of an error in converting a large decimal number from 64-bit to 16-bit representation (Gleck 1996).

The more we automate the critical infrastructures of human society, the more vulnerable we are to hidden software flaws that can have disastrous consequences.

Interactors bring the same wariness to their everyday transactions with digital devices, knowing that a slip of the finger can broadcast an embarrassing email message to a list full of strangers, or delete a year's worth of data, or transfer ten times the intended amount of funds from one account to another. Because the computer acts so quickly and powerfully, we need assurance that we are in control. Our relationship to the machine is therefore not the intimate guidance of the tool, but the *power relationship of the command*. We tell it what to do, and look for confirmation that it is doing what we expect it to do. It is the designer's responsibility to support this relationship: to provide the user with the appropriate commands, and with **feedback** that makes clear what is happening within the hidden recesses of the efficient black box and how to intervene and correct it if it is not what she intended to happen.

As we move from tools to machines we gain scope and lose flexibility. While tools can be responsive to corrections because they are optimized for human gestures,

machines are unforgiving of human error because they are optimized for fixed input followed by fixed sequences of action. The vending machine accepts some coins or bills and spits back the others. The punch-card reader finds the expected holes in the expected columns or chokes on the card, ending the program. The Internet telephone program refuses to let me exit the application until I enter a correct port number, whether I want to or not.

Many of the design strategies of error prevention in **human–machine interaction** aim at constraining the actions of the user to match the inflexibility of the machine. For example, the user is limited to well-formed input by standardized keyboards, letterform conventions, and special fields that only accept specific kinds of characters. In the early days of human–computer interaction **(HCI)**, user input was limited to typing commands. The command line interface, which is still the standard for systems operations, requires the user to be a programmer or trained technician, familiar with a specific abbreviated, formulaic mode of communication that is easier for machines than for humans to decode. Command line interfaces use cryptically abbreviated codes based on chording a command key and an alphabetical key to limit typing and reduce typos. Some old-school computer scientists continue to use command line text editors for their email programs (figure 11.2), just as some people prefer to drive manual shift automobiles, because it gives them more direct control of the mechanism. Though command line interfaces have been replaced with graphical user interfaces **(GUI)** for many decades, command keys remain a part of computer keyboards, and keyboard shortcuts are widely used in word processors, operating systems, and keyboard-based

C-x C-f	find file (open a file in a new buffer)
C-x C-s	save file
C-x I	insert file at cursor positon
C-f	move cursor forward [without arrow keys or mouse]
C-space	set a "mark" to indicate the beginning of a selected region [a selection is bounded by a mark and a cursor position]
C-w	kill a selection
M-w	copy a selection
C-y	paste (yank) a copied or killed selection
M-v	page down
C-x u	undo
C-t	transpose two characters
M-t	transpose two words

Figure 11.2
Among the most beloved commands in the world of hackers are the original keystroke combinations used in one of the oldest text-editing programs, EMACS (Editor MACroS), developed at MIT in the 1970s. They are based on use of the control key (C-x) and the meta or Alt/Escape key (M).

Figure 11.3
Keyboard shortcut commands are listed on the Edit menu of a word processor alongside their human-friendly command names.

Figure 11.4
The World of Warcraft Rookie Guide here calls attention to the keyboard shortcut in the **tooltip** message for the gold cup icon.

video games. It is conventional to list the keyboard commands within the GUIs on the menu next to the appropriate command or in rollover labels associated with icons (figures 11.3, 11.4).

Once the command has been issued, the system should acknowledge it in some way. The computer produces little direct mechanical feedback—no flashing lights or whirring sounds to reassure us that the bits are switching on and off. So visibility must be the result of explicit coding. One of the most basic problems for interactors is knowing whether or not the computer is doing anything in answer to our input.

Figure 11.5

A progress indicator for a web-based university site with very limited visibility, indicating that an upload is in progress but not how long it will take or what percentage of the task has been accomplished. This lack of specific feedback is acceptable if the delay is a matter of seconds.

Figure 11.6

The Fetch program's doggy icon trots eagerly to indicate a file transfer in progress, and in this recent version of an Internet classic program, displays a donut progress indicator as well.

Figure 11.7

TiVo process tracking. The machine is politely acknowledging the presence of the human spectator, as well as providing information that is helpful for repair.

This problem is augmented by our expectation that the computer will be immediately responsive and will perform the requested function instantaneously. When the task requires wait time, designers have invented the convention of the **progress indicator,** which may be an updating text message, progress bar, watch face, hourglass, or spinning icon of some kind that provides the feedback that a command has been received and is being acted on (figures 11.5–11.7).

Whenever possible, designers should use determinate progress indicators that measure the time or tasks remaining in relative ("98% done") or absolute ("1 minute remaining") terms. For lengthy or complex tasks, progress indicators often name and list the intermediate steps and provide estimates of time for each step, increasing the interactor's sense that the machine is under our control, faithfully executing our commands. A web browser usually has a field with small print at the bottom of the window that we only notice when the page fails to load. Typing in "nytimes.com" is something like sending out a dog to fetch a newspaper, so it is reassuring that if the browser is delayed the messages at the bottom of the browser window follow the progress, telling me that some code somewhere is "Looking up nytimes.com," "Connecting to nytimes.com," "Waiting for nytimes.com," and "Transferring data from nytimes.com." As other information devices go digital they require similar strategies to control user impatience and provide feedback on invisible processes (figure 11.7). Even if the human spectators are helpless to affect the process, it is still appropriate to acknowledge their presence by reporting on what is going on.

When the multiple steps are less meaningful, such as the installation of a large software program, designers can still acknowledge the impatience of the user by sending general or even playful messages. For example the MIT Campus Map (<http://whereis.mit.edu>) has a whimsical repertoire of loading screen statements such as:

Please Wait
while the little elves draw your map

Please Wait
the bits are breeding

Please Wait
at least you're not on hold

The Sims games have a signature bogus loading screen message ("Reticulating splines") among other parodic messages that playfully reinforce the dollhouse illusion, like "Making Beds" and "Filling Fridge." Other games provide a static screen with back-story or gameplay information while loading the procedural elements into memory; a few provide a little bit of playful interaction. The moment when the machine is executing the user's command is a not just a moment for efficient feedback but also a chance for the designer to communicate with the user, to characterize the relationship as one of obedient fetching, efficient connectivity, playful collaboration, or however else one wants to position it.

In informational websites and other applications, the waiting interval has been conventionalized into an opportunity for paid advertising, a practice that is likely to continue, even as increased broadband access eliminates the technical lag time. Since we bring expectations of agency to any digital environment, however, interactive

viewers are irritated by this loss of control over playback and welcome the increasingly standard convention of the "skip" button.

Acknowledging input and signaling the user that processing is taking place is the minimal degree of visibility a usable machine should provide. In addition it should be able to report on its inner **state**. The candy machine near my office has a clear window through which I can see the packages of candy stacked one behind another in their separate coded slots. When there is no more of a particular candy left to purchase, the slot appears empty. The state of the system in regard to candy inventory is directly visible to the end-user. Simple mechanical devices also provide indirect visibility. The nearby soda machine is an opaque metal box with no view of the soda cans, displaying a row of lighted buttons labeled with the names of the offered beverages. If a beverage is sold out, the light illuminating its name is turned off, dimming but not erasing the name, a convention for temporary unavailability that is also standard for computer menu items. Graying out disabled choices preserves their place in the mental model of the system while scripting the interactor not to choose them.

The value of the candy machine design reflects a principle of honest salesmanship that has been adapted for software design: "What You See Is What You Get" (**WYSIWYG**). Interactive design achieved a milestone when it adopted WYSIWYG standards for the products that were created on the computer for delivery in other media. For example, the first word processors required users to type in the **markup language** codes for how the text would appear when transferred to paper, so that an italicized title would look like this:

```
<i>War and Peace</i>
```

In 1975 Xerox PARC researchers Charles Simionyi and Butler Lampson created Bravo, the first word processor that allowed on-screen editing of features that were displayed in the same way as they would appear on paper:

War and Peace

But as the black box fills up with more and more hidden processes, what you see may be only part of the picture. Visible results on the computer may come from multiple causes: italics can be the result of applying a style to a class of text objects, such as a heading or a comment, and changing one instance may or may not affect other instances of the same class. A user might not know how to interpret what they are seeing or how to produce the effects they want to see. For example, a word processor displaying

War and Peace

may have turned the text red as a Formatting command or as part of the Track Changes tool. If I am unaware of Track Changes, and I receive a document in which changes

appear in red, I will be baffled over how to deal with it. I may think the changes have been made through the font color tool, and I may be unable to change them back again. If the word processor automatically puts me into the Track Changes mode, and displays my own additions to the text in a third color, I may become doubly confused. A Track Changes mode is very useful for collaboration, but it may be a hindrance to productivity if the interactor is not signaled that they are in a new mode, and given a context for interpreting the computer's actions.

To achieve the design goal of visibility the designer must support the creation of a coherent **mental model** of the computer's processing. Graphical user interfaces, and WYSIWYG displays are only as good as the overall picture they create in the mind of the user. Like other cognitive **schema**, a mental model of a computational application organizes multiple perceptions and actions, allowing us to take in new information quickly and to make testable guesses about what will happen next. A useful mental model need not correspond to the actual working of the machine. For example, thinking of the web as made up of separate "sites" is a useful model even though the sites may not correspond to actual places and we are not really going anywhere when we type in an URL. Similarly, when I feed a check into an ATM machine it displays an image of a wrinkled check being smoothed out. I recognize this as a nonliteral representation of this stage of the ritual of making a deposit: the machine is acknowledging that it has received a check but has not yet recognized the amount payable. If I did not get this feedback I might become anxious by the disappearance of the check. Instead, I have a mental model of what the computer understands and what kind of action it is currently performing; I remain engaged with process, actively awaiting my cue to inspect and verify the deposit amount.

Our mental model of a computer-based environment is reinforced by consistency and immediate **feedback**. Consistency means that interface elements always behave in the same way: double-clicking on a file always opens it; a list with round buttons always allows you to choose only one of several menu items. Feedback means that the computer offers you evidence that it has received and acted on your command: the file folder changes in appearance when you drag a file over it; the trash can makes a crunching sound when you empty the trash. By adhering to these standardized conventions, designers make the actions of the computer visible to the interactor, and reinforce the mental models that set up our expectations for interaction.

Empowering Interactors with Control Structures

Tools are directed by hand. Machines are directed by control panels. Everything that comes between the interactor and computer code can be understood as part of a digital control panel. Our controls have been steadily increasing, but that has not necessarily brought an increase in our sense of control over automated processes. *The computer is*

Figure 11.8
Application programs frequently use their Help menu for locating commands on other menus.

such a versatile machine that it threatens to outgrow our ability to keep track of the many commands we have programmed it to execute.

To perform a task that was once well served by pen and paper, I currently use a word processor that comes with twelve pull-down menus, many of them offering over a dozen choices, including embedded submenus; in addition there can be up to five rows of icons and an adjustable ruler above the document, while underneath the document is another control panel offering a choice of Views and instantaneous updates on the page, line, and column currently being edited. In additon, an optional Task Pane to the right of the document provides eight other possible control panels). Indeed it has become standard to use the Help menu just to locate commands on other menus (figure 11.8). The same explosion of command choices makes games, virtual environments, and professional tools hard to learn and confusing to use. Clearly, the control panel is out of control. The proliferation of icons and menus can paralyze the user with too many choices, destroying transparency by focusing attention on the control panels instead of the task at hand (figure 11.9), or it can become an immersive experience with the allure of a secret society (figure 11.10).

Because the control of increasingly automated and modifiable tasks is so difficult, it is all the more important that designers provide a way to repair errors. In a tool situation with direct manipulation, we can provide step-wise undo commands. In a

Figure 11.9

Photoshop includes multiple submenus for reconfiguring control panels and keyboard commands.

Figure 11.10

World of Warcraft screenshot. The control structure can cover more than half of the screen. The array of cryptic icons enhances the player's sense of belonging to a mysterious world of hidden powers, though it seems to locate the player's agency in the overlay rather than the animated world beneath.

machine situation, the step that caused an unwanted effect is often difficult to identify because it is buried in a black box. Often something that seems to the end-user like a one-step operation (such as plugging into a wireless network or printing a document) actually involves multiple pieces of software and hardware, with many places at which unexpected information can cause the system to fail. Such failures can result in cryptic messages that offer the user no clue about how serious the error is or how it can be rectified or prevented from recurring. Perhaps the single worst example of such an error message is this one, from the Windows 95 operating system:

`This program has performed an illegal operation and will be shut down.`

This notoriously offensive message confuses two domains of regulation: the standardization of machine processes and the legal system. Since it is possible to commit illegal actions with software, such as downloading a copyrighted file or violating a password-protected area, the wording is particularly inappropriate and even alarming. *Software should serve its users, like an obedient dog, not intimidate them like a police officer.*

Less alarming but equally unhelpful are error messages like these:

`Bad Window Class, ignored (Windows 2000)`

`Unable to join the network linksys33 (iPhone)`

`Can't open this item. Could not open the item. Try again. (Microsoft Outlook)`

When categories of errors can be anticipated it is useful to offer error messages that point the user in the right direction even if they do not give completely specific feedback, such as `"This is not a valid measurement"` or `"A required field is empty."` Overly specific explanations can be annoying when they are off the mark. For example, while working on this book, I entered the Save command on my world processor only to receive the alarming and misleading message in figure 11.11. Note that the only option offered is an OK button, though the error and the explanation were certainly not "OK" with me, and the remedies suggested were not helpful.

The most helpful error messages are warnings or alerts that prevent the user from doing something that is permissible but irreversible, such as the messages that ask for confirmation before deleting a file, making a purchase, transferring bank funds, or running a program downloaded from an unknown source. To keep the alert box useful as a convention for arresting attention, designers should only employ it for messages that serve the user, and not for self-serving purposes like demanding that their program be made the default application or soliciting visits to a parent website. Alerts linked to common actions, such as saving a file or exiting a browser, should offer the user the option of suppressing future notices (figure 11.12).

Figure 11.11
Misleading and unnecessarily alarming error message from Microsoft Word 2008 for Mac when a Save command failed. There was no networking error and no disk was inserted. The difficulty was a bug in the newly introduced docx format, so a more correct error message would have prompted the user to save the file in a doc or RTF format.

Figure 11.12
Photoshop alert box. The warning makes clear why the interactor might want to choose a different file format, and it includes the "Don't show again" checkbox.

Much of the frustration of using digital applications results from actions that are "legal" and even reversible but seem to happen of their own accord. Automated formatting in word processors, for example, can introduce unwanted numbering and paragraphing effects that are difficult to reverse. As functionalities are combined through the merger of applications into multiapplication environments, there is a need for an integrated help utility that provides an overview of the many options. For example, a popular suite of applications allows users to create a table in the form of a spreadsheet, slide layout, text document insert, web page grid, or database, each offering a different combination of functionalities and command structures. *For such complex environments to function well, application programs must not function as independent machines but as consistent parts of a single system with simplified, integrated control structures.* Creating such systems will require designers to establish standardized conventions for common operations—such as adding or deleting rows or columns in a table, sorting rows by clicking on columns, inserting formulas, assigning background

colors to individual cells—that work across applications, in the same way that placing Help at the right-most part of a menu bar, or pressing control-S to save a file are conventions that currently work across many diverse applications. *The more we converge disparate devices and applications and extend the functionality of existing consumer products, the harder designers must work to abstract the common processes and actions and to represent them to the interactor as a coherent and consistent model.*

The Appliance Model: Widgets and Applets Sharing Information

The speed and ingenuity of computer processing is rapidly increasing and individual applications are assimilating more and more functions, making them hard to monitor and more challenging to control. The **appliance model** of the computer is an attempt to turn the all-purpose personal computer—a single complex, unwieldy, multipurpose machine—into multiple simpler devices. An appliance is a mechanical/ electrical device built to serve a single function, usually a household need, such as a toaster. In his 1998 book, *The Invisible Computer,* Donald Norman describes the personal computer as hopelessly complex because it tries to do too many things. The "solution" to this complexity is the "information appliance," which Norman defines like this: "An appliance specializing in information: knowledge, facts, graphics, images, video, or sound. An information appliance is designed to perform a specific activity such as music, photography, or writing. A distinguishing feature of information appliances is the ability to share information among themselves" (Norman 1998, 53).

Norman was right in anticipating an increase in digital media and the ubiquitous availability of streams of information that can be picked up and shared by multiple devices. He was also right in identifying the multiple uses of the personal computer as causing confusion in the late 1990s, as users were just beginning to listen to the radio and watch television on the same device on which they did their email, spreadsheets, word processing, image processing, video gaming, and web surfing. By 2010 the same degree of confusion had spread to the mobile phone, and to the general proliferation of devices which afford some combination of these activities, plus telephoning, instant messaging, book and newspaper reading, video recording, GPS directions, access to movie times, . . . and so forth, with no end in sight. A decade after Norman's manifesto for information appliances to replace personal computers, the personal computer is going strong and mobile devices are accumulating functions rather than specializing in fewer of them. I would suggest that this is because the interactor brings the expectation of the same affordances to every digital device. Consumers have rejected the notion of a telephone that does nothing but make phone calls, a television that only receives live scheduled broadcast and cable content, or a music player that does nothing but play music. And although book readers are popular, they have expanded access to the web, especially since the magazines and

Figure 11.13
Amazon's Kindle, when it was released in 2009, offered portability, instant access to books and newspapers over a proprietary net connection, and legibility in low light or direct sunlight, but it was limited by its lack of web access and restriction to black-and-white text and images.

newspapers they offer by subscription are publishing rich media content online (figure 11.13).

The continued increases in processing power, memory, and digital bandwidth have made this convergence less frustrating than it was in the late 1990s.

However, the appliance model is still an important reference point for design, and we can see it not in individual devices, but in the specialized smaller applications that run on these devices, the **widgets** and **applets** built for specific (and often proprietary) platforms. The application rather than the device has become the single-function appliance. Instead of a pocketbook full of separate iPod-like devices for music, text, and Internet, consumers are carrying a single iPod or smartphone or tablet loaded with small, specialized applets (figure 11.14).

Widgets and applets are efficient to produce and disseminate because they leverage the larger platform and user bases. They can be lightweight, made of relatively little

Figure 11.14
Applets on the iPhone offering formerly separate functions on a single device: a telephone, calendar, web browser, clock, GPS system, camera, calculator, notebook, stock market ticker, weather report, and instant messaging.

code, and draw on standardized XML formats like RSS. Widgets often require minimal interaction, giving value by displaying useful, customized information streams like stock portfolios and local weather by preselection. They can make use of information in associated address books and GPS software or plug into existing social networks, so users can share photos or convene games for established "friend" groups. Widgets can be made by a single person or an unfunded development group and find users through established online distribution networks. They are also popular with larger developers and established brands for exploiting the possibilities of **cloud computing**—the migration of data and applications from the individual desktop of a single machine to the always available web.

As Norman pointed out, information appliances can compensate for limited functionality by sharing information. But this is not always the case with existing software widgets or applets, which are often hampered in development by copyright boundaries. Proprietary data formats may suit industries based on copyright exclusivity, but they also inconvenience and irritate interactors who expect a high degree of control over information in digital form. Application appliances are less useful when they lock

Figure 11.15
The CoMotion system shares information across a suite of separate widgets for maps, bar charts, and spreadsheets to create an integrated functionality set for collaborative business applications. CoMotion is produced by General Dynamics.

up data in separate bins, forcing the interactor to copy and paste or even retype the same information from one program to another. *Efficiency attained by limiting functionality, whether in the name of simplicity or proprietary interests, is problematic in an encyclopedic, participatory medium.* Therefore, the appliance model will continue to be under pressure to evolve toward greater interoperability and information sharing across applets (figure 11.15).

Widgets are a versatile and dynamic category of innovation, contributing to and benefitting from an emerging ecology of networked functionalities. Stabilization of platforms always leads to increased development of specialized genres. In this case there are multiple relatively robust platforms, any one of which (a social network, web portal, mobile operating system) could decline or be replaced by an emerging standard from a competitor or a new area of digital practice, such as interactive TV. But though any or all of the existing platforms may disappear, the widget/applet approach will persist because it reflects *the foundational principles of modularity of design and information sharing that makes for successful innovation in the medium as a whole.* Designers will continue to be challenged to invent and refine the functionalities and conventions of interaction that allow specialized applications to leverage participation in a community of similar appliances.

Toward More Expressive Machines

If we are to expand the responsiveness and expressive power of powerful computer systems we must make them more like tools in their support for precise and flexible control of their functioning. Instead of thinking of them as black boxes or limited function appliances, we could think of them as highly responsive power tools that do not take things out of our hands, *but instead magnify the power and extend the repertoire of things we can do by hand.* The industrial age has provided us with some analog

examples of expressive and tool-like machines, such as the jig saw, potter's wheel, food processor, and camera. These artifacts allow for the practice of technique and virtuosity while extending the range of creative possibilities. All of these expressive machines have specialized inputs, precise controls, and predictable output, but they are all flexible enough to be employed with craftsmanship in complex, variable processes. All of these devices are designed by experts and shaped for complex tasks that go beyond what the user could do without mechanical assistance. All of these devices are used differently by individual artisans or performers, and all allow the same user to create a wide range of results, reflecting individual skill and aesthetic choices.

There are already examples of similarly complex, responsive, and expressive digital artifacts, some of which are based on analog models such as digital still and video cameras and photo/video editing software, digital musical instruments and sound recording/editing programs, digital animation software; and some of which are purely digital expressive structures, such as procedural authoring environments like website and game level editors. *The invention and refining of expressive environments like these that put the processing power of the machine into the hands of creative developers will be a growing area of design in coming decades.*

The growing representational power of computation is also enabling us to make the world around us more expressive by embedding processors into devices distributed through the environment, or attaching computer-readable labels to objects in the world. Cognitive scientists think of the world around us as constituting a system of **distributed cognition** in which objects scaffold our individual and collective cultural memory and shape our behaviors. *Media objects are an important part of this distributed cognition.* For example, maps allow us to carry with us more geographical information than we can keep in our heads. Street signs are part of the same distributed cognition system, helping us to locate ourselves and to share our location with others. Computation allows us to automate the operation of these media objects, making them aware of us and able to process information on the spot and on command. A GPS navigator knows where we are and where we want to go and can generate routes and guide us through them, adjusting automatically to our deviations from the plan. We have just begun to explore the possibilities of embedding such smart devices and computer-readable information in objects in the world. The challenge for designers is putting computational power in the right devices and the right places and making their processing visible and sufficiently under our control without letting the machines overstep social boundaries or requiring humans to conform to the rigidity of machines.

The measure of expressivity in digital media is not about using the latest gizmo or achieving the most advanced programming feat. To be an expressive machine, the computational apparatus has to serve an explicit human purpose and to act under our

control, allowing us a range of meaningful discretionary actions, and augmenting our actions in some way with its automated processes. To achieve a high degree of hands-on control and craftsmanship with complex computational systems and emerging computational technologies, interactors need **sandboxes** or other safe modes of operation in which to develop the requisite mastery by repeated experimental exploration. In order to make complex processing power available for expression we have to make computational procedures more visible and computational control systems more flexible. *The more visible we can make the operations of the machine, the more control we can give to the expressive user, and the more we can foster the development of expressive technique.*

Increasing the visibility of computational processes will also strengthen our ability to analyze claims involving computer systems. Designers will often be faced with situations in which meaningless output is overvalued because it has been produced with great expense of computational skill and resources. Technologists and humanists alike can be mesmerized by the processing power of the black box, treating it like an oracle instead of a calculator. Technologists sometimes assume we can increase expressivity by increasing resolution or processing power, but more pixels or more elaborately mined data do not necessarily make for more meaningful information. Postmodern humanists sometimes find expressive achievement in the procedural distortion of images and texts because it makes us aware of the arbitrary nature of signifiers. But erosion of meaning is a limited form of expressive power, though the use of computation can give it an aura of greater significance. And most of us are all too easily seduced by mere novelty, size, or speed. When faced with such claims for the authority of computational solutions, it is useful to remember the sly parable from Douglas Adams's *Hitchhiker's Guide to the Galaxy* (1979) in which the greatest computer in the cosmos, Deep Thought, takes 7.5 million years to compute the answer to the "Great Question of Life, the Universe and Everything":

"All right," said Deep Thought. "The Answer to the Great Question . . ."

"Yes . . . !"
"Of Life, the Universe, and Everything . . ." said Deep Thought.
"Yes . . . !"
"Is . . ."
"Yes . . . !!! . . ."

"Forty-two," said Deep Thought, with infinite majesty and calm. (Adams 1979, chapter 27)

Black-box calculation has tremendous power to exponentially increase our common intelligence, synchronizing the business of life on a global scale and putting a world of information literally at our fingertips, but in the end it is only human intelligence rooted in embodied experience that can create meaningful form.

DESIGN EXPLORATIONS: THE MACHINE MODEL

Recognizing and Controlling Machine Processes
• Look at four videos for the Science Channel program *How It's Made* (available on television and at <http://science.discovery.com>). What makes the depicted processes suitable for automation? What parts of heavily automated processes are done by human hands or by humans operating tools? What makes the human worker valuable in each of these circumstances?
• Make a list of all the machines you encounter in one day. Include power tools, mechanical devices like bicycles and air pumps, anything with a lever (like a see saw) or a pulley (like a clothesline), cash registers, computers and peripherals, cell phones, land phones, kitchen appliances, toilets, and so on.
• Sort the machines into meaningful groups by whatever criteria you think most important in differentiating them (e.g., energy source, size, complexity, kind of motor, kind of function).
• Choose one of the groups and identify conventional features characteristic of the category (e.g., electrical machines have on/off switches and lights to tell you when they are on, portable machines have handles or wheels).
• With reference to the same list of familiar machines: If you were placed in an isolated room with all the necessary components, which of these machines could you reproduce? Which of them could you repair if it were to break?
• For one of the machines create a **state diagram** (see chapter 4) that describes all of its possible states and the transitions between them.
 • Explicitly indicate what level of abstraction you are choosing.
 • How would your representation be different at a higher or lower level of detail?
 • How would it change if presented from a different point of view? For example, a microwave has different salient attributes to the manufacturer (e.g., low/high power) than to a family in the kitchen (e.g., with unpopped, popping, and fully popped popcorn).
 • How much control does the user have over these state transitions?
 • How visible (perceptible) are these states to the user (can you see, hear, smell the difference)?
• For one of the machines on the list create a **flow chart** of how it operates in a typical session of use.
 • What is your mental model of its decision tree and the order in which it performs its tasks?
 • What components do you assume exist even though you can't see them?
 • Can you imagine alternate flow charts that would result in the same visible effects?
 • How much of the processing of the machine is immediately visible?

- Design an interactive model of a physical machine. Create a virtual model of a familiar machine that primarily works on physical objects (e.g., a water heater, a washing machine, a vending machine). Make sure that the process is visible in terms that are meaningful to the user of the machine (e.g., not the wiring or the workings of the engine but the stages and parameters of heating, washing, vending).
 - Locate existing diagrams, prose explanations, and video demonstrations of the functionality, components, and operation of the kind of machine you are modeling. Abstract these explanations into a single coherent schematic representation in any form that makes sense to you. You will probably need a mixture of images and words.
 - Describe the operation of the machine in a flow chart or state diagram or both.
 - Describe the operation of the machine in **pseudocode**. (You can black box some of the specific routines as long as you name the major classes of processes and the variables that control them.)
 - Create a **storyboard** of an interactive implementation of the model that makes visible the otherwise invisible workings of the machine.
 - Implement your storyboard. Test it with other users to be sure the interaction pattern is clear (e.g., that they know how to wash clothes with the model washing machine).
 - Give your digital model to another group of users and after they have used it ask them to describe the workings of the machine.
 - Compare their descriptions to your original schematic explanation.
 - How well did your digital model communicate your mental model of how the machine works?
 - What did your model make perceptible that is not perceptible in the physical machine?

Modeling Hidden Processes

Making the processing of the machine visible to the interactor does not mean that we show the actual circuitry of the machine. We need to create a model that accounts for how things happen and that can guide the interactor's expectations and behavior.

- Choose a puzzling mechanical device or digital system and ask three people to explain how they think it works. For example, you could take a description of an automotive breakdown from the *Car Talk* radio show or an image or animation of one of the devices made by the ancient inventor Heron of Alexandria, or an aspect of a video game that is clearly not random and yet difficult to predict.
 - What experiences and assumptions do their explanations draw on?
 - What aspects of the information you provided them with were the most relevant to their explanations?

- Which explanations did you find persuasive? Could they be validated by further observations of the puzzling device or system?
- For one month, notice every time something happens in a computer-based environment that you find puzzling.
 - Indicate whether or not you found an explanation for it.
 - What was your mental model of the system before the puzzling event?
 - Did this event change your model?

Getting Control of Control Panels

The control panel should provide agency over the workings of the machine, without distracting the interactor from focusing on the task at hand.

- Identify control panels attached to tools in applications other than the ones discussed in this chapter. For example, consider games and mobile applications.
 - Do they make elements visible that are otherwise invisible?
 - Do they quantify elements that observable in different ways?
 - Do they increase your understanding of why things happen as they do?
 - Do they offer you control over variables?
 - Are there other conventions that could be used for the same control tasks? Would they be an improvement or a less expressive choice?
 - Are there conventions used in this example that would work well for control panels in another domain (e.g., using the pie menus from a game in an image-processing program)?
- Observe yourself or a member of your group using a complex application program like Photoshop or Microsoft Word to do a familiar task.
 - Write down all the panel settings, menu commands, dialog boxes, and tools that they actively use in the performance of this task.
 - Create a design for an interface that includes only those features of the program that were used. Feel free to reassign functions if it will make the new application more coherent or functional, such as making a tool palette into a menu or a menu into a tool palette.
- With the user's permission, observe a new user of a complex application that you are familiar with attempt to do a complex task.
 - Note when the user makes mistakes and whether the program gives feedback so that the user can recognize the mistake and its cause.
 - Is the error message system responsive to user mistakes?
 - Does the Help system provide appropriate direction?
 - Observe another member of your team providing active error correction and coaching for the new user.

- What kinds of explanations does the human provide that the system does not provide?
 - What are the advantages and disadvantages of each method?
- How would you design a Help system that would function more like an ideal human helper? (Do not include any cartoon figures.)
 - Are there some aspects of actual human-to-human coaching that you do not want to reproduce?
 - Are there some aspects that are completely beyond our abilities to script with computer code?

Designing Modular Appliances for Shared Information Resources

- Hybrid appliances are becoming increasingly common, creating rough combinations of divergent sets of conventions. Answer one of the following with reference to a particular device and share the answers with others in your group, in order to collectively identify control conventions (e.g., menus, remotes, on-screen buttons, navigation commands, state displays) that are moving from one domain to another:
 - How does a television set support gaming?
 - How does a games console support watching television?
 - How does a phone support television and gaming?
- Look at three examples of applets or widgets in a single category for a single platform, such as a productivity app for a phone platform or a photo-sharing applet for a social networking site.
 - What common conventions do they use?
 - What is the best and worst feature of each of the three applets?
 - To what degree do they share information with other applets or with networked data resources? Are there other possibilities for exchange that are not currently exploited?
 - Make a competitive analysis chart listing feature types on the horizontal rows and the three apps on columns. Indicate which apps have which features.
 - Add a fourth column for an ideal applet that would have all the right features, including ones you may want to add new rows for that none of your sample included.
 - Advanced: Create a storyboard or interactive mock-up that corresponds to the ideal app whose functions you specified in the previous exercise. What conventions would you use similarly to other applets?
 - Advanced: Test the interactive mock-up with other students serving as your test group and improve the design to reflect the results of testing.
 - Advanced: Create a working version of the ideal applet with some or all of the proposed functionality.

• Design and if feasible create a media widget/applet that takes two or more streams of structured data from networked sources or from another applet on the same platform and combines them in a useful way. (For example, an applet on a mobile device might combine music from an Internet radio applet with a photo stream, drawing on applets on the same device.)

• Design and if feasible create a media widget/applet that combines two or more RSS feeds or other preexisting structured data sources, into a single useful display.

 • Identify parameters to put in the hands of the interactor. For example, combine newspaper and radio feeds and allow the interactor to specify place of origin, or combine air quality and weather data and allow the interactor to specify a danger range for temperature and specific allergens or contaminants.

12 The Companion Model: Helpful Accompaniment as a Design Goal

When I hit my thumb with a hammer, I get mad at myself, at the person making me do the work, and at the cruel and malignant universe, but I don't get mad at the hammer. By contrast, when my computer crashes, or fails to give me a file that I know is there, or tells me that I failed to shut it down properly when it was the one that crashed, I get mad at it.

—Christopher Miller (2004)

The Computer as a Social Presence

As we have seen, our "intuitive" responses to the computer often derive from learned responses and media conventions that have become **transparent** to us through habituation. But some of our most powerful unconscious scripts derive not from cultural habituation but from our biology. Although we are usually not aware of it, research has shown that we treat computers as if they were alive (Reeves and Nass 1996). Social scientists explain this phenomenon by pointing out that the human brain evolved long before there were mechanized entities capable of interaction and seems to be hardwired to attribute consciousness to trees, rivers, wind, and statues and to attribute human motivations to wild animals and invisible fairies, based on the evidence of our ancient myths and folk traditions. So it is perhaps not surprising that we see a resemblance to our own consciousness in a machine that initiates actions, makes requests, and responds to our commands.

Therefore, in addition to their expectations that computers will behave like efficient tools and powerful machines, interactors also see digital devices and the programs that run on them as part of the social world, almost as if they were living people. Our sense of the social presence of computers is so strong that as Clifford Nass has demonstrated, people will show politeness to machines, not criticizing them to their "faces" but only sharing negative comments with a second machine, just as we tend to do with other people (Nass, Steuer, et al. 1994). These social expectations add to our pleasure and frustration with digital environments. When a digital environment is transparently helpful and visibly responsive to our

commands it can be experienced as an extension of our own mind, just as a familiar and responsive automobile is experienced as an extension of our own body. Sherry Turkle has referred to this attitude as thinking of the machine as a *second self* (Turkle 1984). Computer environments can become so familiar to us that they seem like an intimate friend who can complete our sentences and whose separate thinking we see as clearly as our own. We share rituals with our interactive devices that are reinforced by thousands of repetitions, creating habitual associations between our own thoughts and desires and the conventions of our smartphones, email programs, social networks, or operating systems. Like strongly identified sports fans, users of PCs or Macs sometimes speak of their chosen platform as if it were part of their personal identity or a tribal affiliation: "I've always been a loyal Mac user." "I'm a PC person." Marketing strategists reinforce these affiliations, associating stylistic elements with recognizable cultural stereotypes—of hipster artist or efficient businessman— but the phenomenon is not merely a creation of corporate image making. Techies who would never wear a branded t-shirt are capable of the same degree of intense personal identification with a favorite programming language or open-source operating system.

Because they are present as almost-living things, digital artifacts have a surprising ability to engage our emotions. We can feel affection for a machine that helpfully accompanies us through our tasks, as we might for a pet dog; I was so charmed by a new and remarkably miniaturized laptop that when prompted for a name for the hard disk I spontaneously called it "Cutie Pie." And by the same token, when we are frustrated by computer functioning, we can feel personally insulted, and respond with an intensity similar to what we would feel in a quarrel with a contrary family member or a habitually obstructive colleague. In 2005 Kent Norman, a researcher at the University of Maryland, conducted a Computer Rage Survey in which users reported hitting computers, making obscene gestures toward them, shouting at them, describing them to others as "evil," as well as more extreme behaviors such as setting them on fire or shooting them; and they were eager to act out their rage for the camera and post the video online to be enjoyed by other enraged computer users (<http://lap.umd.edu/computer_rage>, accessed February 21, 2011).

Computer rage is the flip side of computer longing, of our desire for a machine that effortlessly anticipates and fulfills our needs, making life easier and less lonely. The challenge for designers is to exploit the magic without triggering the rage: to make digital artifacts that are satisfying, predictable, and transparent to use, and whose workings are demystified and visible, however impressive and valuable we may find them. To do this, we must acknowledge the expectations triggered by our unconscious perception of the computer as a social actor or "second self."

Synchronization

As a versatile social actor, the computer can play a number of roles from teacher to game opponent to secretary. Perhaps the simplest of these roles, and the one that underlies all the others in the imagination of the interactor, is that of *companion,* a sentient, thinking consciousness that accompanies the human actor through some activity. *Accompaniment requires synchronization, of the interactor to the computer and the computer to the interactor.* A good example of design for **accompaniment** is the karaoke machine, which allows a user to sing popular songs accompanied by instrumental tracks and synchronized lyrics. Before the invention of the karaoke machine, there were movies made by the Fleischer brothers and television shows produced by Mitch Miller that provided the text of lyrics synchronized with the performance, enabling the audience to sing along. There were also print genres to support sing-alongs, such as sheet music and a once-popular genre of magazine called a "song sheet" that contained all the lyrics to the top-selling records of the day. Karaoke machines automate the sing-along, providing just the right segmentation of the musical signal: all the instrumentation but none of the singing. In more sophisticated systems the music might be varied in tempo or key to suit the individual, but most of the focus of the karaoke machine is to help the human performer to conform to the digital output rather than the other way around.

This karaoke model of computer-driven accompaniment can be made into a challenging game when the computer is used as more than a music player. Computers can model many kinds of performances, and humans can be challenged and scored on their ability to keep in synchrony with a complex and rapid digital output. Games like Parappa the Rapper (Sony PlayStation 1996) in which the player controls an on-screen avatar who mimics the rapping motions of a succession of teacher characters, and the arcade game (later adapted for consoles) Dance Dance Revolution (DDR) (Konami 1998), in which the player performs dance steps on a platform or game mat by following a onscreen notation, exploit the pleasure of achieving synchronization by providing rapid and complex actions for the player to follow. Guitar Hero (Red Octane 2005) and its successors turn music making into a challenging game. As with the karaoke machine, the computer is the pacesetter in all of these games, and it is up to the interactor to imitate the onscreen performers and follow the symbolic score. *Synchronization is achieved because the machine programs the player* (figure 12.1).

Music players have been sources of mechanized social accompaniment in everyday life since the first commercial gramophones were introduced at the turn of the twentieth century (figure 12.2). Transistor radios in the 1960s separated baby boomer teenagers from their surroundings via ear plugs, and allowed them to plug into their

Figure 12.1
Guitar Hero screen for two players provides visual cues to the fingering of the guitar-shaped game controller. The player is following the score, keeping in synchrony with the machine.

identity-defining rock and roll music wherever they went, creating a new category of highly portable music player that was later exploited for portable tapes and CDs, which provided more customized choice of music than the broadcast model. Computation has increased the ubiquity and range of such personal music playing appliances, allowing us to carry vast libraries of performances in ever-smaller devices, and to play them back with greater flexibility. As a result, portable music players are among the most popular and well-established digital artifacts, as stand-alone devices or as applets built into multifunctional mobile devices like smartphones.

Adding computation to the music player not only extends its functionality as a playback device: it also allows us to experience music playing as a form of shared consciousness. For example, some early users of the iPod Shuffle reported thinking of the device as a companion with its own tastes who could also sense their moods and choose to please or to thwart their desires. A Columbia University doctoral student told the *Wall Street Journal* that he was convinced that his iPod "knows somehow when I am reaching the end of my reserves, when my motivation is flagging" during a bicycle workout, and picks the perfect rap song to get him moving again (Dodes 2004). The simple procedural strategy of random selection practiced over an encyclopedic selection makes the results of any pick unpredictable to the listener, and therefore surprising and eventful. Although the computer only understands the songs as interchangeable bit streams, music always has emotional value for human beings, particularly the music we have chosen for our own collections. The unpredictability of the choices, the emotional power of the music, and the intimacy of earphone delivery

Figure 12.2
"His Masters Voice," the original trademark image of the Victor Talking Machine Company, evokes the sense of presence and companionship afforded by recorded music players.

reinforce a sense of the digital music player as not merely an appliance but a companion (figure 12.3).

Because computer environments seem somewhat aware of us and because they are capable of observing and recording our every move, interactors are often uncertain of the degree to which their preferences are understood. Recommendation systems like Amazon's or Netflix's (figure 12.4) raise the customer's expectations that their tastes can be matched, creating more annoyance if the book or film that is being offered especially to them is off base. But improving recommendation systems is difficult because observation of behavior does not offer enough contextual cues to make completely reliable inferences about what consumers value in the items they select. The computer has a limited range of observation: it may perceive what we buy and how we rate it, without having any idea of why we chose it or how we feel about it. People may display the same behavior for very different reasons, and they may base their ratings on very different values. It is much easier to design patterns for machines to execute and human beings to imitate, as in Dance Dance Revolution, than to design

Figure 12.3
An iconic marketing image for the Apple iPod, a device that defined the category of portable music player for the digital era, portrays the listener in a state of altered consciousness. Her body posture and the positioning of her hands suggest the presence of an invisible fantasy dance partner generated by the device.

computer programs that can identify and imitate the complex cultural behaviors of human beings, as recommendation systems attempt to do. Computer-generated recommendations work best when they are offered politely in a way that is easy to refuse, rather than popping up unasked for, inserting themselves between the user and other content, like a bossy salesman or know-it-all friend.

Since we identify with our media choices, users can feel particularly uneasy when recommendation systems mischaracterize us based on their surveillance of our usage patterns. A widely circulated *Wall Street Journal* article captured the anxiety of new TiVo users in 2002. TiVo was the first widely adopted digital video recorder system, and one of its novel and less successful features was an automatic recorder that picked programs it thought the viewer would like, based on similarities to things they had already chosen, and downloaded them without asking: a significantly more intrusive action than a mere recommendation. The WSJ article is tellingly titled "If TiVo Thinks You Are Gay, Here's How to Set It Straight," evoking one of the staples of social

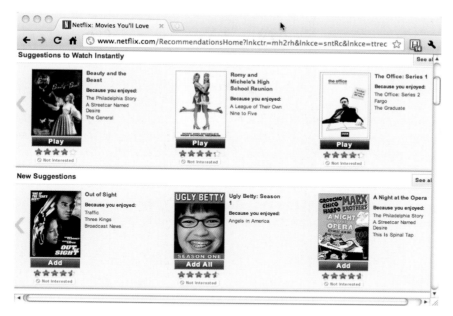

Figure 12.4
The recommendation system from Netflix.com is considered so important to the success of the company that in 2009 Netflix awarded a $1 million prize in a competition aimed at improving the performance of its collaborative filtering algorithm by 10 percent. Although most of these "Movies You'll Love" recommendations seem clearly related to the films the system knows I "enjoyed" and are indeed in my taste range, it is hard to understand what *The Philadelphia Story*, *A Streetcar Named Desire*, and *The General* have in common with *Beauty and the Beast*. (Accessed September 5, 2010.)

stereotyping and comic embarrassment. It described users who were so distressed by the choices made by the program that they actively selected other programs in order to try to change their image in the eyes of the machines. For example:

Mr. Iwanyk, 32 years old, first suspected that his TiVo thought he was gay, since it inexplicably kept recording programs with gay themes. A film studio executive in Los Angeles and the self-described "straightest guy on earth," he tried to tame TiVo's gay fixation by recording war movies and other "guy stuff."

"The problem was, I overcompensated," he says. "It started giving me documentaries on Joseph Goebbels and Adolf Eichmann. It stopped thinking I was gay and decided I was a crazy guy reminiscing about the Third Reich."

The anecdote reveals the crude stereotyping of the recommendation system and the ways in which it can reinforce stereotypical thinking in users. Since programmers will

always be drawn to such handy abstract categories because they are easy to incorporate in automated decision making, it is not surprising that the program generated such exaggerated choices. But why do people who should know better care about such boneheaded judgments? As one user put it, "I know it's dumb to take it personally, but it's in your face. These are supposedly objective computers saying, 'This is what we think of you'" (Zaslow 2002).

Recommendations that have prestige of computation behind them—even patently foolish recommendations—can seem like definitive social judgments. *Making the processing of the machine visible and allowing the consumer to adjust the system demystifies the recommendation process, reducing anxiety and resentment about what the computer "thinks"* (figure 12.5).

Accompaniment with surveillance is an enticing structure for advertisers. The economic model behind online information services, from search engines to mail pro-

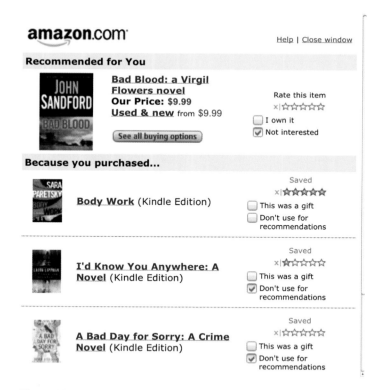

Figure 12.5

Amazon.com explains the basis of recommendations ("Because you purchased") and also provides a feedback mechanism for improving them.

grams to news portals involves monitoring the behavior of users and providing advertising content that matches users' self-descriptions and behaviors. With media-rich mobile devices becoming ubiquitous, there is increasing interest in providing personalized sales messages triggered by geographic location. Designers will have to determine how to provide messages that people want to receive and are likely to act upon. Just because we can observe behavior does not mean that we can use it effectively. Google's online email system (figure 12.6) provides advertising based on message content, raising anxieties about the machine spying on personal mail, but usually demonstrating little comprehension of the text. For example, an email invitation to a Tartan Day Celebration may result in ads for Scottish products (possibly relevant) but also for ads for tattoo removal, skydiving, and other unrelated goods and services.

GPS navigator systems provide much closer surveillance and much more assertive recommendations in the form of turn-by-turn instructions spoken by a simulated

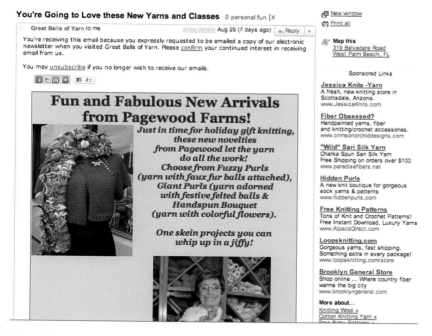

Figure 12.6
Ads generated by Gmail based on message contents. The recommendations are most likely to be relevant when the email is itself an advertisement, as it is here. Ad content attached to the content of personal messages can be unnerving, making us feel under surveillance. It helps that the ads are separated visually in their own column and displayed without distracting graphics or typography.

human voice. When the device is working well it is reassuring to have a calm voice giving advice on when to change lanes and how far it is to the next right turn. But the real world quite often diverges from the computer representation. Construction areas and idiosyncratic traffic patterns make the computer's directions less than optimal at times. The computer does not always know exactly where we are: it can mistake a service road for the adjacent highway, for example. And even when the directions are optimal, they can still be hard to comply with. Human beings make wrong turns or impulsively decide to get off at an earlier exit. Because the GPS system has the ability to observe our behavior in real time and to speak to us in human language, it raises our expectations that it will understand our motives and priorities as well as our geographical positioning. It can therefore arouse antagonism when it responds with the rigidity of a computer to our human spontaneity, telling us to "Please return to the designated route." In circumstances like this the simulation of companionship works against the interaction, since the neutral tone and rigid repetition reproduces the characteristics of a patronizing, passive-aggressive passenger. Some people, having chosen to use the navigator as a convenience, will purposely avoid the prescribed route because of a sense of humiliation at taking orders from an unresponsive companion.

As we move to a world of ubiquitous computing, more and more devices are making recommendations and offering us their advice, challenging designers to minimize the intrusiveness while maximizing the helpfulness of these programs.

Politeness

Just as we expect a tool to be transparent and a machine to be visible, we expect a social agent to behave with politeness. Rituals of politeness, according to social theory, are concerned with saving face, with preventing the humiliation that comes from having others witness our frustrated desires. Politeness softens unwelcome demands and oppositional statements with the explicit acknowledgment that other people have needs as well as oneself. Impolite expressions are baldly stated demands, refusals, or assertions of indifference to the needs of others. Designers can sometimes avoid humiliating users and deflect their anger by employing the same polite expressions that mediate human-to-human interaction.

For example, interruption is an unwelcome social interaction common to humans and computers. In the 1990s, the email program Eudora charmed early adopters of multiwindow environments with the message "Excuse me. Eudora needs your help." The message had a whimsical quality that was subtly consonant with the name of program, which evoked the American Southern writer Eudora Welty, author of a famous short story called "Why I Live in the Post Office." Eudora had no other anthropomorphic elements beyond the genteel phrasing of this alert, so its evocation of a

helper was understated and all the more potent. By framing the interruption as a request for help rather than a demand, it put the program in a submissive social role even though it was popping up unbidden. Like a polite human being, it excused itself, asked for our attention, waited patiently until we turned toward it, and then delivered its message.

Of course the best solution to the problem of interruption is to make it unnecessary, and the Eudora ritual would not have remained charming over time, nor is it scalable to the current application environment in which there may be a dozen programs running at the same time. Instead, we have a new interruption convention of icons jumping up and down for our attention in the "dock" or "tray" at the bottom of the screen. This silent movement in a marginal space is similar to Eudora's "Excuse me," or to a polite knock at the door, while clicking on the icon is like giving a person permission to enter and interrupt us. Ideally the icons should move slowly (like a soft knocking) and allow us a choice of delay or suppression. But even at rapid speed, the bouncing icon is significantly more polite than the pop-up dialog box that insists on top position, obscuring other windows, like a rude guest elbowing through a crowd, and getting in our face. The more we proliferate simultaneous tasks, and the more we send out software agents to bring us information or take actions on our behalf, the more important it will be to establish rituals of politeness that allow human beings to gracefully shift attention when necessary to accommodate automated processes.

Rules of politeness are also a good reference point for the behavior of programs that are downloaded onto our personal devices or imported as an add-on to browsers or other software environments. Politeness rituals establish boundaries between social actors, setting expectations of what sorts of actions by others can take place on our territory. For example, polite guests only come in when invited, do not explore beyond the areas they have been escorted to, and do not inspect or appropriate the hosts' possessions. Similarly, when we download an application program, we do not expect it to bring along other uninvited guests, such as advertising messages or spyware, or make alterations to the system without warning. The need for visibility of functioning coincides with the social norm of asking permission before interfering with someone else's property.

In setting up politeness as a design goal it is important to point out that it is not desirable to literally reproduce the rituals of human etiquette, since the goal is not a two-way social relationship, but a well-formed interaction in which the human being experiences agency. Polite behavior by the computer-controlled processes is a means of ensuring that the human being is in control of the interaction. An interaction with the computer may be structured as a dialog but it is not symmetrical; *the computer should obey rules of politeness, but the human interactor should be issuing clear commands.*

In Stanley Kubrick's *2001* (1968) the supercomputer Hal is the essence of a polite subordinate, even when he is systematically murdering his masters. When HAL says, in his perfectly modulated tones, "I'm sorry, Dave. I'm afraid I can't do that" the politeness of the refusal mocks the abject helplessness of the trapped human being and intensifies the horror. Similarly, when an unresponsive system, such as a GPS navigator or a customer service phone tree, is presented anthropomorphically as a friendly human conversational partner, our frustration is intensified because the verbal politeness of the system is actually enacting a larger rudeness by ignoring our needs. *The most important form of politeness for computer applications is making sure the human interactor is in control of the actions of the machine.*

Conversational Structure

Because we are inclined to see the computer as a social actor, we often experience interaction as a kind of conversation. As designers we can think of all turn-taking human computer interactions as conversational. Pointing, selecting, and then issuing a command can be understood as an utterance, for which the computer's performance of the command is the rejoinder. Media conventions structure the conversation as a whole and provide coherence for each exchange. For example, a purchase in an online store can be understood as a series of conversational exchanges:

Interactor: Enters an online store
Machine: Offers recommendations
Interactor (ignores recommendations) Initiates a search
Machine: Returns a list
Interactor: Selects an item from list
Machine: Displays details about the item
Interactor: Agrees to purchase
Machine: Initiates queries for billing, shipping information
Interactor: Responds to queries
Machine: Asks for confirmation of order
Interactor: Provides confirmation of order
Machine: Confirms completed purchase

These exchanges are coherent because they are structured by a limited number of explicit, shared media conventions such as hyperlinked lists, shopping carts, credit card security codes, and passwords. But the coherence is lost when we try to move from the shared focus of these ritualized exchanges into the vast, ambiguous domain of human language. Although some programs have had limited success in fostering approximations of natural language conversations between human beings and computer programs, coherence can only be achieved by limiting the

input of the interactor, constructing clever default responses that cover the computer's lack of comprehension, and setting up scenarios where trying to figure out which words will produce the desired effect becomes a shared riddle (Weizenbaum 1966; Montfort 2003; Mateas and Stern 2003). As a rule, it is more reliable for dramatic and practical situations to offer interactors multiple-choice menus whose answers can be programmed in advance rather than parsed and semantically analyzed on the fly.

We can think of dialog boxes, such as the alert messages discussed in chapter 11 or Eudora's polite intrusion as time-based control panels that structure interaction into very brief conversations. The conversation is satisfying when the items on the menu give the interactor control over key elements of the program, and the choices are briefly but clearly presented. As Alan Cooper has pointed out, **modal** dialog boxes rudely put the interactor into "interrogation mode," by taking over the screen and freezing other action (Cooper 1995), and even nonmodal boxes can seem imperious, like a hurried waiter who insists we order off the menu with no changes and no explanations. More polite dialog boxes do not interfere with the interactor's agency to move to other windows and provide links to clarifying information when necessary.

Web registration forms and surveys are also kinds of structured conversations, but they can feel like a too-talkative stranger who won't let go of your sleeve, or a salesman who won't leave once he has his foot in your door. A digital form should always indicate its extent and the approximate time it will take to answer it; lengthy forms should make it easy for us to save partial versions and return to them later and to correct part of a faulty form without having to reenter all the correct information, since no one likes to repeat themselves in conversation.

At a deeper level, as Lucy Suchman has pointed out, all of our interactions with machines can be understood as conversations in which each partner has to attend to and interpret the other's contributions. Because interaction is always contextualized (or situated) within a particular set of circumstances—such as the particular image you are editing, or whether you are playing a game in privacy or in front of other people—and specific to an individual, even though the machine may be fairly rigid in its responses, its identical actions may have different meanings. For example, Suchman reports visiting the laboratory of Cynthia Breazeal whose videos present very compelling examples of shared attention with the robot Kismet (Breazeal 2002). When Suchman and her colleagues were unable to produce similar responses, she did not propose that Breazeal's research result were faulty. Instead, Suchman interprets Cynthia Breazeal's interactions with Kismet as a synchronized performance between a particular researcher and a machine, open to multiple meaningful constructions, rather than a repeatable sequence that would work in the same way with anyone (Suchman 2007; see figure 12.7)

Figure 12.7
Kismet and Leonardo, two sociable robots created by Cynthia Breazeal at MIT. Breazeal's Personal Robots Group is working with Leonardo on pointing games that create shared attention through gesture and mutual observation. See <http://robotic.media.mit.edu>.

The Perils of Personification

Conversational structure need not have a personified interlocutor. One of the trickiest issues for designers of accompaniment systems is the problem of anthropomorphism: how much should a computer presence resemble that of another person? Although we may relate to digital artifacts as social actors, we do not really think of them as people. Even when they respond to us in language, we want to talk with them instrumentally, in task-specific ways, without the emotionally charged, relationship-building rituals that characterize our conversation with human beings (Shechtman and Horowitz 2003).

How much do we want computers to take on personalities? Popular culture gives ample evidence of both our fear and our longing for automated companions, from the overcontrolling, ultimately homicidal Hal in *2001* to the lovable, trusty sidekicks R2D2 and C3PO of *Star Wars*. Computer scientists share this fantasy of an animated companion, and have attempted to produce computer-based "creatures with whom you'd want to share some of your life—as with a companion or a social pet" (Bates 1994). As consumer-oriented computer applications grew in the 1980s and 1990s, the desire for an automated companion merged with the desire for a helpful assistant who

could guide users through the increasingly complex processes of daily information processing.

In 1995, Microsoft Corporation invested million of dollars in the hope of satisfying this desire. Convinced that human beings wanted the computer to behave as a social actor, the Microsoft team introduced a new operating system interface called Bob that acted as a companion and coach to guide the user through a set of applications focused on household activities, including a calendar, a simple word processor, and a checkbook. The program replaced the desktop interface with a cartoonlike navigable two-dimensional house, and shaped the interaction as a dialog with a cartoon dog, Rover. Rover spoke by means of text in speech bubbles, supplying guidance and asking questions. (The program could be personalized by substituting other cartoon "friends of Bob," such as a more abrasive Scuz or a cuter Hopper the Bunny.) Rover greeted you when the computer booted up and interacted with the user throughout all the applications as well as at the operating system level.

The Bob operating system is a treasure trove of mistaken design strategies, starting with its too-literal depiction of space, which forced interactors to schlep from room to room when they wanted to switch tasks. The interface also failed to distinguish interactive objects from merely decorative graphic elements, an annoyance that required the remedy of a function key command to highlight the clickable areas of the screen.

Bob was intended to exploit the observations made by Nass and Reeves of "how computer users project human social traits onto computers" in order to "increase the user's feeling of mastery and connection to the program" (Winograd 1996). But it had the exact opposite effect. It is one thing to unconsciously experience an interactive device as a sentient, social being; it is another thing to be presented with a particular cartoon character as representing the machine. Elements of social personality are welcome additions when they help us to predict the computer's behavior or to script our own actions, but they are decorative distractions when they have no **procedural** or participatory role. When Rover tells us he likes to eat table scraps, how do we relate that to his role in helping us with our email? By contrast, Fetch the dog, the personification of a file transfer program, is a much more appropriate use of canine personification, serving as a progress indicator (figure 11.6), and not triggering any other expectations of interactions. Playing fetch with a dog is a good abstract metaphor for the ritual of file retrieval—we signal what we want and the dog or software program goes out and gets it and brings it back to us. Fetch stays within these boundaries, without interfering with the functionality of the program or trying to hold a conversation with us. Rover, on the other hand, is in our face and overly chatty (figure 12.8).

Figure 12.8
Rover, part of Microsoft's notoriously annoying Bob interface, and Fetch, the trusty file transfer mascot.

Another problem with the personification in the Bob system is common to many such helpers: inconsistency in point of view. Just as we expect novelists to make clear whose thoughts they are following, and filmmakers to make clear whose perspective the camera is showing us, designers need to distinguish between statements made by an interactive character, statements made by the computer system, and statements made by the interactor. In the Bob interface, Rover expressed himself through speech balloons, an established cartoon convention, but sometimes the Bob smiley face appeared within Rover's speech bubble, and sometimes the interactor's responses appeared as pull-down menus and **radio buttons** within Rover's speech bubbles, blurring the sense of who was "talking" (figure 12.9). This kind of confusion does not seriously interfere with the user's understanding of whatever is in the speech bubble, but it is distractingly messy, making the interface less transparent. The point-of-view problem permeated the program, starting with the nickname "Bob," which suggests an accessible personality who was behind all the other helpful avatars. Bob was represented by a bland smiley face with glasses, vaguely resembling Bill Gates, who appeared on the splash screen as the brand for the interface. But Bob was not directly available as a guide. It was as if the social presence human beings intuit within the machine was purposely hiding from us. The intrusively chipper avatars seemed like anxious manifestations of an uncooperative, reclusive boss avatar.

Bob was quickly abandoned as a commercial product, leaving behind the almost equally despised Microsoft Office Assistant, better known as Clippy. Like Rover, Clippy was supposed to be a helper companion, but he became notorious for popping

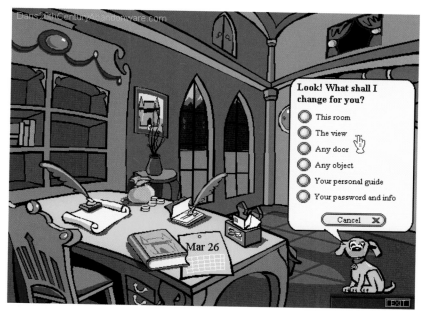

Figure 12.9
In Microsoft's Bob interface, Rover's speech balloon is oddly used for the interactor's choices.

Figure 12.10
Clippy, the notoriously intrusive personification of the Microsoft Office Assistant help utility. The offer of help is too vague and Clippy's concern seems misplaced since few people need help formatting letters, although it is an activity that it is relatively easy for an automated program to identify.

Figure 12.11
Personified companions in role-playing games, like the helper pet in Torchlight, can do useful tasks for the player's avatar such as fighting, carrying inventory, and running back and forth to town to sell off unnecessary inventory.

up uninvited to offer help where no help was needed (figure 12.10). Clippy was discontinued in 2007. The failure of the Microsoft's experiments with personified interface agents makes clear that although users may unconsciously behave toward computers in ways that are similar to human-to-human behaviors, they do not want to be burdened with the time-consuming, attention-demanding rituals of conversations and the distractions of cartoon personalities in order to perform the complex tasks that are the focus of computer applications.

In general, the creation of interactive characters is best left in the realm of games and interactive fictions. The difference between a disappointing Clippy and a satisfying game-based helper (figure 12.11) or nonplayer character is the game structure that constrains the interaction. Characters within games can satisfy our expectations because they are only expected to know about the game world, and to perform actions appropriate to the game. The context makes our actions meaningful to them and their actions meaningful to us. Personified helper figures in other kinds of applications have to create coherence from the unpredictable, unconstrained expectations of the real world; they are like poorly scripted fictional characters without the right lines to create a meaningful dialog.

Fantasies of the Magical Servant

The stunning increase in electronic processing over the past fifty years has repeatedly triggered fantasies of turning our ubiquitous companion machines into magically responsive servants. For example, the widely distributed Knowledge Navigator concept video, produced by Apple Computer in 1987 and set in 2010, features a bow-tied preppy male as the virtual assistant of a male college professor (figure 12.12). The assistant not only recites summaries of his master's phone messages and reminders of his appointments, it automatically shields him from his mother's nagging phone calls, and rapidly tracks down a female colleague who appears via video conference to help him teach his afternoon class. This pre-Google assistant not only finds articles based on misremembered names and vague dates, it graphs the data inside of them as well as generating new graphs of related data on the fly (anticipating the Semantic Web). Viewed two decades later, many of the imagined technologies for accessing, relaying, and displaying information have become commonplace, and most are now delivered not merely on a fixed desktop, as in the video, but also on a wireless mobile device. But none of them are delivered by servant-like talking heads in magical book-like interfaces.

In fact, one of the most striking things about the Knowledge Navigator as a prediction of technological directions is the lack of a keyboard or joystick to control the device: Although there is a touchscreen in some shots, the interaction is produced not

Figure 12.12
Knowledge Navigator (1987), Apple Computer's futuristic vision of a voice- activated, conversational automated assistant who marshals data and human helpers and deflects phone calls from nagging mothers. The video is available at <http://video.google.com/videoplay?docid= -5144094928842683632#>.

by direct manipulation but by talking to the fellow with the bowtie. This emphasis on natural language conversation reflects a belief that was pervasive in the early days of desktop computing, that executives (i.e., men) would not learn to type, and so interfaces would have to respond to speech, like human secretaries.

The same ideal servant fantasy was reflected in the 1990s by Nicholas Negroponte, the founder of the MIT Media Lab, in his often-repeated demand that the computer act like the perfect English butler:

The best metaphor I can conceive of for a human-computer interface is that of a well-trained English butler. The "agent" answers the phone, recognizes the callers, disturbs you when appropriate, and may even tell a white lie on your behalf. The same agent is well trained in timing, versed in finding the opportune moments, and respectful of idiosyncrasies. People who know the butler enjoy considerable advantage over a total stranger. That is just fine. (Negroponte 1995, 150–151)

Negroponte may have had occasion to encounter actual English butlers, but most Americans have never met one. In the movies and the tabloid news English butlers are well represented, however, as the epitome of politeness and personal service. Butlers supply their masters with what they need without being asked. But in fiction and in news accounts butlers are also often treacherous. "The butler did it" is a cliché of murder mysteries because the butler has the access and knowledge to damage his employer if he decides to act autonomously, and the tabloid press reminds us that actual butlers can be excellent sources in a royal scandal. Computer programs that appear to be submissive to our control can be similarly treacherous, destroying our data or revealing it to those who should not see it. But these destructive butler narratives are not part of the technologists' ideal servant fantasy: their ideal butler is watching over us rather than spying on us, acting only for our welfare, and doing so without the need for explicit instructions.

The fantasy of the totally responsive servant is unrealistic as a model for design But the fantasy persists because it reflects deeper psychological needs, rooted in human infancy. The master whose unspoken needs are met so completely and seamlessly, the servant who meets those needs without being asked or expecting anything in return can be interpreted in psychoanalytic terms as a variation on the infantile fantasy of the perfect parent. And unlike a human mother, a virtual butler makes no emotional demands on us in return for his absolute loyalty. As a personification of the computer, the servant fantasy reflects a desire to have our needs met absolutely without the trouble of actively engaging with complex information, ambiguous real-world choices, or emotionally demanding human beings.

The fantasy of the perfect automated companion and servant is particularly persistent among those involved in artificial intelligence (AI) research. Ray Kurzweil, a versatile inventor of pattern-recognition software applications, is among the most

vocal advocates for machine intelligence as the equivalent of human intelligence. Kurzweil has predicted that computers will be indistinguishable from humans by the end of the twenty-first century because exponential increases in processing power will allow us to simulate the processes of the brain. As he wrote in *Scientific American* in September 1999: "Within several decades, machines will exhibit the full range of human intellect, emotions and skills, ranging from musical and other creative aptitudes to physical movement. They will claim to have feelings and, unlike today's virtual personalities, will be very convincing when they tell us so (Kurzweil 1999)."

Building on such visions of the future, Netherlands AI researcher David Levy has predicted there will be marriages between humans and robots by 2050, because the things that make people fall in love—such as feeling that the other person likes them or shares their interests—are reproducible with programming code (Levy 2007). Levy does allow that perhaps only those too shy or unattractive to find human partners would choose intimacy with a robot (Choi 2007).

Citing fears of computers becoming autonomous and acting outside of human control, the Association for the Advancement of Artificial Intelligence (AAAI) held a workshop in 2009 to announce the formation of a committee to study the limits of ethical research. A report of the meeting in the *New York Times* ended with an interview with the current AAAI president, Microsoft researcher Eric Horvitz, and a description of his most recent research project:

Despite his concerns, Dr. Horvitz said he was hopeful that artificial intelligence research would benefit humans, and perhaps even compensate for human failings. He recently demonstrated a voice-based system that he designed to ask patients about their symptoms and to respond with empathy. When a mother said her child was having diarrhea, the face on the screen said, "Oh no, sorry to hear that."

A physician told him afterward that it was wonderful that the system responded to human emotion. "That's a great idea," Dr. Horvitz said he was told. "I have no time for that." (Markoff 2009)

Although computers are certainly able to make up for human failings of memory or calculation speed, it is profoundly misguided to expect automated statements of concern to substitute for human sympathy, as the video of Horvitz's project makes clear (figure 12.13).

The ideal butler understands his master's wishes with a minimal of explicit direction, and is able to anticipate needs and perform them without being asked. The butler can do this (unfailingly in films and perhaps in life as well) because the needs of the English upper class are severely ritualized, with predictable **protocols** of polite behavior, and shared linguistic codes for communications between master and servant. Such synchronization and predictability is considerably harder to pull off in software (figure 12.14).

Figure 12.13
A Microsoft Research automated "caregiver/caregivee" scenario. The computer caregiver is a disembodied and inexpressive female head who speaks in a robotic monotone without emotional inflection. The expression of concern is so patently empty of empathy that it would be disturbing if the situation showed a truly sick child and his mother instead of the earnest pair who are clearly role playing for the sake of the demo.

Figure 12.14
Logo of the search engine Ask Jeeves, established in 1996 with natural language queries. The site became iconic for the exaggerated claims and disappointing performance of many early Internet companies. The logo was retired in the United States in 2006 with a change in ownership and the site was successfully rebranded Ask.com with a more focused query domain.

The model of ideal master/butler exchange is something like this:

Master: We'll have tea in the drawing room, Jeeves.
Servant: Very good, sir.

The assertion of an intention ("We'll have tea in the drawing room") is actually a coded command that triggers a complex set of actions performed by many coordinated actors. The drawing room fire is adjusted, the tea and crumpets appear in the right quantities, with all the right silverware and china. Very little explicit conversation produces very complex results. This is believable because there is so little variety involved in providing tea in the drawing room for the same imaginary, overprivileged household, decade after decade. The butler's tasks are programmable because there is only one right way to do things and a fixed set of things one might be asked to do. And of course ideal butlers are legendary for their loyalty, staying with a single family until they are too old to keep the teapot steady.

But though a fictional English lord may like the same well-brewed tea and the same bland biscuits at the same time every afternoon with no need for further conversation about it, interactors with digital applications are used to mixing things up, taking advantage of the parameterized, multivariant environment to make many explicit choices. And a single program has millions of potential "masters" so it must be prepared to perform many tasks, each of which could be varied in multiple ways. Therefore a model of a conversation between interactor and computer would go something like this:

Master/Interactor: Do THIS!
Servant/Computer: I am ready to do THIS. Here are the choices of ways I can do it. Which ones do you want?
Master/Interactor: Do THIS in THAT way!
Servant/Computer: I am doing THIS in THAT way now (and I am willing to be interrupted for adjustments).
Servant/Computer: I have now done THIS in THAT way (and I am willing to undo it).
Servant/Computer: I am now showing you the result of THIS done in THAT way, (and I am ready to modify it some more or to receive approval).
Master/Interactor: Approved.

The communication is composed of explicit commands on the part of the interactor in response to clear choices offered by the machine, followed by updates and results with the possibility of further commands all along the way. Unlike the unseen, magically responsive Jeeves, the computer needs to ask us what to do and show us what it is up to.

The more particularly we want to be served by the machine, the more explicitly we must specify what we want. It is up to the designer to invent the interaction conventions that will allow interactors to make those specifications.

Figure 12.15
The Roomba vacuum cleaner, the first successful consumer robot, uses an explicit, nonverbal command system.

The servant framework works best when the task is limited and the performance is visible and under our control. Applets, widgets, and appliance-like robots can be faithful servants because their domain is limited, so their behavior can be ritualized into predictable patterns. A vacuuming robot like iRobot's Roomba (figure 12.15) is a better model of an ideal computer servant than the bow-tied assistant in the Knowledge Navigator, the search engine butler, or the eerily disembodied medical assistant. A vacuum has a limited repertoire of appropriately nonverbal behaviors, responding to its environment in a clearly readable way. Since it does not use language or respond to verbal commands, users are free to think of it as a kind of nonspecific, benevolent, animated character or pet without fear of misunderstanding or disappointment. Many of our most reliable repetitive task software artifacts—like backup systems or video recorders—behave in a similar faithful-servant manner. Though they may not be robots, they are designed to do a routinized job reliably with limited direction under our explicit command, which once given does not have to be repeated for the job to be performed reliably.

Scenarios of perfect servant companions are *fantasized projections of human longings rather than achievable design strategies.* Although technology-driven researchers will continue to find the servant scenarios attractive as a way of organizing larger agendas, designers should not lose sight of the fact that *the more we try to make machines in the image of human beings, the more disappointed, humiliated, threatened, and enraged we will*

become at their failure to understand us. It is appropriate for us to expect automated processes to be companionable by responding to our commands and refraining from destructive, intrusive, or interruptive behavior. It is not appropriate to expect a machine to read our minds, empathize with our sufferings, protect us from the demands of emotional intimacy, or simulate a compassion for others that we are too busy to feel.

Responsive Anticipation

Although the fantasy of a perfect servant who understands unspoken or natural language commands is a dangerous model for designers, we can take direction from the servant's ability to anticipate the needs of the master. We must remember, however, that such anticipation is not produced by magic but by the accretion of conventions by which computers learn to pay attention to the things that are important to us. Instead of trying to anticipate users' needs (such as formatting a letter) with intrusive helper figures, designers can provide them with customizable **templates** (such as letterhead formats) so that they can actively shape their tools to anticipate and support their important tasks. Instead of aiming for hands-off systems in which a magical genii retrieves what we want, designers can give interactors more hands-on tools for explicitly tagging and filtering information and for sharing their information organization with one another in the form of controlled vocabulary metadata and structured documents. *Successful design lies not in reproducing human thought and feeling in the machine, but in expanding the rituals by which interactors can serve their own thoughts and feeling within digital environments.*

The digital medium is becoming our powerful, silent servant in the same way that other cultural creations have come to serve us. Societies build up systems of signification that guide individuals like an extension of one's own mind. For example, the social system of place names and street signs, and the media conventions of printed maps form a system of **distributed cognition** each of us can use to get from place to place without having to memorize every landscape feature of every city we visit. Similarly, designers are building computational conventions that serve as guides and markers for the explorations of the interactor. Players do not have to memorize the function of every icon in the World of Warcraft interface, because the icons are all labeled using the established **tooltip** convention (figure 11.10). Web surfers do not have to remember the command keys for capturing images on the web because the established **contextual menu** convention reminds us of our choices (figure 10.12).

The computer is a faithful servant or reliable companion only to the extent that designers anticipate and provide for the needs of interactors. But when designers raise unrealistic expectations, ignore user needs, or deny interactors agency over important

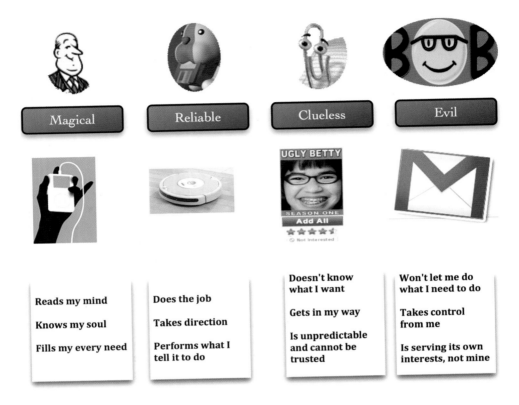

Figure 12.16
The four faces of the computer as our imaginary companion. Our readiness to attribute conscious-ness to the machine intensifies our hopes and fears, satisfactions and frustrations. Designers must therefore be careful to calibrate expectations so that interactors experience agency over the servant-computer as a reliable companion.

actions, then the companion in the machine can seem like an incompetent slacker or super villain (figure 12.16). Our sense of the computer as an intentional, aware com-panion can intensify negative and positive experiences. It can make us more ready to expect magical responsiveness in a media player or a robot; it can also make us more ready to see omnipotent evil when the servant program acts in its own interest and takes away our ability to command it, as when Facebook or Gmail denies us the ability to erase the communications they have been storing for us. Designers should aim to serve the interactor as reliable buddies, doing a predictable job with visibility and con-sultation, and extending functionality without overpromising magical effects. And we should remember that computers do not think in the same way as human beings about the complex cultural rituals that make up the texture of our lives, so that a multimillion

dollar algorithm told to come up with "movies you will love" is perfectly capable of choosing a laugh-machine sitcom based on a rating for a complex theatrical work.

Computer programs are particularly helpful servants when they remember things for us and act on that offloaded memory. Computer software has been integrated into our lives, like a trusty butler into an aristocratic family, to keep track of contacts and dial phone numbers, to keep track of and remind us about our recurring appointments, and to archive and keep at hand our important texts, photographs, and videos. We expect our GPS program to keep track of where we are on the face of the earth, and to remember where we live and what our previous destinations have been. We expect our book reader, media player, or game system to remember where we left off and to return us to the same place the next time we turn to them. And most of us experience the performance of these actions not as unwanted surveillance but as enhanced companionship.

We also expect to collaborate with our systems in actively performing tasks. Google has made excellent use of **predictive text** for search queries by drawing on other users' searches, reducing the need for the interactor to type out the full query, speeding up the search, and sometimes even returning the answer to the question behind the query within the predictive text itself (figure 12.17). Google Chrome extends that anticipatory behavior to the browser, by displaying our recent and frequent web destinations as choices when we open a new browser tab, while still giving us control over what the browser is allowed to remember (figure 12.17).

Designers will be expanding such conventions of responsive anticipation as users' engagement with digital environments expands. One way to identify new areas for deepening the interactor's sense of helpful companionship is to note our own frustrations with things that we wish our software would notice about us. For example, after putting more than two hundred illustrations with cross-references in the text for this book, I would like my word processor to change its default settings to suit my usual practices (figure 12.18).

capital of braz

Brazil — Capital: Brasília 15°45′S 47°57′W / -15.75, -47.95
According to http://en.wikipedia.org/wiki/Brazil
capital of brazil
capital of brazil **map**
capital of brazil **wiki**

Figure 12.17

Before I have finished typing "capital of Brazil" into the Google Search engine (in July 2010), I receive a completion list of predictive text (partially shown here) with the top result drawing on Wikipedia to answer the question behind the search and provide a link to deeper information.

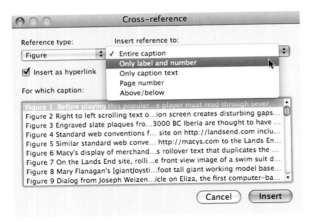

Figure 12.18
Microsoft Word (2008 for Mac) remembers my preference for inserting only the figure number in a cross-reference to an illustration within a single session. But it does not associate my preference with the document or the user, so between sessions it reverts to an irritating default (pasting the entire caption into the body of the text). I would feel more accompanied if the word processor's default was set to reflect its observation of my behavior and more empowered if I could choose to save my preferred cross-referencing format as part of the style settings associated with the document.

In order to reinforce the interactor's sense of accompaniment by a helpful "second self," we do not need to make cuter animated help programs, natural language dialogs, or simulated butlers. For, in fact, *the presence that interactors sense in the machine as a helpful companion is the collective intelligence of the design team,* whose decisions are present in the software just as the mind and heart of a novelist is present in a work of fiction. Therefore we should infuse our decision making throughout the design and development process with the goal of helpful companionship, looking for ways to strengthen the conventions of synchronization, politeness, and conversation that link human consciousness with automated processes in order to expand the ways in which digital artifacts can anticipate and serve human needs. The more we build up our system of mutual communication between human beings and software systems with media conventions that allow us to share attention with one another, the further our digital artifacts can go in helping us.

DESIGN EXPLORATIONS: THE COMPANION MODEL

Creating Synchronization Rituals
• Think of a situation in which you were required to imitate the behavior of another person or someone else was required to imitate your behavior.

- Was the behavior easy or hard to imitate? Why?
- What did the people involved do that made the situation better or worse?
- How did you feel toward the person you were imitating or being imitated by?
- Imagine that the other person was a robot rather than a human being. How would that have changed your subjective experience? How would it have affected the difficulty of the imitation task?
- Play a traditional children's game, such as Follow the Leader or Simon Says, in which the object is to imitate a human being.
 - What makes it hard or easy to succeed? What makes the game pleasurable to play?
 - Would a one-person computer game based on the same traditional game be worth playing? Why or why not?
- Play a video game such as Parappa the Rapper, Dance Dance Revolution, or Guitar Hero or follow the coach in a game system exercise routine like the Wii Fit—any system in which you have the task of imitating an avatar or following the script set by the computer.
 - What makes it hard or easy to succeed? What makes the game pleasurable to play?
 - What is the computer observing about you? How accurate is its observations? How do you feel about the observations?
 - What is the difference in play experience between this game and the human imitation game?
- Design or create an interactive application that entices the interactor to imitate the actions of an automated character or symbolic display.
 - What would make someone want to play this game or do this task?
 - What models can you draw upon from existing situations, games, or artifacts?
 - What would be a winning or losing condition?
 - What would make the game enjoyable as a spectator or party game?
 - What would make the game valuable as an educational experience?
 - How would the game change if it were played by different age, gender, or cultural groups?

Becoming More Aware of Accompaniment with Surveillance

- For one day, **record** all the items recommended or advertised to you on networked devices based on observation of your behavior (such as your previous purchases, or the content of your email, or your participation in a social networking site or location-based service).
 - Which items were particularly apt or inappropriate?
 - How were they were chosen for you?
 - What metadata do you think was associated with each of the offered items?

• How do these marketing programs see you? What do they consider to be your most salient attributes?

• How would the experience of the recommendations or advertisements be different if the items were offered by a human salesperson?

Observing the Rules of Politeness

• In your interactions with human beings over the next twenty-four hours, notice when you invoke rituals and conventions of politeness.

 • What are the rituals?

 • Do other people know and expect the same rituals that you know and expect?

 • How do these rituals and conventions work to save face by avoiding direct exercise of power or direct refusal of a need?

• Notice the next time you are interrupted while engaging with one computer-based process by a message (*not* from a person) but from another computer-based process.

 • How did the message get your attention?

 • Why did it need your attention?

 • Was the automated behavior consonant with the importance of the need?

 • Was the interruption polite?

 • What were your feelings about the interruption?

 • How would you redesign the interaction to improve the experience? If the experience was optimal, what aspects of it would you like to see propagated into other systems?

Recognizing Ideal Servant Fantasies and Other Personifications

• Compare the scenario of the scholar investigating the crossbow in Vannevar Bush's 1945 essay "As We May Think" to the scenario of the professor in the Apple Computer Knowledge Navigator (1987) video or the scenarios of intelligent agents acting on our behalf within the Semantic Web (Berners-Lee, Hendler, et al. 2001).

 • What kind of tasks are these envisioned systems meant to make easier?

 • What kinds of tasks are they meant to eliminate?

 • What is the social role of the computer (or Bush's proposed "memex" machine) in each of these examples? What would be the job description if done by a human being?

 • What human beings or automated systems performed these roles at the time the article/video was created? What human beings or automated systems currently perform these roles?

• The next time you encounter a personified automated system—such as a telephone help line—notice how you react to it.

 • What expectations does it arouse? Does it meet those expectations?

 • How do you picture the person behind it?

- What do think the designers' goals were for the system?
- How would the system be different if the persona were different, for example if it were a dog like Lassie or a cat like Garfield or a human character like Homer Simpson or Maggie Simpson?
- Chose one example of a computer-based character who is presented as a companion to human beings. Your example can come from science fiction or from actual commercial or research projects.
 - What aspects of companionship is the anthropomorphized computer program aimed at fulfilling?
 - What human needs is it expected to anticipate?
 - How are these needs met without computers? What are the real or imagined advantages and disadvantages of meeting them with computers?
 - What design challenges would you expect to encounter if you were charged with creating such an automated companion? Would you expect it to be mistaken for a human companion? How would you go about assessing its effectiveness?
- The mathematician Alan Turing predicted in 1950 that by the year 2000, a human being holding a keyboard-mediated conversation over a teletype network with an unseen interlocutor would not be able to tell if it were a person or a machine on the other end of the wire. His proposal is usually referred to as the **Turing Test**, and it was meant to answer the question of whether machines could be intelligent by separating the functions of mind from their familiar embodiment in human form (Turing 1950). As a research topic, identify instances in which conversations with machines have been mistaken for conversations with real people
 - Have any of these conversations passed the Turing Test?
 - Choose an example of a successful strategy for simulating some aspect of human behavior and describe why it was a success.
 - Could the same strategy be applied to another artifact?
 - If feasible, design or create an artifact that exploits the same strategy.
- Advanced: Taking Eliza or another Chatterbot as your model, design or create a character that can engage in conversational exchanges based on key words.
 - Hints: Start with a scenario in which the interactor's input is highly predictable and make sure that every answer your character provides, and especially the default answers (for when you don't recognize any keywords), include one or more keywords for the interactor to pick up on.
 - What is the maximum number of coherent exchanges your character can sustain?

Designing for Responsive Anticipation

- As you use digital artifacts for the next week, notice every time the software recognizes you by name or restores a previous session.

- How would the experience be different without this feature?
- What is the system recognizing about you besides your name?

• Design or create an interactive artifact that will help you to remember something important that you might otherwise forget. The design can draw on current, futuristic, or imaginary technology (e.g., location-based cell phones, tiny screens embedded in eyeglasses, holographic butlers), but the mechanism of surveillance and alerting should be concretely described. Be sure to specify the kinds of things the artifact would have to be aware of (e.g., your GPS location, whether you can be interrupted, the identity of people you meet) and how it might recognize and reason about them.

• For any existing complex software environment or game (it could be one studied in a previous chapter) document a scenario of a newbie who is trying to learn the basic elements by trial and error exploration without recourse to a printed or online manual. The scenario should involve the accomplishment of a simple goal such as creating an avatar in a game or eliminating red eye with a photo-processing programming. The scenario can be represented as a flow chart, storyboard, annotated screen-capture stills or video, or interactive mockup.

- What conventions would a newbie rely on to tell them what to select and how it will likely behave?
- How well does the system support trial and error exploration (e.g., with tooltips, undo function)?
- How does the system guide the newbie toward the most important basic actions, the building blocks of later, more complex actions?
- How does the system make clear the effect or correct use of tricky commands, icons, or other elements?
- How does the system encourage and support the acquisition of virtuosity?
- Is the overall experience of the existing system one of a reliable helper to a newbie user? If not, what changes to the design would improve it?

• Choose a digital artifact that you use multiple times in a single day, such as a smartphone or a particular piece of software like a word processor or website like Google or your email program.

- For twenty-four hours note every time you look at it or use it in any way, and detail what task you are performing and what role the artifact is playing.
 - How often do you engage with it?
 - How long do your interactions with the artifact last?
 - Do you engage with the artifact any differently when you are with other people?
 - What would you be doing during the same time if you did not have the device?
 - Where would you place the artifact on the spectrum of magical—reliable—clueless—evil companions (it could have elements of more than one)? What does it do that leads you to experience it in this way?

- What do you value most about it?
- How would you improve it?
- Looking at your list of tasks, how did you (or others) perform these same tasks before the invention of the device? Determine how long ago the artifact was invented. Imagine yourself the same amount of time into the future: How do you expect yourself or others to do the same tasks at that time?
- If you can do so without severe disruption, stop using the device or software environment for twenty-four hours. Keep a record of every time you reach for it or are forced to do something differently.
 - Were there things you did not do at all? Did you miss them? What were the consequences of not doing them?
 - Were there things you discovered new ways of doing? Were these new ways better or worse than the familiar ones?
 - Did you have to change other aspects of your routine to accommodate this experiment? Were these changes pleasant or unpleasant?
 - Looking at the list of times you wanted to use the artifact, have you changed your attitude toward any of the tasks you wanted to do?
 - Have you noticed things about the world beyond the artifact that were not apparent before?
 - Do you expect to use the artifact more or less frequently in the future?
 - Have you changed your attitude toward the artifact in any way or noticed things about it you had not noticed before?
- Looking for the Knowledge Navigator servant among current knowledge resources.
 - List all the tasks performed by the automated anthropomorphic assistant in the Knowledge Navigator video, such as taking messages, playing back messages, looking up articles by topic, making graphs from data sets, and so on.
 - Imagine a professor like the one in the video doing the same tasks himself with no assistant.
 - For each of the tasks you identified in the video, list the tools we would currently use to perform them.
 - What functions are missing?
 - Would Semantic Web technologies (as envisioned by Tim Berners-Lee and discussed in chapter 11) be helpful? What other technical infrastructure would be needed?
 - How would you design a system similar to the Knowledge Navigator that would be responsive and helpful, anticipating the interactor's needs, but without the mediation of the anthropomorphic helper?
 - Make a storyboard or interactive mock-up of your system that demonstrates clearly how the interactor would retrieve and manipulate the various knowledge elements.

13 The Game Model: Scripting Interaction as Structured Play

Is play, because it is meta-action, rather than instinctive action, the first appearance of "culture" in animals as well as people?

—Brian Sutton-Smith (Sutton-Smith and Pellegrini 1995)

Game Patterns as Building Blocks for Interaction Design

Games are a fundamental human mode of engaging with the world and one another, and one of the most active **genres** of **digital artifacts**. In this chapter we are concerned not with the design of digital games, but with the ways in which the structured **play** we all enjoy in games can provide a useful model for **interaction design** in general.

Games are a more organized form of the more general experience of play, which is a highly adaptive mode of behavior, common to many living creatures, in which activities are pursued for their own sake without regard for the survival benefits they may offer us, often in an exploratory manner without rules, scores, or winning conditions (Sutton-Smith 1997). Play and especially games take place in a self-contained zone of focused attention that the theorist Johan Huizinga memorably called a **magic circle** (Huizinga 1980), a boundary in space and time, like a theatrical stage during a performance, where actions are detached from the real world. Games may be structured as puzzles or contests, as tests of skillfulness or luck, as controlled performance or the frenzied pursuit of ecstatic disorientation. *What makes all these disparate games— from Pat-a-Cake to bullfights to Scrabble—similar to one another is the explicit rule system that structures the interaction, distinguishing them from free play* (Caillois 1961; Huizinga 1980; Sutton-Smith 1997; Partlett 1999).

Games often exploit the power of external **media** to create shared symbolic tokens of various kinds—playing fields on the grass, game boards carved in wood or printed on cardboard, invading space ships on computer screens. They focus our attention on these media artifacts, and synchronize our behavior with other players. Like digital **artifacts**, games are designed as abstract systems that are only realized by performance; it is not a game until someone plays it, just as digital artifacts only become realized

when the computer code is executed in concert with the **interactor** (Salen, Zimmer-man, 2003). Designers can therefore look at games not only as a vital and growing genre of digital media, but also as a fundamental model of successful **interaction**, like the **tool**, the **machine**, and the helpful **companion**, that can inform our approach to any genre of digital artifact.

We can see the origin of games in the crucial moment when the baby comes to see other people not merely as magical servants of his desires, but as having intentionality and consciousness like his own. When a baby and a parent, having established **joint attention**, find something that makes them laugh, they repeat it over and over again. The parent plays Peek-a-Boo, hiding and reappearing, hiding and reappearing, in exactly the same way. The baby throws a teddy bear out of the crib, and the parent picks it up. Out it goes again, and again it is picked up; repeat forever . . . or until the baby stops laughing or the parent is exhausted. For parent and baby, this prototypical game is a way of celebrating their mutual awareness of one another. It is playfulness becoming ritualized into game.

Playfulness is an attitude of mind that can lead to many behaviors, some of which might be thought of as work under other circumstances: it is exploratory, and moti-vated by curiosity and active engagement; playfulness is usually marked by a desire to try things out and see what will happen, and to repeat a surprising, pleasurable, or emotionally charged cause-effect sequence in order to experience **agency** over it or gain mastery over the requisite skills. Although it may seem contradictory that play-fulness is marked by both an openness to the unexpected and a desire to repeat sig-nificant cause-effect sequences, they can both be seen as part of an active exploration of the rules by which things work. The baby wonders what will happen if he drops that teddy bear, and then he drops it again and again to verify the result and his ability to produce it. When we act playfully we take pleasure in the world around us and also in our own abilities. As a result we get attached to the situations and artifacts that induce a state of playful enjoyment. The conjunction of computation and media has created a potential playground of infinite proportions where *every digital artifact is potentially an opportunity for playful attachment.*

New technologies trigger a state of playful exploration when they afford **direct manipulation** with immediate **feedback**. Designers can exploit this propensity by aiming for a mixture of the familiar and the surprising. If interaction with an artifact is completely predictable and familiar, and the results are merely practical task comple-tion, the element of playful attachment will be minimal. The opposite of playfulness in games is called **grinding,** the repetition of game actions that are so formulaic they become joyless, usually done in order to score points that lead to more enjoyable game play, such as power-ups or admission to a new level of the game. Adventure games and online role-playing games based on character development are often marked by grinding, which players complain about and sometimes illicitly automate or hire out.

On the one hand, once an activity is no longer challenging or fun it becomes work. On the other hand, if an interaction is confusingly unfamiliar and unpredictable, it will produce only minimal playful attachment. But there is a sweet spot in design between the overly familiar and the overly challenging. An artifact that is composed of both familiar and novel elements behaving in a discernable though complex pattern is more likely to arrest our attention, and to create a mood of playful attachment. For example, the classic game Pac-Man (1980) combines familiar game patterns such as a maze, collection of tokens, and enemies for eluding and chasing (behavior which folktales and animated cartoons often associate with ghosts), with novel elements like the central activity of eating, the computer-based automated behavior of the game pieces, Pac-Man's mouthlike shape, and the power pellet upgrades. The direct manipulation of the highly responsive Pac-Mac figure made for a challenging but transparent and learnable interaction, reinforced by rich immediate feedback (figure 13.1). Game designers are always aiming for that sweet spot, but it is an elusive goal, usually requiring intensive game **tuning** through iterative playtesting and redesign (Fullerton 2008).

Games focus playful exploration into repeatable, patterned behaviors. When we put our hands over our faces and then remove them, exclaiming "Peek-a-Boo!" or

Figure 13.1
The game Pac-Man (1980) was developed by a team led by Toru Iwatani at Namco. It provides a useful model for interaction design, mixing familiar and unfamiliar elements in a challenging but learnable environment based on direct manipulation, trial-and-error learning, and the reinforcement of playful exploration with rich feedback.

when we retrieve and return a baby's teddy bear over and over again, or move a bishop chess piece diagonally or press a sequence of keys to make Mario jump across a gap in a platform game, we are performing little rituals of interaction. These **rituals**, once learned, are **transparent** to the players, performed without consciously thinking about them, allowing players to focus their attention on the larger game goals like making the baby laugh, attacking the opposing queen chess piece, or saving Mario from a pursuing enemy. The more repeatable or combinable the game rituals, the more they extend the pleasurable experience of shared attention between human beings, or between the human being and the companionable computer system. Human culture draws on ritualized behaviors that begin as playful exploration—like hand clapping, collecting things, swapping things, associating sounds with gestures or objects—to create coherent symbolic communication and social organization. Once they are absorbed into culture these game patterns become available for playful exploration and then for further ritualization in more expressive games. For example, playful swapping behaviors become patterned into pebble-based games and eventually developed into a monetary system that becomes the basis of play money, which can then be used as part of the real-estate-buying game pattern in a board game like Monopoly.

Game designers build upon such age-old and modern rituals to make the explicit procedures they think of as **game mechanics.** A game mechanic is any behavioral pattern that can be expressed as part of the game rules. Game mechanics specify how players perform game actions and how they evaluate symbolic elements within the game. For example, many games have mechanics for introducing elements of chance into a game, such as picking playing cards from a shuffled deck or letter tiles from a sack or spinning a "wheel of fortune" or using a software-based random-number generator to govern the appearance of nonplayer characters in an adventure game or colored gems in a grid. *Game making involves assembling such mechanics into a coherent, rule-based system that provides a predictable, synchronized, yet surprising experience.* Game designers can draw on a large repertoire of game mechanics. Some of them are cross-genre, like turn taking or score keeping with points, some are specific to particular game genres. For example, the designer of a new board game (Parlett 1999) could draw on such genre mechanics as these:

- Dividing a board into squares or other segments
- Representing players with game tokens that are alike but differentiated
- Moving a token through a segmented path toward a goal
- Using spinner, dice, or cards to calculate moves by chance
- Designating board squares as beginning, end, lucky, or unlucky
- Organizing the winning condition as a race or territorial battle

Figure 13.2
Donkey Kong (Nintendo 1981) designed by Shigeru Miyamoto, the first platform game and forerunner to Super Mario Brothers (Nintendo 1985).

Platformer video games (figures 13.2, 13.3) also have **genre**-specific mechanics, derived from multiple media sources including board games, arcade games, and animated cartoons such as:

• Segmented, obstacle-filled space, traversed by a cartoon figure controlled by the player
• Jumping from platform to platform with penalties for falling
• Enemies who must be jumped over, stomped, or otherwise evaded or destroyed
• Collection of items by colliding with them, usually small and coin-like
• Changes of state of the player character (e.g., bigger, smaller, more powerful)
• Earned or lucky power-ups to create change of state
• Levels with increasing difficulty and novelty of challenges
• "Boss" monster or most powerful adversary in the last level
• A goal, often a rescue or retrieval as the object of the game

The same game mechanic, such as movement across a board in increments determined by chance, can be instantiated using different game actions, such as turning a spinner or rolling dice. And the same mini-mechanics can represent different actions in

Figure 13.3
Screenshot from Super Mario 3 (Nintendo, 1990) here shown in a screenshot from the Wii Virtual Console version (2007). The Mario games extended the gameboard with side scrolling, elaborating the platform jump into the navigation of an increasingly inventive and challenging landscape.

different games: such as rolling dice in a six-year-old's board game, in a role player's battle simulation, or on a Las Vegas craps table.

Designers often exploit the abstract quality of games to generate formulaic versions of the same underlying gameplay with different surface branding or representational elements, such as a stock maze game with a newly popular cartoon figure, or the numerous variants of Monopoly, themed with the Simpsons, Batman, Coca-Cola, or New York City. But there is always room for invention within established genres when designers reimagine the experience of the player in the light of the particular affordances of new platforms or the deeper representational affordances of culturally complex game elements. For example, the game mechanics of the platformer and other video genres have been deconstructed into microgames of WarioWare (Gingold 2005; see figures 13.4, 13.5), and adapted by independent game designers to express themes usually associated with serious dramatic genres like mortality (figure 13.6) and regret (figure 13.7).

Figure 13.4

Screenshots from WarioWare for the Nintendo Gameboy (2003), which makes extremely rapid microgames out of the core mechanics of videogames like the Mario series.

The same playful attitude can also turn the formulaic mechanics of other digital artifacts to more expressive uses. Even the much ridiculed genre of the automated slide show (Tufte 2006) drearily familiar from thousands of predictable business and academic presentations, can be transformed into the expressive subgenre of Pecha Kutcha (see <http://www.pecha-kucha.org>) for imaginative stage presentations by designers; or into a party game in which players are asked to improvise presentations to nonsense slides; or into the idiosyncratic art installations of a former rockstar (<http://www.davidbyrne.com/art/eeei>).

Convening Shared Attention with Game Mechanics

Games exploit the pleasure of synchronized companionship, discussed in chapter 12, to build up complexity. For example, one-year-old children playfully explore the manipulation of their own hands and take pleasure in clapping, and in imitating the clapping of others as a demonstration of agency and sameness. Older toddlers enjoy

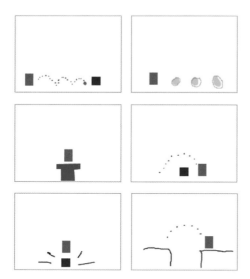

Figure 13.5
The core mechanics of Super Mario Brothers abstracted into WarioWare microgames by game designer/theorist Chaim Gingold: shooting fireballs, collecting coins, entering pipes, dodging enemies, stomping enemies, jumping over gaps (Gingold 2005).

Figure 13.6
Jason Rohrer's Passage (2007), an art game that is an explicitly autobiographical meditation on mortality, in which the protagonist meets up with a mate whose presence limits his access to treasures (like the one in this screenshot) but increases the intensity with which they are enjoyed. The landscape scrolls horizontally like a platform game simulating a life journey ending in death. The nostalgic low-resolution graphics reinforce the theme of the passage of time. Game and artist's statement are available at <http://hcsoftware.sourceforge.net/jason-rohrer>.

the more complex interaction of Pat-a-Cake, which requires more precise timing and observation because the clap is achieved with a partner. Pat-a-Cake turns the skill of hand clapping into a more complex mechanic of social interaction. Games reinforce the synchronization of behavior needed for participation in human society, and game mechanics form an expressive vocabulary that can be adapted and repurposed, providing the basis for survival-oriented social rituals like hunting, gathering, and food sharing, and for the cultural elaboration of social life like singing, dancing, and law

Figure 13.7

Braid (2008), an experimental game created by Jonathan Blow that plays with conventions of the platform game to explore the subjective experience of time and engage themes of regret and failed relationships. In this screen, the design explicitly echoes Donkey Kong. See <http://braid-game.com>.

making. Having mastered just-for-fun synchronized hand clapping as preschoolers, we are prepared for attendance at theater and political events as adults where hand clapping has a semiotic role in expressing approval. Having mastered Pat-a-Cake, we are prepared for handshakes, high fives, fist bumps, and other expressions of exuberant, shared celebration.

We are also prepared for hand-based communication with machines, with joysticks, keyboards, mice, and **haptic** game controllers that respond to our grip by vibrating against our palms. Like game makers, interaction designers build complex structures out of simpler, conventionalized mechanics. Just as game designers adapt the same conventional mechanics of behavior, like rolling the dice, for diverse situations from Shoots and Ladders to Craps, interaction designers draw on standardized *interaction mechanics* to express very different actions. Click-and-drag, for example, is a symbolic ritual, like moving a piece on a game board, that can be mapped to the act of reorganizing a set of file folders or ejecting a hard disk or repositioning a battleship or placing shoes in a shopping bag. Our current interface conventions may someday seem like a kind of human–computer Pat-a-Cake, a primitive language of shared attention that is laying the basis for more complex cultural structures, with larger groups of participants drawn into a global magic circle.

The widespread use of digital mobile devices in the first decade of the twenty-first century has produced new ways of convening groups and focusing the attention of

Figure 13.8
Improv Everywhere MP3 Experiment 7 (2010). Improv Everywhere stages fanciful, synchro-
nized participatory events by drawing on theatrical and game conventions to coordinate the
behavior of crowds of people. The participants download an audio file and show up at the same
time and place to follow the directions of the disembodied pre-recorded voice. See <http://
improveverywhere.com>/ for videos of their past "missions.".

like-minded strangers in live-action public events. Instant messaging, email, and other
digital communication channels were first used as part of the youth culture to organize
"meet ups" and to convene unannounced "flash mobs, " and grew to become an
important form of global political action and a growing site of artistic expression.
Improv Everywhere, an experimental theater group, has playfully explored the pos-
sibilities for coordinated whimsical actions by large groups of people in public places
(<http://improveverywhere.com>), using mobile media players to choreograph their
actions and drawing on play rituals like tossing beach balls around, game mechanics
like Rock Paper Scissors, and theater games that have people imitating outlandish
characters like bumblebees, dolphins, and astronauts (figure 13.8). Such mass-
synchronization events are likely to become increasingly common in coming decades
with greater ambition for the coordination of behaviors across geographical distance,
and expanded use of more complex game mechanics for both serious and playful
purposes.
 Sustained casual games have been an important component of the success of large
social media sites. The huge popularity of the Facebook game Farmville (Zynga 2009),
which had over 80 million players in 2009, was surprising to veteran game designers
because the mechanics seemed so trivial, and the game so unchallenging (figure 13.9).
But simple games work well in social media environments because they produce a
sense of a shared daily ritual that is more about presence than performance. The fun

Figure 13.9
Farmville (2009), a social networking simulation game in which players cultivate farm plots adjacent to those of Facebook friends. The game requires repetitive actions to keep the farm in cultivation, and encourages players to purchase items that give the game world more variety, but it does not reward skill or engage players in mechanics of chance. Farm plots can be adjacent to those of friends and game items can be exchanged, providing some of the pleasures of playful companionship with a relatively small investment of social and cognitive energy. The enormous popularity of Farmville, despite its evident simplicity and crass commercialism, bewildered and irritated both mainstream and independent game designers, a response that is epitomized by the title of Ian Bogost's parody Facebook game, Cow Clicker (2010).

of games like Farmville comes from the low level of coordination and skill needed to achieve a shared play experience with people who are drawn from an already meaningful network of "friends." Young children learn to play together through "parallel play" experiences, sitting beside one another, aware of one another's presence, without directly interacting. Games like Farmville can be seen as parallel play experiences for large virtual communities.

Game mechanics can also be used for researching knowledge transmission across social networks. For example, in December 2009, the U.S. Defense Advanced Research Projects Agency (DARPA) celebrated the 40th anniversary of the establishment of ARPANET, the forerunner of the Internet, with a contest structured like a treasure hunt (<https://networkchallenge.darpa.mil/Default.aspx>). In order to explore what strategies were most effective in obtaining and relaying information quickly across a geographically distributed social network, they launched ten weather balloons in locations across the United States and challenged players to form teams to find them in order to win a $40,000 prize (Greenemeier 2009). The winning team from MIT, who found all ten balloons in under seven hours, motivated participation by sharing the prize money along the chain with the finders of each balloon and whoever was directly

linked to their recruitment. The runner-up team from Georgia Tech, who found nine of the ten balloons in the same amount of time, took a more cooperative approach to motivation by pledging to contribute the prize money to charity. Like the huge raiding parties in World of Warcraft or the plant-gifting Farmville players, information researchers are repurposing ancient game mechanics. Each in their own way is contributing to the common cultural project of reinventing the rituals of shared attention to suit the increased speed and scale of the global village.

Playing with Media Conventions

Games employ many of the same media conventions as nongame applications, often demanding a high degree of focus on complex media objects. One of the most striking examples of a game with elaborate print components is the classic print-based tabletop role-playing game Dungeons & Dragons (D&D), invented in the 1970s as an outgrowth of tabletop war games (Gygax 1978; Fine 1983). D&D is not a single game but an encyclopedic game system for individual game masters and players to use as the basis for improvised collaborative adventures that can be set in elaborately specified D&D fantasy worlds. Gameplay is based on thick books of quantitative tables that specify the rules for creating characters and for performing actions in the game, based on rolls of special dice (figures 13.10, 13.11). Each dice roll provides a significant parameter for the calculation of a dramatic game action, such as whether you have hit a target and how much you have injured the enemy. The point system is cumulative with action in one game session affecting the skill and experience points that your character carries over from one quest to another.

Among the game mechanics that D&D has made conventional for the tabletop role-playing genre are:

• a game master, who sets up game sessions by designing quests and describing the action including the parts played by nonplayer characters
• player-designed characters based on a substitution system of differentiated character types (e.g., warrior, wizard, cleric, thief) and attributes (e.g., strength, intelligence, dexterity, charisma), who persist from game session to game session, changing in experience and skill points.
• a system of rule books with fantasy elements specified as mathematical formulae determining the probabilities of game events
• the use of dice to decide game events
• the use of a grid system for the game map, and of concealed or progressively revealed custom maps as game boards
• the inclusion of nonplayer characters (NPC) controlled by the game master
• team-based gameplay in questing parties of four players with complementary skills

Class Level Name	Level	EP Needed	Hit Points	Open Locks/ Remove Traps	Pickpocket or Move Silently/ Hide in Shadows	Hear Noise D6
Apprentice	1st	0	1D4	15%/10%	20%/10%	1-2
Footpad	2nd	1200	2D4	20%/15%	25%/15%	1-2
Robber	3rd	2400	3D4	25%/20%	30%/20%	1-3
Burglar	4th	4800	4D4	35%/30%	35%/25%	1-3
Cutpurse	5th	9600	5D4	40%/35%	45%/35%	1-3
Sharper	6th	20000	6D4	45%/40%	55%/45%	1-3
Pilferer	7th	40000	7D4	55%/50%	60%/50%	1-4
Master Pilferer	8th	60000	8D4	65%/60%	65%/55%	1-4
Thief	9th	90000	9D4	75%/70%	75%/65%	1-4
Master Thief	10th	125000	10D4	85%/80%	85%/75%	1-4
Master Thief	11th	250000	10D4	95%/90%	95%/85%	1-5
Master Thief	12th	375000	10D4+1	100%/95%	100%/90%	1-5
Master Thief	13th	500000	10D4+1	100%/100%	100%/95%	1-6
Master Thief	14th	625000	10D4+2	100%/100%	100%/100%	1-6

Figure 13.10

A representative Dungeons & Dragons table, used by players for calculating the "experience points" needed to attain the different levels (e.g., Apprentice, Cutpurse, Master Thief) within the overarching professional category of Thief, and showing for each level the values to use in calculating vulnerability to attack and likelihood of success in some of the essential tasks of thievery.

The D&D players are imaginatively role playing in a world of dungeons, dragons, and wizards, and yet the game mechanics involve a lot of arithmetical calculation with reference tables, an activity more generally associated with work than play. The combination of magic and arithmetic works because the dice focus attention in real time within the social world of the players on a chance event happening in the shared fantasy realm. The physical mechanics of choosing and throwing the oddly shaped dice according to instructions in arcane tables is evocative of the world of wizardry and spells that forms the dramatic context of the game.

Moving tabletop team fantasy games to the computer has taken the dice away as well as the physical presence of other players, while opening up many rich representational possibilities. Graphic role-playing games are one of the most popular genres of digital entertainment, with best-selling fantasy games like BioWare's Neverwinter Nights (2002) and Blizzard's World of Warcraft (2004) using interactive substitution displays to emphasize the choices of character classes, attributes, and inventory items open to players (figure 13.12). Digital games preserve the underlying mathematical mechanic for the blow-by-blow calculation of battles, including a randomized element, but eliminate the need to look up tables or roll physical dice.

The D&D calculation tables and dice are transmission codes, and playing with them compared to playing a similar video game is like looking up a phone number in a

Figure 13.11
Dice used in a session of Dungeons & Dragons, from Wikipedia Commons, created by Franganghi.

paper directory and then manually dialing the number, compared to touching a hyper-linked name and letting your smartphone do the lookup and dialing for you. But for tabletop players, the dice and tables are part of the enjoyment of the game, provid-ing a different pleasure from the visualized instantiation of the fantasy world (see <http://www.helium.com/debates/155881-which-is-better-online-roleplaying-games -or-tabletop-roleplaying-games>). In fact, visualizing a role-playing world in moving images can make it less real for some players, just as film adaptations made from novels can disappoint fans of the original, because the film version does not correspond to the individual's imagination of the world.

Interface transparency is not always valuable in a game. We may not want to eliminate the decoding, because logical codes are classic game elements. Symbol systems used in games are interesting to us because of the novelty of the symbol or the intricacy of the system and not, as in life, for what they represent. Clapping in Pat-a-Cake is only clap-ping; it does not hold the meaning of clapping in a theater or high fiving, but is enjoy-able in itself as the synchronized intersection of hand on hand. A map in a game is not interesting as a way of getting around an actual place—it is the place, and the pleasure comes from navigating from one segment to another and noticing the relationship between places. Play money in a game functions like real money, but it has no practical value outside the game. When we receive it as pay, take it from other players, save it,

Figure 13.12
World of Warcraft talent calculator for a member of the Rogue class, including the Mutilate refinement of the talent for assassination.

or spend it, we are enacting rituals that have value in the real world but are pure performance in the context of the game. Words in a crossword puzzle game like Scrabble are equally meaningless. Their denotation and connotation are merely decorative details in the context of our focus on placing letters in legal arrangements to increase our score. Games allow us the pleasure of thinking of clapping, mapping, accumulating money, and formulating words as *abstract codes* and *pure mechanics of interaction* with a satisfying cognitive complexity that is independent of what they buy or mean.

Human beings are capable of seeing any complex set of interactions or media codes as a game, of getting lost in the signifiers and ignoring the things signified. The allure of computational artifacts draws on this pleasure, and it can work against transparency, efficiency, and expressivity—the values we discussed as part of the more instrumental **tool model**. We do not necessarily value efficiency in game interactions; sometimes we value cumbersome processes because the extra effort needed to focus our attention on their arbitrary, excessive elaboration brings us a welcome detachment from the world of time and consequence outside the magic circle. Games allow us to indulge our

predilection to fetishize numbers, letters, or currency-like tokens, or to become enraptured with complexity for its own sake. Completing the *New York Times* Sunday crossword puzzle or assembling a 1,000-piece jigsaw puzzle or an intricate Lego model of the *Millennium Falcon* can create the satisfying sense of absorption and challenge recognized as a **flow** experience (Csíkszentmihályi 1990). The intricacy of a system, the pleasures of manipulating complex coded objects, even when they are part of a real-world task, like moving gambling chips around a colorful roulette table, buying and selling securities, operating a military remote targeting system, estimating the risk of a natural disaster with mathematical probability tables, can create a seductive sense of being in a magic circle, intensely engaged but distant from consequences in the real world. *Computers reinforce the danger of losing sight of consequences in the physical world, even as they help us to manipulate ever more complex and powerful symbol systems. Designers should bear this danger in mind and look for ways to remind interactors of what is at stake in real-world systems whose complexity can create game-like immersion.*

Games also remind us of the human tendency to fetishize cumbersome mechanics when they are embedded in familiar media formats, and to confer the status of specialized wizard upon those who have mastered them. Processes that have long been mystified by paper-based professional rituals, like writing a will or filing a tax return, become more transparent when digital media automates the rules or makes the previously hidden mechanics visible to nonprofessionals. Practitioners who are used to privileged access to the mechanics of their profession often expect designers to reproduce the older, print-based rituals. Literary scholars have made ill-considered but passionate arguments for retaining a library cataloging system based on heavy drawers overstuffed with handwritten index cards. Technologists can be equally passionate in finding hidden virtues in obsolete command-line text editors or seductively complicated and insufficiently tested programming packages. *Designers faced with requests for the reproduction of unnecessarily cumbersome practices or the use of cultish technologies should ask themselves whether the specialists involved are clinging to their magic dice and secret tables, enraptured by the game-like immersion of the secret code, instead of focusing on the best mechanics for instantiating the underlying practical quest.*

The plasticity of bits allows us to blur the boundary between actual artifacts and playful forgeries, everyday identities and masquerades, real events and make believe. The new genres of **alternate reality games** and **pervasive games** exploit this heightened awareness of how easily we can be deceived and focus attention on the game-like structures of our real social, political, and economic structures, by mixing game elements with real-world experiences and convening groups of players to identify, share, and decode the purposely ambiguous puzzle pieces. Instead of setting gameplay within a self-consistent, safely insulated magic circle, alternate reality games often use intrusive tactics such as emails and instant messages, and plots that involve violent conspiracies, suppressed information, and secretive informants to blur the distinction

between in-game events and events in the real world. As pervasive game designer and theorist Jane McGonigal puts it, "If we could make your toaster print something we would" (McGonigal 2005). Pervasive games involve players in highly participatory and complicated games by relying on ritualized mechanics such as mystery solving, decoding of media artifacts, treasure hunting, and fantasy role playing to structure social interactions. Often the game mechanics are meant to serve the purposes of creating enjoyable or ideologically desirable social interactions, rather than creating transparent, immersive, or conventionally satisfying game experiences. As McGonigal points out, designers of such games create team missions

that require players to misread (non-game) people, places and objects as a part of the game. For example: "Some time today you will be approached by the Speaker. The Speaker could be anyone, anywhere. all we know is that the Speaker will say something to you. It could be anything, and you'll only know it's the Speaker if you form a circle around him or her and dance wildly." Or "Sometime today you will find the Mystery Key. It won't look like a key, but it will work some kind of magic when you encounter a locked door later in the game. So make sure you take with you any unusual objects you find along the way." With this built-in ambiguity, teams must approach everyone and everything with a game mindset. When encountering a person, a team must assume he or she is a plant; when finding an object, a team must assume it is a prop to be deployed creatively. These missions require teams to affect a confident belief, to act *as if* the game is everywhere and everything at all times. (McGonigal 2003)

The after effects of the **pervasive game** are as important to McGonigal as the game experiences. People are left with a "game-play mindset" in their ordinary lives, defamiliarizing the **naturalized** environment. Perhaps they become aware of their desire for life to be more like games, more shapely and predictable, with clearer rules of behavior. Perhaps they become aware of their impatience with the rules of existing social games. Participating in a pervasive game with the aesthetic of "performing belief" as McGonigal describes it, invites the players to think of the world as it is as just one instantiation of the possible worlds it could be.

Of course, defamiliarizing the mechanics of interaction only works as a design strategy if the mechanics are already quite familiar, and the point of the defamiliarization is clear. *The risk in creating games or art pieces that subvert familiar media conventions is that interactors will experience frustrated befuddlement rather than the intended heightened understanding of the way the world is put together.*

Art is another kind of playful magic circle, free to invent its own mechanics. Artists explore the plasticity of the new digital medium, intentionally stretching and transgressing familiar media conventions and rituals, and sometimes inventing new expressive mechanics of interaction that can be adapted by designers. For example, Camille Utterback' *Liquid Time Series* (2000–2002) translates the interactor's physical approach to a digital video image into the immediate agency of pushing part of the image "deeper" in time:

Figure 13.13
Camille Utterback's *Liquid Time*, an art installation project in which segments of the moving image change, reflecting temporal movement, in response to the viewer's movements in the space in front of the image.

In the *Liquid Time Series* installation, a participant's physical motion in the installation space fragments time in a pre-recorded video clip. As the participant moves closer to the projection screen they push deeper into time—but only in the area of the screen directly in front of them. Beautiful and startling disruptions are created as people move through the installation space. As viewers move away, the fragmented image heals in their wake—like a pond returning to stillness. The interface of one's body—which can only exist in one place, at one time—becomes the means to create a space in which multiple times and perspectives coexist. (Utterback 2000–2002)

Utterback's piece evokes the continuities and discontinuities between present consciousness and memory, by disrupting "a basic premise of time based media—that the unit of recording is also the unit of playback" (figure 13.13).

Similarly, David Rokeby's *Machine for Taking Time* (2001–2004) displays a composite image that mimics the familiar cinematic pan, from individual images that are continuous in space but compellingly discontinuous in time (figure 13.14), and Jonathan Blow's

Figure 13.14

David Rokeby, *Machine for Taking Time* (2001–2004). The camera pans still images taken at different seasons but stitched together to form a dynamically reconfigured, continuous cinematic space in which "Time moves very slowly and very fast at the same time."

experimental platform game Braid (figure 13.7) offers multiple variations on the theme of rewinding the past as the focus of gameplay. Works like these radically challenge familiar media conventions for structuring time, perhaps providing the basis for new genre conventions that can capture our complex experience of temporality including the distortions of subjective memory, the relativistic time of physicists, or the ways in which our brain dynamically reknits the web of connections linking past, present, and future events.

Playing with Cognition

Game design elements often focus us on and support core cognitive activity such as matching, sorting, collecting, and sequencing, as well as pattern recognition for symbolic codes (like the alphabet), and math skills. For example, the Royal Game of Ur, perhaps the oldest surviving board game, dated to the third millennium B.C., is structured as a race across a game board of meaningfully patterned squares, with patterned tokens differentiated by color, and moves determined by casting dice made of animal bones (Green 2008). Playing this game involves some mathematical and sequencing skills and the ability to interpret a symbol system, which presumably would have reinforced the skills involved in deciphering the proto-alphabetical symbolic writing of the period (figure 13.15).

Since games are interactive systems based on abstract patterns, game conventions can help us to think concretely about complex computational artifacts. For example, consider the classic board game Go (figure 13.16), which is played by placing black or white stones on a board of 19×19 squares in patterns that enclose the opponent's stones. There are few rules beyond placing one stone at a time in alternating

Figure 13.15

The Royal Game of Ur in the British Museum, from a tomb in modern day Iraq, dated to 2600 BC. There are seven white and seven block game pieces, and a game board with inlays of shell, red limestone, and lapis lazuli. The eight-petal rosette squares are believed to confer advantage on the token that lands on them. The game has survived in recognizable form to modern times, and is a forerunner of backgammon.

turns, yet Go opens up a large possibility space, engendering complex strategies. In fact, Go is many times more complex than chess in the possible moves that can be made at any given time and the effect of individual moves on later moves, making it so far impossible for computers to outplay human beings. It serves as a model for interaction design in gaining such expressive power out of such an elegant economy of rules.

Go is also a good example of a game whose **state** is readable from the position of pieces on the game board. *Games in general offer a useful palette of conventions for representing state, which as we saw in chapter 4 is one of the key concepts in a procedural medium.* As game worlds become more elaborate, it is increasingly challenging for game designers to display the many elements that make up the dynamically changing state of the world—a problem that is increasingly important in the visualization of real-world systems as well. Go, like Othello, chess, and checkers, is structured as a contest between tokens of contrasting colors, and viewing their numbers and positions on the board reveals who is winning. Casual video games that focus on removal, such as Tetris, Jewel Quest, Collapse, and Zuma, display state as the number of remaining pieces. In Tetris and Zuma, the position of pieces on the board also

Figure 13.16

A game board for Go, which has been played in China for more than 2,000 years. The object is to surround the opponent's stones in order to occupy the most space. Stones can be placed at any intersection (point) in the grid as long as there is at least one connected point open. Surrounded stones are removed (captured by the opponent). Although the mechanics of the game are very simple, the strategies are in some ways more complex than those of chess.

reflects the building time pressure—as time runs out, the board starts filling up or the pieces get closer to the hole. By eliminating the need for a separate timer, the game designer reduces distraction and increases the dramatic tension of the gameplay. Videogames and board games that focus on the player's movement through an abstract map (Pac-Man, Donkey Kong, Shoots and Ladders) can similarly display state in the positioning of the tokens on a single overview image.

Simulation games, like Civilization, SimCity, and The Sims are so complex that they require multiple displays to keep track of all the changing variables. Players split their attention between the main display, which gives a good summary image of the state of system (for example, in the appearance of the furniture and friends in the Sims house), and the control panels at the margins or on other screens lower in the menu hierarchy. The strategy of a main summary view with strong representational elements—such as a a map or scenario mock-up—augmented by deeper details in

quantitative control panels can be applied to the visualization of other kinds of simu-
lations as well. For example, we might summarize global warming effects with map-
based images of rising sea levels and melting ice caps, while presenting a graph of
specific measurements in a separate display.

Replay as Repetition with Variation

Closely related to the display of state is the game-like pattern of **replay**. **Parameterized**
repeatability, or the ability to replay a game with significant changes, is an important
affordance of digital game environments for the presentation of simulated systems.
In a game like Lemonade Stand, for example (figure 5.5), we can try multiple strategies
for maximizing profit, such as changing the recipe or increasing the advertising
budget. By playing the game more than once we learn from our mistakes and we get
a clearer picture of how the lemonade business is modeled by the program.

Over the past twenty years games have developed elaborate mechanisms for replay,
which can also be useful when applied to informational systems such as educational
simulations. Most games allow players to save the state of the game at intervals in
order to be able to repeat the last portion of the game without having to start over
from the beginning if you lose a round (i.e., if your character dies). In some games
repetition is by levels; in other games it is by puzzles or challenges within a level;
some games will allow greater freedom, so that players can save at will anywhere
throughout the game. Some games allow multiple instances of the same game to be
saved, which allows the player to try out more than multiple strategies and compare
the results. Often a game will establish specific explicit **save points** and will automati-
cally save or prompt the players to save before and after completing a particularly
treacherous challenge. It is conventional to endow characters with multiple lives so
that they can be reinstated after a failed attempt. Often a new instance of a character
who has died but has lives remaining will automatically reappear at the save point.
The many variations on such mechanics for restoring a game world and **respawning**
a character are equally useful for creating simulated worlds for analyzing complex
processes. For example, if we were analyzing the effects of multiple pollutants on the
ecology of a pond, we could save the simulation of a period of time with one hypo-
thetical pollutant, and then run parallel instances of the same time period with and
without a second pollutant. Or we could respawn instances of threatened species to
try multiple strategies for survival, or save multiple versions of the same scenario and
play through them to compare strategies for favoring one species or another.

*Repetitive plays of simulated systems can lead to deeper insight when the scenario
design and interface elements support clear comparison between different instances.* In
quantitative simulations, such as economic models, election forecasting, or
epidemiology studies, providing continuous sliders for key parameters (sales, voters,

vaccinations) and readable color coding for the salient outcome (profit/loss, Republican/Democrat, disease decline/spread) can anchor understanding in physical gestures tied to sensory feedback. Games with sharply differentiated avatar choices (e.g., fighters vs. sneaks, opposing sides in a conflict) encourage repetition for the exploration of alternate strategies or points of view.

Repetition with variation can also lead to dramatically satisfying juxtapositions in interactive narratives. For example, in Sarah Cooper's Reliving Last Night (2001), an interactive romantic comedy, we can juxtapose short scenes covering the same moment under different conditions. The story concerns a young woman entertaining a young man, and the interactor can choose what she wears (sloppy or sexy), what she serves (coke or vodka), and what music she puts on. In every version of the story another young man, whom she has recently broken up with, arrives and reacts to the presence of the potential new boyfriend. The story is divided into short dramatic segments and the navigation scheme allows for repetition of the same scene with different parameters (figure 13.17).

Figure 13.17

Sarah Cooper's interactive story, Reliving Last Night (2001) is divided into dramatic segments that maximize the dramatic contrast between parameterized events. Here an old boyfriend is about to arrive and the protagonist and her potential new boyfriend can be in varying states of inebriation and listening to one of three choices of music, changing the way the scene plays out while keeping the basic characters consistent.

The Mechanic Is the Message

In making an interactive system, as in designing a game, as game designer Tracy Fullerton has pointed out, *the mechanic is the message* (Fullerton 2007). Most commercial games are structured around a small number of mechanics: moving fast, shooting (or knifing, punching, etc.), and evading. But mechanics can have expressive qualities even within this narrow range. Mario, the classic platform game hero, is forced to relentlessly run and jump to evade disaster, squash his enemies, and make his way through the many obstacles of his world. But his jumps are exhilarating and varied, with mushroom-shaped enemies, trampolines, and magic spinners to propel him, and surprising landscapes opening up in unexpected places, constantly expanding the boundaries and the inventive possibilities of the game. Mario's cheerful resiliency is like the dogged hopefulness of the slapstick film hero Buster Keaton or the antic evasiveness of Bugs Bunny. Like all archetypal comic heroes, Mario can be beaten down, but he will always rise up again; or he will as long as the player is willing and able to enact his story. By playing Super Mario Brothers we enacting a rule system in which the villains will keep coming but the hero will triumph in the end if the player puts in the time and effort to master the necessary skills. The game is a semiotic system encoding meanings about what makes for success in a thrilling but hostile, competitive world.

The Sims finds expressive mechanics in the everyday rituals of middle-class suburban life, like finding a job, taking a shower, picking things off the floor, asking friends to a party, and giving someone you like a backrub. The ordinary furnishings of a home are game objects with behaviors that satisfy our expectations taken from the real world and affect the state of the game. For example, you can use the telephone to order a pizza for your Sims. The pizza will be delivered in a dramatized event that will decrease the amount of money the household has and satisfy the appetite counter of the characters who eat it. It will also create trash that will impact the messiness counter and require cleaning up afterward. The Sims is an interpretation of the rewards and risks that attend our everyday activities.

Many of the activities we are familiar with can be recast as game mechanics and interpreted as part of a cause-and-effect rule system. We are surrounded by systems of ritualized behaviors, and we can choose to represent them as games by identifying the reward systems they belong to, the limited resources they use up, the competitions they are part of, and so forth. For example, a family holiday celebration might be represented by game mechanics based on any of the following elements:

- scoring of points in bragging contests
- competing for consumption of food
- depletion of limited resources (money for presents, food)

- scoring of transgressive behavior (nose rings, alcohol consumption)
- rituals of synchronized behavior (singing, echoing praise, gift exchange)
- role playing (nurturer, authority figure, trickster, political opponent)
- contests for attention
- success at keeping/revealing secrets
- using the dinner table as a game board with place settings representing territory, and placement reflecting teams' organization

In ordinary life we may find ourselves playing multiple games at the same time and losing track of the score in some of them. We may be assigned to roles in social games that we do not want to play or do not know how to play. We often find ourselves in social situations that feel like a single playing field is being used simultaneously for conflicting sports, as if some players are suited up for football while others are in a leisurely round of miniature golf. The pleasure of actual games is that they substitute a controlled, consistent area of focus where a limited group of people agree, within the constraints of the game, to act according to the same rules. *An awareness of the game-like structure of social behavior can provide a palette of interaction mechanics for designers, and should be increasingly helpful as computation is embedded in more and more ever-day objects and becomes increasingly important to everyday social rituals* (Goffman 1959, 1967; Berne 2004).

Because games are such a fundamental building block of culture, they are often used as a metaphor for social situations ("He won't play by the rules." "They threatened to pick up their ball and go home." "That remark was out of bounds."). Games can also be used as a conceptual framework for understanding complex issues. The branch of applied mathematics called **game theory** attempts to reduce the messy world of social organization into neat game-like abstract patterns, so that they can be analyzed by mathematicians and philosophers and used by economists, political scientists, and computer scientists to model social behavior. For example, the Prisoner's Dilemma game is based on a scenario in which each of two prisoners can either cooperate with one another or defect from their partnership to seek individual advantage:

Two suspects are arrested by the police. The police have insufficient evidence for a conviction, and, having separated both prisoners, visit each of them to offer the same deal. If one testifies (defects from the other) for the prosecution against the other and the other remains silent (cooperates with the other), the betrayer goes free and the silent accomplice receives the full ten-year sentence. If both remain silent, both prisoners are sentenced to only six months in jail for a minor charge. If each betrays the other, each receives a five-year sentence. Each prisoner must choose to betray the other or to remain silent. Each one is assured that the other would not know about the betrayal before the end of the investigation. How should the prisoners act? (<http://en.wikipedia.org/wiki/Prisoner%27s_dilemma> retrieved August 8, 2009)

Game theory analysis of the Prisoner's Dilemma usually stresses the advantage of the defection choice, and is based on an assumption that the partners have no reason to be loyal to one another against their own self-interest. The scenario has been extensively used as a way to understand a wide range of social behaviors, from nuclear disarmament to steroid use among athletes, where choices have to be made between self-interest and collective interest, and where there is imperfect knowledge and distrust among the participants. Game theory scenarios form the basis for much large-scale economic modeling, and they have been used in everyday practical applications such as the automated auction system used by Google for selling online advertising (Levy 2009).

Although some would claim that such economic game scenarios can explain many complex social phenomena, such approaches have been criticized as ahistorical (Levitt and Dubner 2005; Fine and Milonakis 2009). Humanistic disciplines, like history and literary studies, are skeptical of approaches that reduce human behavior to logical formulas, believing that our actions reflect complex cultural motivation, social traditions, and unconscious needs and desires that resist quantification. The Prisoner's Dilemma game assumes that ideology, moral values, personality, and personal relationships are irrelevant to prisoners' choices. This is not a value-neutral or scientifically objective assumption; it reflects an **ideology**, rooted in modern European political thought, that focuses on narrowly defined self-interest as a determinant of human behavior and privileges quantifiable phenomena (How much time do they spend in prison?) over qualitative phenomena (What is the relationship between the two prisoners? What is their attitude toward the police?). In the actual world, people regularly act against their rational self-interest, and economists as much as anyone else can be deceived in assessing the value of objects of desire. Though game theory models seem reductive to humanists, they will continue to be seductive to social scientists, if only because they lend themselves so well to programmed simulations. *Designers should look to game theory for useful procedural models of behavior, while remaining skeptical about how well their compelling mathematical complexity represents the complexity of the real world.*

Once more, designers will do well to remember the programmer's adage, Garbage In, Garbage Out. The representation of a situation as a quantitative game is not necessarily more reliable or precise because it involves complicated computer-based calculations. It is part of the designer's responsibility to make sure that users of such a system fully understand the rules of the underlying game, including what has been left out of the representation.

Patterns Make Reality

We have been concerned in this book with understanding the patterns by which we can design more expressive and coherent interactive artifacts and advance the

development of the new digital medium. In summing up this effort I return to Danny Hillis's words, the epigram for this book: "Whenever I design a chip, the first thing I want to do is look at it under a microscope—not because I think I can learn something new by looking at it but because I am always fascinated by how a pattern can create reality" (Hillis 1998).

Patterns make reality, and media patterns—like the circuits on a computer chip, the divisions on a map, the fields in a database, the sections of a Wikipedia page, and the mechanics of a game—shape reality by providing the templates by which we exchange meaning with one another. Games are a fundamental building block for designers because they ritualize behavior. But playfulness is even more important because it disrupts ritual patterns and reconfigures reality. *I encourage every designer reading this book to approach your career with an attitude of radical playfulness, looking for ways to disrupt the patterns that define us in order to reconfigure reality to better serve human needs.*

Patterns make reality. What we can represent determines what we can do, what we can know, and who we can be. The hardware and software platforms on which digital information is inscribed and transmitted will change over the coming decades, as will the job opportunities in this evolving field. But the task of shaping a powerful new medium of representation will remain the same.

The creation of a more coherent and expressive digital medium is not something that is achievable in any single project or over the course of a single career, nor is the future inevitably weighted in favor of free expression and deeper knowledge. We did not come into possession of the computer as a medium of representation through patterns of perfect benevolence, but through the common human history of exploitation and conflict as well as aspiration and achievement. But design is an intrinsically optimistic profession, and a more expressive medium is worth reaching for, and achievable through a collective professional dedication to the principles of design as a cultural practice.

The contribution of digital design to human culture goes beyond the usefulness of any particular application. Every designer who struggles to make a particular artifact more coherent and expressive is contributing to the collective project of expanding human understanding by inventing the medium.

DESIGN EXPLORATIONS: THE GAME MODEL OF INTERACTION

Recognizing the Conventions and Structure of Games
• Play a game (like bridge or charades) that involves closely coordinating your thoughts with a partner or teammates.
 • How well could your partner read your thoughts and intentions?
 • How well were you able to read your partner's thoughts and intentions?

- When were you most in sync? What produced the common understanding?
- When were you least in sync? What produced the communication gap?
- Did the opposing team members coordinate their behaviors differently than you did? How so?
- Identify a game that you play or watch regularly with other people either in person or over the Internet.
 - What generation and gender are the people you share this game with?
 - Are you affiliated with them in other ways besides your playing or watching the game together? Does playing together change the intensity or quality of your affiliation?
 - Are there rituals to your interaction that are not in the official rules of the game?
 - Have you noticed significant differences in the experience if a new player is added or a game-related ritual is disrupted?
- Games can function as **boundary objects**, uniting disparate social groups for whom playing the game means different things within a single functional system.
 - Is the preceding statement true of your experience of any games?
 - Is it true for the role of public games such as Olympic contests or organized team sports?
 - Identify a game that functions as a boundary object and describe the important features of the game from the perspective of two or more categories of player/spectators.

Translating Legacy Game Mechanics into Procedural Computer Code
- Play the same game (e.g., Scrabble, chess) in at least two of these ways: using a nondigital game board and playing against a real person; using a digital game board and playing against a real but remotely located person; using a digital game board and playing against a computer-generated opponent. What is the difference in your expectations, attention, and behavior in each of these situations? Is there a difference in degree or kind of satisfaction you experience?
- Design an interactive version of a simple board game. Identify a board game aimed at children under seven years old and analyze all the mechanics of the game (the rules, the tokens, and game board).
 - Make a mock-up of the game board and all the tokens. If there are dice or a spinner in the game, invent a digital equivalent to generate a random number in a limited range through the imperfect agency of the player.
 - Describe how all the objects in the game will behave using procedural notation such as flow charts, state diagrams, or pseudocode.
 - Make a paper version of the game and playtest your rules with potential users to be sure the mechanics are clear and consistent. The game may require tuning to make it harder or easier or more or less complicated.

- After analyzing the results of the playtesting, redesign the game and revise your documentation.
 - If possible, implement the game and do further iterative playtesting.
- Design and if possible implement a similar game to the one in the preceding exercise, with the same underlying abstract mechanics but different surface content.

Making Meaning with Replayability

- Design a replayable version of a family holiday dinner in which there are at least four characters with two or more visible states (e.g., sleepiness, intoxication, anger, parental doting, etc.).
 - Describe a positive outcome of the dinner as an event with clear preconditions expressed as character states (e.g., a young couple will announce their engagement at a dinner but only if they are feeling loving toward one another and if the drunken uncle has fallen asleep and the mother is not angry at the father and if the father is still in the dining room.)
 - Describe a negative outcome of the dinner as an event that results from the combination of a set of individual character states (e.g., the young couple will leave early if any two of the following take place: the uncle has become enraged by a political argument, the mother has retreated to the kitchen in tears, the father has retreated to the den to watch the football game.)
 - Describe a neutral outcome of the dinner (e.g., the young couple will stay until the end of the dinner but will keep their engagement a secret, if not enough bad or good things happen to force one of the more extreme events.).
 - Describe three time periods within the dinner and actions that the characters can take during each of these periods that will affect their own or other people's states.
 - Mock up your replayable scenario, making the actions and the effects as visible as possible through graphic dramatization, verbal dramatization, control panels, or a combination of these.
 - Decide on an interaction mechanic: Which characters does the interactor control? What important choices can the interactor make?
 - Play through multiple combinations of states and make each one as dramatically interesting as possible.
 - When you are satisfied with your replayable scenario, test it with others and adjust the visibility and cause-and-effect structure as necessary. Pay attention to the tuning of the game, making sure that the good or bad effects are motivated by the choices of the interactor.

Making Meaning with Expressive Game Mechanics

- Take a familiar expression that uses games as a metaphor (e.g., "That remark was out of bounds"; "We want to level the playing field for the disadvantaged") and design

a game mechanic that expresses the relationship captured by the metaphor. Is there a clearly defined contest? a scoring mechanism? Are cheating behaviors visible?

• Design and mock up (and, if possible, create and iteratively test) a game based on the Prisoner's Dilemma scenario that includes the same outcomes as the original game, but more contextual detail and different decision factors (other than simple, competing self-interest) for the characters to take into account. For example, you could include the nature of the crime in the scenario or more information about the relationship of the perpetrators. You could differentiate between what the lawyers advise each prisoner to do and what they decide to do. How do the values behind your model differ from the values behind the classic scenario?

• The video games of Jason Rohrer (such as Passages and Gravity) are explicitly auto-biographical. Play one or both of these games (they are available at <http://hcsoftware. sourceforge.net>) and read the associated artist statements.

 • What recognizable game mechanics is Rohrer using?

 • What game genres do these mechanics come from? What other mechanics are in these game genres that he doesn't use?

 • What conventions does he take from other narrative genres such as film? To what extent do the actions of the interactor carry the emotion of the piece?

 • What is the difference between presenting this experience as a game and presenting it as a short animated film?

 • How do you imagine the mechanics of the game would be different if another member of Rohrer's family designed them?

• Design your own autobiographical video game (or create a biographical video game for a fictional character) building upon Rohrer's expressive use of game elements and using elements from any video game genre.

 • Identify the protagonist and describe in words the game's scenario, literal action, emotional analogy, and the life experience it symbolically enacts.

 • What is the mood of the game? Does it have a "winning" state?

 • Does it have a clear termination point?

 • Identify a visual style and any auditory assets for the game, such as music or sound effects.

 • Make a storyboard for your game.

 • Prepare a flow chart of game action with state diagrams if appropriate.

 • Describe the action of elements in the game world with pseudocode.

 • If possible, implement one part of the game and playtest it with others.

 • If possible, implement the whole game and playtest it with others.

Glossary

Abstraction A representational strategy used in computer programming that involves analyzing data and processes so that they may be specified by their most generalized components. The objective of data abstraction and procedural abstraction is to create components that can be reused in the widest possible range of cases while still maximizing the efficiency of the individual case. A **database** is an example of **data** (or information) abstraction. A set of rules for alphabetizing any list in any language is an example of **procedural** abstraction. Abstraction is sometimes described as "hiding" the extraneous, more specific information.

Abstraction Layers Nested layers of increasingly complex symbolic code. For examples, **ASCII** code is an abstraction layer that represents letters in the form of 0s and 1s; it rests on top of the lower layer of abstraction that represents electrical charges as 0s and 1s, and it supports higher levels of abstraction that represent words and programming instructions using ASCII letters. Establishing appropriate abstraction layers in a system is strategy for the design of complex systems. See also **Abstraction, Encapsulation, Modularity.**

Accessibility Affording access to people with special needs. Accessibility design guidelines provide direction for designers on ways to compensate for limitations in sight, hearing, mobility, and other abilities with the goal of making information and participation available to as many people as possible. Digital affordances support wider access by allowing us to provide multiple instantiations of the same item, and multiple ways of communication, for example, through both written text and speech for web pages and virtual communities. (For information on web accessibility standards see <http://www.webaim.org>.)

Accompaniment Used here to describe the pleasurable feeling that a digital artifact has been designed to anticipate and serve an interactor's needs, creating a sense of a partner intelligence, similar to Sherry Turkle's notion of a the computer as a "second self" (Turkle 1984).

Active Creation of Belief The experience of trying out actions in a interactive environment such as a game world, and finding that things act in accordance with your expectations, reinforcing your belief in the virtual world (Murray 1997). See also **Agency, Interactivity, Immersion.**

Affordance A concept used in the field of **human–computer interaction (HCI)** to describe the functional properties of objects or environments—the properties that allow particular uses. For example, a blackboard affords writing and erasing; a low, flat, supported surface thirty inches

square affords sitting. The term "affordances" was first used by James J. Gibson in "A Theory of Affordances" (1977) to mean the "action possibilities" of a material object in relationship to a potential user, and was adopted by Donald Norman (1989) in *The Design of Everyday Things* in which it is defined as "the perceived and actual properties of the thing, primarily those fundamental properties that determine just how the thing could possibly be used." In the context of this book—as in chapter 3 of *Hamlet on the Holodeck* (Murray 1997)—the **digital medium** itself is taken to have four affordances or properties that are useful for **representation**: the **procedural, participatory, encyclopedic**, and **spatial affordances**. In addition, individual platforms have affordances: for example, mobile platforms afford location-specific information services.

Affordance Grid As presented in chapter 3, an aid for analyzing and designing digital **artifacts**, by visualizing the design space as composed of opportunities to maximize each of the four characteristic properties of the digital medium: the **procedural, participatory, encyclopedic**, and **spatial** affordances.

Agency In this book, as in chapter 4 of *Hamlet on the Holodeck* (Murray 1997), agency is defined as an aesthetic pleasure characteristic of digital environments, which results from the well-formed exploitation of the procedural and participatory properties. When the behavior of the computer is coherent and the results of participation are clear and well motivated, the interactor experiences the pleasure of agency, of making something happen in a dynamically responsive world. The term "agency" is meant as a corrective to the inexact use of "interactive" as both a descriptive and an evaluative term. See **Dramatic Agency**.

Agent In computer science, an agent is a piece of computer code that can make decisions and initiate behaviors autonomously (rather than as a centrally controlled subroutine) within a larger computational environment. An agent has goals and preferences and often acts like a human agent, (e.g., a real estate agent, a talent agent) in seeking information or negotiating exchanges on behalf of an actual person.

A-life (Artificial Life) In computer science, the name given to programming code that, on execution, mimics life forms in some way, such as becoming self-replicating, displaying genetic mutation, or simulating a biological ecology. The classic example of A-life is John Conway's Game of Life (Gardner 1970).

Algorithm A well-defined set of rules for accomplishing a calculation, search, or other objective of a programming environment. Software engineering involves the use of established algorithms and the development of new ones for more efficient processing of information. Algorithms are abstract methods, separate from the specific computer code in which they are written.

Alternate Reality Games Games that take place on multiple real-world and digital platforms and simulate events happening in the real world, often involving conspiracy plots, puzzles, and codes that are unraveled by groups of players in loose confederations or organized teams. See also **Pervasive Games**.

Analog Analog forms of representation record information in a continuous stream with analogous qualities to the recorded phenomena. For example, the chemicals in photographic

film vary continuously in direct proportion to the light emitted. Analog representation is often differentiated from **digital** representation, which relies on discrete samples, such as pixels on a screen.

Applet A small application that runs on a mobile platform or other specialized device and usually has highly focused functionality, such as a single game, an email program, or weather update. See also **Widget.**

Appliance Model An approach to the design of digital artifacts as networked versions of old appliances (such as a home heating system hooked up to the Internet) or in specialized new "information appliances" (such as a dedicated music player). The appliance model reflects a view of computers, articulated in Donald Norman's *The Invisible Computer,* as invisibly embedded inside other limited-use objects (Norman 1998).

Artifact Used here to mean any material entity created by a human being on purpose and with some degree of expertise for the purposes of representation, such as letters carved in stone, a paper shopping list, a portrait done in oils or by photography, a film, an interactive website. **Digital artifact** is the broadest term for anything made of bits and processors, such as a website, a virtual reality environment, a wireless network, a mobile phone, the Internet as a whole, and so on.

Artificial Intelligence (AI) A specialized field of computer science that attempts to model the processing of the human brain or imitate higher-level reasoning in computer code. Also used for characters within games that act as autonomous agents and make decisions based on their situated experience.

ASCII American Standard Code for Information Interchange, pronounced "ask-key," associates a binary code (using only 0s or 1s) with each letter of the alphabet so alphabetically encoded information (everything written in letters and words) can be inscribed in computer bits and transmitted across digital networks. First devised in the 1960s.

Asynchronous Not synchronous, that is, not happening at the same time. Asynchronous discussions and collaborations are a characteristic feature of digital communication, because designers have invented conventions such as email, blog threads, and Facebook wall posts that allow contributions to be made to a subject of shared focus by people in different locations who are participating at different times.

Attribute A quality of an abstract entity expressed as a generalized category (e.g., "color" is an attribute of flowers). Attributes have **values** that vary with particular **instances** of the abstract entity they describe (e.g., the color "red" of a particular flower). Such attribute/value pairs can take the form of fields in a database or metadata tags or **variables** attached to **objects** in computer programs.

Avatar Derived from the Hindu concept of a god embodied in different beings. A digital avatar is a character within a virtual world who represents the interactor or player. Avatars can be specified by gender, appearance, affiliation, personality, and skills using avatar-builder programs that allow the user to pick and choose from a **substitution system** of attributes or to assign points in

a **resource allocation system**. In fictional role-playing games avatars often belong to fanciful "races" like elf, vampire, or Klingon.

Binary Having two possible values, as bits in a computer have values that we interpret symbolically as either 0 or 1. Everything that is represented in the digital medium, including the commands it executes, the values it calculates, and the information it stores, is represented within the machine as a group of binary bits, a collection of 0s and 1s.

Bit A single unit of electrically charged material within a computer. A bit (originally an abbreviation for binary digit) can be in one of two states, symbolically represented as 0 or 1. Bits are arranged in groups of eight known as **bytes**.

Bitmap A computer system's internal representation of an image as an array of pixels in which one or more **bits** represent each pixel. Familiar graphics formats like JPEG are compressed bitmaps. Bitmapped graphics are often differentiated from **vector graphics**, which are stored as a set of instructions for redrawing the image.

Black Box A convention for describing a process that is a component of a **modular** software system without specifying how the process works, but indicating what its **inputs** and **outputs** are. See also **Encapsulation**.

Boundary Object Any classification system or standardized form or other cultural convention used by multiple distinct communities that would otherwise be separated by conflicting understandings of a shared domain. Defined by Bowker and Star (1999) as "those objects that both inhabit several communities of practice *and* satisfy the information requirements of each of them" (16). For example, a system for classifying the work of nurses may bridge the very different understanding of patient care held by the nursing community of practice and that of the hospital accountants.

Branching Tree A common metaphor for the spatial representation of a computer program in which alternate sequences of action diverge (branch off) from common decision points.

Byte A group of eight **bits**, or the smallest unit of computer memory that can represent a single letter of information.

Categorization Placing items in categories based on common elements. Differs from **classification** in that categories may or may not be well ordered.

Cell In a spreadsheet or **database table**, the intersection of a single **record** and a single **field** makes one cell, into which a **value** can be entered.

Channel Derived from the analogy of the channel of a river, a path through which **information** flows. Channels are used in three related but different ways: 1. In **information theory,** the channels can be analyzed for the relationship of **signal** (coherent, intentionally transmitted, meaningful information) to **noise** (meaningless interference, like static in a radio broadcast). 2. Cognitive scientists often speak of perceptual channels such as vision, hearing, and touch. 3. In common experience, channels are a feature of legacy radio and television transmission—separately administered sources of similar information, often associated with entertainment networks (e.g., NBC,

PBS, BBC) that provide the primary means for choosing an information source (tuning to a channel). Each of these uses can be fruitful as a reference point for digital design, but it is important not to confuse them.

Chunk, Chunking A segment of information. According to cognitive scientists, we remember information best when it is organized into chunks, aggregating many smaller units into fewer larger ones (Miller 1956). Chunking—separating information into memorable larger units—is therefore an individual cognitive strategy and also a strategy for the design of complex artifacts and large information resources. See **Semantic Unit.**

Class, Classes A data abstraction in **object-oriented programming** for specifying sets of **objects** that share common structures, in the form of attributes and processes (**methods**). Members of a class are **instances** of the underlying pattern. Members of a class can differ from one another because the attributes and processes can be described as containing **variables** and **parameters**. For example, one might define a class of monsters and give them the general attribute of height, a variable that can have a specified range of values, and a general method of finding food that can have parameters to specify what kind of food a particular monster prefers and how it goes about harvesting or hunting it. Classes can be nested within one another with child classes inheriting properties from parent classes. For example, a water-monster class could **inherit** size attributes and eating habit methods from the parent monster class, and then add its own attributes and methods, like fins and swimming, appropriate to the water.

Classification A classification (or classification scheme) is an ordered system of classes that attempts to account for all the items within the larger domain, and to differentiate them unambiguously, based on their most important attributes and relationships. Classification schemes often include hierarchies. Examples: the biological classification taxonomy (domain, kingdom, phylum, class, order, genus, species) for living things, the Library of Congress Classification (LCC) system for books.

Cloud Computing The location of an individual user's documents, media files, and software applications on a server accessible over a network and available in multiple locations and on multiple devices (and therefore imagined to be in a ubiquitous but nonmaterial cloud) rather than in a single location or on a single-person desktop or laptop machine. The user's access to the data and software is through an account with the company hosting it.

Code A set of symbols—socially fixed patterns—that are associated with experiential phenomena or with another set of symbols, or both. Visual alphabets encode spoken language; Braille and Morse code represent visual alphabets; computer languages represent instructions that make sense to humans (e.g., "calculate paycheck") in symbols that make sense to computers (0s and 1s). Correspondences between codes, such as the equivalence of a set of dots and dashes to a particular set of letters, can be specified without ambiguity; but the relationship of symbolic codes to the realm of human experience, such as the meaning of words or gestures, is ambiguous, indeterminate, and a matter of interpretation. See also **Semiotics.**

Codex A manuscript divided into pages and bound together like a modern book, as differentiated from a scroll (plural: codices).

Collocate, Collocation Collocation is the principle in information science of locating like things together, such as books by the same author collocated on the same shelf, or papers about the same topic collocated in the same file folder. Pronounced "co-locate."

Companion Model One of the four models of interaction discussed in part V. Digital artifacts serve as companions to human interactors because we think of anything animated as a social actor (Reeves and Nass 1996), because we can give it behaviors that emulate human actions (such as playing a musical instrument), and because we can engage in imitation games with it, with the computer echoing human actions (as in control of an avatar with a joystick) or with the human imitating the computer (as in dancing and musical performance games). Design goals for the computer as companion include synchronization, politeness, and conversational responsiveness. See also **Game Model**, **Machine Model**, and **Tool Model**.

Complexity The representation of complexity is an important goal of computation. Computer systems are symbolic representations of processes and entities, and they become more powerful by standardizing components and combining them into larger units. Complexity is built up in computer programming systems through **Modularity, Encapsulation,** and nested **Abstraction Layers**.

Computer A computer is an object or set of objects that changes state in a perceivable way in response to a new set of stimuli, and in accordance with a previously inscribed set of conditional instructions. We currently implement this machine using electronic circuits, but it could conceivably be implemented in other materials. It is not the bits that make a computer, but the behavior—the ability to execute a variable process described in symbolic code.

Conditional Statement In computer programming, an instruction that has multiple outcomes based on the state of a variable. The simplest and most common conditional instruction is in the form: IF X is true, THEN do this, ELSE do something-else. Conditional statements can also specify multiple responses for multiple conditions, or prescribe conditions for continuing or exiting from a repeated sequence of actions. See also **Loop**.

Connotative The implied, associated meaning of a **semiotic** symbol, as distinguished from the **denotative** and **ideological** meaning. For example, an American flag may officially denote the nation known as the United States of America, but it may have additional connotations of military service when it appears on an elderly man's lapel pin; or of celebration of community when carried by child on the Fourth of July.

Constraint The constraints on a design project are limitations of any kind, such as time, money, human resources, computational power, bandwidth, and skill. Specific client needs, such as branding or institutional values, can also constrain the range of acceptable design solutions. Platforms of implementation are an important source of constraint. For example, a web project might be constrained in color palette, privacy rights, download time; a mobile application might be constrained by screen size, video formats, attention time. See also **Affordance**.

Container A common concept in computing, referring to a unit that holds **information** and has its own name and location. All information systems from ancient baskets and jugs to terabyte hard drives have the concept of a container. Containers usually have **labels** and nest inside one

another, like **fields** in a record and **records** in a **database** or files in folders that are enclosed in other folders.

Contextual Menu A specialized menu that appears on demand and only when needed, usually in association with a particular object, such as an object in a virtual world or a file in an operating system. Contextual menus have limited options and appear in physical proximity to the object they control. They are usually called up by selecting the object or pressing a control key, or both. Also called pop-up menus.

Controlled Vocabulary A set of descriptors used in a standardized and consistent manner to ensure precision of reference and retrieval, for example, street names within a single city, subject categories within the Library of Congress Classification (LCC) system, and the Getty Thesaurus of Art and Architecture. See also **Folksonomy, Namespace, Nomenclature.**

Conventions Social practices and communication formats shared by members of a **culture** or subculture, as well as media formats shared by **artifacts** within the same **genre.** Conventions routinize and ritualize repeated interactions, providing a familiar way of addressing novel situations or receiving novel information—for example, shaking hands, printing newspaper headlines in larger type, or displaying hyperlinked text on a web page in a different color. Conventions become **transparent** from familiarity, allowing us to focus on the new information—the particular person we are greeting with a handshake, today's headlined news, or the destination the linked word is pointing to. Conventions are most often recognized when they are violated in some way, making us aware of our routine expectations, as when someone refuses to shake hands or a boldfaced word on a web page is not clickable.

Convergence In digital media, convergence means the intersection of genres that were formerly separated by incompatible means of inscription and transmission, such as television and print journalism. Discussions of convergence often focus on the commercial institutions and revenue models that are disrupted by the movement from analog to digital delivery systems, on the erosion of familiar conventions, and on the increased participation of the mass audience as active content producers. See Jenkins 2006.

Culture Human culture is a system of shared meaning resting on the singularly human practice of symbolic communication. Culture encompasses all the complex socially transmitted practices, **rituals, codes**, and beliefs shared by the members of a society, including all the media **formats, genres**, and **conventions** by which **shared attention** is focused and meaning is expressed. Cultural meaning is not fixed, but always a matter of interpretation (Geertz 1973, 89). See also **Discourse Community.**

Data Any collection of symbolic units, often quantitative, collected or presented for the purpose of analysis. Data become most useful when structured by **semantic segmentation** into labeled units. Data are sometimes differentiated from **procedures** (in programming language) and from **information** (in information science.) Procedures take data as an input, perform operations on data, and may also output data in the form of lists or tables. In information science, data are seen as a raw representation of facts or perceptions while information is more meaningful than data because it includes interpretation.

Database An information structure composed of identically structured **records,** which can be created, modified, and accessed individually, such as an electronic address book. Each record of a database contains segments called **fields.** The set of all records sharing the same field structure is called a **table.** Databases structured as a single table are called **flat file databases;** those with multiple interlocking tables are **relational databases.**

Decision Space The complete set of possibilities available when making a decision.

Denotative The literal level of meaning, the thing most explicitly invoked by a **semiotic** symbol, like the name of a person, place, or thing, as opposed to the **connotative** and **ideological** levels of meaning.

Descriptor An indexing term that describes a media object of some kind and allows it to be accessed, such as the name of an item in a catalog, a search term attached as metadata to a video clip, or a bar code printed on a piece of merchandise. See also **Metadata, Structured Document, Tags.**

Design The process of intentionally shaping a specific **artifact** or process by choosing among alternate strategies in order to achieve explicit goals. Design is shaped by the specific **constraints** and **affordances** of the available resources and by the explicit and implicit needs, desires, and taste preferences of the **user** group.

Digital The adjective used to identify artifacts and processes composed of and performed by computers based on electronic **bits.** The word "digital" is derived from digit (fingers), and it means divided into discrete, that is, separate, parts, like the fingers of a hand. Digital representation is often differentiated from **analog** representation, which records information as a directly varying continuous stream rather than as discretely sampled points. For example, the magnetism of predigital audiotape directly varied analogously with (in the same proportions as) the sound waves continuously captured by the microphone. A digital recorder would set individual bits to 0 or 1 at discrete microsecond intervals.

Digital Medium The **medium** that rests on the **inscription, transmission,** and **representation** of information by electronic **bits,** using the **procedural, participatory, spatial,** and **encyclopedic affordances** of computation.

Direct Manipulation An interface design strategy in which the user is able to affect an object that is either directly present on the screen (such as text in a word processor) or represented through a visual depiction (such as an iconized file folder), with a direct physical action without having to communicate through a mediating command line or menu. For example, clicking and dragging the icon of a file from one iconized folder to another is direct manipulation. The phrase was coined by pioneering **HCI** researcher Ben Shneiderman (1992).

Disambiguate To resolve ambiguity by assigning a single meaning where there are multiple possible meanings. For example, if there are three authors with the same name, disambiguation results when a librarian or encyclopedia editor or database creator provides a separate listing with a unique identifier for each.

Distributed Cognition A theory of cognition that holds that knowledge and understanding are distributed between our minds and our material artifacts and between an individual mind and larger groups of individuals. For example, our limited individual memory can be augmented by referring to notes on a blackboard, scanning the titles of books on a shelf, or consulting Google or Wikipedia. Bees in a hive have distributed cognition of where to find nectar and how to make honey, with no single bee knowing the whole process. Media conventions are part of our human system of distributed cognition, making the knowledge of many available to the individual, and shaping our behaviors into coordinated rituals with limited individual coaching.

Discourse Community A group of people who communicate in shared genres (such as scientific articles, political blog posts, teenagers' instant messages). Discourse communities understand one another in part because of their mastery of the media conventions specific to their genres: Teen- agers recognize abbreviations and slang, and the appropriate range of responses to a novel but familiar situation, such as a fashion mistake or a sports defeat; scientists recognize specialized vocabularies, and the familiar conventions by which a new experimental finding is presented. The term was coined by sociolinguist Martin Nystrand (1982). The related term "interpretive communities" was coined by literary critic Stanley Fish (1980), as part of an argument that liter- ary texts are only meaningful in the context of the cultural assumptions of specific groups of readers.

Distributed Creation of Resources The practice of creating a networked resource, such as a Wikipedia page or a set of tagged photographs, by coordinating the contributions of creators located in different places and working independently through the use of a common framework.

Distributed Cognition A concept in cognitive science that describes the process of knowing things as a collective enterprise, encoded in the built environment, in shared **rituals**, in other minds, and in media objects. For example, we find our way around an unfamiliar city by way of maps and signage and by following other people, building on a limited amount of first-hand individual knowledge of the environment. The design of interactive systems, like the design of physical tools or printed diagrams, is a contribution to the distributed intelligence resources of a society.

Document A media object such as a text, image, or animation. **Structured documents** are divided into meaningful segments using **metadata tags** such as <heading> or <table of contents>.

DOI Digital object identifier. A standard for assigning a unique numerical identifier to any digital representation for the purpose of naming it with bibliographic precision and accessing it consistently though its **URL** may change. DOIs can refer to fixed information, like an article in a digital library, or to a container for changing elements, such as an official membership list.

Dramatic Agency The experience of **agency** within a **procedural** and **participatory** environment that makes use of compelling story elements, such as an adventure game or an interactive nar- rative. To create dramatic agency the designer must create transparent interaction conventions

(like clicking on the image of a garment to put it on the player's avatar) and map them onto actions that suggest rich story possibilities (like donning a magic cloak and suddenly becoming invisible) within clear stories with dramatically focused episodes (such as, an opportunity to spy on enemy conspirators in a fantasy role-playing game).

Element An **entity** created with **metadata tags** that functions as a **primitive** component or building block of **structured documents**. For example, an **XML schema** that defines a particular kind of document, such as a catalog listing, is composed of elements, such as author and title. Elements can form hierarchies and can be associated with **attributes.**

Emergent Behavior Describes a phenomenon characteristic of complex systems where unforeseen or unforeseeable behaviors arise as the result of the individual actions of multiple agents. Emergent behaviors are sometimes **self-organizing.** For example, flocking is an emergent behavior of geese, resulting from each goose locating itself with reference to its immediate neighbors but no goose having a goal of creating the emergent chevron shape of the group. Computational systems can exhibit similar emergent behavior, such as **A-life** systems. Also used for the unexpected behavior of human beings in virtual environments, such as the use of quest-related game spaces as virtual picnic grounds.

Encapsulation An abstraction strategy used in computer programming in which **chunks** or **modules** of processing code are embedded in larger systems without having to list all the components of the module. For example, the Print module is encapsulated within the Print command that appears on the File menu of an application. The programmers who write the word processor or the photo editor applications only have to know how to take the user's input and passing it to the encapsulated Print module as a set of **parameters** (such as name of the file, size of the paper, margin size, type and location of printer). The commands that go to the printer are hidden from the application programmers, encapsulated within the single Print command. Encapsulation is therefore a crucial strategy of modular programming and a means of building up **abstraction layers** to create a complex system.

Encyclopedic Affordance With the **procedural**, **participatory**, and **spatial** properties, one of the four defining representational **affordances** of the **digital medium**. The digital medium is encyclopedic in three ways: its capacity—the vast number of bits of information it can contain; its extensive range of legacy and computational media **formats** and **genres**, including text, moving images, photographs, drawings, animations, musical recordings, audio recordings, live image and sound, three-dimensional models, databases, search engines, and video games; and its ability to represent any process through logical symbolic representation, including **simulations** of highly complex systems. When the encyclopedic affordance is appropriately exploited, large information resources are **semantically segmented** at multiple levels of **granularity,** sorted, **classified,** and labeled with **controlled vocabularies.** When informational spaces or virtual worlds are well organized with clear boundaries, consistent navigation, and encyclopedic details that reward exploration they create the experience of **immersion.**

Entity Any abstract item in a computer program that can be given a unique name. Entities often have **attributes.**

Expression In its simplest sense, expression is the effective communication of ideas or feelings by any means. All media of communication are used for expressive purposes and **digital media** have many potential modes of expression, including the verbal, visual, auditory, and tactile. Expression is a different goal from usefulness, the goal of products of engineering, which are expected to function instrumentally, as tools for accomplishing a task. But highly useful devices can also function as expressive media, reflecting and reinforcing status relationships and other cultural values. For example, an airplane cockpit can be seen as primarily a set of tools (an "instrument panel") for accomplishing the task of flying an airplane, but its design is also an expression of the social hierarchy of pilot, copilot, cabin crew, and passengers. The same object can be expressive of quantitative scientific data and of more ambiguous qualitative values like social relationships. The design of utilitarian digital devices and the creation of digital works of art and the design of everything in between are all part of the collective effort of expanding the expressive power of the emerging digital medium. An expressive **tool** allows the user an appropriate degree of choice, inflection, and individual adjustment, supporting the development of expertise, craftsmanship, and technique.

Extensible, Extensibility An important design value, extensibility is the capacity to add additional functionality or capacity to a finished artifact, such as additional memory added to extension slots in a camera or additional templates added into an extensible folder of a word processor. In programming, extensibility refers to the ability to add new constructs to a language, so the Extensible Markup Language or **XML** is a framework for elaborating new tagging structures, independent of its predecessor the **HyperText Markup Language (HTML)**.

Facet One of several sets of search terms associated with the same item, allowing for search or filtering by multiple attributes or by multiple independent classification systems.

FAQs Stands for "Frequently Asked Questions," a useful feature of websites and other communications of organizations.

Feedback, Feedback Loop In interface design, feedback refers to the signal the machine returns to the user as the result of a user action. Ben Shneiderman's Eight Golden Rules of Interface Design include "Provide Informative Feedback" for every user action, with the most significant feedback for "infrequent, major actions" (Shneiderman 1992). Feedback can be visual (highlighting a selected object), auditory (the clicking sound of a mouse button), haptic (the vibration of a game controller), or verbal ("Windows is shutting down").

In systems theory, feedback is the system mechanism that signals an effect of an action, and sometimes results in a change to the system. The classic example is the change in temperature that provides feedback to a thermostat in a feedback loop that causes the air conditioner or heater to switch off when the desired temperature is reached, and to switch back on when it gets too hot or too cold.

Field In a **database**, a field is a segment of a **record** with a fixed length and data type that corresponds to a single **semantic unit**, like a name, address, or social security number.

Filter One of the essential functions for interaction with large data resources, Filtering is done by changing the **value** of one or more **attributes** or data **fields** in a search query or

parameterized display in order to remove items from a larger set. If I am searching for movies made by Humphrey Bogart in the American Film Institute online database, I might filter them to include only those made between 1940 and 1955, or only the ones that Lauren Bacall was also in, or only those with both attributes.

Flow The experience of pleasurable absorption in a task that is neither too easy nor too challenging, identified by Mihály Csíkszentmihályi. Flow is characterized by clear goals, a sense of control, concentration on an intrinsically pleasurable activity, loss of self-consciousness, and a distorted consciousness of time (Csíkszentmihályi 1990).

Flow Chart A diagram made up of boxes and arrows used to describe a computer program or other branching process that makes clear the individual actions and decision points leading to divergent outcomes. Flow charts can be used for the computer's processing, the interactor's decision path, or for decision trees that describe conditionalized abstract processes of any kind, such as the question and answer script for a telephone help system.

Folksonomy A set of descriptor **metadata tags** that are created by mass participation without editorial control, Folksonomies are created in shared web resources such a web-based photo archive. They are often shown in overview as **tag clouds**. See also **Controlled Vocabulary**, **Taxonomy.**

Format A standardized aggregation of technical and social **conventions** governing the **inscription** and **transmission** of symbolic patterns so that they form recognizable **media artifacts**. Formats serve as containers for the creation, transmission, and reception of meaning. Examples of formats: the URL protocols and HTML code that shape web pages; the paper sizes and column arrangements that shape newspapers.

Formative Evaluation Testing that takes place while an interactive project is in development, with collection of results to influence **iterative design** decisions. Testing done to assess the value of the completed product or project is *summative evaluation.*

Frame In cognitive science, computer programming, and interaction design, this term refers to a structure, framework, or **schema** that provides a controlling pattern into which formulaic elements can be fitted. A frame can shape interactions between people (e.g., ordering a meal in a restaurant) or the processing of information in a media artifact (a political news story). Culturally familiar frames allow us to assimilate new events and perceptions into established patterns, sparing us confusion and misunderstanding. When two interactors, or the creator and receiver of a message, do not share the same frame as a context for decoding a message, they may understand each individual sign but still fail to communicate. For example, a host may rise and a guest may not understand that this is the signal to take one's leave. Larger cultural frames, such as **ideologies**, allow us to interpret complex new events within familiar contexts. Framing a problem is a crucial step in any design process, and often involves **reframing** from the original presentation to a broader perspective. See also **Culture**, **Genres.**

Function A small **procedure** that is usually part of a larger software system. A function and its **inputs** are specified in abstract form, and inputs are passed to the function as the **parameters**

when it is called (i.e., when it gets the signal to execute its instructions) by another part of the system. So a function named ADD that is specified in the code like this:

```
ADD (numberone, numbertwo) [how to call the function]

Sum = numberone + numbertwo [what the function does]
```

might be called with specific numerical values in a statement like this

```
ADD (3,44)
```

It would then execute the following:

```
Sum = (3+44) = 47
```

The function ADD would receive the numbers 3 and 44 as **input** and return the **value** 47 as **output.** Functions can also handle nonquantitative symbolic processes. See also **Method, Procedure.**

Functional Specification A document created at the beginning of the design process for a computational artifact indicating what the final product is expected to do. Designers should be careful to question a client's specifications in order to identify the core underlying requirements and to avoid reproducing inefficient legacy processes. In the ideal design process the creation of the functional specification document will be a collaborative activity, with strong user participation, and will provide the opportunity to collectively rethink the larger context of interaction in the light of the **affordances** of the **digital medium**. See also **Wireframes.**

Game One of the oldest cultural forms, a structured form of **play,** in which human beings direct **joint attention** to symbolic media (like playing cards or game boards), often within a **magic circle** that shuts out real-world concerns. Games rest on the pleasure that comes from synchronized behavior and a mutual awareness of shared attention (Murray 2003). Games are often structured as contests or puzzles (Murray 2006) but can best be thought of as system of behavior that involves game **mechanics,** rules, and often has winning conditions (Salen and Zimmerman 2003).

Game Mechanics The rule-based, abstract processes and rituals by which games are structured, often involving symbolic game elements, movement around a game space, possession of tokens within the game, turn taking, and score. For example, rolling dice to move around a game board is a mechanic in many games; jumping over obstacles is a mechanic in platform games. Mechanics can be thought of as composed of physical and logical components: one can change the dice to a spinner in the board game or change the input device from a game controller to a keyboard in the platform game while retaining the logical structure of the underlying mechanics. Mechanics can also map symbols to the actions they represent, such as identifying a roll of the dice in Dungeons & Dragons with the performance of a spell in the game world.

Game Model One of the four models of human–computer **interactivity** discussed in part V. Games are an ancient genre of **representation** that focuses our playful **shared attention** on synchronized, pleasurable rule-based systems of interaction. Digital **artifacts** elicit playful behavior and shape interaction into similarly rule-based systems of shared attention that resemble games.

Design goals for the computer as game include convening synchronized participants through shared rituals and encouraging kaleidoscopic playfulness.

Game Theory A field of study in mathematics concerned with calculating outcomes of game-like situations that has been applied to the study of strategic decision making in social science, political science, and economics. Game theory produces **simulations** that are usually based on the assumption that human beings are rational actors trying to maximize their advantages in unpredictable situations.

Genre A term of categorization within literary and communication studies, referring to representational artifacts that are characterized by similar **conventions** and formulas. Genres can have subgenres (e.g., the novel and the detective novel) and can be media-specific within a single medium such as print (news article, feature article), film (buddy movie, gross-out teen movie), television (sitcom, hospital show). Genres also exist across media (detective story, exposé, romance, allegory, tragedy). "Genre fiction" is a term that refers to stories that have more exaggerated genre formulas such as horror films, medieval fantasies, murder mysteries, science fiction. Genres serve as cultural **frames** and cognitive **schemas** for understanding a new media artifact as a member of a familiar group with predictable conventions. The advantage of writing or designing within recognizable genres is that the audience can form expectations of what is likely to happen based upon familiarity with the conventions. Interactive role-playing games are often based on genre fiction conventions, starting with the popular Dungeons & Dragons games based loosely on Tolkien's fiction. Digital genres and subgenres include: video game, first-person shooter game, simulation game; website, university web page, newspaper site, political blog, online store. See also **Conventions.**

Gentle Slope System The term refers to the slope of the learning curve, which takes the learner from novice to expert. If it is too steep then learners become discouraged. A gentle slope system introduces new material in small increments.

GIGO "Garbage in, garbage out," a proverbial expression in computer programming, a corrective to the false authority often attributed to computer-generated information, and a reminder that you cannot make reliable calculations on the basis of false or sloppy input data.

Global Variable A global variable in a computer software system is accessible to every module in the system, as opposed to a local variable that is only seen and acted upon by a single module.

Granularity The size of a chunk of information within a larger unit. Information can be either **coarse-grained** or **fine-grained,** composed of larger or smaller chunks. The smaller the chunks the more detail we understand and the greater the degree of precision with which we can reference the resource. For example, if we refer to books by page numbers we are doing it at a finer granularity than if we just refer to the author, title, and date of publication. **Semantic segmentation** of a resource often results in useful chunking at multiple degrees of granularity. For example, a film can be usefully divided by single frame, line of dialog, continuous shot, or dramatic scene, or (less logically) DVD "chapter."

Grid A form of visual organization of intersecting horizontal and vertical lines based on the **table**, one of the earliest forms of information design.

Grinding A pejorative term for boring, repetitive gameplay that is necessary for the achievement of a **game** goal. Building a character in an online role-playing game often requires hours of grinding to increase skill levels.

GUI Graphical user interface, a combination of computer display and input devices that provides the **interactor** with an abstract or concrete representation of the system as the basis of interaction with the machine: for example, the familiar **WIMP** desktop environment.

Haptic Referring to touch, and to the interface devices that address the sense of touch through pressure and vibration.

Harmony One of the goals of visual design. Harmony is achieved by balancing visual elements across the vertical and horizontal axes of the image. For example, a square-shaped object on the upper right may be balanced by a square-shaped object on the lower left. The more harmonious the elements the less obtrusive each individual element will be, allowing the viewer to explore them evenly, as we do the letterforms on the page because of the harmonious balance at the root of book design (Dondis 1973).

HCI See **human–computer interaction**.

Heuristic A generally reliable but imprecise procedure for accomplishing a task, such as using the proverbial "rule of thumb" instead of a precisely calibrated ruler for making approximate, but good-enough measurements.

Hexadecimal A counting system using base 16 instead of base 10 (like our conventional numerals) or base 2 (like the 0s and 1s of computer code). The 16 integers of the system are represented by the symbols:

```
0 1 2 3 4 5 6 7 8 9 A B C D E F
```

Hexadecimal functions as a kind of shorthand for binary representations, allowing humans to read it more easily and using only two digits to represent eight binary bits.

For example the hexadecimal **code** for the color violet is

```
CC33FF
```

representing the more cumbersome **binary** code:

```
1100 1100 0010 0010 1111 1111
```

Hierarchy A system of organization in which some elements are subsumed by others within a multitier structure, for example a computer file system in which files are contained in folders and folders are nested one inside the other; a library **classification** system of categories and subcategories; or the chain of command of a military organization from commander to generals to privates. In creating a hierarchical organization it is important that items at the same level of the hierarchy be appropriately similar to one another.

Human–Computer Interaction Human–computer interaction (HCI), the field that applies empirical methods to the design and evaluation of computer-based artifacts, drawing on multiple

disciplines. The major professional organization for researchers in the field is CHI, a special inter-est group of the Association for Computing Machinery (ACM): <http://www.sigchi.org>.

HyperText Markup Language (HTML) HyperText Markup Language, invented by Tim Berners-Lee as the basis for the World Wide Web, and made public in 1991. It is based on the international standard SGML (Standardized Generalized Markup Language), which was originally developed for the representation of print documents in electronic form. HTML created a notation for **hypertext** that has become the global standard, and provided the basis for the standardized linking and display of documents independent of the platform, operating system, and applica-tion in which they were created. See also **XML**.

Hypertext Electronic text that contains hyperlinks—words or images that when clicked on lead to other documents or parts of documents. Hypermedia is a collection of hyperlinked media objects that includes other media formats, usually temporal formats such as audio or moving images in addition to text and still images. Ted Nelson is credited with coining the word "hyper-text" in the 1960s and has expressed disappointment with the structure of the World Wide Web, which he considers inferior to his proposed architecture that included, among other things, two-way hyperlinks and **transclusion**. Nelson's vision of computer-based hypertext echoed Van-nevar Bush's call for a "memex" machine based on earlier microfilm technologies (Bush 1945; Nelson 1987).

Icon A visual **sign** in which an image is used to represent a digital object or action through its resemblance to a highly salient, characteristic, recognizable aspect of the thing it signifies. Since digital actions are often quite different from those in the physical world, icons often refer to analogous physical actions, such as using an image of a scissors to represent deletion of part of a document.

Ideology A set of ideas and beliefs, held consciously or unconsciously, and often associated with an ideal of social organization or with the program of a particular political faction or cultural tradition. Ideological assumptions provide an important interpretative **frame** in which meaning is transmitted or inferred, and it is often the controlling frame in which **denotative** and **connota-tive** meanings are assessed. For example, ideological beliefs about the nature and appropriate social role of women may shape the way in which female **avatars** are constructed in virtually worlds. Other areas of contested ideological assumptions include political systems; economic systems; stereotypes of nationality, gender, race, age, and occupation; sexual morality; religious doctrines; nationalism; pacifism; vegetarianism; secularism, and so on. There is no way to make completely neutral cultural choices, since we are all products of particular cultures and tolerance is itself an ideology. Nonetheless, designers have a responsibility to be mindful of the effects of ideological assumptions upon design choices, to be explicit about choices that are ideologically driven, and to avoid design choices that intentionally or inadvertently reinforce questionable beliefs and values.

Immersive, Immersion Immersion is an experience of the **interactor**, a sense of being contained within a space or state of mind that is separate from ordinary experience, more focused and absorbing, and requiring different assumptions and actions (like swimming when immersed in

water). Immersive experiences are disrupted by inconsistency and incompleteness of the environment, and reinforced by **encyclopedic** detail and a sense of vast spaces within clearly marked boundaries. Immersion is further reinforced in digital environments by the **active creation of belief,** by which the interactor is cued to explore and to take actions within the immersive world and is rewarded for the actions with appropriate responses. Immersion and **interactivity** are characteristic pleasures of digital environments. See also **Agency.**

Information Information is **data** that has been organized, contextualized, and interpreted.

Information Design The arrangement of information in any medium so that it is available for retrieval and optimized for understanding. Information *designers* and information *architects* create organizational structures to store, retrieve, and present information as clearly as possible, mastering complexity through the use of appropriate conventions of format and representation. In digital media the most common objects of information design are databases, archives, and media-rich websites.

Information Theory A branch of research and engineering practice at the intersection of electrical engineering and mathematics. Information theory is based on the **transmission model** of communication elaborated by Claude Shannon and Warren Weaver, which sees all exchanges of meaning between animals, people, and/or machines, as the transmission of a **message** from point A where the sender encodes it, through a **channel** that maximizes **signal** and minimizes **noise,** to point B where the signal is decoded by the receiver into the original message (Shannon and Weaver 1963).

Inherit, Inheritance In **object-oriented programming**, a **class,** or generalized description of an object, can inherit attributes and methods (processes) from a *parent* class of which it is a subcategory. For example, the class of toasters could inherit the attribute of electrical switches from the parent class of appliances.

Input The **data** that is fed into a computer-based **procedure**. See also **Output.**

Inscription Inscription is the intentional shaping of a receptive physical material with an appropriate technology so that it produces a perceptible result. Inscription requires an intentional agent, a markable material, an appropriate technology, and a perceptible result. Inscription, **transmission**, and **representation** are the three functions of a **medium**. See also **Convention, Format, Genre.**

Instance, Instantiation In computational systems, computer code describes entities as generalized cases that are realized in run-time as specific instances or instantiations. The word "instantiation" can also be sued to refer to the process of creating specific instances from abstract representations. Although one can speak of the instantiation of any generalized procedural object, such as a **vector graphic** or a video game, it is most often used in the context of **object-oriented programming**, where it refers to specific run-time versions of a general **class** of computational **objects**. Instantiation is an important representational strategy characteristic of the **digital medium**, derived from its **procedural** and **encyclopedic affordances**. See also **Abstraction.**

Intellectual Access A goal of informational systems: to provide access to material held in a collection based on the meaning of the content. For example, finding a book through the subject catalog provides intellectual access, whereas finding it by its ISBN does not.

Interaction An instance of related behavior between two entities that are acting upon one another, usually through a common medium or some shared or transferred artifact; for example: a spoken conversation, a telephone call, a purchase in a store, a street fight. The parties to an interaction can be living things (like human beings or plants in pond ecology) or mechanical devices (like vending machines or computers) or dynamic elements in a complex **emergent** social system such as mortgage rates, bank capital, and regulation constraints within the global economy. In digital media, human actions and computer responses are shaped into discrete interactions, which, if well formed, elicit the experience of **agency** in the **interactor**. Digital environments can also represent complex systems of interaction in **simulations**.

Interactive, Interactivity A design term that is often used too loosely, and is sometimes confused with mere activity or potential actions. Composed of three separate entities: the **procedural** and **participatory** affordances of the **digital medium**, and the associated aesthetic pleasure of **agency** that results when the interactor is appropriately scripted to perform actions that the computer code can respond to appropriately. See also **Immersion.**

Interactor The human being who is interacting with a digital **artifact**. Preferable to "**user**" because the **artifact** is not necessarily a **tool.**

Interaction Design An emerging discipline that structures people's relationship to artifacts and systems, especially but not only those that make use of the **affordances** of the **digital medium**. Interaction designers emphasize the fit between human actions and system responses.

Interface Generally used to indicate the perceptible parts of a computer program that stand between the code and the user. A useful term, though misleading as the focus of digital design since **interaction design** is more inclusive and has supplanted it as a description of professional practice.

Intuitive An often-misused term applied as a design value for digital environments. A truly "intuitive interface" draws on **tacit knowledge** and well-established **conventions** to cue the behavior of the interactor to act appropriately in a new environment without explicit direction. For example, if we approach a mysterious new gizmo and it has a big red button in the middle of it, we will "intuitively" try to press it.

Internet The system of transmitting computer-coded electronic signals around the globe through a distributed network formed by connecting millions of smaller networks, using standardized **formats** and **protocols,** and composed of computers, electrical wires, fiber optic cables, and radio waves.

Iterative Design A necessity for interactive projects whose hidden user requirements, programming glitches, and interaction design flaws only become apparent as the design is realized as **use case, functional specification, mock-up, storyboard, prototype,** and working **modules**. Iterative design is dependent upon **formative evaluation** with users outside the development team,

whose supervised sessions provide feedback on what is working and what needs to be modified.

Joins In relational databases, the technical term for a table that unites fields from two other tables. Also the name of a database search command that seeks information from multiple tables.

Joint Attentional Scene Social interactions between a young baby and a caregiver in which they are both paying attention to the same thing and they are also both aware of their shared focus are called joint attentional scenes. Joint attention is a starting point for the acquisition of language (Donald 1991; Donald 2001; Tomasello 2001) and the foundation of all media design.

Label One of the building blocks of information organization, a form of **metadata** that identifies or describes the object that it is attached to. Labels are often associated with **containers**.

Legacy Media Media whose **conventions** and **formats** predate the digital revolution, such as print, television, still photography, telephony. The term derives from information architecture, which is frequently concerned with building new systems while making provision for the archiving and retrieval of existing data stored in older systems and formats, referred to as *legacy data*. Examples of legacy formats: vinyl record albums, paper-based books, half-hour television programs. Examples of legacy conventions: holiday music albums, page numbers in books, television commercial breaks. Designers should draw upon but not blindly reproduce legacy media formats and conventions in digital environments. Instead they should ask what purpose the conventions served in their original context, and if the underlying purpose is still valid (e.g., providing advertising revenue), they should determine how best to serve it using the **affordances** of digital media.

Lifeworld Used here to mean the messy world of culture and embodied experience that we inhabit in our daily lives, where meaning is ambiguous and shifting depending on the frame of reference, and where we understand one another through repeated acts of negotiation and empathy, mediated by symbolic representations like language and digital artifacts. The term was introduced by the philosopher Husserl and has a similar but more technical meaning in the field of phenomenology. Here it is contrasted to the order we seek in the neat categories of our classification systems.

Linear Having a single sequence from beginning to end, as in a straight line. Used to describe legacy media such as **books** and **films**, and sometimes used pejoratively of **unisequential** digital artifacts. **Hypertext** and experimental digital art is often described as **nonlinear**. It is problematic, however, to design for a negative quality, so nonlinear is not helpful as a design term. See also **Multiform** and **Multisequential**.

Link The building block of **hypertext**. The link came into most active use with the popularity of the World Wide Web in the late 1990s, but was explored earlier starting with the proposals and demonstrations of Douglas Engelbart, Alan Kay (at Xerox PARC), and Ted Nelson; the Movie Manual Project of the Architecture Machine Group (the precursor to MIT's Media Lab); Brown University's Hypermedia project; the University of Virginia's StorySpace Project later published by Eastgate Systems; Apple Computer's HyperCard; the independent commercial project Super-Card; IBM's Guide.

List One of the earliest forms of information organization, common to oral (memorized, recited) media and early writing. As writing developed, lists could be expanded and spatialized into **tables**. One of the signs of an immature **medium** or a disordered domain is a reliance on overlong lists, rather than tables and **hierarchies**.

Loop A foundational programming structure in which a set of instructions is executed repeatedly until an exit condition is met. Infinite loops—programming sequences that repeat forever, or until the process is terminated or the computer crashes—are a common cause of program failure.

Machine Model One of the four models of **interactivity** discussed in part V. A machine is any manufactured device that augments human effort, performing its automated task with minimal human intervention. Design goals for the computer as machine include maximizing human control, and making the hidden processing **visible** to the interactor. See also the **Companion Model**, **Game Model**, and **Tool Model** of interactivity.

Magic Circle An intermediate or liminal space (Turner 1966), isolated in space and in time, between the real world and the world of the imagination in which playful cultural experiences can take place, such a baseball stadium or a card table during a **game**, or a theatrical stage during a performance. The term was coined by Johan Huizinga in *Homo Ludens*, where he describes magic circles as "temporary worlds within the ordinary world dedicated to the performance of an act apart" (Huizinga 1938/1980, 10).

Markup Language A standardized annotation system for specialized documents. **HTML** is a **Hypertext Markup Language** that is used for defining the elements of web pages, using **tags** embedded within the document, like this

```
<h1>Markup for Level One Heading</h1>.
```

XML is a more abstract markup language that can be used for defining other markup languages.

Mechanics See **Game Mechanics**.

Medium, Media Any combination of materials and **cultural** practices that is used to support intentional, meaningful communication by affording **inscription**, **transmission**, and **representation**. We can think of anything made on the **computer** as belonging to a single medium: the **digital medium**.

Megabyte A unit of computer memory, equivalent to one million **bytes** (roughly one million letters) or eight million **bits** (eight million 0s or 1s).

Memex Machine Vannevar Bush's conception of an associative, hypertext reference system as described in his article, "How We May Think" for *Atlantic Magazine* (1945), which foreshadowed and helped to inspire the invention of later computer-based **hypertext** systems, including the World Wide Web. Bush was concerned with solving the problem of the twentieth-century information explosion, which had in his view outrun the ability of traditional libraries to serve the advancement of knowledge. The memex is based on microfilm rather than computer display

screens (which had not yet been invented). Bush's concept was taken up by Douglas Engelbart and Ted Nelson in the 1960s when computer terminals became available in research laboratories (Bush 1945; Engelbart 1962; Nelson 1974a and b).

Mental Model The mental representation of an entity, process, or system. Mental models usually include assumptions about cause and effect, based on the user's interpretation of the behavior of digital artifacts. Once formed, they guide the user's behavior and can lead to errors if they do not align with the actual structure of the system. According to Donald Norman, a user's "mental model of a device is formed primarily by interpreting its perceived actions and visible structure" (Norman 1988, 17). It is therefore up to designers to make sure that the visible actions of the system support the user in forming a mental model that leads to successful interaction. This need not be a completely faithful representation of the how the machine or program actually performs its part of the process, as long as it is helpful as a framework for the actions of the user.

Menu Bar The hierarchical list of command categories that extends across the top of the screen of computer applications. A key design element that was standardized in the Macintosh Human Interface Guidelines (first promulgated in 1987), in ways that have remained useful to this day, such as always placing the File and Edit commands on the left and the Help commands at the extreme right. The expansion of commands as applications take on more functionality has threatened the capacity and coherence of the menu bar (AppleComputerInc 1992).

Message In standard **information theory**, the meaningful unit initiated by a sender that is translated into a coded signal that is transmitted and decoded into the original message. **Semiotics** would expand the model to include more ambiguous cultural messages, including those we send by our clothing, gestures, and tone of voice as well as by our words (Shannon and Weaver 1963; Chandler 2001; Finnegan 2002).

Metadata **Data** about data. Descriptors attached to media objects (such as books, films, video, works of art, or digital files of any kind) that describe the structure, use, ownership, or content of the object. Library catalogs, whether on paper or online, contain metadata about the books in the collection, including the author, title, subject, number of pages, date of publication, and so on. See also **Folksonomy, Controlled Vocabulary.**

Metaphor A fundamental strategy of human cognition, by which we understand one thing by mapping it onto something else, usually something drawn from concrete physical experience (Lakoff and Johnson 1980). Metaphors are also a strategy of interface design, most notably in the desktop metaphor by which files, folders, trash cans, and (in a separate, inconsistent metaphor) windows are visual representations of abstract entities within the machine. Metaphors can help us to form useful **mental models** of a digital environment, but they are also potentially misleading since digital processes often diverge from physical processes, and if taken too far can introduce unnecessary effort. For example, in the notorious Microsoft Bob system, applications were placed in separate graphically represented "rooms," distracting users from the task at hand by asking them to create a spatial mental model and to navigate through unnecessary virtual places.

Method In **object-oriented programming** systems, a named, separately executed **procedure** that is associated with a particular object. For example, an Employee object might have a method called calculateHours associated with it.

Micropayments A system of small payments, advocated by Ted Nelson and others, that would compensate copyright holders for digital documents excerpted or reproduced by others in a network. See also **Transclusion.**

Microworld An interactive model that provides a useful abstraction of much larger complex system. Microworlds were first proposed by educational theorist Seymour Papert as a way of using computers to support exploratory learning of subjects like Newtonian physics (Papert 1980).

Mock-up A rapidly produced rough approximation of a product, often a noninteractive digital image of an interactive environment. Mock-ups are useful for communicating design ideas, for comparing alternate approaches, and for guiding development. They can be used for paper-based testing or hardwired to simulate the processing of the final system in a particular **use case,** to serve some of the same purposes as a truly functional **prototype.** See also **Iterative Design Process, Storyboard, Wireframes.**

Modal, Mode An interface design strategy based on establishing different **states** of the system in which the same user actions have different results. For example, modal dialog boxes take over control of a window-based interface, keeping the user within the dialog window until a choice is selected. This is a violation of user **agency** and is best used for brief interruptions like announcing a security alert or asking for terms of service to be accepted.

Modular, Modularity A desirable attribute of software systems that entails decomposing a larger program into smaller, coherent units with clearly defined protocols for interactions between the separate modules. Modularity is a key strategy of **abstraction,** foundational to the design of complex systems.

Moore's Law The observation, prediction, and development goal articulated by Intel Corporation cofounder Gordon Moore in 1965. It states that the capacity and speed of computer processing chips doubles every eighteen months to two years, a continuing trend that has made computational devices exponentially more powerful, and therefore ever smaller, lighter, and cheaper over the past four decades. As a result, it has been safe for designers to assume that processes that are too slow today will be widely available at satisfactory speeds at some point in the future.

Multiform Having more than one configuration based on the same general components or framework. **Games** are often based on multiform scenarios, dynamically generating variant **instances** of a character type, place, or event, from an underlying procedural abstraction, or assembling variant combinations from a **substitution system**.

Multimedia Composed of media objects in multiple **formats,** corresponding to **legacy media** types, such as video and text in a single document.

Multisequential A multisequential story or a multisequential information space is one in which there is more than one valid, coherent path through a set of segments. The distinction between

multisequential and **unisequential** is more helpful for design choices than **linear** and nonlinear, since multisequentiality is more specific, connoting coherence and greater complexity, while nonlinearity is less specific and negative.

Naturalize To assume that social or representational conventions are natural rather than the result of historical and **cultural** forces; to take familiar behaviors, **artifacts**, or design features for granted without noticing their origins. Naturalizing is an effect of **ideology** and power structures; for example, the powerlessness of women in nineteenth-century English was taken for granted as a part of nature until challenged by feminists. Naturalizing is also an effect of habit; for example, by the end of the twentieth century people took the telephone for granted as an ordinary part of life, only noticeable by its absence. By the early twenty-first century, the cell phone had become similarly unremarkable. Naturalizing is a useful concept for calling our attention to what we notice and what we don't notice in social structures and the design of artifacts.

Namespace Sets of related names within a **nomenclature** that are used consistently to identify and differentiate sets of objects, such as names of vegetables applied to a group of computer servers, or names of trees applied to roads in a subdivision.

Navigation Bar In a spatialized information structure, like a website, the "nav bar" is a menu bar that remains in the same physical place, like the top or left side of a web page, to give access to all the distinctly labeled areas within the space. Navigation bars should also give intellectual access to the contents of the space, providing an overview of what is to be found on a website in the same way that a table of contents presents an overview to a book's contents.

Network A set of **nodes** connected to one another, often drawn as circles connected by arcing lines or directional arrows. Networks are often offered as a form of information design and social organization that is more democratic than hierarchical **branching trees** (although a branching tree is in fact a particular kind of directional network). But networks can also reinforce existing power structures and privilege some nodes over others.

New Media A vague term that refers to the new formats and genres created by the introduction of computer processing into communication in the last half of the twentieth century. This book argues for thinking about digital artifacts as comprising a single new **digital medium**.

Node A meaningful unit, connected to other meaningful units within a **network**. In spatial design, such as urban planning, the area around a metro station or a shopping district can be thought of as a node, connected to other activity areas by **paths**.

Noise In **information theory**, the disruptive, meaningless, or extraneous part of a meaningful transmission, like static in a radio broadcast, as opposed to the meaningful **signal**.

Nomenclature Any system of names that is socially agreed upon, such as the Latin names for parts of plants, the days of the week and the months of the year, or roads of the U.S. highway system. Nomenclatures are made up of one or more **namespaces**.

Nonlinear A vague descriptor for artifacts that deviate from **unisequential** organization. Nonlinearity cannot be a design goal because it is a negative value. Disrupting linearity is a limited goal and may lead to incoherence, since merely tearing out pages of a book or editing

a film in random shot order would create a nonlinear artifact. A more specific goal is **multisequentiality,** creating a more complex structure of multiple coherent sequences instead of only one.

Object Objects are high-level programming concepts that combine data and procedures (methods). Objects are defined as **classes**, generalized clusters of attributes and behaviors; a specific object is an **instance** (or **instantiation**) of the class patterns, with its own variation. For example, if an object FLOWER has the attribute COLOR with several possible values, a single instance of the class might be a YELLOW FLOWER or a RED FLOWER.

Object-Oriented Programming (OOP) A programming structure and set of practices that is afforded by a number of languages, beginning with Alan Kay's SmallTalk (1974) and most commonly associated with C++ and Java. OOP is characterized by an abstraction hierarchy in which elements of the system, called **objects,** are specified as members of **classes** with shared characteristics. Objects combine data structures and related processes or methods. The methods are often written as event-handlers, to be triggered by an interaction initiated by a human interactor, another object, or another computational process.

Ontology In philosophy, a definition and specification of the essence of an entity, as in the statement that "God is Love," or matter is composed of irreducible atoms. In computer programming, ontology is an explicit formal specification of the objects, concepts, and other entities that are assumed to exist in some area of interest, and the relationships that hold among them, as in an ontology of human diseases and treatments.

Orature A body of composed works in oral form, parallel to the term "literature" for written works, and coined to recognize the many cultural forms that arise from societies without writing technology or that are sustained independent of traditions of writing. Also called "oral literature."

Output The **data** that is produced by a computer program and passed on to other processes and sometimes to the **interactor**. See also **Input.**

Parameter, Parameterize A **variable** whose value changes the way a programming **function** is calculated or an **object** is **instantiated**. For example, a program function may be written as Get-Price (item, color, quantity). A program may call this function by specifying the parameters like this: GetPrice(blouse, red, 3) causing the program to return the price of three red blouses. The variables that specify the attributes of instances of a class are also parameters, as when we instantiate the class defined as flower(color) with the statement "new flower(red)". Parameterized objects and processes are characteristic of computational structures.

Participatory Affordance With the **encyclopedic**, **procedural**, and **spatial** properties, one of the four defining representational **affordances** of the **digital medium**. The digital medium is participatory in allowing an **interactor** to manipulate, contribute to, and have an effect on digital content and computer processing. Participation combined with procedurality create **interactivity,** which means that the designer must script the behavior of the computer and the behavior of the interactor. When participation has been well shaped the interface becomes **transparent.** Transparent participation combined with **visible** procedurality creates the experience of **agency** for the interac-

tor, a key design goal for any digital artifact. The participatory affordance can support but should not be confused with *social participation* in online communities or with the **participatory design** practices that foster extensive user involvement in the development process.

Participatory Design A design tradition with its roots in Sweden that seeks to include marginalized groups like poor people or technological novices in every step of the design process, not merely as informants or testers but as collaborating members of the design team.

Pattern A recognizable configuration, especially those that can be perceived and recognized by sight or sound. Cognitive patterns, called **schema,** provide **frames** for assimilating new experiences to known configurations. **Media conventions** are patterns that fit together into **formats** and **genres,** allowing us to convey the meaning of a novel communication by shaping it into a familiar configuration.

Pervasive Games Games that take place in real-world locations or that use informational computer technologies like email or social networks for gaming purposes while blurring the boundary between the everyday world and the game. See also **Alternate Reality Games.**

Place A memorable, differentiated area within a navigable space. Designing navigable digital environments requires the creation of distinct places through consistent labels, visual cues, and especially through association with memorable events. See also **Active Creation of Belief, Immersion, Spatial Affordance.**

Platform Fixed configuration of inscription materials and transmission codes, of hardware and software, that forms a foundation for multiple media artifacts. Examples of stable digital platforms: an operating system like MS-DOS, Windows, Mac OS X; a game console like Nintendo Wii, Microsoft Xbox, Sony PlayStation; a browser like Explorer, Firefox, Chrome; a DVD format like Blu-ray. Platforms have affordances and constraints. The existence of a stable platform encourages the growth of standardized **formats** linked to **conventions** of **representation** leading to the development of **genres.** For example, the popularity and stability of the iPhone platform has led to the development of several genres of phone applications, in the common format of an iPhone "app." Once developed, genres can become independent of their incubating platform, although they may still retain features that reflect the affordances and constraints of the originating environment.

Platformer, Platform Game A classic videogame **genre** in which the player controls a character who jumps from one platform to another on a single stationary screen, as in Donkey Kong (Miyamoto 1981), or moving from left to right in a continuously scrolling multiscreen landscape, as in Super Mario Brothers (Miyamoto,1985).

Play A mode of behavior, found in many animals and humans, involving pleasurable and often exploratory or creative activities not directly related to survival. Activities usually associated with hardship or work, such as running up hills, hunting for something rare, or performing repetitive tasks can be undertaken for their own sake. Play can serve developmental purposes, provide practice for skill mastery, give contained expression to antisocial emotions, dramatize our vulnerability to chance events or our commitment to succeed by focused effort. It may also make us more resilient by keeping alive alternate behavior patterns that would not otherwise be part of

our repertoire (Sutton-Smith 1997) . Digital artifacts that respond to direct manipulation with immediate feedback, like a handheld device that changes in some way with the swipe of a finger, can induce a playful state of mind. See **Game**.

Predictive Text Text that pops up automatically in response to partially entered text, filling in what has not yet been entered. Predictive text relieves the burden of repetitive typing on awkward mobile devices and provides search engines with the ability to steer queries to known areas. Interactors are usually given a choice of accepting or rejecting the completion text which may appear in line as if typed by the interactor or in a separate line for confirmation.

Primitives The smallest units in a processing system, with which the more complex units can be built. The 00s and 11s of machine code are the lowest level primitives of programming languages. The representations of alphanumeric characters and other data types sit on top of these representational primitives, as do the operations of the computer. On top of these patterns of 00s and 11s are built the higher-level primitives of assembler language such as ADD and GOTO Structured languages have more complex primitives such as IF THEN and CASE statements, and are translated by special programs called compilers into the primitives of machine code that allows the computer to execute them. It is a principle of good programming to establish primitives and build complexity from efficiently designed simpler elements. Similarly, designers can think of participatory actions, like pointing and clicking, as primitives of interaction, and interface elements like menus and buttons as primitives of visual interaction design.

Procedures In programming, procedures are sets of instructions that the machine will execute. **Functions** and **methods** are procedures, and the word is sometimes used to distinguish the instruction part of a software environment from the **data**.

Procedural Affordance The most important of the four **affordances** of the **digital medium**, the processing power of the computer that allows us to specify conditional, executable instructions. The procedural affordance has created a new representational strategy, as powerful as spoken language or recorded moving images: the simulation of real and hypothetical worlds as complex systems of parameterized **object**s and behaviors. When procedurality is well designed the actions of the computer have **visibility**, and the parameters are in the control of the **interactor**. Procedurality and participation are the affordances that create **interactivity,** and visible procedurality combined with **transparent participation** creates the experience of **agency** for the interactor, a key design goal for any digital artifact. Not to be confused with the use of the word "procedural" to describe the more linear programming strategies that predate **object-oriented programming**. See also **interactivity, agency,** and the **participatory, spatial,** and **encyclopedic affordances.**

Progress Indicator A convention for providing **feedback** to interactors on an otherwise invisible automated process, like downloading a file, which requires waiting. For example the familiar progress bar represents the task as a line moving left to right filling up a space in proportion the degree of completion. Progress indicators often have explicit calculations of time left to wait, and are associated with a cancel button allowing the interactor to quit a too-slow process.

Protocol A formal standard specification for exchanging communication in systems of people, machines, or both combined. Diplomatic protocol is a code of conduct that includes, for example, specifications of how ambassadors and heads of state are greeted and seated at international functions in order to ensure that no one will be confused, misunderstood, or offended. Internet Protocol (IP) is a suite of standard formats and processes for transferring information across machines and transmission technologies.

Prototype A crucial element in the design process, a simplified version of the final system, which communicates to potential users, developers, funders, and other stakeholders the key functionality and design elements. Rapid prototyping allows design teams to share ideas and to critique approaches to a design problem based on hands-on interaction. See also **Iterative Design Process, Mock-up, Storyboard.**

Prototype Theory A strategy of classification for ambiguous sets of artifacts, established experimentally by Eleanor Rosch, based on identifying representative exemplars and shared attributes, such as "chair "and "sofa" as exemplars of the category "furniture" (Rosch 1975). A cognitive model that can be employed as an alternative design strategy to (or a way of eliciting the necessary distinctions for) fixed definitions and hierarchical **taxonomies.**

Pseudocode Imitates computer code without attention to rigid syntax and without abbreviations that may be mysterious to humans. Pseudocode is the human-readable, step-by-step logic of a computer algorithm expressed in a syntax that is similar to programming syntax but is meant to be read by humans rather than machines.

Radio Button An **interface convention** defined in the Macintosh Human Interface Guidelines, as one of a set of buttons in which only one can be chosen at any time. Radio buttons are round, and the chosen one is marked by a dot in the middle. Radio buttons are differentiated from sets of check boxes, which are square, and which afford multiple simultaneous marked (checked) choices.

Recoding A concept in cognitive science referring to the reconceptualizing of information in order to make it more memorable, especially the **chunking** of smaller items into larger conceptual units, such as the breaking down of a long string of numbers into multiple smaller units.

Record An entry in a **database** representing a single item, made up of discrete **fields.**

Reframing An important part of the design process that involves reassessing the original context in which a design problem is presented in order to substitute a different viewpoint or widen or otherwise refine the context. See also **Frame.**

Refining An important part of the process of creating new media genres is the refining of existing **media conventions.** For example, as part of the process of reinventing television news, designers refined the headline scroll so that it moves vertically instead of horizontally, assuring that viewers always see a complete headline.

Remediation The phenomenon of reproducing the conventions or content or both of one **medium** in another. Also the theory, advanced by Jay Bolter and Richard Grusin, that "new

media" always reconfigure older media, and in particular that digital forms both borrow from and seek to suppress earlier forms (Bolter and Grusin 1999).

Representation With **inscription** and **transmission** a primary component of any **medium**. The process or effect of creating meaning by connecting **signs** (e.g., the set of vocalizations pronounced "tree," the written word "tree," a sketch of a trunk and branches) with referents in the world (a particular tree) or abstract concepts (the general category of "tree"). Representation is supported by socially constructed **codes,** and meaning is created within specific cultural communities of interpretation, such as French courtiers of the seventeenth century or contemporary American urban teenagers.

Representational **codes** are sometimes distinguished from *presentational* codes, which involve immediate bodily presence (e.g., gestures, clothing) rather than mediated communication such as writing. In acting, "representation" refers to a detached style rejected by **twentie**th-century theorist/teachers like Stanislavsky and Strasberg in favor of "embodying" the character. See also **Medium, Semiotics.**

Resource Allocation A kind of game mechanic in which a player is given a limited quantity of some resource (money, weapons, land, **avatar**-building skill points) to distribute among a range of desirable choices. Resource allocation games (e.g., Civilization, SimCity, The Sims) force players to think strategically. The mechanic is applicable not only to games but also to **simulations** in general, and to the avatar-building phase of games in many genres.

Respawning The generation of a new **instance** of an object or character in a simulated world or game. The Pac-Man ghosts respawn after dying, as does Pac-Man himself until he has used up all his lives. Usually respawning happens at a designated place in a game world, often setting the player back to an earlier stage.

Rituals Standardized patterns of interaction that are performed in a predictable, prescribed, or spontaneously elaborated but consistently repeated manner among members of a culture. Rituals may be written down and repeated verbatim (as in religious and legal ceremonies) or they may provide a general framework for interaction (like greeting guests at an informal party). Rituals often assign different *roles* to the participants, such as the bride, groom, minister, ring-bearer, and so on, at a wedding. Familiar rituals organize social life for large-scale events (like elections) and repeated events (like leave-taking). According to James Carey, ritual is a foundational interpretative model for understanding all of communication, providing a more complex framework for understanding meaning than the transmission model of **information theory** (Carey 1989). **Interaction design** can be thought of as the creation of appropriate rituals for coordinating human–computer interactions and human-human interactions mediated by computer.

Robustness A desirable quality in computer systems, indicating reliability and flexibility, especially the ability to recover from error-inducing conditions such as poorly formed input or other conditions that the developers could not explicitly foresee. **Modularity** supports robustness by allowing programmers to isolate elements that can lead to program failure, such as hardware-specific drivers that will need to be updated separately from the rest of the system. See also **Modularity, Scalability.**

Sandbox An area in a complex computer system or game where interactors can practice with the tools and commands at their disposal without consequences in the main system. Also used to describe games or environments that allow the player to construct their own virtual objects, such as Spore Galaxies or Second Life.

Save Point A place or level in a game at which the player is allowed to save the current **state** to be returned to on replay if they reach a losing state—usually the player's character dying or failing irreversibly at a task—before reaching the end of the end. Some save points, like the start of a new level, are automatic, and some require the player to issue an explicit game-saving command. Platform games like *Super Mario* will automatically **respawn** a new **instance** of a character at save points.

Scalability A desirable quality in computer systems, indicating an ability to accommodate more users, larger data sets, and other increases in the scale of processing without crashing or having to be reengineered. Scalability is also a useful concept for human systems, which often work at the small-scale level, such as the accounting system in a family-run pizza parlor, but do not "scale" appropriately to accommodate a larger enterprise, such as a chain of pizza parlors. See also **Robustness.**

Scenario A story-like **abstraction** of a dramatic situation that focuses key elements of a design problem, as in a **use case,** or of a replayable simulated process, as in a military training system. See also **Storyboard.**

Schema An organized, abstract representation of knowledge, pluralized as schemas or schemata. The term can be used to refer to mental constructs (cognitive schemas representing, for example, our general concept of a house, a newspaper, or the grammatical structures of a language), classification schema (like the Dewey Decimal system), or computational objects (e.g., **XML** schemas for standardized documents, components of computational knowledge representations). See also **Frame, Class, Pattern, Substitution System, Taxonomy, Template.**

Search Engine A computer program that matches input words or phrases with items in a networked information resource or database. Google succeeded in the 2000s in displacing other search engines for the World Wide Web because its algorithm made use of the linking structure of the web, taking into account the links into and out of a site as well as the content of the site itself in determining relevance and value.

Segmentation Division of information into its constituent units. Segmentation is one of the key tasks of information design. The **granularity** with which information is segmented is always an important design decision, with the goal of creating **semantic units** that provide both precision of reference and preserves the context of the larger unit. Legacy segmentation conventions often reflect the constraints of predigital materials, such as the paper page or the vinyl record album.

Semantic Unit A unit of information in which a single physical form is associated with a logical division in meaning. A paragraph is a semantic unit, but a page is a physical segment that may or may not correspond to a meaningful content division. Other examples of semantic units are: a spoken or written word, a sentence, a chapter, a database field or table, a shot in a movie, a

single photograph, a sequence of shots or photographs detailing a unified action. Semantic units may overlap one another or be nested one inside the other. In representing information in digital form it is important to **segment** it into semantic units of multiple levels of granularity for indexing and display.

Semantic Web A goal articulated by Tim Berners-Lee and pursued by the World Wide Web Consortium (W3C) for integrating vast distributed knowledge resources through common information structures such as permanent addresses and **XML** document **schemas** (Berners-Lee, Hendler, and Lassila 2001; Shadbolt, Hall, Berners-Lee, and Shadbolt 2006).

Semiotics The study of **signs**, such as language, gestures, and written or graphical texts for the purpose of understanding what they mean and how that meaning is constructed within specific cultural contexts. Important theorists of semiotics include Ferdinand de Saussure, A. J. Greimas, Roland Barthes, and Umberto Eco.

Shared Attention The basis of all communication. Media **conventions** and **genres** create shared attention by establishing common formats, expectations, and semantic associations. To invent a new medium is to expand the human capacity for shared attention, to increase the complexity of our reasoning about the world and to deepen our capacity for mutual understanding. See also **Joint Attentional Scene.**

Simulation A system with behaviors, implemented as a human-performed game or a computer program or a combination of the two, that **abstracts** and imitates key components of an imaginary or real system, usually composed of multiple actors and complex causal relationships. Simulations are usually run multiple times to assess the effect of changing **parameters.**

Sign A sign is a **conventionalized** physical form (signifier) that is recognized as referring to something other than itself (the signified) within a specific **discourse community.** A sign can be a *symbol* (like letters), an *icon* (like the stick figures differentiating male and female public toilets), or an *index* (like smoke is for fire).

Signal A form of patterned **data,** perceivable by machine or human, that is **inscribed** and **transmitted** in a **medium,** such as audio transmitted as a radio wave or letters transmitted by telegraph. In **information theory**, signals are corrupted by **noise.**

Situated Action Theory A framework for understand human–machine interactions as conversations in which both parties are constantly assessing the state of the other. In the situated action model, the user's knowledge of a process is not identical with a single step-wise decision tree or plan, but inextricably tied to a much less predictable sequence of embodied actions. It is therefore the designer's job to enhance communication, anticipating the user's state, making the machine's assumptions visible, and giving the user control over the sequence rather than expecting her behavior to conform to invariant scripts (Suchman 1987). See also **Distributed Cognition.**

Spatial Affordance With the **encyclopedic, participatory,** and **procedural** properties, one of the four defining representational **affordances** of the **digital medium.** Digital environments can represent space using all the strategies of traditional media, such as maps, images, video tracking, and three-dimensional models. Unlike older media, however, and similarly to the experiential

world and the designed spaces of landscapers, urban planners, and architects, digital media artifacts can be navigated. This affordance is not a function of visual representation, since it can be produced in text adventure games like Zork and Adventure, which created navigable spaces without any images. It is byproduct of the procedural and participatory affordances, of setting up rules of interaction that have the consistency of navigating a fixed landscape, and of the innate human propensity to make sense of the world through spatial **metaphors**: we are predisposed to spatialize our experience, turning the appearance of text on our screen into the experience of "visiting" web*sites*. Navigable space is created by clearly distinguishing one **place** from another and creating consistent interaction patterns that support movement between spaces. When encyclopedically large and detailed informational spaces or virtual worlds are well organized with clear boundaries, consistent navigation, and encyclopedic details that reward exploration they create the experience of **immersion**.

State In computer-based environments, the state of a system at any moment is the set of current values of all the system **variables**. The concept of state is useful to the designer in understanding the range of possibilities for elements of a system (such as characters within a virtual world, documents within an archive) as well as for the system as a whole.

State Diagram A representation of a complex system as a network in which the **nodes** are distinct **states** and the directional lines connecting individual nodes (called edges, and drawn as arrows) representing the conditions under which the system will change state. For example, a state diagram of a graduate student could have a node labeled "ABD" (all but dissertation) connected by an arrow labeled "Dissertation Accepted" to another node labeled "PhD."

Storyboard A design tool consisting of a sequence of single images, like a comic strip, illustrating a temporal sequence, used in the preproduction phase of a film, animation, or interactive digital artifact. Storyboards are used as a strategy for thinking through design, and can be used early in the process, in conjunction with **mock-ups** to illustrate the **interaction**, or to illustrate a written **use case**. See also **Iterative Design, Scenario, Wireframes**.

Structured Archive A set of digital artifacts that have been semantically segmented and indexed with controlled metadata. Structured archives are similar to physical and digital libraries, but they may contain a wider range of media formats and unpublished as well as published items.

Structured Document A document, like an **HTML** page or a podcast, composed of discrete parts labeled with **metadata tags**, which provide **semantic segmentation** similar to the **fields** in a **database record**. A large repository of similarly structured media files is a structured archive. See also **Semantic Web**.

Substitution System A way of generating variation within a fixed **template**, by identifying slots that can be filled by any one of a set of similar elements. Language is a grammatical substitution system, allowing us to substitute any noun or noun phrase, for example, as the subject of a sentence. Style sheets for web pages are substitution systems, establishing a fixed pattern for the display of variable content. Game avatars are constructed with substitution systems that allow players to interchange hairstyles, facial features, body shapes, and clothing, creating elaborate

variation within a fixed, easily extended framework. Substitution systems can be used as an information design and presentation strategy to establish genres that focus shared attention, and as a software design strategy to reduce the complexity of the programming task while expanding the interactor's range of choice and experience of variety. Proceduralized substitution systems can generate highly complex variations by assembling the templates and filling the slots dynamically according to **parameterized** rules.

Subroutine In computer systems structured with a single central control program, subroutines are subordinate programs that are passed information to do specific tasks and then return information and control to the master program. Creating subroutines is an example of **modularity** in programming. See also **Function**.

Synchronous Happening at the same time, like a live chat via voice, text, or video. See also **Asynchronous**.

Table One of the basic building blocks of information design, an extension of the **list** through spatialization and the basis for **database** design. See also **Field, Grid, Record.**

Tacit Knowledge Unconscious, unarticulated, situation-specific knowledge that has been learned from experience although not explicitly. Tacit knowledge often forms a part of expert or veteran "know-how," and it can be hard to capture by novices or in design interviews, since the knowledgeable person is not aware of drawing upon it. See also **Intuitive**.

Tag A **descriptor** used as **metadata** and attached to the whole or a part of a media object, such as a photograph or a heading in a web page as indexing, structural, or formatting terms. Indexing tags identify content, such as the place or date of a photograph. Formatting tags identify structural parts of a document, such as <heading> or display <italics>.

Tag Cloud A way of providing overview and access to an archive of media artifacts, such as online photo collections, by displaying metadata tags as an alphabetized array of tags whose size, color, or other visual characteristic indicates the quantity, popularity, recency, or other attribute of the tagged artifacts. Tag clouds can be automatically generated for expanding, unregulated collections' user-generated tags, making them a popular interface strategy for **folksonomy** collections.

Taxonomy A consistent, standardized classification schema for dividing a complex set of elements into hierarchically organized, discrete categories and subcategories. A taxonomy is an attempt to account for all the elements in a particular knowledge set (such as all living things) without ambiguity, and to provide category divisions that reflect expert knowledge of the field (such as cellular and noncellular life).

Template A fixed media **format** that provides slots for varying information, such as a job application form or a **record** in a **database**. Templates are important building blocks of **information design** and in **object-oriented programming**. See also **Class, Instantiation, Schema, Structured Document, Substitution System.**

Temporal Media Media that are time based, such as spoken language, audio, and video recordings. Temporal media in digital formats can be more difficult to search and to present in overview

than text documents or arrays of still images. Information organization strategies for temporal media include transcripts, descriptive metadata, playback control with fast forward and rewind, and excerpting.

Thesaurus In general a thesaurus is a list of words and their synonyms. In information design, a thesaurus is a list of all the standardized descriptors in a **controlled vocabulary,** including guidance on the correct word to use when more than one refer to the same thing (e.g., "residence," "house," or "home") and the relationships between terms, such as which broader terms are implicitly included in narrower ones (e.g., "sister" implicitly includes "sibling" which includes "family member").

Think-aloud Protocol A method for studying the responses of users to interactive artifacts, by asking them to articulate for the tester what they are thinking as they use the system. See also **Iterative Design, Formative Evaluation, Usability.**

Thread A form of information organization convention used in online bulletin boards and discussion groups and later adopted for email that collocates items with the same subject line, usually by stringing them together in order of the time of posting. Some systems recognize subtopics and create hierarchies of discussion threads.

Timeline A two-dimensional visual organizing framework for the presentation of information chronologically, usually in a left-to-right horizontal configuration. Timelines are useful for displaying dated artifacts in an archive or for displaying a changing, quantifiable phenomenon over time (such as occurrences of a particular proper name in the news), but the encyclopedic capacity of digital environments can make it difficult to display all the relevant items in a single line, a problem that is sometimes solved by providing a zoom feature for the timeline. Timelines have also been widely used as interfaces for so-called **multimedia** authoring environments, where they can sometimes reinforce **unisequential** structure and discourage **interactivity.**

Time Step A segment of time within a computer **simulation** in which the **state** of the system is recalculated. Often in simulation games the action is explicitly paused while players make **resource allocation**. Time steps are also perceptible in the updating of counters or other displays in control panels of simulations, and in scientific simulations processes may be recorded and graphed by time step.

Threshold Object An object in the real world, like a game controller, that has an effect in the virtual world, taking the interactor over the threshold from the real to the virtual, and increasing immersion by reinforcing belief in the virtual world (Murray 1997).

Tool Model One of the four models of **interactivity** discussed in part V. A tool is a found or created object that fits in and extends the power of the human hand, whose value lies in its instrumentality, that is, its usefulness in accomplishing a task. Design values for digital tools include **direct manipulation**, learnability, **transparency,** and expanded **expression**. See also **Companion Model**, **Game Model**, and **Machine Model.**

Tooltip Information that appears on rollover associated with an icon in an application program or game interface.

Transclusion A word coined by the **hypertext** visionary Ted Nelson, and a key feature of his proposed Xanadu hypertext system, referring to the inclusion of one text within another while maintaining a single unique copy of the original, which remains under authorial control. In Nelson's design, the author would be able to make changes to a single original and have those changes appear in all the compound documents in which it was transcluded (Nelson 2007).

Transmedia A production and marketing strategy that distributes branded content over multiple existing **platforms**, such as a videogame or fan-driven website that is integrated into the same fictional universe as a television program (Jenkins 2006).

Transmission With **inscription** and **representation,** one of the three components of a **medium. Transmission is** the transfer across space or time or both of a perceptible pattern based on a socially agreed upon **schema** like the alphabet or Morse code. See also **Convention, Format, Genre.**

Transmission Model Describes all exchanges of meaning among animals, people, machines, or a combination of these as the transmission of a **message** from point A where the sender encodes it, through a **channel** that maximizes **signal** and minimizes **noise** to point B where the signal is decoded by the receiver, into the original message (Shannon and Weaver 1963). Also called **information theory**, and often contrasted with **semiotic** theory.

Transparency A desirable quality in a tool or interface, which is said to be transparent when it disappears from the awareness of the user, who focuses instead on the task itself. A touch-typist experiences the keyboard as transparent; a confident driver experiences the automobile controls as transparent. Transparency is achieved by direct manipulation, continuous feedback, ease of use, and familiarity. Transparency is thwarted by cumbersome input procedures, hidden and interruptive processes, and a steep learning curve, all of which make the interface opaque, obscuring the task at hand.

Tree See **Branching Tree.**

Treemap An information visualization technique that allows for overview of a thickly branching hierarchical **tree** in a constrained space by nesting items within rectangular containers representing categories (such as sectors of the economy) whose relative size reflects an important measurement of the data (such as market capitalization). The proximities of items at the top level may or may not be semantic, since the mapping software tries to place all the boxes within a limited screen display. Treemaps were developed by Ben Shneiderman's group at the University of Maryland (Shneiderman and Plaisant 2009).

Tuning When used by **game** designers, the process of iterative playtesting and redesign by which an almost finished game is made to support **transparent** interaction and to induce the experience of **flow** by being neither too difficult nor too easy.

Turing Test A hypothetical test suggested by cryptographer and mathematician Alan Turing for distinguishing between a computer and a human being in a conversation held as an online text exchange (Turing 1950).

Unisequential A more specific term than "linear" to describe media artifacts that are read, listened to, or viewed in a single authorized sequence, like the order of pages in a book or the temporal order of a film or podcast. Interactive documentaries and simulation games, by contrast, are **multisequential,** allowing the interactor to experience multiple coherent authorized sequences.

URI Universal Resource Identifier. A standard format for referring to a networked resource of any kind, consisting of a protocol code like http:// or mailto: and a unique identifier. See **URL, DOI.**

URL Universal Resource Locator, a form of **URI** that begins with the http:// protocol. A standard format for referring to sites on the World Wide Web. The confusion between the URI, the more general term, and the URL reflects the fact that a digital identifier can be either a name or a location or both. See **DOI.**

Usability A design goal that is closely related to specific empirical methods for creating and evaluating designs aimed at achieving the goal. Usability refers to the ease with which users of digital tools and informational resources can perform tasks. Usability methods emphasize empirical observation of users, explicit error messages, efficiency in task performance, lack of ambiguity, learnability, and **formative evaluation** through the measurement of task performance time, error rate, interface response time, and **think-aloud protocols** to capture frustrations and confusions in the user's cognitive process.

Use Case In a design document for a software application or other interactive artifact, a use case is a **scenario** describing a fictional but representative user, including the social context, goals, and steps the user would take in achieving the goals. The use case serves to focus design in the early stages of development and to explain the functionality to potential new users once the artifact is built.

User A common term for the human being who interacts with a digital artifact, which assumes a tool and task orientation, as compared with the *player* of a video game or the more inclusive **interactor** who may be playing or performing a task or perhaps following a **multisequential** story, or exploring a virtual world.

User Testing A crucial element of **formative evaluation** and **iterative design** for interactive artifacts. See also **Agency, Usability.**

Value, Value List Used in programming for the number or text in a container whose contents can change. **Variables** in programs have values, as do **fields** in **databases**, and **attributes** of **elements** in structured documents. Value lists are made for containers that have a fixed set of possible values (like provinces in Canada).

Variable A named unit of data specified in a computer program that can change its value during the execution of the code. Variables are "local" if they only can be read and modified by one part of a program and "global" if they can be read or modified by all parts of the program. The opposite of a variable is a constant, which has an unchanging value, such as the mathematical constant Pi.

Vector Graphics Digital images that are represented within a computer system as a set of instructions for drawing the geometrical components (e.g., polygons, lines, points) for them rather than as a **bitmap**. A vector is a continuous rather than a fixed variable (a relative quantity rather than a specific number) so vector graphics can be resized without loss of information (the lines will always be drawn in the same relative proportions at the same angles no matter how long they are).

Visibility The design value of making the processing of the computing machine clear to the interactor before, during, and after it takes place. See also **Transparency**, **Machine Model**.

Widget A simple program or **applet** that can be plugged into a common platform, like a web widget into an HTML page, and often into a proprietary platform like the Apple Dashboard. Widgets generally are limited in function and easy to plug in or delete from the host environment.

WIMP Interface Acronym for the common desktop graphical user interface (GUI), standing for **W**indows, **I**cons, **M**enus, **P**ointers.

Wireframe A schematic drawing of an interface, indicating the size and shape of key areas and the functionality of interactive elements, but lacking the actual graphic and textual content. Web wireframes are usually based on a **grid** and can be used to establish a style sheet or template to ensure uniformity in a multipage site. Wireframes can also be used as a focus of design team discussion and as the basis of paper-based user testing, in order to concretize thinking about interaction early in the design process.

World Wide Web (WWW) The global information resource invented by Tim Berners-Lee in 1989–1990 when he proposed and implemented the now-standard protocols for addressing, displaying, and hyperlinking information over the Internet. Berners-Lee ensured continued open access and expanded shared standards of information transmission by setting up the W3C (World Wide Web Consortium), which is hosted at MIT. See also, **HTML, Semantic Web, XML**.

WYSIWYG An acronym for "What You See Is What You Get" pronounced "wiz-ee-wig." WYSIWYG interfaces replaced markup interfaces for word processing in the 1980s. Previously, word processors required the use of codes similar to **HTML**, so that an italicized word would have to be coded as

```
<i>Hello!</i>
```

instead of appearing on the screen as *Hello!*—just as it would in print. WYSIWYG interfaces in general are desirable because they allow for **direct manipulation.**

XML XML stands for **Extensible** Markup Language, a proposed successor to **HTML** developed by the W3C under the direction of Tim Berners-Lee as part of its effort to create a **Semantic Web** that would be better organized for information sharing and knowledge creation than the current **World Wide Web**. XML is a metalanguage, a format for creating metadata sets that form the basis of **structured documents.**

Bibliography

Adams, Douglas. 1979. *The Hitchhiker's Guide to the Galaxy*. New York: Pocket Books.

AppleComputerInc. 1992. *Macintosh Human Interface Guidelines*. Reading, MA: Addison-Wesley.

Bates, Joseph. 1994. The Role of Emotion in Believable Agents. *Communications of the ACM* 37 (7): 122–125.

Benjamin, Walter. 1968. *Illuminations*. New York: Schocken.

Berne, Eric. 2004. *Games People Play: The Psychology of Human Relationships*. New York: Ballantine Books.

Berners-Lee, Tim. 2007 Giant Global Graph. *timbl's blog*. <http://dig.csail.mit.edu/breadcrumbs/node/215>, posted November 21, 2007, accessed February 25, 2011.

Berners-Lee, Tim, James Hendler, and Ora Lassila. 2001. The Semantic Web. *Scientific American* (May). <http://www.scientificamerican.com/article.cfm?id=the-semantic-web>.

Berners-Lee, Tim, Nigel Shadolt, and Wendy Hall, 2006. The Semantic Web Revisited. *IEEE Intelligent Systems*. May/June.

Black, Edwin. 2001. *IBM and the Holocaust: The Strategic Alliance between Nazi Germany and America's Most Powerful Corporation*. New York: Crown Publishers.

Blank, Mark, P. David Lebling, and Timothy A. Anderson. 1977. Zork text adventure game for mainframe computers. Re-released 1980 by Infocom.

Blizzard Entertainment. 2004. World of Warcraft. Networked massively multiplayer game.

Blow, Jonathan. 2008. Braid. Art game. <http://facebook.com>.

Bogost, Ian. 2006. Oil God, Persuasive Games. <http://www.persuasivegames.com/games>.

Bogost, Ian. 2010. Cow Clicker. Networked Game. <http://facebook.com>.

Bogost, Ian. 2007. *Persuasive Games: The Expressive Power of Videogames*. Cambridge, MA: MIT Press.

Bolter, Jay David, and Richard Grusin. 1999. *Remediation: Understanding New Media*. Cambridge, MA: MIT Press.

Borges, Jorge Luis. 1975. *The Analytical Language of John Wilkins. Other Inquisitions 1937–1952*. Austin, TX: University of Texas Press.

Bowker, Geoffrey, and Susan Leigh Star. 1999. *Sorting Things Out: Classification and Its Consequences*. Cambridge, MA: MIT Press.

Breazeal, Cynthia L. 2002. *Designing Sociable Robots*. Cambridge, MA: MIT Press.

Brown, Eric, Asi Burak, Patrick Banan, Tim Tournay, Bill Ulrich, and James McGirk. 2007. Peace-Maker. Impact Games.

Bush, Vannevar. 1945. As We May Think. *Atlantic Monthly* 176 (1): 101–108. <http://www.theatlantic.com/magazine/archive/1969/12/as-we-may-think/3881>.

Caillois, Roger. 1961. *Man, Play, and Games*. New York: Free Press of Glencoe.

Carey, James W. (1989). *Communication as Culture: Essays on Media and Society*. Boston: Unwin Hyman.

Casson, Lionel. 2001. *Libraries in the Ancient World*. New Haven, CT: Yale University Press.

Chandler, Daniel. 2001. *Semiotics: The Basics*. London: Routledge.

Choi, Charles Q. 2007. Forecast: Sex and Marriage with Robots by 2050. *LiveScience*, posted October 12, 2007. <http://www.livescience.com/technology/071012-robot-marriage.html>, accessed July 21 2010.

CNN. 1999. "Nasa's metric confusion caused Mars orbiter loss," posted September 30, 1999. <http://www.cnn.com/TECH/space/9909/30/mars.metric>, accessed March 4, 2011.

Cooper, Alan. 1995. *About Face: The Essentials of User Interface Design*. Foster City, CA: IDG Books Worldwide.

Csíkszentmihályi, Mihály. 1990. *Flow: The Psychology of Optimal Experience*. New York: Harper and Row.

Crowther, William, and Don Woods. 1976. Adventure. Text adventure game for mainframe computers.

Davenport, Glorianna, T. A. Smith, and N. Pincever. 1991. Primitives for Interactive Cinema. *IEEE Computer Graphics and Applications* 11 (44): 67–74.

Dearden, Andy, and Haider Rizvi. 2008. Participatory IT Design and Participatory Development: A Comparative Review. *Proceedings of the Tenth Anniversary Conference on Participatory Design*. Bloomington, Indiana, Indiana University, 81–91.

Dehaene, Stanislas. 2009. *Reading in the Brain: The Science and Evolution of a Human Invention*. New York: Viking.

Diamond, Jared. 1999. *Guns, Germs and Steel: The Fates of Human Societies*. New York: W.W. Norton and Company.

Dodes, Rachel 2004. Tunes, a Hard Drive, and (Just Maybe) a Brain. *New York Times*, circuits section.

Donald, Merlyn 1991. *Origins of the Modern Mind: Three Stages in the Evolution of Culture and Cognition*. Cambridge, MA: Harvard University Press.

Donald, Merlyn 2001. *A Mind So Rare: The Evolution of Human Consciousness*. New York: Norton.

Dondis, Donis. 1973. *A Primer of Visual Literacy*. Cambridge, MA: MIT Press.

Eisenstein, Elizabeth. 1979. *The Printing Press as an Agent of Change: Communications and Cultural Transformations in Early Modern Europe*. Cambridge, UK; New York: Cambridge University Press.

Elkins, James. 1999. *Why Are Our Pictures Puzzles?: On the Modern Origins of Pictorial Complexity*. New York: Routledge.

Engelbart, Douglas. C. 1962. *Augmenting Human Intellect: A Conceptual Framework*. Menlo Park, CA: Stanford Research Institute.

Engelbart, Douglas. C. 1968. Demonstration of a "A Research Center for Augmenting Human Intellect," (video of live demonstration). <http://dougengelbart.org>.

Fekete, Jean-Daniel, and Catherine Plaisant. 2002. Interactive Information Visualization of a Million Items. Proceedings of the IEEE Symposium on Information Visualization, 117–124.

Fine, Ben, and Dimitris Milonakis. 2009. *From Economics Imperialism to Freakonomics: The Shifting Boundaries between Economics and Other Social Sciences*. London: Routledge.

Fine, Gary A. 1983. *Shared Fantasy: Role-playing Games as Social Worlds*. Chicago: University of Chicago Press.

Finnegan, Ruth. 2002. *Communicating: The Multiple Modes of Human Interconnection*. Oxford: Routledge.

Fish, Stanley E. 1980. *Is There a Text in This Class?: The Authority of Interpretive Communities*. Cambridge, MA: Harvard University Press.

Frasca, Gonzolo. 2001. Kabul Kaboom! <http://ludology.org>.

Frasca, Gonzolo. 2003. September 12th. <http://newsgaming.org>.

Frasca, Gonzolo. 2004. Madrid. <http://newsgaming.org>.

Friedman, Ted. 1999. The Semiotics of Sim City. *First Monday* 4 (4) <http://131.193.153.231/www/issues/issue4_4/friedman>.

Fullerton, Tracy. 2007. The Game Mechanics of Reality. Living Game Worlds III Symposium, Georgia Tech, Atlanta, GA, March 29, 2007.

Fullerton, Tracy. 2008. *Game Design Workshop: A Playcentric Approach to Innovative Games*, 2nd ed. Morgan Kaufman.

Gardner, Martin. 1970. Mathematical Games: The Fantastic Combinations of John Conway's New Solitaire Game "life." *Scientific American* 22 (October): 120–123.

Geertz, Clifford. 1973. *The Interpretation of Cultures*. New York: Basic Books.

Giles, Jim. 2005. Internet Encyclopedias Go Head to Head. *Nature* 438: 900–901. <http://www.nature.com/nature/journal/v438/n7070/full/438900a.html>.

Gingold, Chaim. 2005. What WarioWare Can Teach Us about Game Design. *Game Studies* 5 (1) <http://gamestudies.org/0501/gingold>.

Gleck, James. 1996. Little Bug, Big Bang. *New York Times* (December 1, 1996), Technology section, <http://www.nytimes.com/1996/12/01/magazine/little-bug-big-bang.html>.

Goffman, Erving. 1959. *Presentation of Self in Everyday Life*. New York: Anchor Books.

Goffman, Erving. 1967. *Interaction Ritual*. New York: Anchor Books.

Graetz, J. M. 1981. The Origin of Spacewar! *Creative Computing Video & Arcade Games* 1 (1): 78. <http://www.atarimagazines.com/cva/v1n1/spacewar.php>.

Green, William 2008. Big Game Hunter. *Time special issue: Summer Journey 2008 (July 19, 2008)*. <http://www.time.com/time/specials/2007/article/0,28804,1815747_1815707_1815665,00.html>.

Greenemeier, Larry. 2009. Inflated Expectations: Crowd-Sourcing Comes of Age in the DARPA Network Challenge. *Scientific American* (December 21, 2009). <http://www.scientificamerican.com/article.cfm?id=darpa-network-challenge-results>.

Gygax, Gary. 1978. *Advanced Dungeons & Dragons Players Handbook*. A compiled volume of information including character races, classes, and level abilities; spell tables and descriptions; equipment costs; weapons data; and information on adventuring. Lake Geneva, WI: TSR Hobbies; distributed in the United States by Random House.

Hearst, Marti. 2006. Design Recommendations for Hierarchical Faceted Search Interfaces. ACM SIGIR Workshop on Faceted Search, Seattle, WA, August 2006.

Hillis, Daniel W. 1998. *The Pattern on the Stone: The Simple Ideas That Make Computers Work*. Boston: Basic Books.

Huizinga, Johan. 1938; 1980. *Homo Ludens: A Study of the Play-Element in Culture*. London: Routledge.

Isbister, Katherine, K. Höök, J. Laaksolahti, M. Sharp. 2007. Sensual Evaluation Instrument: Developing a Trans-cultural Self-Report Measure of Affect. *International Journal of Human-Computer Studies* 65 (4): 315–328.

Iwatani, Toru. 1980. Pac-Man (videogame). Namco.

Jenkins, Henry. 2006. *Convergence Culture: Where Old and New Media Collide.* New York: New York University Press.

Jones, Dave. 1997. Grand Theft Auto. Rockstar Games.

Krzywinski, M. 2004. Schemaball: A New Spin on Database Visualization. *Sysadmin* 13 (8). <http://www.theillien.com/Sys_Admin_v12/html/v13/i08/a4.htm>.

Kubrick, Stanley. 1968. *2001: A Space Odyssey.* Film.

Kurzweil, Ray. 1999. The Coming Merging of Mind and Machine. *Scientific American*, Special Report on Robots (September 1, 1999). <http://www.scientificamerican.com/article.cfm?id=merging-of-mind-and-machine>.

Lakoff, George. 1987. *Women, Fire, and Dangerous Things: What Categories Reveal about the Mind.* Chicago: University of Chicago Press.

Lakoff, George, and M. Johnson. 1980. *Metaphors We Live By.* Chicago: University of Chicago Press.

Lamping, John, Ramana Rao, and Peter Pirolli. 1995. *A Focus+Context Technique Based on Hyperbolic Geometry for Visualizing Large Hierarchies.* Proceedings of the SIGCHI Conference on Human Factors in Computing Systems. Denver, CO: ACM/Addison-Wesley.

Laurel, Brenda. 1993. *Computers as Theater.* Reading, MA: Addison-Wesley.

Leveson, Nancy, and Clark S. Turner. 1993. An Investigation of the Therac-25 Accidents. *IEEE Computer* 26 (7): 18–41.

Levitt, Steven D., and Stephen J. Dubner. 2005. *Freakonomics: A Rogue Economist Explores the Hidden Side of Everything.* New York: William Morrow.

Levy, David N. L. 2007. *Love + Sex with Robots: The Evolution of Human-Robot Relations.* New York: HarperCollins.

Levy, Steven. 2009. Secret of Googlenomics: Data-Fueled Recipe Brews Profitability. *Wired* 17 (06). <http://www.wired.com/culture/culturereviews/magazine/17-06/nep_googlenomics>.

Library of Congress. 1997. Overview of the National Digital Library Program. <http://memory.loc.gov/ammem/dli2/html/lcndlp.html>, accessed August 14, 2010.

Lillios, Katina T. 2003. Creating Memory in Prehistory: The Engraved Slate Plaques of Southwest Iberia. In *Archeologies of Memory*, ed. R. V. Dyke and S. E. Alcott. Hoboken NJ: Wiley-Blackwell,126–150.

Lovelace, Ada Augusta. 1843. Notes by A. A. L. Taylor's Scientific Memoirs vol. III. London, Taylor, and Francis, 666–731.

Lynch, Kevin. 1960. *The Image of the City.* Cambridge, MA: MIT Press.

Manovich, Lev. 2001. *The Language of New Media.* Cambridge, MA: MIT Press.

Manovich, Lev. 2003. *Making Art of Databases*. Rotterdam: V2 Pub./NAi Pub.

Markoff, John. 2009. Scientists Worry Machines May Outsmart Man. *New York Times*.

Mateas, Michael, and Andrew Stern. 2003. Façade: An Experiment in Building a Fully-Realized Interactive Drama. Game Developers Conference. San Jose, CA.

Mateas, Michael and Andrew Stern 2005a. *Façade*, an interactive drama. <http://interactive story. net>.

Mateas, M., and A. Stern. 2005b. Structuring Content in the Façade Interactive Drama Architecture. Artificial Intelligence and Interactive Digital Entertainment (AIIDE). Los Angeles, June 2005. <http://www.interactivestory.net/papers/MateasSternAIIDE05.pdf>.

McGonigal, J. 2003. A Real Little Game: The Performance of Belief in Pervasive Play. Digital Games Research Association (DiGRA) "Level Up" Conference Proceedings, Utrecht, November 2003. <http://www.avantgame.com/MCGONIGAL%20A%20Real%20Little%20Game%20DiGRA% 202003.pdf>.

McGonigal, J. 2005. All Game Play Is Performance/Game Play Is All Performance. Manifesto for Playful: The State of the Art Game, May 2005. <http://avantgame.com/McGonigal_preview%20 manifesto_The%20State%20of%20the%20Art%20Game_May%202005.pdf>.

McLuhan, Marshall. [1964] 1995. *Understanding Media*. Cambridge, MA: MIT Press.

Meier, Sid 1991. Civilization. MicroProse, simulation game.

Miller, Christopher A. 2004. Human-Computer Etiquette: Managing Expectations with Intentional Agents: Introduction. *Communications of the ACM* 47 (4): 30–34.

Miller, George A. 1956. The Magical Number Seven, Plus or Minus Two: Some Limits on our Capacity for Processing Information. *Psychological Review* 63 (2): 343–355.

Miller, Robyn, Rand Miller. (1993). Myst. Broderbund.

Minsky, Marvin. 1986. *The Society of Mind*. New York: Simon and Schuster.

Miyamoto, Shigeru. 1981. Donkey Kong. Nintendo.

Miyamoto, Shigeru. 1985. Super Mario Brothers. Nintendo.

Miyamoto, Shigeru. 1986. Legend of Zelda. Nintendo.

Miyamoto, Shigeru. 1998. The Legend of Zelda: Ocarina of Time. Nintendo.

Montfort, Nick. 2003. *Twisty Little Passages: An Approach to Interactive Fiction*. Cambridge, MA: MIT Press.

Moreno, Eugene, Jay Bolter, and Blaire MacIntyre. 2001. *Alice's Adventures in New Media: An Exploration of Interactive Narratives in Augmented Reality*. Bonn, Germany: CAST.

Morningstar, Chip, and Randy Farmer. 1991. The Lessons of Lucasfilm's Habitat. In *Cyberspace: First Steps*, ed. M. Benedikt. Cambridge, MA: MIT Press, pp. 273-301.

Murray, Janet H. 1997. *Hamlet on the Holodeck: The Future of Narrative in Cyberspace*. New York: Simon & Schuster/Free Press.

Murray, J. H. 2003. Is there a story-game? In *First Person: New Media as Story, Performance, and Game*. eds. P. Harrington and N. Wardrip-Fruin. Cambridge, MA: MIT Press.

Murray, Janet H. 2006. Toward a Cultural Theory of Gaming: Digital Games and Co-evolution of Media, Mind and Culture. *Popular Communication* 4 (3): 185–202.

Nass, Clifford, and Jonathan Steuer, Ellen R. Tauber. 1994. Computers Are Social Actors. *CHI '94: Human Factors in Computing Systems*. Boston: ACM Press, 72–78.

Negroponte, Nicholas. 1995. *Being Digital*. New York: Knopf.

Nelson, Theodor. 2007. *Transclusion: Fixing Electronic Literature*. Google Video.

Nelson, Theodor. 1974a. *Computer Lib: You Can and Must Understand Computers Now*. Chicago: Nelson, [reprint available from Hugo's Book Service].

Nelson, Theodor. 1974b. *Dream Machines: New Freedoms through Computer Screens—A Minority Report*. Chicago: Nelson, [reprint available from Hugo's Book Service].

Nelson, Theodor. 1987. *Computer Lib; Dream Machines*. Redmond, WA: Tempus Books of Microsoft Press.

Nelson, Theodor. 1992. *Literary Machines 93.1*. Sausalito, CA: Mindful Press.

Neumann, Peter G. 1990. Cause of AT&T Network Failure. *The Risks Digest*. 9 (62). <http://www.phworld.org/history/attcrash.htm>.

Nintendo. 2003. WarioWare: Mega Microgames. Nintendo.

Nitsche, Michael. 2008. *Video Game Spaces: Image, Play, and Structure in 3D Game Worlds*. Cambridge, MA: MIT Press.

Norman, Donald. 1988. *The Psychology of Everyday Things* (later reissued as *The Design of Everyday Things*). New York: Basic Books.

Norman, Donald. 1998. *The Invisible Computer: Why Good Products Can Fail, the Personal Computer Is So Complex, and Information Appliances Are the Solution*. Cambridge, MA: MIT Press.

Norman, Kent. 2005. *Computer Rage: Exploring Distributions of Frustration and Dealing with Issues in the Analysis of an Online Survey*. University of Maryland. Unpublished Study. <http://lap.umd.edu/computer_rage>.

Nunberg, Geoffrey. 2009. Google's Book Search: A Disaster for Scholars. *The Chronicle Review*. (August.) <http://chronicle.com/article/Googles-Book-Search-A/48245>.

Nystrand, Martin. 1982. *What Writers Know: The Language, Process, and Structure of Written Discourse*. New York: Academic Press.

On, Josh. 2004. They Rule. Interactive application. <http://www.theyrule.net/2004/tr2.php>, accessed February 26, 2011.

Onyett, Charles. 2009. Red Dead Redemption: A Man and His Horse: The First Part of an Epic Talk with Rockstar Co-founder Dan Houser. IGN. <http://xbox360.ign.com/articles/981/981349p1.html>, accessed September 10, 2010.

Papert, Seymour. 1980. *Mindstorms: Children, Computers, and Powerful Ideas*. New York: Basic Books.

Partlett, David. 1999. *The Oxford History of Board Games*. Oxford: Oxford University Press.

Pawlowski, Suzanne D., Dan Robey, and Arhab Raveb. 2000. Supporting Shared Information Systems: Boundary Objects, Communities, and Brokering. International Conference on Information Systems (ICIS), Brisbane, Queensland Australia, December 1013, 2000, 329338.

Pearce, Celia. 2009. *Communities of Play: Emergent Cultures in Multiplayer Games and Virtual Worlds*. Cambridge, MA: MIT Press.

Perlis, Alan J. 1996. Foreword. In *Structure and Interpretation of Computer Programs*, H. Abelson and G. J. Sussman. Cambridge, MA: MIT Press.

Petroski, Henry. 2000. *The Pencil*. New York: Knopf.

Reas, Casey, Ben Fry. 2007. *Processing: A Programming Handbook for Visual Designers and Artists*. Cambridge, MA: MIT Press.

Reeves, Byron, Clifford I. Nass. 1996. *The Media Equation: How People Treat Computers, Television, and New Media Like Real People and Places*. Stanford, CA; New York: CSLI Publications; Cambridge University Press.

Rockstar San Diego. 2010. Red Dead Redemption. Rockstar Games.

Rohrer, Jason. 2007. Passage. Art game. <http://hcsoftware.sourceforge.net/passage>.

Rokeby, David. 2001–2004. Machine for Taking Time. Art installation. <http://homepage.mac.com/davidrokeby/machine.html>.

Rosch, Eleanor. 1975. Cognitive Representation of Semantic Categories. *Journal of Experimental Psychology* 104: 192–233.

Ruiz, Suzanna, Ashley York, Mike Stein, Noah Keating, Kellee Santiago. 2006. Darfur Is Dying. mtvU. <http://www.darfurisdying.com>.

Salen, Katie, and Eric Zimmerman. 2003. *Rules of Play: Game Design Fundamentals*. Cambridge, MA: MIT Press.

Samanci, Özge. 2009. *Embodying Comics: Reinventing Comics and Animation for a Digital Performance*. Gedrgia Institute of Technology. Dissertation.

Shadbolt, Nigel, Wendy Hall, and Tim Berners-Lee. 2006. The Semantic Web Revisited. *IEEE Intelligent Systems* (May/June).

Shannon, Claude, and Warren Weaver. 1963. *Information Theory*. Urbana-Champaign: University of Illinois Press.

Shechtman, N., and L. M. Horowitz. 2003. Media Inequality in Conversation: How People Behave Differently When Interacting with Computers and People. Proceedings of the SIGCHI conference on Human Factors in Computing Systems, Ft. Lauderdale, FL: ACM Press.

Shneiderman, Ben. 1992a. *Designing the User Interface: Strategies for Effective Human-Computer Interaction*. Reading, MA: Addison-Wesley.

Shneiderman, Ben. 1992b. Tree Visualization with Tree-Maps: 2-d Space-filling Approach. *ACM Transactions on Graphics* 11 (1): 92–99.

Shneiderman, Ben, and Catherine Plaisant. 2009. Treemaps for space-constrained visualization of hierarchies, posted December 26, 1998–June 25, 2009. <http://www.cs.umd.edu/hcil/treemap-history/index.shtml>, accessed March 5, 2011.

Spielberg, Steven. 2002. *Minority Report*. Film.

Starr, Paul. 1994. Seductions of Sim: Policy as a Simulation Game. *American Prospect* 17 (Spring): 19–29.

Suchman, Lucy A. 1987. *Plans and Situated Actions: The Problem of Human–Machine Communication*. Cambridge, UK: Cambridge University Press.

Suchman, Lucy A. 2007. *Human–Machine Reconfigurations: Plans and Situated Actions*. Cambridge, UK: Cambridge University Press.

Surowiecki, James. 2004. *The Wisdom of Crowds: Why the Many Are Smarter than the Few and How Collective Wisdom Shapes Business, Economies, Societies, and Nations*. New York: Doubleday.

Sutton-Smith, Brian. 1997. *The Ambiguity of Play*. Cambridge, MA: Harvard University Press.

Sutton-Smith, Brian., and Anthony D. Pellegrini. 1995. *The Future of Play Theory: A Multidisciplinary Inquiry into the Contributions of Brian Sutton-Smith*. Albany: State University of New York Press.

Svenonius, Ellen. 2001. *The Intellectual Foundation of Information Organization*. Cambridge, MA: MIT Press.

Tomasello, Michael. 2001. *The Cultural Origins of Human Cognition*. Cambridge, MA: Harvard University Press.

Tuan, Yi-Fu. [1976] 2001. *Space and Place: The Perspective of Experience*. University of Minnesota Press.

Tufte, Edward. 1983. *The Visual Display of Quantitative Information*. Cheshire, CT: Graphics Press.

Tufte, Edward. 2006. The Cognitive Style of Powerpoint (pamphlet). Graphics Press.

Turing, A. M. 1950. Computing Machinery and Intelligence. *Mind* 59: 433–460.

Turner, Victor. 1966. *Ritual Process: Structure and Anti-structure*. Chicago: Aldrine.

Turkle, Sherry. 1984. *The Second Self: Computers and the Human Spirit*. New York: Simon and Schuster.

Utterback, Camille. 1999. *Text Rain*. Interactive art installation documented at <http://camilleutterback.com/projects/text-rain>, accessed March 4, 2011.

Utterback, Camille. 2000–2002. *Liquid Time Series*. Interactive art installations documented at <http://camilleutterback.com/projects/liquid-time-series>.

Viégas, Fernanda B., Martin Wattenberg, Kushal Dave. 2004. Studying Cooperation and Conflict between Authors with *history flow* Visualizations. CHI '04, Vienna, Austria, April 24–29, 575–582.

Zynga. 2009. Farmville. Networked game available on <http://facebook.com>.

Wardrip-Fruin, Noah. 2009. *Expressive Processing: Digital Fictions, Computer Games, and Software Studies*. Cambridge, MA: MIT Press.

Weizenbaum, Joseph. 1966. Eliza—A Computer Program for the Study of Natural Language Communication between Man and Machine. *Communications of the Association for Computing Machinery* (ACM) 9 (1): 36–45.

Weizenbaum, Joseph. 1976. *Computer Power and Human Reason*. New York: Freeman.

Winograd, Terry. 1996. *Bringing Design to Software*. Reading, MA: Addison-Wesley.

Winograd, Terry. 1997. From Computing Machinery to Interaction Design. In *Beyond Calculation: The Next Fifty Years of Computing*, ed. Peter Denning and Robert Metcalfe, 149–162. New York: Springer-Verlag.

Wittgenstein, Ludwig. 1958. *Philosophical Investigations*. New York: MacMillan.

Wright, Will. 1989. SimCity. Maxis Software.

Wright, Will 2001. The Sims. Maxis Software.

Wright, Will 2008. Spore. Maxis Software.

Zaslow, Jeffrey. 2002. If TiVo Thinks You Are Gay, Here's How to Set It Straight. *Wall Street Journal*, November 26, 2002.

Image Credits

0.1 Top row: Promotional image, Oster, and promotional image, Pop Art, from <http://gizmodo.com>. Bottom row: Promotional image, Philips; promotional image, Ivo Vos, Toaster from Brunch collection, <http://www.ivovos.com/brunch.php>.

0.2 Promotional image, <http//flipboard.com>, accessed June 15, 2011.

0.3 Interaction feature, Catan: The First Island for iPhone, exozet games.

0.4 Author's photograph of TV broadcast, June 2009, ABC7 Los Angeles.

0.5 From Leisner, G., and Vera Leisner (1951). Antas do Concelho de Reguengos de Monsaraz. Lisbon, Uniarch. Available at <http://research2.its.uiowa.edu>, the ESPRIT archive, compiled by Katina Lilios. Courtesy of Katina Lilios.

0.6 Interaction feature from <http://nytimes.com>, accessed June 15, 2011.

1.1 Interaction feature from <http://landsend.com>, accessed August 27, 2010.

1.2 Interaction feature from <http://macys.com>, accessed October 26, 2010.

1.3 Interaction feature from <http://macys.com>, accessed May 31, 2010.

1.4 Interaction feature from <http://landsend.com>, accessed May 31, 2010.

1.5 Mary Flanagan's [giant Joystick] (2006), courtesy of Mary Flanagan. See <http://maryflanagan.com/giant-joystick>, accessed June 15, 2011.

1.6 Left: Promotional image of Clay tablet from <http://christianimageresource.org/catalog7.html>. Right: Promotional image, <http://perceptivepixel.com>, founded by Jefferson Y. Han of NYU, <http://cs.nyu.edu/~jhan/ftirtouch>, all accessed June 15, 2011.

1.7 Promotional image from <http://apple.com>, accessed June 15, 2011.

1.8 Douglas Engelbart's Mouse, composite made by author from U.S. Government Patent 3,541,541and still frame from recording of demonstration "A Research Center for Augmenting Human Intellect," December 1968, available at <http://dougengelbart.org>, accessed August 27, 2010.

2.1 Interaction feature from Adobe Flash.

2.2 Interaction feature from <http://facebook.com>, accessed August 27, 2010.

2.3 Interaction feature from <http://amazon.com>, accessed August 27, 2010.

2.4 Interaction feature from Google Map Street View, accessed October 26, 2010.

2.5 Interaction feature from <http://youtube.com>, accessed June 13, 2010.

2.6 Promotional images from BBCTV, accessed August 27, 2010.

2.7 Promotional image, Microsoft Corporation.

2.8 GPS System, promotional image, Sanyo.

2.9 Promotional images for <http://yelp.com>, accessed June 15, 2011.

2.10 Images by Artemesia, courtesy of Celia Pearce, reprinted from *Communities of Play: Emergent Cultures in Multiplayer Games and Virtual Worlds* (MIT Press 2009).

2.11 The Sensual Evaluation Instrument (SEI) from (Isbister et al. 2007), courtesy of Katherine Isbister.

2.12 My Life Bits project documentation by Gordon Bell, from PowerPoint, Auto Digital Diary Using Location (2007), available from <http://research.microsoft.com/en-us/um/people/gbell/Auto_Digital_Diary_using_location.ppt>, accessed October 26, 2010.

2.13 Interaction feature illustrating Google Books, from <http://books.google.com>, accessed August 27, 2010.

2.14 Image of Xerox Star taken from <http://digibarn.com>, where it appears thanks to Dave Curbow. Digibarn curator is Bruce Damer. Used under Creative Commons Attribution-Noncommercial 3.0 license, accessed June 15, 2011.

2.15 Images illustrating interaction feature of Lisa Office System version 3.1. Courtesy of J. Musheneaux, who created the screenshot, and Nathan Linebeck, creator of Toasty Tech website, <http://toastytech.com/guis/lisaos3.html>, accessed June 15, 2011.

2.16 Interactive features from Apple Macintosh, image from Wikipedia, source unknown. Operating system copyright Apple Computer.

2.17 Interaction feature from Spacewar! (1962), programmed by Steve Russell, Martin Graetz, and Wayne Witaenem at MIT on the DEC PDP-1.

2.18 Aspen Interactive Movie Map (1978), created by the Architecture Machine Group at MIT, the forerunner of the MIT Media Lab. Image courtesy of Andrew Lippman.

2.19 Still image from promotional video (2008), copyright material from Disney World and Google Earth, available from YouTube at <http://www.youtube.com/watch?v=_wmdCeFUQH4>, accessed August 28, 2010.

2.20 Santa Barbara Allospere, still image from informational video at <http://www.allosphere. ucsb.edu>, accessed September 7, 2010.

2.21 Interactive feature from Amazon.com, accessed June 3, 2010.

2.22 Interactive feature from Visual Dictionary Online, <http://visual.merriam-webster.com>, accessed August 28, 2010.

2.23 Charles Joseph Minard, *Figurative chart of the successive losses in men by the French army in the Russian campaign 1812–1813* (1869). Public Domain.

2.24 Interactive feature, British Heart Foundation, designed by Sennep, from <http://www.bhf. org.uk/annualreview2008/#/home>, accessed June 15, 2011.

3.1 Graph of Wikimedia growth, from Wikipedia Commons, <http://en.wikipedia.org/wiki/ History_of_wikipedia>, accessed June 15, 2011.

3.2 Earliest Wikipedia entry, from Wikipedia Commons, <http://en.wikipedia.org/wiki/ Wikipedia:UuU>, accessed June 15, 2011.

3.12 Promotional image for Pac-Man (Namco 1980), designed by Toru Iwatani.

3.13 Interaction feature from <http://unam.com>, accessed November 6, 2009.

4.1 Vacuum tube image from Wikimedia Commons, <http://en.wikipedia.org/wiki/File:Ibm-tube.jpg, contributed by Dave Fischer, accessed June 15, 2011.

4.2 Promotional image, from <http://innovision-group.net>, accessed June 15, 2011.

4.3 Promotional image, Intel Tukwila (later called Itanium) chip.

4.6 Still image from video available at <http://www.youtube.com/watch?v=vxENKlcs2Tw>, from <http://www.zutopedia.com> (accessed August 29, 2010).

4.7 Interaction feature from Apple operating system.

4.9 Excerpts from Will Wright's notes dated January 23, 1997, scanned and posted by Don Hopkins, available at <http://www.donhopkins.com/drupal/node/148>, in"The Soul of the Sims," posted February 10, 2008, accessed March 5, 2011. Used by permission of Will Wright.

4.10 Promotional image for Super Mario Brothers, Nintendo DS version.

5.1 Promotional image, World of Warcraft (Blizzard Entertainment, 2004), image retrieved 2010.

5.2 Promotional image, Facade (2005), by Michael Mateas and Andrew Stern.

5.4 Promotional image, Sim City 2000 (Maxis).

5.5 Interaction features, Lemonade Stand games. Screenshots: left from the Yahoo Games Lemonade Tycoon; upper right from iPhone app Lemonade Stand; lower right from <http:// lemonadestandgame.com> web-based game, accessed June 15, 2011.

5.6 Still image from animated gif made by Rodrigo Silveira Camargo on March 10, 2008, for Wikimedia Commons, <http://en.wikipedia.org/wiki/File:Gospers_glider_gun.gif>, accessed June 15, 2011. Public domain.

5.7 Promotional image, Darfur is Dying, designed by Susana Ruiz <http://www.darfurisdying. com>, accessed June 15, 2011.

5.8 Interaction feature, Madrid (2004), by Gonzalo Frasca, <http://www.newsgaming.com/ newsgames.htm>, accessed June 15, 2011.

5.9 Interaction feature, Madrid (2004), by Gonzalo Frasca, <http://www.newsgaming.com/ newsgames.htm>, accessed June 15, 2011.

5.10 Promotional image, Peacemaker (Impact Games 2006), <http://www.peacemakergame. com>, accessed June 15, 2011.

5.11 Oil God by Persuasive Games (2006), available at <http://www.persuasivegames.com>, accessed June 15, 2011. Image courtesy of Ian Bogost.

6.1 Interaction features from Apple operating system.

6.2 Interaction features from <http://www.risd.edu>, <http://nsf.gov>, <http://nytimes.com>, and <http://washingtonpost.com>, accessed September 11, 2010.

6.3 Promotional image of FlipBoard from <http://flipboard.com>, accessed June 15, 2011.

6.4 Interaction feature, Google's Chrome Browser.

6.5 Shiftbrowse (2009), Georgia Tech Digital Media Masters Project, used by permission of creator Abhishek Gupta.

6.6 Interaction feature from <http://tsquare.gatech.edu>, accessed June 15, 2011.

6.7 Promotional image, Red Dead Redemption (Rockstar Games 2010).

6.8 Promotional images, Second Life.

6.9 Interaction features, BBC Archive online at <http://www.bbc.co.uk/archive>, accessed October 29, 2010.

6.10 Zork Map, created by Steven Roy, published in The DEC Professional, November 1982, scanned and reproduced widely on Internet.

6.11 Interaction feature, Akamai, <http://www.akamai.com/html/technology/visualizing_ akamai.html>, accessed June 15, 2011.

6.12 Interaction feature, <http://maps.panedia.com>, accessed December 18, 2009.

6.13 Interaction feature, <http://bandittracker.com/map>, accessed December 18, 2009.

6.14 Interaction feature, <http://nytimes.com>, published April 2, 2010.

6.15 Social network diagram from Wikimedia Commons, created with public domain graph visualization software, Guess, <http://graphexploration.cond.org>, accessed June 15, 2011.

6.16 Promotional image, Myst (Broderbund 1993), by Robyn and Rand Miller.

6.17 Promotional image, Legend of Zelda (Nintendo 1986), by Shigeru Miyamoto.

6.18 Zelda: The Ocarina of Time (Nintendo 1998), by Shigeru Miyamoto, fair use, from Wikipedia, <en.wikipedia.org/wiki/File: ZELDA_OCARINA_OF_TIME.jpg>, accessed June 15, 2011.

6.19 Promotional image, Grand Theft Auto III (Rockstar Games 2001).

6.20 Interaction feature.

6.21 Promotional image, Virtual Iraq, from Virtually Better, <http://www.virtuallybetter.com/IraqOverview.html>, accessed June 15, 2011.

6.22 Promotional image from <http://www.virtusphere.com>, accessed June 15, 2011.

6.23 Promotional image from Cisco, <http://www.cisco.com/en/US/netsol/ns669/networking_solutions_solution_segment_home.html>, accessed June 15, 2011.

6.24 Interaction Feature, Baby Name Voyager (2005).

6.25 Interaction Feature, SIMILE Timeline.

6.26 Treemap created by Jean-Daniel Fekete and Catherine Plaisant (2002), used by permission of the creators.

6.27 Interaction feature, <http://newsmap.jp>.

6.28 Promotional image from Zylab, <http://www.zylab.com/Solutions/visualization.html>, accessed October 31, 2010.

6.29 Interaction feature from JavaScript InfoVis Toolkit, <http://thejit.org>, accessed September 12, 2010.

6.30 Promotional image, visualization made by Martin Krzwinski's Schemaball, <http://mkweb.bcgsc.ca/schemaball>, accessed June 15, 2011.

6.31 Interaction feature, <http://nytimes.com>, published December 15, 2007.

7.1 From Understanding MARC, Library of Congress, <http://www.loc.gov/marc/umb>, accessed November 5, 2010.

7.2 Adapted from Understanding MARC, Library of Congress, <http://www.loc.gov/marc/umb>, accessed December 4, 2010.

7.3 Adapted from Library of Congress wsite, <http://www.loc.gov/standards/mods/mods-outline.html>, accessed November 5, 2010.

7.4 Adapted from Library of Congress website, <http://www.loc.gov/standards/mods/mods-outline.html#typeOfResource>, accessed November 5, 2010.

7.5 Interaction elements from Duke Online Papyrus Archive, Magical Handbook fragment (Item 749v) in Duke Rare Books, Manuscripts, and Special Collections Library, <http://scriptorium.lib. duke.edu/papyrus/images/150dpi/729v-at150.gif>, accessed September 2, 2010. Used by permission of Duke University.

7.6 Screenshot of interaction feature with promotional image, <http://amazon.com>, accessed October 31, 2010.

7.7 Screenshot of interaction feature from ACM Digital Library, <http://portal.acm.org>, Beta version of interface, accessed September 3, 2010.

7.8 Excerpted from Google Maps, <http://maps.google.com>, accessed July 4, 2010.

7.9 Excerpted from MIT Campus Map, <http://mit.edu>, accessed July 4, 2010.

7.10 Excerpted from Library of Congress online catalog, <http://catalog.loc.gov>, accessed November 5, 2010.

7.11 Author's photograph of sign at Georgia Aquarium, July 2010.

7.12 Chart from public information. Dewey Decimal system is administered by the Online Computer Library Center (OCLC), <http://www.oclc.org/dewey>.

7.13 Chart of public information from Library of Congress, <http://loc.gov>, accessed June 15, 2011.

7.14 Interaction feature, AOL Web Portal Services, <http://aol.com>, accessed December 4, 2010.

7.15 Interaction feature, Yahoo Web Portal Services List, <http://yahoo.com>, accessed December 4, 2010.

7.16 Interaction feature, <http://MSNBC.com>, accessed September 3, 2010.

7.17 Interaction feature, <http://nytimes.com>, accessed October 31, 2010.

7.18 Interaction feature, Library of Congress, <http://loc.gov>, accessed November 5, 2010.

7.19 Interaction feature, Washington Post <http://washingtonpost.com>, accessed November 5, 2010.

7.20 Interaction feature, Wikipedia, Analytic Philosophy entry, <http://en.wikipedia.org/wiki/ Analytical_philosophy>, accessed November 5, 2010.

8.1 Interaction feature, Palm Desktop.

8.2 Promotional image, <http://www.hudl.com>, accessed September 3, 2010.

8.3 Promotional image for Lev Manovich's *Soft Cinema: Navigating the Database* (2005).

8.4 Interaction feature, Georgia Tech online system for faculty, <http://oscar.gatech.edu>, accessed December 13, 2009.

8.5 Interaction feature, <http://www.smartmoney.com/map-of-the-market>, accessed September 3, 2010.

8.6 Interaction feature of gapminder software, <available at http://gapminder.com>, using composite of still images from Hans Rosling's talk "200 years that changed the world," available at <http://gapminder.com> and <http://youtube.com>, accessed September 3, 2010.

8.7 Interaction feature of Guardian Data Store and Data Blog from <http://www.guardian.co.uk/data-store> and <http://www.guardian.co.uk/news/datablog>, accessed September 11, 2010.

8.8 Census Form, U.S. Government, 2010.

8.9 Interaction feature, <http://theyrule.net>, accessed July 11 2009.

9.1 Promotional image for Ted Nelson's Xanadu system, <http://www.xanadu.com.au>, accessed September 4, 2010.

9.2 Interaction feature, <http://gnu.org>, accessed July 21, 2009.

9.3 Interaction feature, <http://www.architecture.org>, accessed July 21, 2009.

9.4 Interaction feature, <http://twitter.com>, accessed September 4, 2010.

9.5 Interaction feature, tag cloud from <http://flickr.com>, accessed March 11, 2007.

9.6 Interaction feature, tag cloud from <http://delicious.com>, accessed September 4, 2010.

9.7 MARC record from the Library of Congress, <http://www.loc.gov/marc/bibliographic/examples.html#motion>, accessed March 4, 2011.

9.8 Dublin Core Metadata Element Set 1.1, <http://dublincore.org/documents/dces> and <http://dublincore.org/documents/dcmi-type-vocabulary>, accessed September 4, 2010.

9.9 Interaction feature, <http://craigslist.org>, November 1, 2010.

9.10 Wikipedia disambiguation page for "Force," accessed November 1, 2010.

9.11 Interaction features from <http://google.com>, <http://yahoo.com>, and <http://bing.com>, accessed November 1, 2010.

9.12 Interaction feature, <http://google.com>, accessed November 1, 2010.

9.13 Interaction feature, <http://yahoo.com>, accessed November 1, 2010.

9.14 Interaction feature, <http://bing.com>, accessed November 1, 2010.

9.15 Interaction feature, <http://nytimes.com>, July 15 2010.

9.16 Interaction feature, <http://nytimes.com>, July 15 2010.

9.17 Interaction feature, Flamenco search engine, designed by Marti Hearst, <http://orange.sims.berkeley.edu/cgi-bin/flamenco.cgi/nobel/Flamenco>, accessed September 4, 2010.

9.18 Interaction feature from <http://deadline.com, <http://gizmodo.com>, <http://huffpost.com>, <http://allisonwinnscotch.blogspot.com>, <http://injennifershead.com>, <http://timbeyers.com>, accessed September 4, 2010.

9.19 Interaction element, <http://Wikipedia.com>, accessed September 4, 2010.

9.20 Policies and guidelines, <http://Wikipedia.com>, accessed September 4, 2010.

10.1 Promotional image, Sony Corporation.

10.2 Promotional image, Brookstone.

10.3 Promotional image, iPad, Apple computer.

10.4 *Text Rain* (1999), by Camille Utterback and Romy Achituv. Interactive installation and screen view, courtesy of Camille Utterback.

10.5 Promotional Image for *Minority Report* (2002), directed by Steven Spielberg, Dreamworks/Twentieth Century Fox.

10.6 Emmanuel Moreno, Jay Bolter, and Blair MacIntyre, Augmented Alice Project (2001), images courtesy of the developers.

10.7 Promotional image, IRISCOM system (2009), <http://www.iriscom.org/webant/english.htm>, accessed December 14, 2010.

10.8 Promotional image, Brain Ball (2001), Interactive Institute, Sweden, project leader Magnus Jonsson, <http://www.mindball.se>, accessed December 14, 2010.

10.9 Promotional image, Mindflex.

10.10 Interaction element, Photoshop CS2.

10.11 Interaction feature, Microsoft Word 2008.

10.12 Interaction feature, Chrome browser 9.0 (2010).

10.13 Promotional image, EA Mobile version of the The Sims.

10.14 Promotional image, SONY DualShock 3 game controller.

10.15 Interaction feature, Heavy Rain (Quantic Dream 2010).

10.16 Promotional image, Twiddler, <http://www.handykey.com>, accessed June 15, 2011.

10.17 Promotional image, iPad, Apple computer.

10.18 Promotional image, <http://perceptivepixel.com>, founded by Jefferson Y. Han of NYU, <http://cs.nyu.edu/~jhan/ftirtouch>, accessed June 15, 2011.

10.19 Sketchtop, Multitouch Table project, created by Paul Clifton, Ali Mazalek, Jon Sanford at Georgia Tech, courtesy of developers.

10.20 Image from research documentation video, MIT Media Lab, Pattie Maes and Pranav Mistry, Sixth Sense from <http://www.pranavmistry.com/projects/sixthsense/#VIDEOS>, accessed November 1, 2010.

10.21 *Egg's Journey* (2007), created by Ozge Samanci, Yanfeng Chen, and Ali Mazalek, <http://synlab.gatech.edu>, accessed June 15, 2011. Stills from documenting video.

11.3 Interaction feature, Microsoft Word 2008 for Mac (2010).

11.4 Promotional image from Rookie Guide, World of Warcraft, <http://www.wow.com/rooki>, accessed November 2, 2010.

11.5 Interaction feature, <http://tsquare.gatech.edu>, accessed July 17, 2010.

11.6 Promotional image from Fetch Softworks, <http://fetchsoftworks.com>, accessed August 4, 2008.

11.7 Photograph by author of TiVo interaction element.

11.8 Interaction feature, Adobe Photoshop CS2.

11.9 Interaction feature, Adobe Photoshop CS2.

11.10 Promotional image, World of Warcraft (2004), Blizzard Entertainment, published with review in <http://pc.gamespy.com/pc/world-of-warcraft/571585p4.html>, accessed November 2, 2010.

11.11 Interaction element, Microsoft Word 2008 for the Mac.

11.12 Interaction element, Adobe Photoshop CS2.

11.13 Promotional image, Amazon Kindle.

11.14 iPhone 4.2 Widgets screen capture (2010).

11.15 Promotional images from CoMotion, produced by General Dynamics <http://www.gdc4s.com/content/detail.cfm?item=32341561-76f9-40f8-8ad5-0f0d66dd240e>, accessed November 2, 2010.

12.1 Promotional image, Guitar Hero (RedOctane 2005).

12.2 Public domain, Wikimedia Commons, 20th Century RCA trademark derivative of painting by British artist Francis Barraud entitled "His Late Master's Voice."

12.3 Promotional image, iPod, Apple Computer.

12.4 Interaction element with promotional images, <http://netflix.com>, accessed September 5, 2010.

12.5 Interaction element with promotional images, <http://amazon.com>, accessed November 2, 2010.

12.6 Interaction element with promotional images, from <http://gmail.com>, accessed September 5, 2010.

12.7 Images of two robots created by Cynthia Breazeal of MIT. Kismet photograph (2005) from Wikimedia commons, taken by Jared C. Benedict; Leonardo photo from project documentation at <http://robotic.media.mit.edu>, accessed August 2008.

12.8 Promotional image, Microsoft corporation; promotional image, Fetch Softworks, accessed September 5, 2010.

12.9 Promotional image, Microsoft corporation.

12.10 Promotional image, Microsoft corporation.

12.11 Promotional image, Torchlight (Runic Games 2009).

12.12 Still image from promotional video, Apple Computer (1987), <http://video.google.com/videoplay?docid=-5144094928842683632#>, accessed November 2, 2010.

12.13 Still image from promotional video, Microsoft Corporation, research by Dan Bohus and Eric Horvitz, Medical Baysian Kiosk, Situated Interaction Project, <http://research.microsoft.com/enus/um/people/horvitz/Medical_Bayesian_Kiosk.wmv>, accessed July 29, 2010.

12.14 Logo of search engine, <http://ask.com>, accessed March 10, 2008.

12.15 Promotional image, Roomba, <http://irobot.com>, accessed June 15, 2011.

12.17 Interaction element, <http://google.com>, accessed July 22, 2010.

12.18 Interaction element, Microsoft Word 2008 for Mac.

13.1 Promotional image, Pac-Man (Namco 1980), designed by Toru Iwatani.

13.2 Interaction feature, Donkey Kong (Nintendo 1981), designed by Shigeru Miyamoto; still image from video of tool-assisted speedrun of NES version, played by Phil Coté, available at <http://tasvideos.org> and <http://www.youtube.com/watch?v=Qr351cwtieI>, accessed October 28, 2010.

13.3 Promotional screenshot for Super Mario 3 on the Wii (2007), <http://media.wii.ign.com/media/950/950868/imgs_1.html>, accessed November 2, 2010.

13.4 Interaction Features, WarioWare (Nintendo 2003).

13.5 Chart courtesy of Chaim Gingold. From C. Gingold (2005), "What WarioWare can teach us about Game Design," *Game Studies* 5(1).

13.6 Promotional image, Jason Rohrer's Passage (2007), <http://hcsoftware.sourceforge.net/jason-rohrer>, accessed March 4, 2011.

13.7 Promotional image of experimental game Braid (2008), created by Jonathan Blow, available at <http://braid-game.com>, accessed December 30, 2009.

13.8 Promotional image for Improv everywhere MP3 Experiment 7 (2010), videos available at <http://improveverywhere.com> or on YouTube channel, accessed November 2, 2010.

13.9 Promotional image, FarmVille (Zynga 2009).

13.10 Taken from <http://members.cox.net/brucemohler/D&D/odnd.HTML>, where it is described as part of the original Dungeons and Dragons rules, public domain, accessed August 6, 2009.

13.11 Image of D&D dice from Wikimedia Commons, contributed by franganghi, <http://commons.wikimedia.org/wiki/File:Dice_in_DnD_session.jpg>, accessed August 6, 2009.

13.12 Promotional image, World of Warcraft, Blizzard, <http://www.wowarmory.com/talent-calc.xml?c=Rogue>, accessed December 27, 2009.

13.13 Liquid Time—Tokyo (2000–2002), by Camille Utterback, interactive installation view, courtesy of the artist.

13.14 Machine for Taking Time (2001–2004), by David Rokeby, video documentation at <http://homepage.mac.com/davidrokeby/machine.html>, accessed June 15, 2011. Image courtesy of the artist.

13.15 Royal Game of Ur, in the British Museum, image available through Wikimedia Commons, accessed July 24, 2010.

13.16 Promotional image for Goban application for playing Go online, <http://www.sente.ch/software/goban>, accessed November 3, 2010.

13.17 Sarah Cooper, *Reliving Last Night* (2001), masters project, Georgia Tech Graduate Program in Information Design and Technology, Georgia Tech. Image courtesy of Sarah Cooper.

Index

Page numbers in italics indicate figures or tables.